TURNER AND ITALY

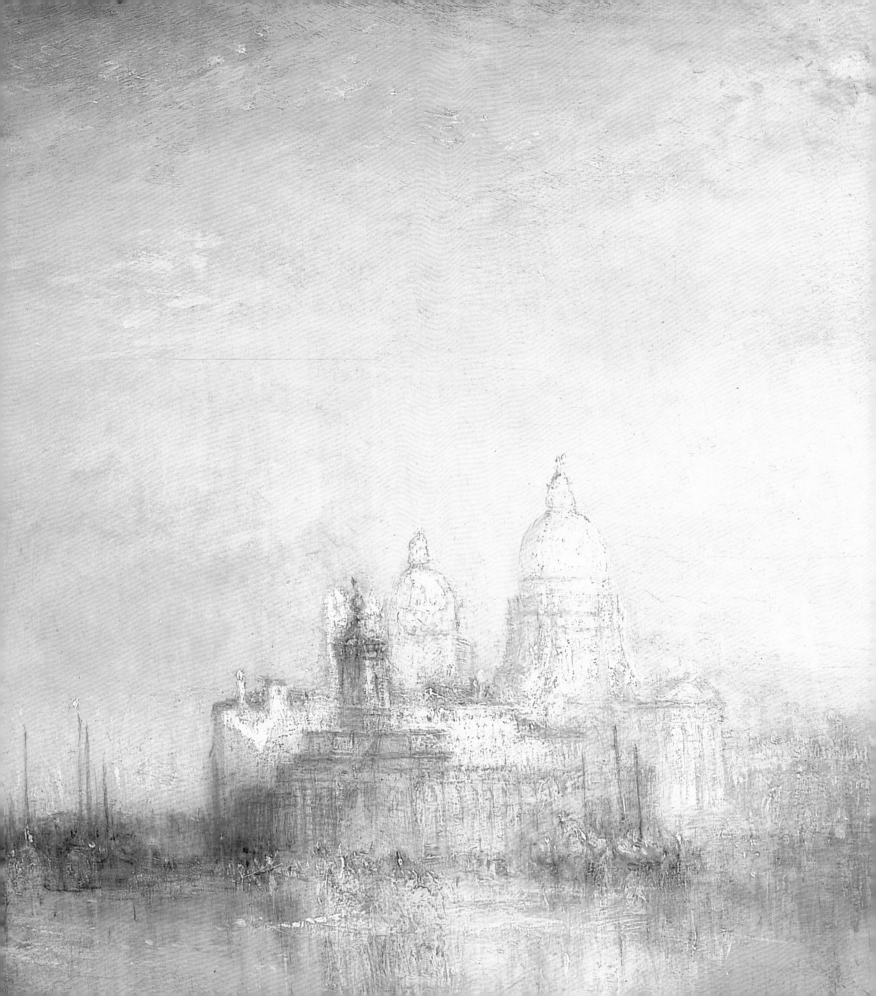

JAMES HAMILTON

WITH CONTRIBUTIONS FROM CHRISTOPHER BAKER
NICOLA MOORBY & JACQUELINE RIDGE

TURNER & ITALY

NATIONAL GALLERIES
OF SCOTLAND

EDINBURGH
2009

Published by the Trustees of the National Galleries
of Scotland, Edinburgh, to accompany the exhibition
Turner and Italy held at the National Gallery Complex,
Edinburgh from 27 March to 7 June 2009, organised
by the National Gallery of Scotland and Ferrara Arte in
collaboration with the Museum of Fine Arts, Budapest.

ISBN 978 1 906270 16 2

Designed by Dalrymple
Typeset in Garamond Premier and Throhand
Printed on 150gsm Gardamat by Conti Tipocolor, Italy

Unless otherwise stated all works illustrated
are by J.M.W. Turner

Front cover: detail from *Modern Rome – Campo Vaccino*,
1839 [94], The Rosebery Collection on loan to the
National Gallery of Scotland

Frontispiece: detail from *Dogana, and Madonna della
Salute, Venice,* 1843 [112], National Gallery of Art,
Washington DC, given in memory of Governor Alvan
T. Fuller by The Fuller Foundation, Inc.

Back cover: *Turner's Bedroom in the Palazzo Giustiniani
(the Hotel Europa), Venice,* 1840 [109], Tate, London

The proceeds from the sale of this book go towards
supporting the National Galleries of Scotland, a charity
registered in Scotland (no. SC003728)

www.nationalgalleries.org

Contents

7 Foreword

9 Introduction *Christopher Baker*

TURNER AND ITALY *James Hamilton*

Dreams of Italy 13

From the Mountain Top: Turner's First Sight of Italy 19

'Turner should come to Rome' 27

Turner's Route to Rome 39

Assimilating the Italian Sun 55

A Roman Triumph 69

Italy Ancient and Modern 79

The Light of Venice 91

Radical Old Man 103

111 An Italian Treasury: Turner's Sketchbooks *Nicola Moorby*

119 Turner and Munro of Novar: Friendship, Collecting and Italy
Christopher Baker

129 The Rosebery Turners *Jacqueline Ridge*

135 Chronology

141 Exhibition Checklist

146 Bibliography

149 Notes and References

157 Acknowledgements

158 Index of Names and Places

Foreword

Turner embraced the chance to travel across Europe, and new experiences fired his imagination nowhere more so than in Italy. The results – outstanding oil paintings and watercolours – created an intoxicating view of the landscapes and cities of Italy, which has endured. It has an appeal that crosses national boundaries, and so it is especially appropriate that this ambitious exhibition should be seen not only in Italy but also in northern and central Europe – in Scotland and Hungary. The idea of mounting an exhibition on Turner's love of Italy was first suggested by Andrea Buzzoni, Director of Ferrara Arte, and it has been a great pleasure to develop it with him and his colleagues, ensuring that the best of Turner's art is admired in one of Italy's most beautiful cities. It is especially gratifying that it will also be enjoyed by many visitors to the Museum of Fine Arts in Budapest, and for this we are most grateful to László Baan, the Museum's General Director, who enthusiastically took up the idea of collaboration. The co-ordination of the exhibition has been undertaken by Christopher Baker, Deputy Director at the National Gallery of Scotland. We are enormously grateful to him for the vision and scholarship he has brought to bear on all aspects of it.

From the outset, the Turner scholar, James Hamilton, Hon. Reader in the History of Art at the University of Birmingham, provided invaluable advice about the selection of works for the exhibition and his elegant and richly informative text forms the central part of this book which accompanies the show. This is complemented by essays from Christopher Baker, Nicola Moorby and Jacqueline Ridge, which consider the patronage Turner enjoyed, his use of sketchbooks, and his technical brilliance as a painter.

Any exhibition which relates to Turner is dependent upon the goodwill of Tate Britain which cares for and promotes the greatest of all collections of his work; we are therefore delighted to acknowledge the remarkable generosity of Stephen Deuchar, Tate Britain's Director, and Ian Warrell, whose role as lenders and advisors has been crucial to this project. Their colleagues Nicola Moorby and Julia Beaumont-Jones have also provided very valuable help.

It is a great privilege to have on loan at the National Gallery of Scotland the two magnificent Rosebery Turners, *Modern Rome* and *Rome from Mount Aventine*. We extend our warm thanks to Lord Dalmeny for kindly agreeing to include these important pictures in the exhibition – they very much form its centrepiece.

The many other lenders to *Turner and Italy* also deserve our sincere thanks, especially as they have temporarily parted with what are often some of the most treasured works in their collections: Ulster Museum, Belfast (Jim McGreevy, Clifford Harkness); The Bowes Museum, Barnard Castle (Adrian Jenkins); Williamson Art Gallery, Birkenhead (Karl Heatlie, Colin Simpson); Birmingham Museums and Art Gallery (Glennys Wild, Varshali Patel); Blackburn Museum and Art Gallery (Paul Flintoff); National Museum of Wales, Cardiff (Oliver Fairclough, Tim Egan); The Herbert Museum and Art Gallery, Coventry (Ron Clarke); National Gallery of Ireland, Dublin (Raymond Keaveney, Anne Hodge); Scottish National Portrait Gallery, Edinburgh (James Holloway); Kimbell Art Museum, Fort Worth (Malcolm Warner, Patty Decoster); Glasgow Culture and Sport (Mark O'Neill, Vivien Hamilton, Jeff Dunn); Abbot Hall Art Gallery, Kendal (Edward King, Hannah Neal); National Museums Liverpool (Reyahn King, Godfrey Burke, Alex Kidson, Nicola Christie, Anne Fahy, Sandra Penkeith); Guildhall Art Gallery, London (Vivien Knight); Royal Academy of Arts, London (Helen Valentine, Edwina Mulvany, Rachel Hewitt); Manchester Art Gallery (Virginia Tandy, Phillippa Wood); The Whitworth Art Gallery, Manchester (Maria Balshaw, Gillian Smithson); National Gallery

of Victoria, Melbourne (Gerard Vaughan, Janine Bofill);The Beaverbrook Art Gallery, New Brunswick (Bernard Riordon); Yale Center for British Art, New Haven (Amy Myers, Angus Trumble, Tim Goodhue); National Gallery of Canada, Ottawa (Pierre Théberge, Ceridwen Maycock); Musée du Louvre, Paris (Henri Loyrette, Vincent Pomarède, Guillaume Faroult); Philadelphia Museum of Art (Shannon N. Schuler); The Huntington Library, Art Collections, and Botanical Gardens, San Marino (John Murdoch, Jacqueline Dugas); National Gallery of Art, Washington DC (Earl A. Powell III); and the Sterling and Francine Clark Art Institute, Williamstown (Michael Conforti). We also gratefully acknowledge the generosity of those lenders who wish to remain anonymous.

Exhibitions such as this, especially when they take the form of an international tour, require the assistance of many friends and colleagues. In Italy we would like to thank: Alessandra Cavallaroni, Tiziana Giuberti, Barbara Guidi, Ilaria Mosca, Federica Sani, Chiara Vorrasi and especially Maria Luisa Pacelli: in Hungary, Henrietta Galambos, Zsuzsa Hudák, and especially Zsuzsa Gonda: and in the UK Brian Allen, Colin Harrison, Meredith Hale, Emmeline Hallmark, Lowell Libson, James Miller, Ronald Munro Ferguson, Mary Anne Stevens, Dr Joyce Townsend and Andrew Wyld.

Christopher Baker would like to thank for their expertise and patience: Janis Adams, Patricia Allerston, James Berry, Hannah Brocklehurst, Rosalyn Clancey, Patsy Convery, Robert Dalrymple, Susan Diamond, Bill Duff, Susan Godfrey, Graeme Gollan, Valerie Hunter, Lorrain Maule, Elinor McMonagle, Helen Monaghan, Keith Morrison, Jan Newton, Alastair Patten and the art handling team, Antonia Reeve, Jacqueline Ridge, Charlotte Robertson, Sarah Saunders, Olivia Sheppard, Helen Smailes, Will Snow, Leigh Stevenson, Lesley Stevenson, Agnes Valencak-Kruger and Ross Wilson.

Turner visited Scotland six times and travelled to Italy on seven occasions; the two countries mark the most northern and southern extent of his tours across Europe. Now in Edinburgh we can celebrate his brilliant vision of the sunlight and culture of the warm south.

JOHN LEIGHTON
Director-General, National Galleries of Scotland

MICHAEL CLARKE
Director, National Gallery of Scotland

Introduction

CHRISTOPHER BAKER

J.M.W. Turner (1775–1851) conducted a love affair with Italy throughout his professional life. He was enchanted by its climate, landscapes, architecture, customs and art, and *Turner and Italy* sets out to explore this complex and enduring relationship.

Turner's fascination with Italian culture developed initially when, as a young man in London, he studied oil paintings, watercolours, sculptures, prints and books which gave a taste of the sites and treasures of Italy. His long held dream of actually travelling there and experiencing the reality only became possible as political circumstances allowed – during the peace of 1802, when the chaos of the Napoleonic wars briefly ceased – and later when a more sustained period of stability across Europe made travel safe. Turner took full advantage of this, and from 1819 to the 1840s he made six further journeys to the sun-lit south.[1] The effect was profound and liberating, and, 'when he ... began to recreate his impressions in his studio, the memories of Italy were like fumes of wine in the mind, and the landscape seemed to swim before his eyes in a sea of light'.[2]

The onslaught of mass tourism had not yet begun, and an adventurous painter could not only delight in, but also exploit all he experienced. Turner used Italy to inspire the two most successful aspects of his career in Britain: the creation of ambitious oil paintings which were exhibited annually and repeatedly re-invented his reputation for a startled public, and the production of watercolours that were engraved for publication, so spreading his vision far beyond his metropolitan audience. He never matched the clichéd 'romantic' image of an artist – a lone figure only driven by his vocation and unconcerned by the market for his work. Turner had instead a sound sense of self-promotion and business skill, prompted perhaps by a desire to rise above his humble origins as the son of a Covent Garden barber, which he succeeded in doing with remarkable speed.

The perception of Italy Turner built upon with the works he created for collectors and publishers was richly layered. Those who admired his paintings and prints in the early nineteenth century had often acquired as a standard part of their education some knowledge of the classical inheritance (in the form of sculpture, architecture, history and poetry), and the art of the Renaissance. Their image of the landscapes and cities Turner explored was also formulated by the work of painters such as Claude, Canaletto, Richard Wilson and John Robert Cozens, which, thanks to the energies of Grand Tour collectors of the previous century, were represented in many British collections. In addition, there was a powerful stock of literary imagery to build upon. This ranged from the dramas of Shakespeare set in the courts and cities of northern Italy, to Byron's *Childe Harold's Pilgrimage* (1812–18), which featured rhapsodic descriptions, notably of Venice, and was the publishing sensation of the period. Turner knew all this, and by combining it with his own direct experience and mercurial imagination created something entirely new from it.

He was not alone in being a curious and cultured traveller. During the years in which Turner journeyed to Italy, many accomplished British artists, such as Samuel Palmer, Edward Lear and Richard Parkes Bonington, also undertook tours and created memorable works. Turner's interest was however more sustained; he was insatiable, not just depicting the picturesque highpoints of a conventional tour, but also devouring visually much of what he saw between them. Consequently, there are thousands of pencil drawings which record the minutiae of his observations, and hundreds of watercolours and numerous oil paintings that survive. This great body of work has become the subject of many books and exhibitions, which have tended to focus on a particular aspect of his engagement with Italy, such as his visits to Venice.[3] *Turner and Italy* is, however, an attempt to create a new

overview of his interest in *all* things Italian, starting with his training in London in the 1790s, when he was studying the work of an earlier generation of tourists, and culminating in the masterpieces of his maturity – sparkling evocations of cities he had by then come to know intimately. Because Turner's enthusiasm for Italy was sustained throughout his career, it illustrates all the distinct stages in the stylistic evolution of his work, and the transition he made from early, conventional topographical studies to the highly charged, emotive, and visionary pictures of his later years. By focusing on Turner's enthusiasm for Italy what also emerges is a compelling and down to earth picture of a travelling artist who encountered many practical problems, including grim sea crossings, dangerous coach journeys and the threat of bandits. He is also shown to be a man who carefully prepared for his travels, by poring over guidebooks, and became part of communities of artists and patrons abroad, notably in Rome. The city was described by him as the 'Land of all Bliss', but it did not repay the compliment, as his only exhibition mounted there was ridiculed.[4]

It was back in London that Turner continued to enjoy commercial success, perhaps because his paintings of Italy provided such potent images of escapism. It would be far too simplistic to suggest that he only saw Italy as a counterpoint to Britain and the changes it experienced during his lifetime, such as a population explosion and the advance of industrialisation; he was just as happy to use and depict a revolutionary form of transport, the steam boat, on the Thames, in the western isles of Scotland, and in the Venetian lagoon. But, in his grandest meditations on Italy and its culture he did explore the past in an epic and operatic manner, perhaps more profoundly than in many of his British works. Turner contemplated the decline of civilisations and the cycle of renewal over centuries, through landscapes, architecture, light and colour. Having lived through the fall of the ancient Venetian Republic in 1797, and the years of Napoleon's brittle empire, Italy became for him a vehicle for considering the broad sweep of history – a celebratory and humbling history – far removed from the shock of rapid political, social and technological change, and the vexations of daily life.

This preoccupation with Italy's past is explained in part by Turner's connection with the institution he was most closely allied to – the Royal Academy of Arts – which placed an overwhelming emphasis on the experience of classical and Renaissance Italy as the source of all

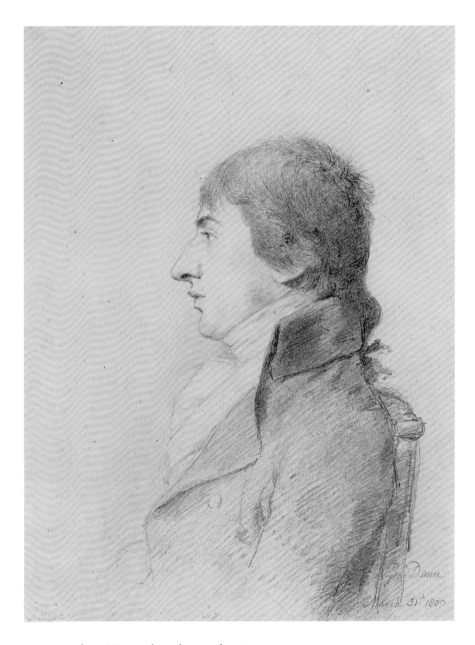

artistic wisdom. He was elected an academician in 1802, at the age of twenty-seven, and for thirty years was the Academy's Professor of Perspective. Through its teaching of the practice and theory of art from Sir Joshua Reynolds onwards, the Academy sought to legitimise British painting by giving it an authority based on the Italian 'Grand Manner'. The expectation that you should have some knowledge of what this meant was also shared by Turner's patrons, some of whom had themselves undertaken Italian tours, and acquired an enthusiasm for ancient ruins and sculpture, the achievements of Raphael and Titian, and the intensity of Mediterranean light.

[1] George Dance, *Joseph Mallord William Turner*, 1800
Royal Academy of Arts, London

These were not just the trappings of a liberal education, but signified wealth, class and taste.

Because his instinct was so often to look back, Turner only connected with the culture of contemporary Italy at certain points: he was a close observer through his sketchbooks of street life, and took some interest in the rituals of the Catholic Church. Among contemporary Italian artists, he notably came into contact with Canova, the great neoclassical sculptor who recommended his admission to the Academy of St Luke, the artists' academy, in Rome. But, in other spheres of the arts or politics his knowledge was derisory or non-existent; this was the age of the operas of Rossini, Bellini and Donizetti, and the stirrings of the Risorgimento, the political struggle to become a nation state, and there is no hint that Turner was aware of such achievements or events.

Increasingly, as his career progressed, Britain became a country viewed by Turner through the eyes of an artist immersed in Italy and its art. He was perhaps most profoundly affected by the work of the great seventeenth-century painter Claude Lorrain who spent most of his career in Rome and did more than any earlier artist to heighten the status of landscape painting. The sunlight of Claude's pictures seeped into the scenes Turner depicted from Devon to County Durham. Claude's art had cast a spell over many other British painters, including Turner's great contemporary John Constable, who drew from it a sense of clear compositional structure for his paintings. Turner certainly used it in this way, but more fundamentally adopted Claude's preoccupation with directly observed sunlight, which dazzles the viewer and penetrates the surrounding land, sea and buildings. This interest went far beyond being merely an act of homage to an illustrious predecessor, and became the dominant feature of much of Turner's late work. Light no longer simply established the time of day, set a mood, or defined the forms and colour of his paintings of Italian cities and vistas, but overwhelmed and dissolved them. Such pictures were made at a time when his status was secure and he could afford to experiment, and were undoubtedly the most troubling of his creations for contemporary viewers. When his *Neapolitan Fisher-girls Surprised Bathing ...* was first exhibited at the Royal Scottish Academy in 1845 a critic writing in *The Scotsman* newspaper declared that Turner 'succeeds in producing brilliant things ... which ... men may not fully comprehend, but cannot help admiring'.[5]

It was more severe adverse comments about one of Turner's slightly earlier Italian works which sparked what was to become the most sustained written defence of an artist ever mounted. His painting *Juliet and Her Nurse* of 1836 was savagely criticised in the Edinburgh-based *Blackwood's Magazine*. This prompted John Ruskin (who was only seventeen at the time) to leap to Turner's defence, an action that ultimately led to the writing of his monumental, five volume, *Modern Painters* (1843–60), which he originally planned to call *Turner and the Ancients*. Although very testing for readers today, as it runs to over 600,000 words, in some respects *Modern Painters* still flavours our understanding of Turner. Ruskin's text celebrated the dialogue he undertook with the old masters, his formidable powers of observation, and the sensual appeal of his paintings – all achievements that were distilled in his Italian work.

Although an appreciation of Turner's Italian pictures cannot be entirely disconnected from the insights of Ruskin (or indeed Byron), they also speak directly to viewers today. His oil paintings and watercolours are admired for their technical wizardry, and are seen as a touchstone of British Romantic art, which encapsulates an irresistible combination of yearning for new experiences and past glories.

Dreams of Italy

Turner grew up no more than two hundred yards from a piece of Italy. Born in 1775 and raised at least in his early years in Maiden Lane, Covent Garden, he had only to walk out of his house, turn right and right again, to find himself under the portico of the Italianate church of St Paul, looking out on a piazza. From the days of Inigo Jones, the seventeenth-century architect of this scheme, the square surrounded by arched colonnades on three sides was known as Covent Garden Piazza. This sensational architectural development for London must have given the young Turner some fresh experience of the elegance and scale of a typical Italian townscape. This was not 'pure' Italy, of course: the light was English, as were the shadows, the modest scale and the mess.

Turner's father was a barber, whose clients included members of the aristocracy, actors, artists and magistrates, and thus the boy was exposed at an impressionable age to a wide range of sophisticated, intellectual achievement, and perhaps given vicarious experience of continental travel. When Turner was about eleven years old family circumstances were such that he found himself living with his uncle's wife's sister, Sarah Lovegrove, and her husband in Sunningwell, near Abingdon.[1] On the other side of the village pond, opposite the Lovegrove's house, was, and still is, the thirteenth-century St

Leonard's Church, with a sixteenth-century classical porch, the Jewell Porch, named after the local benefactor John Jewell. An early drawing shows Turner's close interest in the architecture of the porch, while other drawings from this youthful period reveal that he travelled from Sunningwell into Oxford, where a living encyclopaedia of some of the finest European architecture was laid out for him to see.[2] From the English ecclesiastical gothic of Merton College to the pure Roman classicism of Christ Church's Canterbury Gate, Oxford provided for the young Turner a pattern book of building styles. James Wyatt had just completed Canterbury Gate, so its limestone was bright and sharp when Turner first saw it, and indeed, around 1800, drew it [2]. Nicholas Hawksmoor's Clarendon Building, with its detached portico and giant Tuscan columns, was a quarter of a mile away, adjacent to Christopher Wren's Sheldonian Theatre, an Italian baroque church lifted out of Rome and deposited in damp, middle England.

Architecture supplied the rootstock to Turner's art. Very few of his finished landscape paintings or drawings do not have a building or group of buildings in them somewhere. Where architecture forms the core structure of a work, such as *Aosta, The Arch of Augustus* [3], it is profoundly considered, and in weight, perspective and order, usually convincing. Turner's early training in architects' offices in London ran parallel with his formal training as a student of drawing at the Royal Academy, where, as a central part of his studies, he drew from plaster casts of classical sculptures. While personal and political circumstances and the nature of his upbringing did not allow him to see Italy until he was twenty-seven, he was able as a youth to go as far south as the Isle of Wight, west as far as Cardigan, and north as far as Blair Atholl. Once he was able to leave these shores, he moved with speed, alacrity and nerve.

Turner did have, however, friends and mentors who

left: detail of [7]

[2] *Canterbury Gate, Christ Church, Oxford* from the 'Smaller Fonthill' sketchbook [Finberg XLVIII], *c*.1799
Tate, London

had been to Italy. He greatly admired the architect John
Soane, more than twenty-five years his senior, who had
spent two years in Italy in the late 1770s. The architect
with whom Turner briefly worked in the late 1780s
and 90s, Thomas Hardwick the Younger, had himself
spent two years studying the architecture of Italy, as
had two other architects who taught him, James Wyatt
and Joseph Bonomi, an Italian born in Rome. With
the entire caucus of ambitious artists around the Royal
Academy, to whom Italy was both a lure and a snare, the
young Turner will not only have dreamt of Italy: Italy
was on everybody's lips, not least in the rhythm of the
names of Italian artists and architects.

In his closing address to students, on 10 December
1790, the retiring president of the Royal Academy, Sir
Joshua Reynolds, allowed himself a moment to remi-
nisce.[3] 'I was acquainted at Rome, in the early part of
my life,' he said, 'with a student of the French Academy,
who appeared to me to possess all the qualities requisite
to make a great artist.' This student, Reynolds went on to
suggest, had compromised his studies with too narrow
a view of nature and art theory, and Reynolds urged
those before him to avoid giving too much indulgence
to 'peculiarity', by which he meant 'specialisation'. He
also urged students to avoid half-baked theories, or, as
he put it, 'newly-hatched unfledged opinions', and to
consider 'once and for all, on what ground the fabric of
our art is built'. He meant, at root, Italy, and went on to
single out two revolutionary artists, Michelangelo and
Parmigianino (whom he called Parmeggiano) as exam-
ples of mentors. The young Turner, aged fifteen, was in
the audience for this farewell discourse, and it will have
been clear to him that Reynolds was urging that Italian
art underpinned the arts of Britain, from architecture,
through literature, to painting.

Italy also came to Turner directly through the paint-
ings of its masters, notably Titian, Veronese, Poussin
and Claude [5] and through engravings after these
artists. The prints of Giambattista Piranesi, depicting
eighteenth-century Rome in all its ruin and decay, also
brought Italy home to Turner, to lasting effect [47]. He
had opportunities to see old master paintings, prints and
drawings in salerooms and exhibitions, and at the town
and country homes of early supporters and patrons.
These included John Julius Angerstein, Dr Thomas
Monro and Sir Joshua Reynolds in London, and William
Beckford and Sir Richard Colt Hoare in Wiltshire. In
Monro's apartment in the Adelphi, a modern building in

[3] *Aosta: The Arch
of Augustus, Looking
South to Mt Emilius*
from the 'Grenoble'
sketchbook [Finberg
LXXIV], 1802
Tate, London

[4] John Robert
Cozens, *The Colosseum
from the North*, 1780
National Gallery of
Scotland, Edinburgh

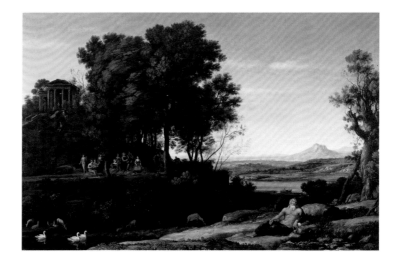

[5] Claude Lorrain,
*Landscape with Apollo
and the Muses*, 1652
National Gallery of
Scotland, Edinburgh

[6] *Vesuvius and the Convent of San Salvatore*, 1794–7
National Gallery of Scotland, Edinburgh

[7] *Rome: The Tiber with the Aventine on the Left*, 1794–7
National Gallery of Scotland, Edinburgh

[8] *Dolbadern Castle, North Wales*, 1800
Royal Academy of Arts, London

the classical manner on the north bank of the Thames, Turner studied and copied drawings of Italy by, among others, John Robert Cozens, a watercolourist whose work evoked the crepuscular light of Italy [4]. Cozens's characteristic delicate, blue-grey palette was echoed by Turner in these early years in pale wash drawings of Italian subjects such as *Vesuvius and the Convent of San Salvatore* and *Rome: The Tiber with the Aventine on the Left* [6, 7]. Both of these subjects were, twenty or thirty years later, to be transformed by the same artist's brush into canvases rich in colour and light.

Paintings and engravings provided for Turner, as for his British contemporaries, the route through which an idea of the light, landscape and history of Italy could pass. Sublime and majestic though the best of them were, pictures were only edited versions of Italy, and no substitute for the real thing. At this period in his youth Turner was also beginning to discover the classical authors, Virgil, Homer, Ovid, and Livy, whose writings were to enrich his life profoundly, and to explore in his own early paintings the history and architecture of Britain.[4] Turner's *Dolbadern Castle* [8] depicts an obscure story from British history in which a Welsh prince is released from years of imprisonment in a remote and gloomy castle. This narrative of oppression and liberty, rooted in the work of the Italian painter, Salvator Rosa, has vivid overtones from classical history. The picture was exhibited with the Italianate title *Landscape with Banditti* at the British Institution in 1854.

In a small pocket book which he kept in the late 1790s, the 'Wilson' sketchbook, Turner made copies of quintessential Italian views including the Temple of Clitumnus near Spoleto, and the Bridge of Augustus at Rimini.[5] These purposeful studies were made, as the title given to the sketchbook suggests, after works by Richard Wilson, the eighteenth-century Welsh painter. Wilson's paintings of Italian landscape and myth [9], and the engravings made from them by such accomplished engravers as William Woollett, energised the younger generation of travellers, writers, architects and artists. Influenced and affected by the paintings of Claude, Wilson had travelled to Italy in the 1750s, staying in Rome for six or seven years. In their turn, following the examples set by Wilson, Hardwick and Reynolds, artists such as Turner knew that their education was not complete until they had crossed the Alps and seen Italy for themselves.

[9] Richard Wilson, *Rome from the Ponte Molle*, 1754
National Museum of Wales, Cardiff

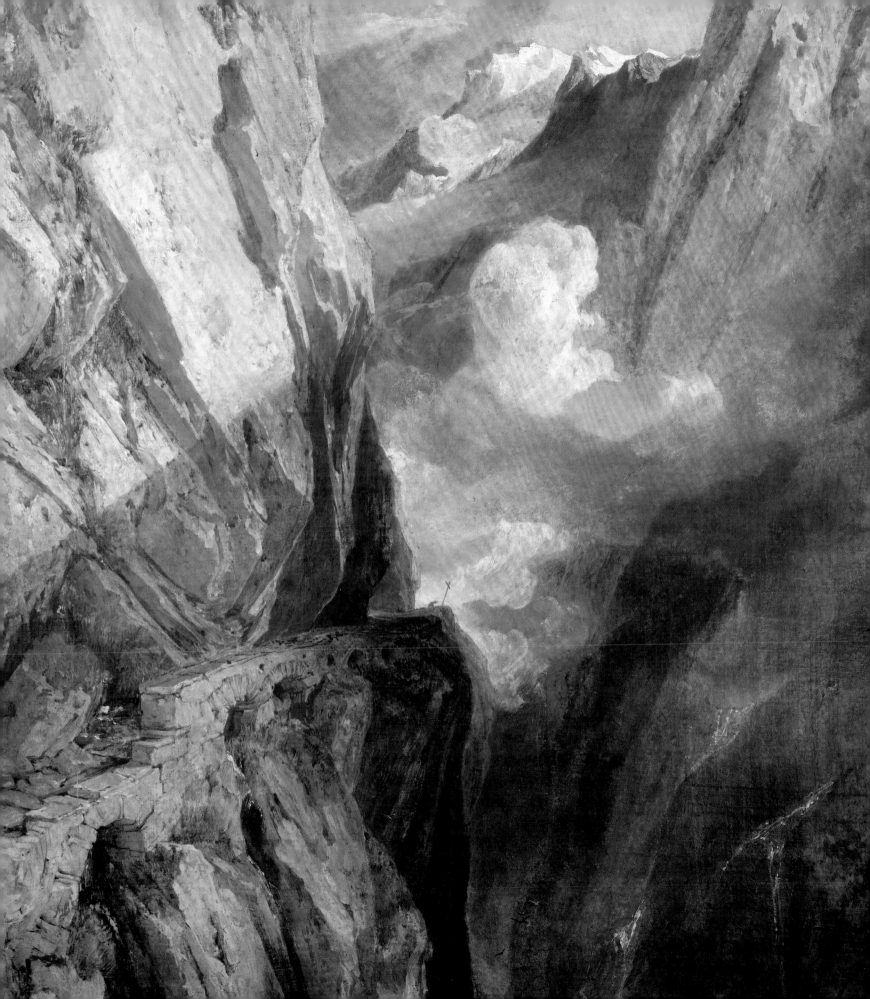

From the Mountain Top: Turner's First Sight of Italy

The journey that Turner undertook to Italy in August 1819 is generally spoken of as his first. It was, in fact, his second, the first having taken place seventeen years earlier in 1802.

The Peace of Amiens, a brief interlude which started on 27 March 1802 when the warring armies of France and Britain tried to make a permanent peace, lasted just over a year. During this time the little boats of England made a most lucrative and unanticipated trade by transporting thousands of British men and women across the English Channel from the Kentish and Sussex harbours, and back again. The artist and diarist Joseph Farington made the crossing for half a guinea.[1] The traffic went both ways. French travellers and refugees came over to England without the added frisson of escape from revolutionary chaos, while the British had the artistic riches of Paris to attract them, and the prospect of European sun. The engraver Abraham Raimbach made the crossing on 8 July 1802 in the same foul weather that was to greet Turner on his own crossing exactly a week later, and noted that:

It would be difficult to convey an idea of the rush that was made to the French capital by persons of every class who had the means of transit in their power. The artists in particular mustered in much greater force on this occasion than could have been anticipated, taking into account the proverbial scantiness of their resources.[2]

The particular sensation that drew English artists to Paris was the Louvre, whose galleries were being filled with works of art removed from all over Europe by Napoleon's armies. By 1802 looted works included, from the Vatican, the *Belvedere Torso*, the *Apollo Belvedere*, the *Laocoön*, the *Venus de Medici*, and *The Communion of St Jerome* by Domenichino; from Venice, Titian's *The Death of St Peter Martyr* and Tintoretto's *Conversion of St Mark*; and from Parma *The Marriage of St Catharine* and *St Jerome* by Parmigianino. An inscription on the cornice of the Louvre boasted, 'Les fruits de nos victoires!' Raimbach and Farington met many English artists in the Louvre, including the president of the Royal Academy, Benjamin West, the portrait painters Thomas Phillips, Martin Archer Shee, and John Opie, the sculptor John Flaxman, and Turner. Raimbach reports that he met Turner in the Louvre within a few days of his arrival, but that:

he stayed but a short time in Paris, where his residence became irksome, partly from his want of acquaintance with the language perhaps, and partly from the paucity of materials afforded to his particular studies. He very soon directed his steps to the south of France and Italy.[3]

But this was not before Turner had looked closely at the paintings, and written some notes into what he titled his 'Studies in the Louvre' sketchbook. If by 'paucity of materials' Raimbach meant an apparent lack of material to interest Turner, he was quite wrong. Either before travelling south, or on his way home via Paris, or both, Turner took the opportunity to draw in the galleries, as did many English artists. This journey added immeasurably to his understanding and experience of Italian old master painting. The 'Studies in the Louvre' sketchbook shows that he very carefully examined Titian's *Young Woman at her Toilet*, thought at one time to be a double portrait of Alfonso d'Este of Ferrara and Laura di Dianti,[4] his *Death of St Peter Martyr* and *The Entombment*, as well as Domenichino's *Mars and Venus* [10] and works by Poussin and Correggio. Other artists he studied included Rembrandt, Rubens and Ruisdael. Raimbach's indication that Turner's working visits to the Louvre might have taken place before he travelled south is supported by the fact that he made early notes on two old master paintings, Titian's *The Entombment* and *The Communion of St Jerome* by Domenichino, on the last few pages of the 'Small Calais Pier' sketchbook, used on the voyage across the English Channel.[5]

left: detail of [15]

On 'Titian and his Mistress', the title then given to *Young Woman at her Toilet*, Turner writes:
A wonderfull specimen of his abilities as to natural color, for the Bosom of his mistress is a piece of nature – in her happiest moments. The Arm beautifully colour'd, bust rather heavey – and the shadow perhaps too Brown for the shadow of the neck (which appears to have been produced by a body of grey colour over a rich ground of the colour of the face, then heighten'd in the lights which are truly brilliant.)[6]

Turner's level of analysis, both written and in drawn and painted studies, is maintained throughout the sketchbook. In his detailed, perfectly legible and clearly expressed notes, Turner created a bank of information that would come to be of continual importance to him. It certainly explains and amply justifies the expensive leather cover and brass clasp which he subsequently had made for the sketchbook, for which he clearly anticipated a long, useful life.[7]

Turner's commentary on Titian's now lost *Death of St Peter Martyr* begins:
This picture is an instance of his great power as to conception and sublimity of intelect – the characters are finely contrived, the composition is beyond all system, the landscape tho' natural is heroic, the figure wonderfully expressive of surprize and its concomitate fear.[8]

This was one of the first paintings that Turner saw in the Louvre, and he directly and rapidly adapted it

to his own purposes [11]. In his *Venus and Adonis* [12] Turner reverses the mood from rapid, violent death to an intimate but dramatic and erotic moment in which coming terror is implied by the behaviour of the baying hounds. His extraordinary obscuring of the faces is unprecedented in the iconography of this subject.[9]

Turner had a companion on his journey to Paris and the south, a collector and amateur artist of about his own age, Newbey Lowson, from County Durham.[10] Neither was short of a penny for their adventure. Lowson had money of his own, and Turner's expenses were being paid by three aristocratic or landed collectors, one of whom was Lord Yarborough, and another likely to be the Earl of Darlington, of Raby Castle.[11] The third may have been the Yorkshire landowner Walter Fawkes.[12] Being in the company of Lowson, a neighbour and close friend of Lord Darlington, Turner will have been mindful of the purpose, indeed the conditions, of his sponsorship. This was later referred to in the words 'Lord Yarborough with two other noblemen, subscribed a sum of money to enable Turner, when a young man, to study on the continent the works of the old masters.'[13]

From Paris, Turner travelled south via Lyon, Chalons and Macon. The party then explored the western Alps and crossed at the Petit St Bernard Pass, bumping down the long, steep road to Aosta, just inside Italy. This crossing of the Alps provided Turner with ample material for many years, and from it he produced a quantity of oil

left to right:

[10] Copy of *Mars and Venus* by Domenichino from the 'Studies in the Louvre' sketchbook, 1802 [Finberg LXXII]
Tate, London

[11] After Titian, *Death of St Peter Martyr*
The British Museum, London

[12] *Venus and Adonis*, c.1803–5
Private Collection

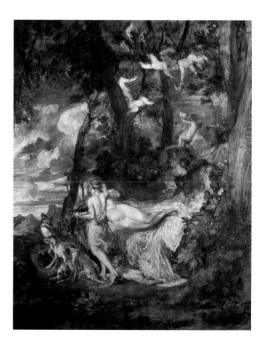

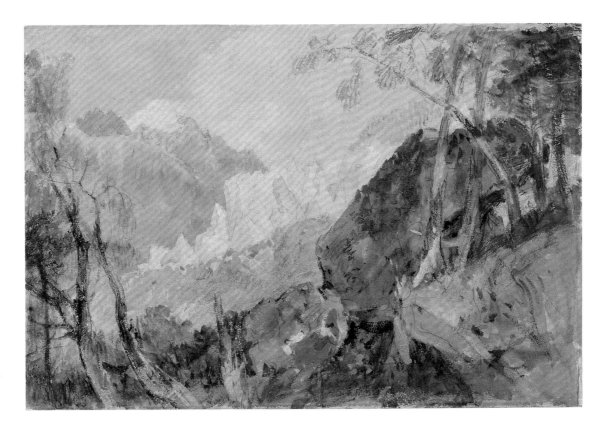

[13] *Chamonix:*
Glacier des Bossons,
1802
Private Collection

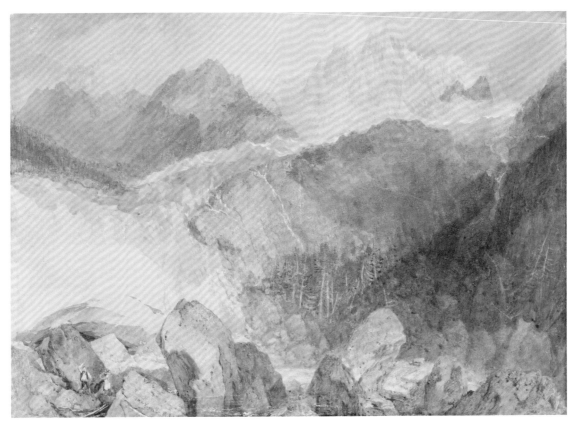

[14] *Montanvert,*
Valley of Chamouni,
1806 (?)
National Museum of
Wales, Cardiff

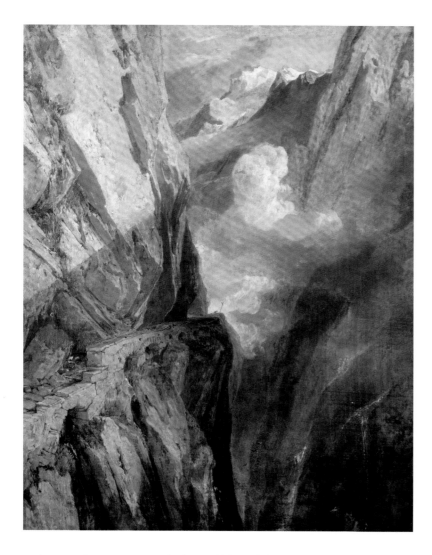

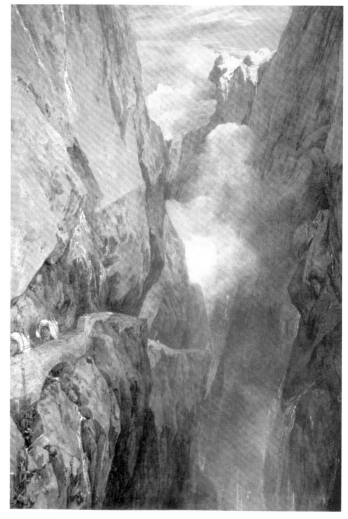

and watercolour paintings which would have defined a lesser artist's career. The Alps were the necessary filter through which Turner and his contemporaries had to pass to reach Italy [13–16].

The mountains are a dramatic backdrop to Aosta, a four-square city whose Roman remains then, as now, dominate the streetscape. There is a triumphal arch to Emperor Augustus [3], after whom the city is named, an amphitheatre, a city wall and a great gate, all of which provided Turner with subject matter that whetted his appetite for classical ruins, even if it failed to challenge him significantly in terms of composition. What he did experience, however, was his first taste of Italian light, and the hard, sharp shadows cast by its architecture.[14] Turner and Lowson returned to Paris via the Great St Bernard Pass, to Martingny, Lake Geneva, and Interlaken, Grindelwald and the Reichenbach Falls,

up the Rhine valley and across to Paris via Strasbourg and Nancy. They reached Paris, according to Farington, on 27 or 28 September,[15] having been on the road for about eight weeks. While many English artists of all ages enjoyed the delights of Paris in 1802, very few, if any, apart from Turner, had taken the opportunity to travel as far south as Aosta while the political situation allowed it.[16] Thus, Farington quizzed him closely on his experiences and reaction to the Alps and the northern foothills of Italy. He reported:

He was three days at Lyons. He thinks little of the River Rhone at that place; but the views of the Saone are fine. The buildings of Lyons are better than those of Edinburgh, but there is nothing so good as Edinburgh Castle. The Grande Chartreuse is fine; – So is Grindelwald in Switzerland … The rocks above the fall [at Schaffhausen] are inferior to those above the fall of the Clyde, but the fall itself is much finer.[17]

[15] *The Pass of St Gothard,* 1803–4
Birmingham Museums and Art Gallery

[16] *The Passage of Mont St Gothard, Taken from the Centre of the Teufels Broch (Devil's Bridge), Switzerland,* 1804
Abbot Hall Art Gallery, Kendal

Turner does not seem to have talked to Farington about Aosta, so all there is in terms of his response to the town are his drawings, and the significant fact that he was to return. In the week or so that he stayed in Paris, Turner worked with characteristic energy and commitment. He visited the Louvre again and again, achieving a self-directed, all-round education in the old masters which led to exhibits in the 1803 Royal Academy exhibition that surprised his contemporaries and set a standard for the future.

Turner was back in London by mid-October 1802, giving himself about six months to prepare for the coming Academy exhibition. The majority of the finished drawings and watercolours that he brought back with him, or made on his return, are overwhelmingly of Alpine scenes, but there are studies in the 'Calais Pier' sketchbook which show him struggling with ideas, some of which would evolve into the paintings exhibited in and around 1803. There are landscape studies which formed the basis of *Festival Upon the Opening of the Vintage at Macon* [17], others for a *Holy Family*, and one for *The Parting of Hero and Leander*. This would not evolve into a painting for thirty years. Turner worked ahead, and kept his sketchbooks by him throughout his life until they were needed.

As a new Royal Academician, at twenty-seven the youngest ever elected, Turner had to make his mark at the earliest opportunity. His choice of exhibits ranged across the taste of the day, and revealed in the clearest possible manner the breadth of his talents. His was a public performance, par excellence. Turner's success in this strategy, for that is what it must have been, was

acknowledged in the journal the *British Press*. The work in the 1803 exhibition it said, 'presents a singular and studied variety of subjects and effects'.[18] Turner's skill in marine painting, on a very large scale, was declared in *Calais Pier, with French Poissards Preparing for Sea: an English Packet Arriving* (National Gallery, London); classical landscape painting, derived directly from Claude, he demonstrated in *Festival Upon the Opening of the Vintage at Macon*; High Renaissance religious figurative painting, derived from an amalgam of the Venetian masters Titian, Giorgione, and Veronese, is the root of *Holy Family* [18]; and his skill in the painting of mountainous landscape, fresh from personal recollection, is shown in two oils of the Château de St Michael, Bonneville, Savoy [19, 20],[19] and two large watercolours. Turner's performance at the 1803 exhibition was extraordinary and utterly unprecedented. Two paintings in particular reveal the contrasts in mood that he was able to orchestrate from his study of, for example, Titian. *Venus and Adonis* has a breathtaking silence that foreshadows impending terror, while the *Holy Family* exhales inner calm. The artistic source for the latter is the *Holy Family and a Shepherd* (London, National Gallery), a Titian which Turner could have seen when it appeared in the London sale rooms in 1801. This work may have had a personal resonance for him. In late 1800 or early 1801 Turner became a father, his companion Sarah Danby giving birth to their daughter, Evelina. It is worth considering that Turner may have conceived his *Holy Family* before he left England.

Turner knew how to work the art market, and from the early 1790s had appealed to aristocratic and

[17] *Festival Upon the Opening of the Vintage at Macon*, 1803
Sheffield Galleries and Museums Trust

[18] *Holy Family*, 1803
Tate, London

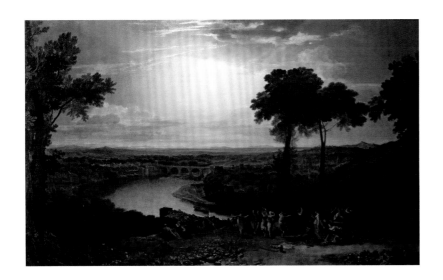

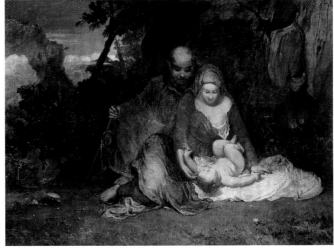

connoisseur collectors to the extent that even before he was twenty-one he was amassing a growing fortune.[20] Coming from the lowly social background that he did, this was a remarkable achievement in which high artistic talent and endeavour matched canny financial acumen. With his father, the businesslike barber William Turner of Maiden Lane as adviser and promoter, Turner knew his worth. This knowledge was apt to cause aggravation when collectors fought over his work, as they did with *Festival Upon the Opening of the Vintage at Macon*. Farington reports how Turner asked 300 guineas for it at the exhibition, to which Sir John Leicester responded with an offer of 250 guineas. A year later Leicester increased his offer to the original asking price, at which point Turner 'now demanded 400 guineas, on which they parted'.[21] According to a later report,[22] Turner settled on the price of 300 guineas when he sold the painting to Lord Yarborough in 1804. A factor in his decision to sell at that price will undoubtedly have been that Yarborough was one of the collectors who paid for Turner's 1802 journey to the Continent. Other purchasers of paintings that resulted from the 1802 tour included the banker Samuel Dobree, who gave Turner some uncertainty about whether he wanted the large cloud painted in or left out of *Château de St Michael, Bonneville, Savoy* [19].[23] The Yorkshire landowner and politician Walter Fawkes bought one of the two large Alpine watercolours from the 1803 exhibition, and went on to buy another thirty or more such subjects, while John Soane acquired the second exhibited watercolour, a dramatic narrative of a historic local event, *St Huges Denouncing Vengeance on the Shepherd of Cormayer, in the Valley of Aosta* [21]. This elaborate narrative reflects Turner's gifts as a story-teller, however obscure the particular story might be.

Dobree, Fawkes, Leicester, Soane and Yarborough were five very different men, and represented a cross-section of the moneyed society in which Turner discovered his market. Samuel Dobree was a city merchant and financier who collected work by the sculptor Francis Chantrey and the painter David Wilkie as well as that of Turner. Dobree was greatly loved amongst his contemporaries and 'His heartiness of speech ... was quiet, warm and winning. A few words, in his *sotto voce* way of uttering them, found their way directly to your heart.'[24] Walter Fawkes came from deep-rooted Yorkshire stock, having inherited a grand country house at Farnley, north of Leeds, and a fortune to go with it. This he spent rather

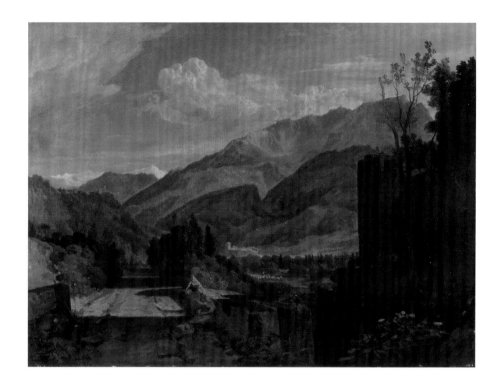

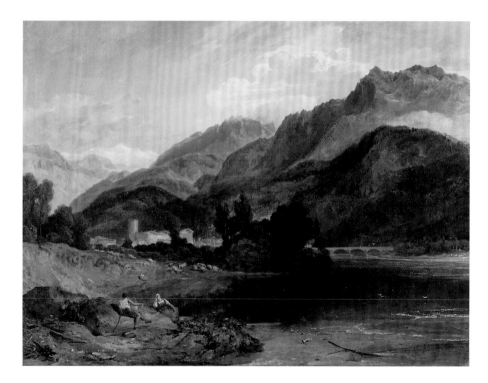

[19] *Château de St Michael, Bonneville, Savoy*, 1803
Yale Center for British Art, New Haven, Paul Mellon Collection

[20] *A View of the Castle of St Michael, near Bonneville, Savoy*, 1812
Philadelphia Museum of Art, John G. Johnson Collection, 1917

too well on collecting paintings – mainly by Turner – and on extending Farnley Hall and keeping a grand town house in Grosvenor Place in London. Bluff, generous and hospitable, he was active in national politics as a reformer, giving staunch support to the radical M P Sir Francis Burdett, and briefly, in 1806, becoming an M P himself. He gave Turner open house both at Farnley and London, and entertained his large circle of friends to hunting, shooting and fishing. When he died he was heavily in debt.[25] Sir John Leicester was socially more sure-footed than Fawkes, and more focused in his activities. He inherited his baronetcy and his large country house, Tabley in Cheshire, at the age of eight, and gave his life to collecting, and to the founding and patronage of societies which promoted the arts of painting and printmaking. He was a founder member of the British Institution, which established itself in Pall Mall as an alternative exhibition venue to the Royal Academy, being run by collectors rather than artists. He both bought and commissioned work by British artists, including Gainsborough, Reynolds, Romney and Lawrence, and built his own plush gallery in Hill Street in 1806 to house his collection. He entertained Turner at Tabley, allowing him to fish in the lake and the River Dee, and commissioned him to paint two views of the house from across the lake.[26] Towards the end of his life Leicester offered his collection to the nation as an embryonic National Gallery of British Art, but the nation refused it.

John Soane was, like Turner, a self-made man, the son of a bricklayer from Berkshire. By 1803, after training at the Royal Academy and two years study in Rome, he had become one of the most sought-after architects of his generation, wealthy, ambitious and well-connected. Although twenty-two years older than Turner, he had had a slower start to his career, and was only elected Royal Academician on the same day as the young artist with whom he was to share a lifelong friendship.[27] Soane, like Leicester and Turner himself, built his own gallery, indeed in his case an entire house and museum, in a terrace in Lincoln's Inn Fields. Unlike Dobree, Fawkes, and Leicester, Soane was not a regular patron of Turner's, buying in addition to the 1803 watercolour only one oil painting, in 1831. He did, however, have first refusal of Turner's *Forum Romanum* [75] in 1826, but rejected it.

The fifth of Turner's patrons from 1803 was Charles Anderson-Pelham, Lord Yarborough, who had five years earlier commissioned Turner to make watercolour drawings of the mausoleum, built to James Wyatt's designs, which he had had built to honour his late wife. The mausoleum was based on the Temple of Vesta at Tivoli, which Wyatt had studied on his own six-year period in Italy where he became well-known for his daring in taking measured drawings. He was once seen under the dome of St Peter's in Rome, 'lying on his back on a ladder slung horizontally, without cradle or side-rail, over a frightful void of 300 feet'.[28] Yarborough went on to buy Turner's oil painting, *Wreck of a Transport Ship* in 1810.

At least two common threads unite these five very different men – banker, politician, benefactor, architect, and peer. One is the consistency of their patronage and friendship to Turner: a patron of the artist, it seems, always tended to come back for more. A second thread is that at least four of them – Yarborough, Fawkes, Leicester, and Soane – had themselves travelled in Italy, and so had acquired their own Italian taste through personal experience. Yarborough, in addition to commissioning a version of the Temple of Vesta, had bought Bernini's sculpture *Neptune and Glaucus* (V & A, London), and installed it at Brocklesby in Yorkshire. Thus all were fully in tune with, and no doubt sympathetic to, Turner's Italian ambitions, however lightly he might have expressed them in 1803.

[21] *St Huges Denouncing Vengeance on the Shepherd of Cormayer in the Valley of Aosta*, 1803
Sir John Soane's Museum, London

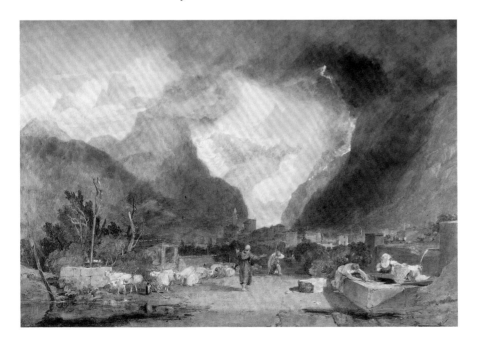

'Turner should come to Rome'

After some blazing rows with older members at the Royal Academy in 1804, the headstrong young academician stormed out of Somerset House, and went west as far as Isleworth to cool his heels in the Thames.[1] He had argued about committee procedure and internal politics, and was accused by his elders of leading younger artists astray through 'the empirical novelty of his style'. By this they meant that Turner was felt to be too experimental in his technique; one wag nicknamed him 'the over-Turner'.[2] He had a furious row with an older member, Sir Francis Bourgeois, a dull artist, and had had the nerve to sit in Farington's chair at an Academy Council meeting, and berate the members for improper procedure. In short, he was an unruly new influence of a kind more associated with young artists of the twentieth century than those of the early nineteenth. This was the price the Academy paid for having a star in its midst.

Rowing or tacking up and down the Thames, as he did in the summer of 1804, Turner saw in his mind's eye an England transformed into Arcadia with temples and distant villas rising through the mist [22]. Turner found calm at a time when England was under severe threat of invasion from Napoleon's army, which was waiting in its encampments along the northern French coast. This was not just a sentimental reverie, but a call for courage. As an artist, Turner found the courage on the Thames to create pictures in a manner which was considered unusual and ill-advised at the time by painting in oil, on board and canvas, in the open air, directly in front of the subject. His friend from childhood, the Revd Henry Scott Trimmer, lately appointed vicar of Heston, Middlesex, reported to Turner's first biographer, Walter Thornbury that, 'he [Turner] had a boat at Richmond, but we never went farther than the water's edge, as my father had insured his life ... From his boat he painted on a large canvas direct from nature.'[3]

Henry Scott Trimmer had known Turner from their boyhood.[4] Trimmer's mother, Sarah Trimmer, a distinguished pioneer of children's education, was one of a handful of men and women who spotted Turner's extraordinary talent early on. Henry had studied classics at Merton College, Oxford, graduating in 1802, the year Turner made a watercolour of Merton for engraving for the *Oxford Almanack*. They evidently kept in touch, or rediscovered one another when Trimmer moved to the living of Heston. This was only a short distance from Isleworth, where Turner himself was by now renting a house.

Whether by coincidence or not, it was in and around Isleworth, with the classics scholar Trimmer nearby, that Turner came to think in some depth about Greek and Roman literature, and to begin making lists of possible subjects for paintings. Thus in his 'Studies for Pictures: Isleworth' sketchbook he notes down, 'Meeting of Pompey and Cornelia', 'Parting of Brutus and Portia', 'Cleopatra in her barge', and so on.[5] Inside the cover of his copy of Oliver Goldsmith's *The Roman*

left: detail of [34]

[22] *The Thames at Isleworth* from the 'Wey, Guildford' sketchbook, 1805 [Finberg XCVIII] Tate, London

History Turner writes, 'Hannibal Crossing the Alps; his Departure from Carthage; the Decline of the Roman Empire; Regulus Returns'.[6] These are all subjects that Turner was to paint. In the margins of two of the pages of his copy of Goldsmith's *The Roman History* Turner made small pencil drawings of Caesar being presented by Ptolemy with the head of Pompey, and recoiling in horror, and Cleopatra and her younger brother being crowned joint monarchs of Egypt [24].[7] With these drawings, made surely in the immediate excitement of a first reading of the text when no other paper was to hand, ideas from Roman history were already flooding Turner's mind. They were not limited to Roman history, as Homer's stories from the *Odyssey*, including the episode of Ulysses and his companions escaping from the giant Polyphemus, were also among the subjects of his studies.[8]

Turner's discord with the Royal Academy was such that he did not exhibit there in 1805, choosing instead to exhibit at his own gallery which he had opened at some personal expense behind his house in Harley Street in 1804. When Turner next chose to show in public it was not at the Royal Academy but, in February 1806, at the new and rival organisation, the British Institution in Pall Mall. There he exhibited *Narcissus and Echo* (Tate, and National Trust, Petworth House), which he had first shown at the Academy in 1804, and a new large enigmatic canvas on which he had expended considerable reflective thought and poetic invention. This was *The Goddess of Discord Choosing the Apple of Contention in the Garden of the Hesperides* [25].

The story that Turner tells here is rooted in the literature in which he was already immersed: Homer's *Iliad*, Virgil's *Aeneid* and Spenser's *Fairy Queen*. The Goddess of Discord, or Strife, known as Ate or Eris, is offered the choice of two golden apples by the Hesperides, the daughters of Atlas. The apples, which come from the tree that had been planted by Juno, Goddess of Wisdom, represent the produce and wealth of the earth, and are guarded by the beautiful sisters. They and their garden are in turn guarded by the dragon Ladon, who lies out on the distant rock, breathing fire. Enter the two-timing, double-dealing, disobliging and decrepit old woman, Eris, who chose the apple marked 'for the fairest', and took it away to throw among guests at the wedding of Thetis to Peleus to which she had not been invited. Thus began the Trojan War, and, through Homer and Virgil, the beginnings of western European literature.

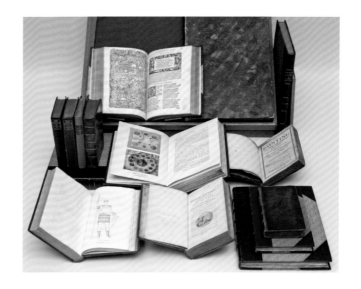

[23] Books on Italy and Roman history in Turner's library
Private Collection

Egyptian army with loss, and at last, joining with Cæsar, attacked their camp with a great slaughter of the Egyptians; Ptolemy himself, attempting to escape on board a vessel that was failing down the river, was drowned by the ship's sinking, and Cæsar thus became master of all Egypt without further opposition. He then appointed Cleopatra, with her younger brother, an infant, joint governors, according to the intent of their father's will, and drove Arsinoë with Ganymede into banishment.

Having

[24] Marginal drawing by Turner in his copy of *The Roman History* by Oliver Goldsmith, published 1786 (drawings c.1804–6)
Private Collection

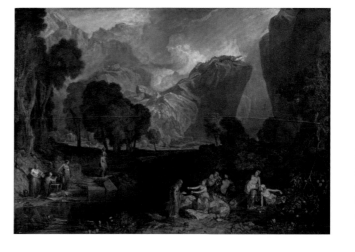

[25] *The Goddess of Discord Choosing the Apple of Contention in the Garden of the Hesperides*, 1806
Tate, London

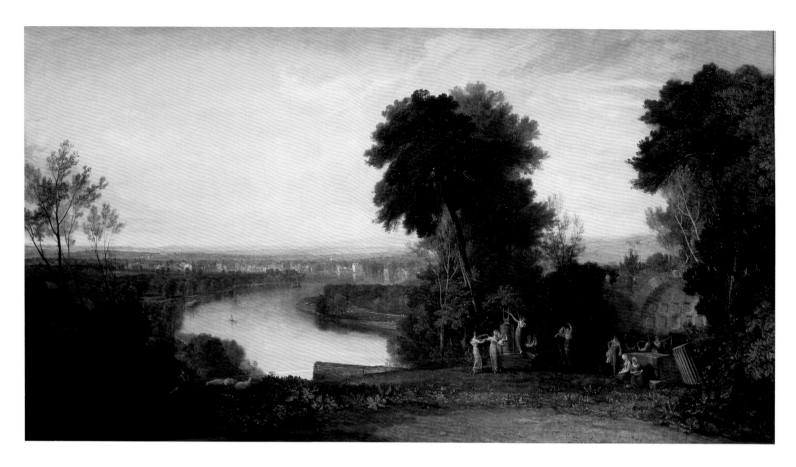

[26] *Thomson's Aeolian Harp*, 1809 Manchester Art Gallery

Turner perhaps used this complex allegory, in which are interwoven traces of the biblical stories of the Tree of Knowledge in the Garden of Eden, to issue a warning of his own. It is likely that he had begun the painting, or at least thought it out, before the Battle of Trafalgar had been fought and won on 21 October 1805,[9] creating a personal, highly allusive perspective on the dangers that Britain was facing at this period of the Napoleonic War.

It was becoming a characteristic of Turner that he would use historical or literary subjects as metaphor, a practice that was, and is, in danger of being over-interpreted. His poetry suggests that Turner himself tended to over-interpret his subject pictures, as did the critic and writer John Ruskin in volume five of his *Modern Painters,* saying that *The Goddess of Discord* was Turner's: *first great religious picture; and exponent of our English faith. A sad-coloured work, not executed in Angelico's white and gold; nor in Perugino's crimson and azure; but in a sulphurous hue, as relating to a paradise of smoke. That power, it appears, on the hill-top, is our British Madonna.*[10]

Ruskin's yardstick here is Italian Renaissance painting. Turner sets his garden of the Hesperides in a Poussinesque, Italian alpine landscape, one dominated by a rock which has grown out of an enormous boulder on the southern slopes of the Petit St Bernard Pass above Aosta. This is not Italy as Turner knew it, but as Poussin evoked it.

It may have been at this time that Turner acquired two volumes that were to be the mainstay of his working life, and of his growing library. Leather-bound editions of Alexander Pope's translations of Homer's *The Odyssey* and *The Iliad* are still in Turner's library, which has miraculously survived largely intact [23].[11] Turner was a collector of books, prints, and other artists' paintings and drawings. Throughout his life, he, or an agent acting for him, attended auction sales, and visited print shops and art dealers. Thus, as the years went by, he bought or otherwise acquired seventeenth- and eighteenth-century books on subjects related to the classical world such as *Orlando Furioso* by Ariosto, *The Painting of the Ancients* by Franciscus Junius, *Romae Antiquae Notitia* by Basil Kennett, and John Henley's edition of *The Antiquities of Italy*. This last volume has the revealing inscription, in pencil on the flyleaf, 'Mr Turner 47 Queen Ann St / first

door West of Harley', suggesting delivery instructions from a bookseller, and indicating that it was bought after about 1820 when Turner's house was re-numbered from forty-four to forty-seven.

Turner's months painting in the open air on the Thames led to twenty oils of specifically Thames subjects, some incorporating classical remains, and all of which he exhibited between 1806 and 1812.[12] In addition to these there are over thirty studies and unfinished oils on canvas and board which were painted across the same period in and around the Thames. The area was, evidently, of critical importance to him as a painter, and not only for its value as landscape, nor because he had grown up there. The Thames and its floodplain between Abingdon and London were redolent with literary and historical associations. This was the landscape in which Alexander Pope had translated *The Odyssey* and *The Iliad*, and Turner's painting of 1808 *Pope's Villa at Twickenham* (Private Collection) was a subtle expression of fury at the wanton destruction of the house.[13] Richmond and

Twickenham were also the landscape of the poet James Thomson, whose long poem *The Seasons* evokes Italian landscape and myth as a means to celebrate a dynamic, mercantile Britain.

The aura of Italy's classical past lingers in a number of paintings Turner made in these years, in particular *Thomson's Aeolian Harp* [26], so much so that when this was shown in 1862 at the International Exhibition at South Kensington, now the Victoria and Albert Museum, it was entitled 'Italy'. This is yet another example of a British scene by Turner being mistaken, decades later, for an Italian subject.[14] Despite appearances, however, this is not Italy, but the valley of the Thames as seen from Richmond Hill, looking out towards Twickenham. In Turner's alchemical practice, he extracts the essence of Italy from this stretch of the Thames, just as he had extracted the essence of Burgundy and the Saône valley using the same composition in *Festival Upon the Opening of the Vintage at Macon* in 1803. Here, however, Turner's intention is to make England and Italy indivisible. While

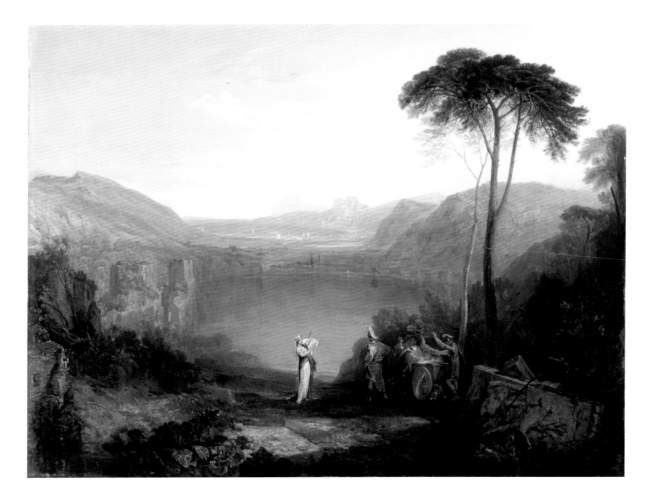

[27] *Lake Avernus: Aeneas and the Cumaean Sibyl*, 1814–15
Yale Center for British Art, New Haven, Paul Mellon Collection

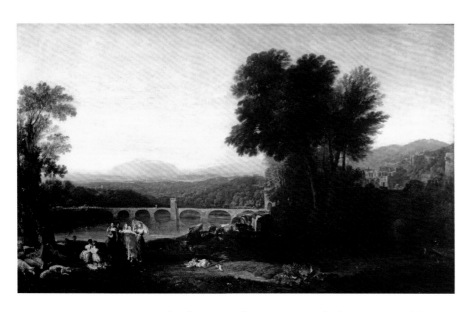

[28] *Apullia in Search of Appullus, Vide Ovid*, 1814
Tate, London

catalogue entry, and named Alexis, the boy-lover of the shepherd Corydon from Virgil's *Eclogues*, in his epigraph.[18]

After his concentrated run of canvases devoted to Thames-side scenes, Turner changed location and produced many Devonian and Cornish landscape subjects in both oil and watercolour, culminating in 1815 with *Crossing the Brook* (Tate, London). He also began a second wave of seminal, large works on classical mytho-logical themes producing from 1811 to 1814: *Mercury and Herse* and *Apollo and Python*; *Apullia in Search of Appullus, Vide Ovid* [28]; *Dido and Aeneas*; and *Lake Avernus: Aeneas and the Cumaean Sibyl* [27]. He was working on similar themes at the same time, in sketch-books, watercolour and on canvas, and it is important to understand where he was and what he was doing while these creative tides were ebbing and flowing within him.

Having been elected Professor of Perspective at the Royal Academy in 1807, Turner spent anxious days over a number of years studying in the Royal Academy and the British Museum libraries, preparing illustration diagrams and heavily working his texts for the lectures which he was evidently nervous of presenting.[19] He delayed, with ineffective excuses, until he had no choice but to confront his fears and step up to the lectern in January 1811. Later that year he made a long tour to the West Country to collect landscape studies for an extensive series of over thirty watercolours entitled *Picturesque Views of the Southern Coast of England*, which he had been commissioned to produce for engraving by George Cooke. A poem of about seven hundred lines, which he wrote before he left London, gives an indication of the seriousness of his attitude to his task, and of the depth of his preparatory reading.[20] A pride in and genuine under-standing of the making of the English landscape evolved in Turner from his reading of the work of antiquaries and historians of the eighteenth century and from his general knowledge of British history. Prolonged read-ing and a deeply innate patriotism and sense of national self-worth empowered Turner, and he left for the West Country a few weeks after exhibiting *Mercury and Herse* and *Apollo and Python* at the Royal Academy. The Prince Regent had given Turner some false encouragement over the former canvas, leading the artist to the unfounded understanding that the prince might buy the work.[21] This did not come about, but it did appear to fire Turner with the belief that his work was greatly admired at the highest level of British society.

the distant landscape suggests the busy nature of the Thames at the heart of London, the foreground, with its ruins, Thomson's tomb, nymphs dancing and crowning the Aeolian harp with a laurel wreath, has a wistful air reminiscent of Claude and Poussin. But a closer look at the flowers in the foreground reveals that the country must be England and the month April or early May. The horse chestnut is in bloom, as is honeysuckle, and the silver birch is budding. Behind the tomb, two rustics walk home with scythe and billhook, tools suggesting autumn, and on the left on a slope in the middle ground a shepherd is playing his pipes and tending his sheep in a patch of sun suggesting summer. If the crystalline distant buildings are interpreted as frosted winter then all of Thomson's seasons appear in one canvas – spring, summer, autumn, winter. Although other sources for the painting have been suggested, a passage in Thomson's *The Seasons* which has a strong Virgillian sense of locality may be the inspiration:
The matchless vale of Thames; / Fair winding up to where the muses haunt / In Twit'nam's bowers,' and goes on to praise this part of Surrey with the words: 'O vale of bliss! O softly-swelling hills! / On which the power of cultivation lies, / And joys to see the wonders of his toil.[15]

While being a painter of genius and drive, Turner was also a tyro poet, an art at which he struggled and, ultimately, failed.[16] Nevertheless, his admira-tion for poets of earlier generations was genuine and unbounded, and he read and quoted poetry widely.[17] When *Thomson's Aeolian Harp* was first exhibited Turner appended thirty-two lines of his own poetry to its

Back in London by the autumn, Turner set to work on a multitude of tasks, making the first watercolours for the Southern Coast project, developing some of these as oil paintings, and also beginning his masterpiece, *Snow Storm: Hannibal and his Army Crossing the Alps* exhibited in 1812 [29]. The initial inspiration for this canvas was a storm that Turner had witnessed a year or two earlier in Wharfedale, but it also grew out of Turner's reading of Roman history, and the story of the continuing struggle between Carthage and Rome. Hannibal's heroic and foolhardy crossing of the Alps, with tens of thousands of men and a column of elephants, touched a sensitive spot among British artists in the years immediately after Trafalgar. Britain's struggle with the evil empire of Napoleon's France, and the boldness as displayed at Trafalgar, was a clear parallel with this episode in the early history of Rome. Turner, and many other artists, took on the subject of Hannibal, Turner choosing a moment of doubt and despair amongst the Carthaginian forces as Hannibal attempted to rally them to begin the long trek down the mountain and into the valley of Aosta and Italy beyond.

While Roman history provided the motive force for *Snow Storm: Hannibal and his Army Crossing the Alps*, Turner's three other classical subject pictures, *Apullia in Search of Appullus, Vide Ovid, Dido and Aeneas* and *Lake Avernus: Aeneas and the Cumaean Sibyl* came out of the artist's reading of Ovid and Virgil. The first, which echoed Claude's *Jacob with Laban and his Daughters* owned by Lord Egremont, was shown at the British Institution in January 1814, the second at the Academy in the spring of that year. *Lake Avernus*, painted for Sir Richard Colt Hoare, was a version of the same subject originally painted by Turner around 1798 (Tate, London).[22] Turner strove for accuracy in his account of architectural and other significant detail, to the extent that he omitted bridles from the line of horses appearing from the right in *Dido and Aeneas*, because he had read that Lybian horsemen did not fit bridles to their horses.[23] So rarefied were some of his details that only he could possibly have chuckled over them: it took nearly a hundred and seventy years for anyone to spot that the figure of one of the nymphs in *Apullia in Search of Appullus* is based on an early eighteenth-century personification of Apulia, the region at the heel of Italy.[24]

Turner tended to paint and exhibit pictures in pairs. This was a practice he followed all his life from as early as 1801 when his *Dutch Boats in a Gale*, the 'Bridgewater

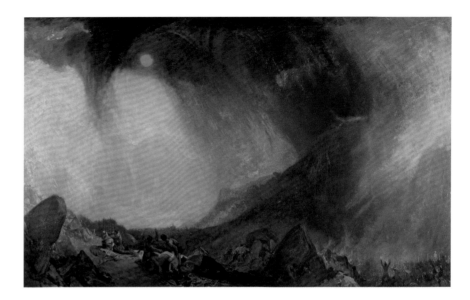

Seapiece', was painted to hang beside a masterpiece by Willem van der Velde. The pairs painted in his mature years were not necessarily pendants, that is to say painted to hang together, ideally in perpetuity, but canvases essaying related subject matter, suggesting the continuing progress of a train of thought or commission. Thus in 1811 he produced *Mercury and Herse* and *Apollo and Python*; in 1814 *Apullia in Search of Appullus, Vide Ovid* and *Dido and Aeneas*; and in 1816 two important Greek subjects, *The Temple of Panellenius Restored* and *The View of the Temple of Jupiter Panellenius*. A pair whose genesis stretched across two years is *Dido Building Carthage; or the Rise of the Carthaginian Empire* [30] from 1815 and *The Decline of the Carthaginian Empire* from 1817 [31]. When *Dido Building Carthage* was being painted Napoleon had been captured and was imprisoned off the Italian Mediterranean coast on the island of Elba. Thus its theme of the construction of a great civilisation chimed well with the national mood which had expressed itself with some determined partying during the course of the summer of 1814. There were fireworks and festivals, celebratory balloon flights, and a mass influx of foreign royalty, including the Czar of Russia and the King of Prussia and their entourages.

London was reviving itself as a city of peace and prosperity, and as William Jerdan, the editor of the *Literary Gazette* remembered, Londoners were plunged into 'an activity for pleasure-hunting, as if the British empire had been turned into one Greenwich fair'.[25] The war, after twenty-two years, was over. The publisher John Murray saw the commercial possibilities of peace, and in April

1814 wrote to Lord Byron, whose long narrative poem *Childe Harold* he was publishing in parts. 'Bonaparte has either solicited or accepted formal retirement upon a *Pension* in the Isle of Elba,' he told Byron, 'A Fine subject for an Epic.'[26] Byron in these years was creating even more of a stir in the literary world than Turner had in the world of painting. Debonair, handsome and aristocratic, he had a distinct advantage over the short, plain, barber's son in the social whirl of early Regency London. Turner did not compete socially, and there is no evidence that he and Byron ever met.[27]

During this time, Turner was working on the composition of *Dido Building Carthage*. Figures busy themselves with the construction of public buildings, assemble materials to build their ships, and set about creating their own independent civilisation.[28] Busying herself in supervision, like an operatic diva in the centre of a grand scene, is Queen Dido herself, directing her men amongst building materials, plans and equipment. On the opposite bank of the river, where the work is complete, is an edifice that incorporates the tomb of Dido's murdered husband, Sychaeus. The inscription 'SICHAEO' is just visible on his tomb, and over all the sun is rising. So, Turner suggests, empires rise, through hard work and co-operation, continuous memory, and the ever-arching sun. It might be reasonably supposed that when Napoleon escaped from Elba in March 1815 and regrouped his forces, the irony and sheer unfairness of the new situation flashed briefly through Turner's mind: the painting of reconstruction is nearly finished, and war is again a possibility.

Two years later, after the Battle of Waterloo had finally brought closure to Napoleon's ambitions, Turner exhibited the companion to *Dido Building Carthage*. The full title to the work clearly sets out its meaning and intention and there can be no mistake that here the artist proposes to recount a warning. So determined is Turner to explain what he wants people to understand when looking at the painting, that it might make his meaning even clearer to a present day audience if the title is read as narrative text. Turner's extension to the title of *The Decline of the Carthaginian Empire* reads: 'Rome being determined on the overthrow of her hated rival, demanded from her such terms as might either force her into war, or ruin her by compliance. The enervated Carthaginians, in their anxiety for peace, consented to give up even their arms and their children.' These words were composed not as an epigraph – that is provided by six further lines of Turner's poetry – but as an integral part of the title. This is moral blackmail, of a kind practiced by nation upon nation again and again in later centuries. While we might see these two works as pendants, they cannot, of course, be described as such because they straddle a great historical event, the Battle of Waterloo, which changed everything.

Turner's profound and continuing interest in Roman history is clear from the subjects he painted and from the books he kept in his library. He even found the opportunity to slip a bit of Roman interest into a watercolour of Gibside, County Durham. His view of this extensive landscape, looking south and west towards the sun, includes a woman draped in a toga carrying an urn on her head [32]. What also emerges from the volumes he owned is an equal and practical

[30] *Dido Building Carthage; or the Rise of the Carthaginian Empire*, 1815
The National Gallery, London

[31] *The Decline of the Carthaginian Empire*, 1817
Tate, London

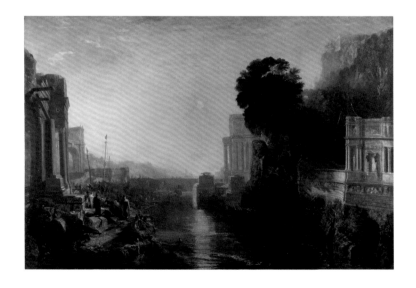

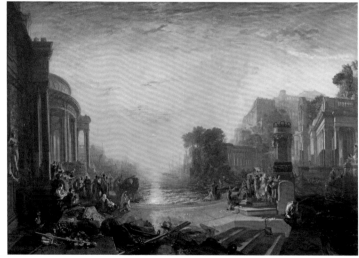

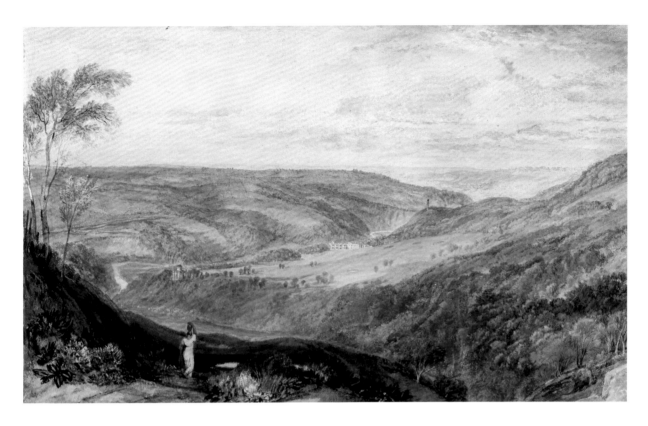

[32] *Gibside, Co. Durham, from the South West, c.*1817
The Bowes Museum, Barnard Castle, County Durham

interest in how he would get to Italy. Thus, he has a copy of his long-term patron Richard Colt Hoare's *Hints to Travellers in Italy* and *A Journey to Rome and Naples* by Henry Sass.[29] Colt Hoare is extremely practical on the subject of travel. 'Every traveller', he writes, 'ought to have two objects in view: the one, to amuse himself: the other, to impart to his friends the information gained.'[30] Henry Sass takes matters further and discusses particular traits of other European countries demonstrating something of his sense of superiority, typical of many Englishmen of his generation.[31] Turner's main source of advice about how to traverse Italy came, however, from elsewhere. He listened patiently to his architect friend James Hakewill who wrote out pages of advice for him in his 'Route to Rome' sketchbook, and recommended a route: Milan, Genoa, La Spezia, then Pisa, Lucca and Florence.[32] 'Don't go the Ferrara road to Venice, tis very bad', Hakewill advises.[33] With Hakewill, Turner had already whetted his appetite for Italy by painting a series of watercolours of Italian scenes from original pencil drawings by Hakewill (British School at Rome Library)[34]. Hakewill's are workmanlike studies [37] made with a camera lucida which Turner transformed for *A Picturesque Tour of Italy* published by John

Murray in 1820 [33, 34, 36, 38, 39]. The commission no doubt fired Turner up to see the real thing, and Hakewill was generous with his advice. 'On no account trust yourself in a felucca,' he advised Turner, 'but hire horses and guides to Spezia … Take some mode of travelling gently to Rome, as Perugia, Spoleto, Terni, Narni, Civita Castellana should all be stopped at.'[35]

An alternative approach to journeying in Italy was offered by the Revd John Chetwode Eustace whose four-volume treatise *A Classical Tour through Italy* was first published in 1813, and had been reissued twice by 1815. With extensive and fascinating accounts of the classical and literary history of the towns and villages on his route, Eustace takes the traveller another way. Preparation, preparation, preparation, he advises the intending traveller. He continues, 'He who goes from home merely to change the scene and to seek for novelty need only want a convenient post-chaise, a letter of credit, and a well-furnished trunk.' But:
He who believes with Cicero, that it becomes a man of a liberal and active mind to visit countries ennobled by the birth and the residence of the Great … will easily comprehend the necessity of providing before-hand the information requisite to enable him to traverse the country without constant

right:

[33] *Roman Forum, from the Capitol, c.*1816
The Whitworth Art Gallery, The University of Manchester

[34] *Forum Romanum,* 1818
National Gallery of Canada, Ottawa, gift of F.J. Nettlefold, Nutley, Sussex, England, 1948

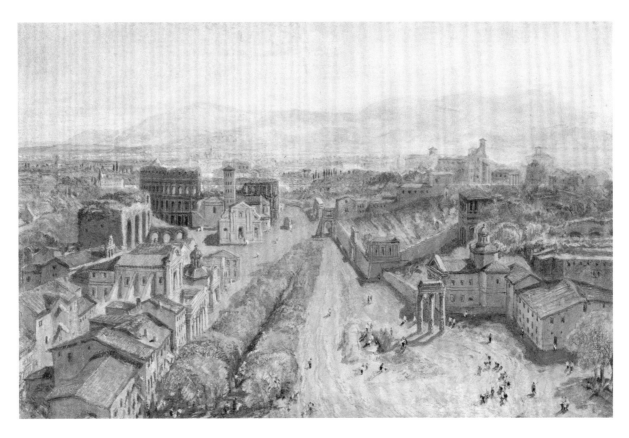

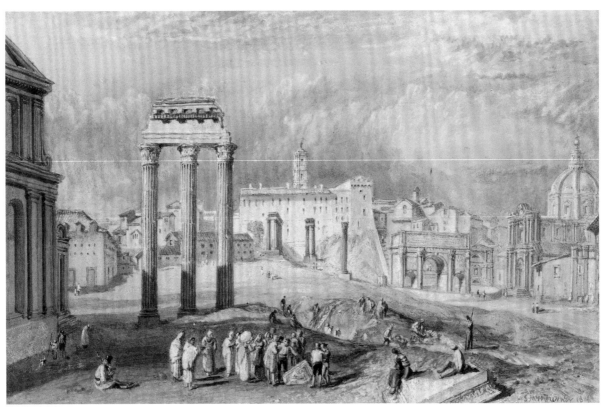

difficulty, doubt, and inquiry ... Familiar acquaintance or rather bosom intimacy with the ancients is evidently the first and most essential accomplishment of a classical traveller.[36]

Eustace, with his quotations from classical texts and abstracts of Greek, Roman and modern history, provided much more sustenance to Turner than Hakewill ever could. But there were times when Turner deviated from Eustace's instructions, or took his advice for 'bosom intimacy' too literally: he made a note in his abstract of *A Classical Tour through Italy* of where 'the prostitutes sleep at night' in Paestum.[37] He also made thumbnail drawings from *Select Views in Italy* published in the 1790s by John 'Warwick' Smith, William Byrne and John Emes of some of the many great sites he should call at – these include Bologna, the Temple of Clitumnus, the Bridge of Augustus at Narni, and Civita Castellana, and appear in his own 'Italian Guide Book' sketchbook [40]. With Hakewill's help Turner had arranged the 'convenient post-chaise', and he was well experienced in matters concerning the letter of credit and the well-furnished trunk. It was, however, Eustace's advice above all other that enriched him and empowered him to become what he was, 'a *classical* traveller.' Before he left home Turner read Eustace closely, and took notes directly from it to the extent that the word order in his 'Italian Guide Book' follows Eustace exactly, down to the number of stages between one town and another, the mileage, and the sights to be seen in the order that Eustace gives them.

As Turner was preparing himself for his journey and thinking constructively about Italy, his friends appeared to have had much the same idea on his behalf. Early in July 1819 Sir Thomas Lawrence, who was staying at the Quirinal Palace to work on a commission for the Prince Regent, wrote to Joseph Farington:

Turner should come to Rome ... His genius would here be supplied with materials, and entirely congenial with it ... He has an elegance, and often a greatness of invention, that wants a scene like this for its free expansion; whilst the subtle harmony of this atmosphere, that wraps everything in its own milky sweetness ... can only be rendered, according to my belief, by the beauty of his tones ... It is a fact, that the country and scenes around me, do thus impress themselves upon me; and that Turner is always associated with them; Claude, though frequently, not so often; and Gaspar Poussin still less.[38]

At much the same time, Walter Fawkes offered Turner

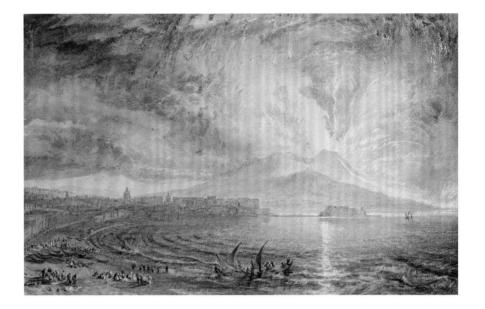

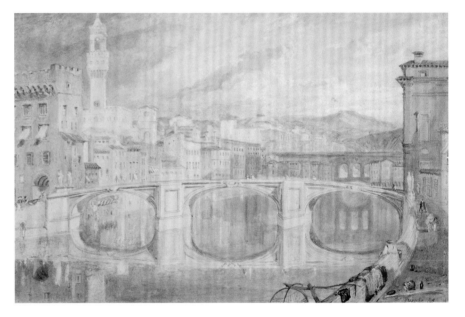

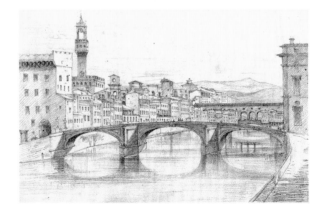

[35] *Bay of Naples (Vesuvius Angry)*, c.1817
Williamson Art Gallery, Birkenhead

[36] *Florence, from the Ponte alla Carraia*, c.1816–17
The Whitworth Art Gallery, The University of Manchester

[37] James Hakewill, *Ponte della Trinità on the Lung'Arno, Florence*, 1816
The British School at Rome Library, Hakewill Collection (no. 2.36)

the compliment of being the star attraction of a large exhibition in his London house in Grosvenor Place. There, in the hall and the saloon, were hung works by nineteen artists, including over sixty watercolours by Turner commissioned or otherwise acquired by or lent to Fawkes over the previous fifteen years. The exhibition was an enormous success, being visited by people in their hundreds, to the extent that, as the *Literary Gazette* put it:

[We] remained jammed in on the landing place for at least half an hour, during which we saw rouge melted, teeth dropped, feathers broken, bonnets crushed, flounces torn, humps pulled off [and] heard Dandy laces give.[39]

Turner was not the only artist exhibited, but nevertheless he treated the exhibition as his own, and made sure that everybody was aware of his presence. One visitor, William Carey, remembered the occasion clearly: 'While he leaned on the centre table in the great room, or slowly worked his rough way through the mass, [Turner] attracted every eye in the brilliant crowd.' He seemed, Carey added, 'like a victorious roman General, the principal figure in his own triumph'.[40]

below:

[39] James Hakewill, 'Cascade of Terni' from *A Picturesque Tour of Italy from Drawings made in 1816–1817,* published 1820
Private Collection

[40] *Perugia; Assisi; Temple of Clitumnus; Castle of Spoleto; Approach to Cascade of Terni; Cascade of Terni; Etc.,* twelve thumbnail sketches from the 'Italian Guide Book' sketchbook [Finberg CLXXII], 1818–19
Tate, London

[38] *Cascade of Terni, c.*1817
Blackburn Museum and Art Gallery

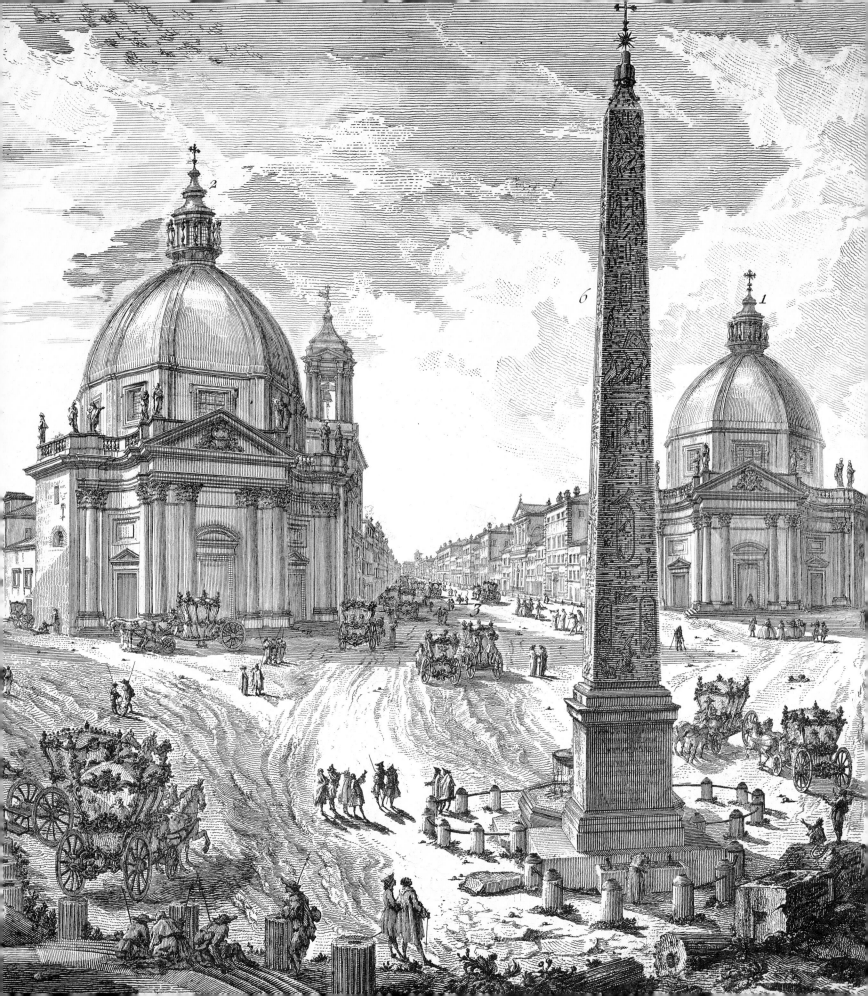

Turner's Route to Rome

A dated letter to the Edinburgh engineer Robert Stevenson gives a fairly clear idea of when Turner left London for his momentous journey to Italy. Thanking Stevenson for his cheque in payment for the watercolour *The Bell Rock Light House*,[1] Turner writes in a postscript: 'I think of leaving London for Italy on Saturday', that is on 31 July 1819. Turner was patient, courteous and accommodating to his patrons, taking particular care, when consigning the *The Bell Rock Lighthouse* to Scotland, that Stevenson should know exactly which sailing smack it was being carried on, when it might reach Leith, and how Stevenson might best frame it.[2]

Turner's production as an artist over his lifetime is prodigious. Even a quick survey of his enormous output prompts the question, how ever did he have the physical energy, quite apart from the genius, to do it? Such a range of work, and such a prolific contribution to exhibitions, to his patrons, to the engravers who reproduced his work, to his students who listened to his long, dutifully-prepared but barely comprehensible lectures, demands the response that perhaps he never stopped working. Turner's output as a letter writer, too, was probably enormous, although fewer than four hundred letters survive.[3]

The sketchbooks are our first window into what might have been going on in Turner's mind and his life. There are suggestions in the sketchbooks he took with him to Italy in 1819 that he set off with high expectations of himself that even he was not able to maintain. The first page of the first book has some lines written in pencil with such a dash and a delight in detail and anecdote, that we can draw the reasonable conclusion that he had started as he meant to go on.[4] He is writing a diary, not a mode of expression for which Turner is noted: 'Left Dover at 10 [presumably Sunday 1 August]. Arr. At Calais at 3 in a Boat from the Packet Boat. Beset as usual. Began to rain the next morn on the setting

out of the Dil[igence].' Being 'beset as usual', Turner is probably remembering the first time he crossed the English Channel, in September 1802, when the wind was such that the packet boat was, as he wrote in the margin of a drawing at the time, 'nearly swampt'.[5] This was the first time he had crossed the English Channel since then. It took five hours to cross, and the next day, crammed in a public diligence, or stagecoach, with a Russian, two Frenchmen, two Englishmen on the outside, and another three inside, he was as much joining in with the conversation as he was looking at the landscape. Evidently he was doing no drawing at all as there are no sketches until he reaches Paris, when there are a few pages of urban studies. After Paris, there is a drawing of the tollgate at Passy, beside the Seine, then very little until studies of Tournus and Chalons, towns three hundred miles further south on the River Saône. He draws busily in the mountains on the route via the Mont St Cenis Pass, with studies of Turin, Lakes Como and Maggiore, and drawings inscribed 'Domodossola'. These indicate that he made a significant diversion via Como to Lake Maggiore, and north-west towards the Simplon Pass, before returning to Milan via Arona [44].[6] In the ninety pages of the third book used on this journey, there are perhaps twenty pages of studies in Milan, some lakes and mountains, and ten or so of Verona. The first indication that Turner has arrived in Venice comes in the 'Milan to Venice' sketchbook in which he has made a simple but fairly detailed study of the traditional, flat-bottomed sailing boat, the sanpierota, unique to the region.

Travelling as he was from the west, Turner will have reached Venice from Vicenza and Padua, crossing the Lagoon at Mestre. Although the mode of transport was very different, the same journey is taken today by visitors arriving at Venice Marco Polo airport who use the Alilaguna waterbus. Turner will have taken the 1819

left: detail of [47]

equivalent of the waterbus, the sanpierota, and made his first landfall at the Dogana, where all travellers were noted and had their papers examined. A few days after their arrival some of them were listed in the *Gazetta Privilegiata di Venezia*, the daily journal which published foreign news and the latest amendments in regulations for natives and visitors living under the complex Venetian bureaucracy. Almost every issue carried the names, nationalities and usually the business of arriving and departing travellers, as well as the Italian or other state from which they had just come. On departure their immediate destination is noted. Lawyers from France and Germany, physicians, army and naval officers, and men and women who were simply described as 'Viagg. Ing.' (English travellers) crop up in the lists. Lord Byron left Venice for Ravenna on 1 June,[7] the neoclassical sculptor Antonio Canova and his brother the Abbate Sartori, arrived from Possagno on 15 July,[8] and other travellers had come and gone during the course of August and September from Naples, Milan, Padua, Florence and Trieste.

Entries in the *Gazetta Privilegiata* suggest that Turner arrived in Venice on 1 September.[9] He stayed on the Grand Canal, a few hundred yards south of the Rialto, at the Albergo Leone Bianco, which he described beside a sketch of part of the building, as 'The Inn of Great Britain'[45].[10] Many travelling Englishmen stayed there. The Leone Bianco, now the City of Venice Registry of Births, Marriages, Divorces and Deaths, has been refurbished to the extent that little or none of its original fittings remain. In the courtyard, however, now moved to the side, is a typical white marble Venetian well-head decorated with a shield on which is carved a rampant lion.

Turner seems to have used three sketchbooks in Venice.[11] Two are filled with a total of about 140 pencil studies, while the third, 'Como and Venice', now dismembered, contained four watercolours of Venice along with two of Lake Como and a view over Milan rooftops.[12] That there are only four watercolours of Venice also suggests that information gathering, rather than painting, was his priority here. There are pencil studies of St Mark's Square, and of gondolas and sailing boats in St Mark's basin, so evidently he hired a craft to take himself out onto the water. He also went on a long, slow journey up the Grand Canal from St Mark's all the way from the Salute and the Accademia to Ponte degli Scalzi, now the bridge nearest to the railway station, and the Ghetto. Taking great pains to express with his pencil the staggering complexity of the architecture and activity of the Grand Canal, Turner also reveals the paradoxical nature of Venice: its wide open skies, its generous stretches of water, and its welcoming urban vistas which can so suddenly close down to appear claustrophobic and frightening. One dramatic drawing shows the arch of the Rialto rising up over the boats beneath, and framing the view of the buildings beyond [42].[13] With its snaking double bend, the Grand Canal in Venice, thronged with craft, lined with buildings, and alive with movement and light, is like nowhere else in Turner's experience other than the Thames in London. The Grand Canal is narrower than the Thames, but their comparable roles as their city's arteries, and as their stages for commerce and pageantry cannot have been lost on Turner.

right, clockwise:

[41] *Piazza del Popolo, Cesena, from the First Floor of the Hotel Leon d'Oro* from the 'Venice to Ancona' sketchbook [Finberg CLXXVI], 1819
Tate, London

[42] *The Rialto Bridge from the South* from the 'Milan to Venice' sketchbook [Finberg CLXXV], 1819
Tate, London

[43] *Piazza del Popolo, Faenza, with the Steps of the Cathedral and Fountain* from the 'Venice to Ancona' sketchbook [Finberg CLXXVI], 1819
Tate, London

[44] *The Cathedral, Milan* from the 'Milan to Venice' sketchbook [Finberg CLXXV], 1819
Tate, London

below:

[45] *The Rialto Bridge from the Albergo Leone Bianco* from the 'Milan to Venice' sketchbook [Finberg CLXXV], 1819
Tate, London

Some exploration along the back canals and 'ria' of Venice took Turner to the north of the city to San Zanopoli, where he sketched a detail of Titian's *Death of St Peter Martyr*, a work he had first seen seventeen years earlier in the Louvre.[14] He drew from the Tintorettos in the Scuola di San Rocco and visited the Accademia, but from the evidence of the sketchbooks and the four limpid watercolours, Turner's greatest interest was not so much in the old master paintings that hung in the city's palazzi and churches, but in the light and the detail of the multitudinous activity of the city outside. Two inscriptions sum this up. On a drawing of boats he has written, 'Each Boat the Sail has a Long Yard to keep the sails full tho' beyond the Bar.'[15] Beside drawings of figures in costume he notes, 'Soldiers drab jacket and cuffs and Skirts ... white breeches and boots. / Undress white long coat Blue pantaloons and H B. Blue cap.'[16] Turner examined everything. The last drawing of Venice in the 'Venice to Ancona' sketchbook is a panorama of the Giudecca, with the evocative inscription 'all the steeples blood red'.[17]

Three or four days after Turner left for Ferrara, two other Royal Academicians arrived in Venice. John Jackson and Francis Chantrey, both of whom were listed as 'membro della R Accademia di Londra', making no mistake as to their status, came from Milan in Turner's footsteps. Turner himself had been discreet to the authorities regarding his profession; not so Jackson and Chantrey, two very active and successful London artists who felt that they had nothing to be modest about. This

was Chantrey's first visit to Italy, during which he would see the marble quarries of Carrara. Both artists would later meet Turner in the convivial surroundings of the English community of Rome. They left for Florence, bent on the more orthodox route to Rome, between 16 and 18 September, a day or two after Byron returned to Venice, from Rovigo.[18] For Turner, the route south to Bologna was not the one that Hakewill had advised,[19] but the one previously followed by Eustace. He passed through Padua, Rovigo and Ferrara, which he will have reached after perhaps three or four days travel at the most, and then on to Bologna.

As he crossed the River Po and the 'waveless plain of Lombardy',[20] as Shelley had described it a year earlier, Turner refers to little except a charming drawing of a calf[21] followed by two or three pages of nondescript studies of landscape and buildings before the first study made in Bologna.[22] Surprisingly, he does not appear to have drawn in Padua, with its vast and unique thirteenth-century Palazzo della Ragione (Palace of Law) decorated with frescoes, nor in Rovigo, nor even in Ferrara. If Turner was conserving his creativity, it was released when he arrived in Bologna. Coming from the north, he passed first through the Porta Galliera and headed for the Piazza Maggiore and Piazza Nettuno where Giambologna's Neptune fountain stands.[23] There he drew the fountain and the buildings surrounding it, and walked on to draw the nearby Torre degli Asinelli and the Torre Garisenda, two structures which he had seen in engravings, but whose great height and unintended precarious angle were quite beyond his experience. He travelled around the town recording views from a moderate distance, principally from Montagnola, now near the railway station, and made the ambitious carriage journey out of town up a long hill to the sanctuary of the Madonna di San Luca. This eighteenth-century domed building is linked to the surrounding valley by a unique and remarkable structure, an unbroken sequence of 666 arches, longer than any line of arches in Europe.[24]

With the help of a friend or fellow traveller, Turner brushed up on his Italian. Despite his years of travelling, and try as he might, he never did master foreign languages. Either in Venice or Bologna he wrote in his sketchbook: 'Dove a la Academia dei belli Arte / Where is the Academy?' to remind himself what to say when asking directions.[25]

Turning east from Bologna, Turner's sketchbook shows him to have passed through Imola, Faenza, Forlì

and Cesena, on the Via Emilia, the Roman road to the coastal city of Rimini. The manner in which he treats the urban subjects in the sketchbook gives a very clear idea of how fast he travelled and the length of his stay. After Bologna, of which he made twenty-three pages of studies, the next town he draws is Imola and the next, Faenza. Imola is given only cursory attention, while in Faenza Turner made a detailed drawing of the Piazza del Popolo, suggesting he spent more time there[26] [43]. Continuing on to Cesena there are a number of brief studies of the intermediate towns Forlì and Forlimpopoli, but he makes a well-considered drawing of Cesena (twenty miles from Faenza), of the main square from the first floor balcony of the Hotel Leone d'Oro[27] [41]. From the evidence of the time Turner spent on his drawings it is reasonable to suggest that he stayed the first night after Bologna in Faenza, the second at Cesena, and the third at Rimini, nineteen miles further on, where he put great care into drawing the bridge and arch of Augustus, and recording their inscriptions.[28]

It is also possible to estimate Turner's timetable by comparing the slight drawings of Pesaro, about fifteen or sixteen miles from Rimini, with the detailed studies of Fano, Foligno, Spoleto, Terni, Narni and Civita Castellana further along in the journey, and deduce that he spent the night in those small towns.[29] The value of this is that it helps to estimate the date of Turner's arrival in Rome. By making a calculated guess at the places where he stayed the night, it appears that it took Turner eighteen or nineteen days after leaving Bologna to reach Rome. Adding this to what might have been three days travel from Venice to Bologna, and perhaps two nights in Bologna, a journey from Venice to Rome of twenty-three to perhaps twenty-five days seems reasonable. So leaving Venice on 9 September, Turner would have accomplished all he did and reached Rome by 4 or 5 October. 'Mr Turner is come,' Lawrence told Farington on 6 October 1819. He continues:
I had the sincerest pleasure in seeing him for he is worthy of this fine City, of all the Elegance and Grandeur that it exhibits. He is going immediately to Naples, but his longest stay, doubtless, will be here. He feels the beauty of the Atmosphere & Scenery as I knew he would. Even you would be satisfied with his genuine and high Respect for [Richard] Wilson, and the pleasure he feels at so often seeing him, in and around the campagna of Rome … Many perhaps may agreeably represent the scenery that I have

witnessed but none but Turner or after him Mr Callcott can (as far as human means go) do it justice. He would not I think be displeasd that I name him first. It is essential evidence of the truth of his Superiority, that his ablest Rival has never seemed to have a feeling of rivalry towards him and I am certain that neither of us Portrait Painters can say that of each other.[30]

Turner made his entry into Rome down the Via Flaminia, under the Porta del Popolo, and into the great Piazza beyond. This is the grand entrance to the Rome of the Popes, orchestrated in the 1530s by Pope Paul III, and easily matching in magnificence the entrances to the Eternal City created by a succession of Roman Emperors in antiquity. While the ancient Via Appia made its entrance at Rome's bloody southern end by the Circus Maximus and the Colosseum, the modern popes welcomed visitors from the north by way of a magnificent piece of urban theatre, the Piazza del Popolo, an enormous stage set laid out on ground that slopes gently down from the entrance, and dominated then, as now, by a twenty-four metre high Egyptian obelisk. This view would have been known to Turner by his familiarity with the work of Piranesi. Directly ahead of the arriving traveller, across the square, are the twin baroque churches Santa Maria dei Miracoli and Santa Maria in Monte Santo. These mark the termini of three streets which radiate to the heart of Rome, the Via del Babuino, the Corso and the Via di Ripetta [46]. Anticipating this, Turner had written in his 'Italian Guide Book', following Eustace: *Modern Rome / 3 Main Streets the Corso from Piazza or Porte / del Popolo anciently the Via Lata terminating / at the Capitol Strada del Babuino ending at the / Piazza de' Espagna. Strada Ripetta. Via Popoli / leading to the Tibur, Strada Giulia della Longara.*[31]

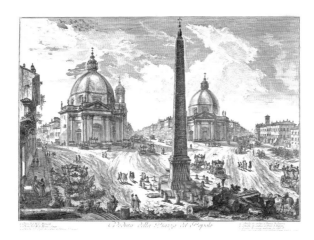

So he was well prepared to make the short journey from the Piazza del Popolo, by way of the Customs House off the Corso, to the Piazza di Spagna and the Spanish Steps. He may have been surprised at the state Rome was in, though it was no dirtier than London. He would also have been warned about conditions by his friend the scientist Mary Somerville who wrote to her mother, 'I am forced to say poor fallen Rome, sunk in meanness, filth, and dissipation, disgusting you at every step, rousing indignation and contempt.' But nevertheless Mary Somerville was, like all travellers, transported by what she saw:

The whole hill [Palatine] is strewn with broken columns and marbles of the most exquisite workmanship, and numberless ruins of halls towering in majesty the habitation of bittern and owl and adorned by every variety of plant a shrub blooming even at this season mingled with the dark green leaves of the Ilex. Every step was interesting and beautiful.[32]

Tucked in behind the Spanish Steps is the Piazza Mignanelli, where, at the top of another flight of steps, the Rampa Mignanelli, were rooms taken by Turner's English friends Captain Thomas Graham RN and his wife Maria. The house belonged to the Roman sculptor Giuseppe Ugo, who lived there with his wife and three children.[33] The Grahams were brave and regular travellers who in early September, perhaps around the time Turner was in Venice, had returned to the city after a summer spent in the mountains east of Rome. Their address, 12 Piazza Mignanelli, along with two others, are written into the 'Vatican Fragments' sketchbook, a book that seems to have been in use fairly early in Turner's period in Rome, before he went to Naples.[34]

It is not clear if Turner stayed at Piazza Mignanelli in 1819, although he was to do so when he made his second visit in 1828 [48]. Another address associated with him on this visit is Palazzo Poli, the building from which the Trevi Fountain flows: he wrote a letter from here

[48] *Pianta Topografica di Roma Moderna, estratta dalla grande del Nolli an. 1820.* The Spanish Steps and Palazzo Mignanelli are shown top right.
National Library of Scotland, Edinburgh

to Canova, dated 27 November.[35] A third is 'Thomas L. Donaldson / 46 Via Gregoriana / Trinità de' Monti', written out in the sketchbook in somebody else's hand, possibly Donaldson's. Via Gregoriana runs from the top of the Spanish Steps, directly above and behind Piazza Mignanelli, towards the Quirinal Hill.

Thomas Donaldson was a particularly promising student of Turner's at the Royal Academy, studying architecture and attending Turner's lectures on perspective. Aged twenty-two, he had come to Rome via Milan, Genoa and Florence in November 1818.[36] Perhaps he and Turner met each other immediately after the older man's arrival, because they were very shortly to travel to Naples together. The part of Rome around the Piazza di Spagna was throughout the nineteenth century a haunt of the British, of artists and tourists. Indeed it remains so, having the Babington Tea Rooms (founded 1893) still doing business at the bottom of the steps on the left, and the Keats-Shelley Memorial House open to the public on the right. Claude and Poussin had lived nearby in the Via Margutta in the seventeenth century, but in the 1820s it was believed that Poussin had lived even closer, in a house to the right of the church of Santissima Trinità del Monte, and Claude had been just across from the church in the Tempietto which, at least until the 1870s, was directly above and behind 12 Piazza Mignanelli.[37] No doubt Turner was happy to be assured that the great Claude had actually lived there, and that his ghost was looking over his shoulder. Richard Wilson in the 1750s lived near the Spanish Steps, and John Flaxman inhabited the Tempietto from 1788 to 1794. All this gave added frisson and sense of place to the streets and hillside.

While Turner was moving energetically around Rome, Maria Graham had set to work writing up her account *Three Months Passed in the Mountains East of Rome, During the Year 1819*, published the following year in London by John Murray. Reflecting on what she, her husband and their travelling companion the young artist Charles Eastlake had experienced, she touches on a subject that affected every traveller in rural Italy, and in particular those crossing the Apennines as Turner himself had so recently done. The landscape was seething with bandits, who demanded food and money with extreme menaces, such as hostage-taking, maiming and murder. The Grahams may not have seen the bandits, but they certainly heard of them:

Every day while we remained at Tivoli, brought some new particulars concerning the [outlaws'] marches. It was ascertained, that the whole number amounted to about one hundred and forty, divided into companies, not exceeding twenty in each … [T]he most enterprising gang lingered about Tivoli, where there are a number of rich proprietors, who might have furnished a considerable booty.[38]

These 'outlaws' were violent and murderous men with prices on their heads. The situation had reached the stage where the Pope's Secretary of State Cardinal Consalvi issued an edict which obliged local communities to destroy robber bands, in return for which they would be released from salt and corn-grinding taxes for two years, for every three banditti killed.[39] Turner's route to Rome from the north passed through country quite as dangerous as the mountains east of Rome – Tivoli, Palestrina and Poli – where the Grahams had spent their summer. He arrived in one piece, so it can only be assumed that the journey was, from the point of view of bandit activity, uneventful. He was, however, well prepared, as he kept in his umbrella handle a two-foot long dagger.[40]

As he wound his way by mail coach along the Adriatic coast and across the Apennines, a similar journey was followed, a few days later, by a handsome private carriage bearing other distinguished travellers from London. These were the scientist Sir Humphry Davy, his wife, his servant and her lady's maid. The Davys had taken a route almost as roundabout as Turner's, travelling down the west coast of Italy as far as Massa and the quarries at Carrara. The party then turned east via Florence to the Adriatic at Fano, from whence they travelled to Rome via Nocera and Foligno, avoiding Ancona and Loreto, adopting a more southerly route than that of Turner.

Davy had set himself a number of tasks to perform in Italy, and had written these out as an aide memoire in one of his personal notebooks.[41] One was to conduct experiments 'to determine if the spots in Carrara marble are *iron oxide* & if they can be *obliterated*'. These marks, in the view of sculptors like Chantrey, spoilt the cold, sheer face of pure Carrara marble. Another was to investigate the so-called Monte Testaccio, the artificial hill on the east bank of the Tiber composed entirely of broken pottery jars and amphorae. Davy wanted to find out if 'the cold in the cellars under Monte Testaccio is greater than elsewhere in Rome & if the *cause* be the radiation from the *Potsherds*'. A third task brought his and Turner's interests directly into line and this was 'to ascertain if anything can be done to preserve the frescoes of Raphael in the Vatican'.[42] A further mission, at the command of the Prince Regent, was to try to find ways, using chlorine

and iodine, to unroll papyri discovered at Herculaneum without them crumbling to pieces.[43] Davy was surrounded in Rome by Englishmen of scientific bent: 'Lord Spencer [President of the Royal Institution] is here ... I believe we have managers of the RI here sufficient to form a committee.'[44]

Turner and Davy were part of a cohort of English men and women pouring into Rome in the autumn of 1819. We know something of the social activity in the city this year through the journals of the poet Thomas Moore, who gives a detailed account of the people he met, travelled with, and entertained. They all entered Rome with some natural caution, and Turner was not the only Englishman to carry personal protection, as Moore suggests. Feeling too tired after a long day's sightseeing at Tivoli to go out in the evening, he noted, 'who can enjoy such a party of pleasure as we had to-day, armed as we were with pistols, daggers, sword-canes

[49] *Parts of the Ash Urn of T. Flavius Eucharistus; and Parts of the Base of the Statue of Attius Insteius Tertullus*

[50] *A Torso; Grave Altar of Q. Gaius Musicus and Volumnia Ianuaria*

from the 'Vatican Fragments' sketchbook [Finberg CLXXX], 1819

Tate, London

left:

[51] *The Castel dell'Ovo, Naples, with Capri and Sorrento in the Distance: Early Morning* from the 'Naples: Rome: Colour Studies' sketchbook [Finberg CLXXXVII], 1819 Tate, London

&c &c'.[45] Thomas Moore was an entirely different kind of traveller from Turner and Davy. He was a successful poet and satirist, but one with never enough money in his pocket to pay for the social and literary life he so desired. Moore visited the sights with Lady Davy, talked with the Duchess of Devonshire, sang songs with Lady Mary Fortescue, and called on Lady Charlemont, Lady Mansfield, and Lady Burghersh.[46] With Maria Graham and Charles Eastlake he went up the Palatine Hill,[47] and kept company with Chantrey, Jackson, Lawrence and Turner. As the writer Mariana Starke put it in her *Letters from Italy* published in 1815:

The society at Rome is excellent: and the circumstance of every man, whether foreigner or native, being permitted to live as he pleases, without exciting wonder, contributes essentially to general comfort. At Rome, too, every body may find amusement; for whether it be our wish to dive deep into classical knowledge, whether arts or sciences are our pursuit, or whether we merely seek for new ideas and new objects, the end cannot fail to be obtained in this most interesting of cities.[48]

We know from Lawrence's letter that Turner went 'immediately to Naples', although this may have been after he made an initial visit to the Vatican. Perhaps the most intensive and dedicated detail of any of Turner's Roman sketchbooks is found in 'Vatican Fragments'.[49] This contains about 120 pages of careful pencil studies of antique Roman sculpture, sarcophagi and inscriptions which were then, as now, displayed both in the immensely long but regular corridors of the Vatican Museum, and in the Capitoline Museum.[50] The Vatican Museum was entered (and still is) from the northern extremity of Vatican City. Hakewill would probably have shown Turner the arrangement of the building from the plans and illustrations of the Vatican which he published in his *Tour of Italy*. Among the early drawings in Turner's sketchbook is the sarcophagus with the Three Graces,[51] and the tombstone of A. Antestius and his family, both now in the Lapidary Gallery. Another is the urn which originally contained the ashes of T. Flavius Eucharistus, whose three figures Turner painstakingly drew, as well as noting down the inscription[52] [49]. The sketchbook contains a maintained level of detail, and one page has a delightful drawing of the left and right hand side reliefs of the funerary altar of L. Cornelius Atimetus and L. Cornelius Epaphra, showing the interior of a workshop

[52] *The Arch of Constantine and the Colosseum* from the 'Rome: Colour Studies' sketchbook [Finberg CLXXXIX], 1819 Tate, London

with hanging tools, a bench and a hammering figure [50]. Turner has drawn both reliefs, and added a three-quarter view for good measure.[53] Some sculptures are drawn from odd angles, and it is reasonable to wonder why, for example, he gives a corner view of the grave altar of Q. Gaius Musicus and his wife Volumnia Ianuaria.[54] All becomes clear when trying to photograph it today as it is set in the Court of the Belvedere close behind an enormous porphyry bath, and so can only be seen from an oblique angle. The arrangement that Turner saw in 1819 is the arrangement now.

Turner and Donaldson travelled together to Naples which they had reached by 16 October, the date shown in Donaldson's passport.[55] There Turner worked as usual at speed. He seems to have used three sketchbooks, visiting the harbour, the hills above the town, and climbing up Vesuvius itself.[56] The volcano was grumbling, and an eruption was generally expected, but, according to Turner's pencil and watercolour studies, activity was minimal. Indeed, his interest seems hardly to have been engaged by the volcano at all, except as a distant background feature. Once again, Turner chose not to follow well beaten paths, but made other views of the town. He went up to Castel Sant'Elmo and San Martino from where there are wide views of the bay, and took a boat around the harbour. He drew with the same speed, attention and detachment that he had employed in towns such as Bologna and Ancona on the route to Rome, and the similarity of Naples to Ancona cannot have been lost on him. There are only six watercolour studies of Naples [51], all unfinished, and the city is not comparable to Rome as a magnet for Turner's attention. One young Englishman whom Turner knew in London, and met again in Naples, was the younger John Soane, the son of the architect. In a letter, he reflects revealingly on Turner's practice, 'Turner is in the neighbourhood of Naples making rough pencil sketches to the astonishment of the fashionables, who wonder what use these rough drafts can be – simple souls!'[57] Given the fury and drama that Turner gave to the three imaginary volcanic eruptions he had painted in previous years – Vesuvius twice and the Souffrier Mountain on the Island of St Vincent in the West Indies[58] – he was surely hoping that he would see Vesuvius erupt. Had he stayed on until the end of the month he would have been satisfied, but what Turner missed Davy saw. 'The event which I have so much longed to witness has occurred,' Davy wrote on 10 December to his assistant in London, Michael Faraday:

[53] Study for *Rome from the Vatican* from the 'Rome: Colour Studies' sketchbook [Finberg CLXXXIX], 1819 Tate, London

Vesuvius has been for some days in a state of eruption. I have already made many expts on the lava at the moment that it issues from the volcanoe [sic] & I should have completed them but for a severe indisposition owing to my having remained too long in that magnificent but dangerous situation, the crater within 5 or six feet of a stream of red hot matter fluid as water of nearly three feet in diameter & falling as a cataract of fire.[59]

From Naples, Turner travelled south to Pompeii, Herculaneum, Sorrento, Amalfi and Paestum – part of the journey by sea – and then via Naples which he departed on 4 November for Rome. He passed through Albano, fifteen miles from Rome, according to a drawing dated 15 November.[60] He drew all the way, inquisitive, erudite, and persistent as he was. The landscape, the inscriptions, the remains, all caught his eye, and when he found one particular site, Virgil's tomb at Mergellina, his heart must have leapt. Transcribing the inscription in Latin, he adds the translation, 'This [sic] are the remains of a Tomb which / contained the cinders of him who sang the / pastorals of the Country.'[61] Either as part of this journey, or at another time during his tightly-packed Roman schedule, Turner visited Tivoli, twenty-five miles away, and made there two hundred or more sketches in and around that bandit-ridden town in the hills.[62]

It is impossible to construct a reliable sequence of events in Turner's weeks in Rome from the sketchbooks alone.[63] The eight which comprise a predominant number of Roman subjects[64] can be divided into two groups: six have pencil drawings made directly in front of the object or view, and clearly indicate where Turner was standing at the time, [46, 52, 53] two have added watercolour and gouache, some of which may have been drawn and coloured on the spot, and others will have been coloured up later [54–7]. These were both titled by Turner on their covers 'Rome: C[olour]. Studies.'[65] Evidently, there is a system in process. The pencilled sketchbooks represent prolonged periods of gathering information, specifically, in the Vatican Museum, St Peter's Basilica and the Forum. The sketchbooks with colour take a step further towards the realisation of finished images for eventual sale, engraving or development into exhibition oil paintings. The main areas of Turner's interest, as reflected in the pencil and coloured drawings are the Vatican and St Peter's – particularly the Vatican Museum and the Raphael Loggia – the Forum, and the views across the city from high points on the Janiculum, Quirinal, Palatine, Pincian and Esquiline Hills. Across the twenty subsequent years in which he painted Roman subjects, Turner covered the entire city, from all angles. He also visited the Villa Medici and the Corsini, Borghese and Farnese Palaces, where he made studies of more sarcophagi and of frescoes by Annibale Carracci, and travelled to the outskirts, for example to St John Lateran, the Monte Testaccio, and along the Appian Way.[66]

The Vatican Museum is full of visual surprises, not only the peerless collection of sculpture that lines every wall and niche. Tricks of perspective are built into the architecture and decoration: for example, at the top of the short flight of stairs leading from the Museo Chiaramontini, the western corridor of the Vatican complex, the marble door jamb adjacent to the sarcophagus of Scipio Barbartus has a distorted coffered archway which dictates a left turn towards the Court of the Belvedere.[67] Another deception is the fresco at the far end of the Lapidiary Gallery, where a pair of doors is set at an approximately 120° angle to each other. The left-hand door leads directly into the lower floor of the series of loggie overlooking the papal palace, while the other, painted with trails and arabesques, appears to prepare the visitor for a shallow right turn. This is a trick: the turn is sharp right, leading towards the Sistine Chapel. The architecture, by Bramante, compromises the visitor's instinctive free will. These and other ingenuities in and around the Vatican, such as Bernini's Scala Regia, and the placement there of his equestrian statue of Emperor Constantine, will have mightily amused the Professor of Perspective at the Royal Academy as he came to decide on how he was to express the multitude of impressions that Rome was making on him.

In the Vatican, Turner would have found his way to the second floor loggia, painted by Raphael and his students. His drawings suggest that the arched loggia was not glazed as it is now.[68] Among his first studies were some of the painted panels, with illustrations from Genesis, and others of the architectural decoration. He also made colour and composition notes in his small and sometimes illegible hand.[69] A drawing on a separate sheet, showing the loggia, with a member of the papal Swiss Guard lounging on a chair beside a bust of Raphael at the far end, also reveals the panoramic view of the city, and the corner of the papal apartments nearby [53]. Also in the 'Tivoli to Rome' sketchbook are some drawings of the architecture of the loggia inhabited by figures. In one

[54] *Ruins in Rome: View from the Palatine* from the 'Rome: Colour Studies' sketchbook [Finberg CLXXXIX], 1819
Tate, London

[55] *The Claudian Aqueduct* from the 'Rome: Colour Studies' sketchbook [Finberg CLXXXIX], 1819
Tate, London

[56] *The Colosseum and Basilica of Constantine* from the 'Rome: Colour Studies' sketchbook [Finberg CLXXXIX], 1819
Tate, London

[57] *View over the Roman Campagna* from the 'Rome: Colour Studies' sketchbook [Finberg CLXXXVII], 1819
Tate, London

of these drawings, the figure in a floppy hat, the dramatic pose, the propped canvases and a reclining nude – an unexpected sight in the Vatican – suggest that he is an artist. Other studies, for example the Alessandro d'Este bust of Raphael,[70] indicate that the composition evolving is that of Turner's large oil *Rome, from the Vatican* [59] which he painted on his return home, to exhibit in the Royal Academy the following April.

Another temporary resident in Rome was Thomas Lawrence who was there to paint portraits of Pope Pius VII and Cardinal Consalvi for the Prince Regent. Consalvi, whose campaign against the bandits was a serious political and social issue in 1819, was one of the architects of the diplomatic intervention that, in 1816, successfully resulted in the restitution of the works of art that Napoleon had looted from the Vatican and the Italian states, and installed in the Louvre.[71] Lawrence also painted a portrait of Canova,[72] and a portrait of Maria Graham, which he left unfinished (National Portrait Gallery, London).[73] Lawrence was a mouthpiece and newsvendor for the English community, and being something of a gossip, was rather good at it. There was much talk about Raphael's frescoes, both in the Loggia and the adjoining rooms, the so-called Raphael Stanze, which had suffered not only from weather and damp, but also from the depredations of Napoleon's troops during the French occupation of Rome. Lawrence had already warned Farington of the condition of the frescoes and of the Sistine Chapel: 'In both the Sistine Chapel and the Rooms of Raffaelle all in too many parts is ruin and decay, at least it appears so to me who is not sufficiently prepared for the ravages of Neglect & Time.'[74] The condition of the frescoes was a particular concern in the scientific and artistic circles of London: Farington, Chantrey, Davy and others were prepared to use their scientific and archaeological knowledge to assist in the conservation by whatever means they could. Henry Sass had brought the issue into the open a year earlier when he published *A Journey to Rome and Naples* in which he commented, *But what a lamentable account am I to give of their present state! The most culpable negligence, the blindest indifference, seems to pervade the Papal government. ... The paintings of Raphael from the Bible in the Corridor are almost destroyed by damp.*[75]

A letter from the Prince Regent's private secretary to Cardinal Consalvi brought matters to a head: *Desiring that these copies be made as accurately as possible,*

HRH hopes that his holiness may be pleased to grant such a request (that is the copying) with, however, those limitations which Your Eminence shall judge sufficient to protect the originals from any risk of damage.[76]

The request was received politely, and the Prince Regent instructed Alexander Day, an art dealer and miniaturist thoroughly familiar with Rome,[77] to oversee the copying of Raphael's Loggia frescoes. But a senior papal official told Gaspari Landi, President of the Accademia di San Luca, Rome's equivalent of the Royal Academy, that the frescoes should not be traced, for fear of adding to their damage.[78]

[58] *Christ Driving the Traders from the Temple, c.*1832
Tate, London

These issues were being discussed at the highest level when Turner was in Rome: the papal letter is dated 10 December 1819, but the approach from the Prince Regent will have come much earlier. It might reasonably be suggested that the matter may have prompted Turner to make his studies of the Loggia, which are far more detailed than he would reasonably need if he were not sympathetic to, and even complicit in, a complete copying of them. Throughout his artistic career, Turner only used a fraction of these studies, in, for example, *Rome, from the Vatican* [59] and in later canvases on Roman and mythological subjects such as *The Golden Bough* [92]. Such intensive study of the Raphael Loggia by Turner may suggest an ulterior motive, a proposed and more or less complete evocation of the frescoes which came to fruition as *Rome, from the Vatican*. This provides an additional reason why the Accademia di San Luca were grateful to Turner, and elected him to membership on 22 November. While not going so far as to record the crumbling frescoes, Turner made so many notes that *ipso facto* he collected enough information to make *Rome, from the Vatican* as clear an evocation of them as he possibly could. When the Accademia honoured him as a great landscape painter, they were also acknowledging his profound and constructive sympathy for their difficulties.

There seem to be two distinct purposes afoot in Turner's production in Rome: the intensive information-gathering in the Vatican Museum, St Peter's and the Forum; and the sixty or seventy general views in the two Rome: 'Colour Studies' sketchbooks made in gouache and watercolour in all conditions of light and atmosphere. The studies in the Forum led to works such as *Forum Romanum* [75] painted for John Soane in 1826, while the multitudinous figures drawn in the Vatican led to paintings such as *Christ Driving the Traders from the Temple* [58] painted around 1832. This is clearly a work that has a double Roman source, pagan and Christian, for the 'temple' from which Christ is driving the traders is of course St Peter's, details of which, including the twisted columns of Bernini's baldacchino and the papal tomb, derive from studies in the 'St Peter's' sketchbook of 1819. The figures reflect the complex compositions Turner discovered on sarcophagi, and also echo some of the figures in the Raphael Stanze.

The large group of general views of Rome has a unity in its diversity which is akin to the dozens of Wharfedale, Rhine, and English southern coast subjects

that Turner had made in the earlier years of the decade. These had patrons of sorts, Walter Fawkes, the engraver George Cooke and the publisher John Murray, with whom Turner had a contract to provide around thirty watercolours ready to be engraved as *The Picturesque Views of the Southern Coast of England*. As Murray had had his fingers burnt over both the Southern Coast and the Hakewill projects,[79] he would not have been a likely partner in any Roman venture. But the Prince Regent, if an item dated 20 November 1819 in the usually reliable *Literary Gazette* is anything to go by, was another matter. The paper reported from Rome that:

Mr Turner, the English painter, has arrived here. It is said that he is as great in landscape painting as Sir Thomas Lawrence in portrait ... Mr Turner is to paint the most striking views of Rome, for his royal highness the Prince Regent.[80]

While being a single-minded and self-motivated artist, never at a loss for a subject to paint, Turner's greatest single driving force was the market. He painted for himself in his later years, often without hope or intention of sales, but in his early and mature career Turner was a one-man business; he painted what he either knew, or was pretty certain, he could sell. There are many lists throughout the sketchbooks of patrons, the subjects they had had or might commission and the price to be paid. How the anonymous reporter got hold of the information about Turner and the Prince Regent is not clear, although Turner himself is the obvious source, speaking proudly, and perhaps with some wishful thinking, to a correspondent about why he is in Rome and what he proposes to do while he is there. It appears likely that when travelling to Rome, and while in Rome, Turner was in anticipation of a royal patron, and continued with that belief for some months after his return to England.

Assimilating the Italian Sun

Turner left Rome early in January 1820 and headed home. Within a month, on 1 February, he had arrived in London having travelled 1,200 miles from Rome, via Florence and the Alps at Mont Cenis, where he endured a coach crash in a storm. Rather than shut himself away, exhausted, in his studio, he was quickly up and about, and the next day sat beside Joseph Farington at a dinner at the Royal Academy. Farington's reports of conversations are normally quite detailed, so it may be that Turner was more than usually monosyllabic after the effort of his long journey. All Farington notes is that 'Turner returned from Italy yesterday: had been absent 6 months to a day. Tivoli – Nemi – Albano – Terni – fine.'[1]

There were no more than ten weeks between the beginning of February and the date in the second week of April on which paintings had to be delivered to Somerset House for the hanging of the spring exhibition at the Royal Academy. So if Turner was to make his characteristic splash at the Academy, he had a great deal of work to do. The last painting he had shown there had been the majestic *England: Richmond Hill, on the Prince Regent's Birthday*, but now he had an even greater impact in mind – two canvases of the same huge dimensions as *England: Richmond Hill*. Having left behind a classic image of England when he went to Italy, he proposed to mark his public return with two sensational Italian subjects.

Venice and Rome had provided him with the greatest and most concentrated visual excitement of his trip. From Venice he could find in his sketchbook the long sequence of pencil drawings he made from a gondola on the Grand Canal, including the dramatic composition of the arch of the Rialto with buildings and waterborne activity nearby. In his Roman sketchbooks he had already found a promising subject in his initial compositional drafts of Raphael and his model in the Vatican.

This study evolved into *Rome, from the Vatican* [59], completed and exhibited at Somerset House after what must have been an extraordinarily concentrated burst of work.

The drawing of the Rialto evolved in turn into another long canvas, but this was never completed.[2] There are a number of reasons why this might have been so. When Turner left London, workmen had begun demolishing his house at 44 Queen Anne Street, which was listed as 'empty and in building' in the Marylebone rate returns of Christmas 1819.[3] It was still uninhabitable when he returned home, and Turner was living in his country house, Sandycombe Lodge at Twickenham, as well as with friends.[4] A canvas as large as *Rome, from the Vatican* could not have been painted in the small house in Twickenham, so he must have made other arrangements, working perhaps at Somerset House. With such added complications it is highly unlikely that Turner could also have completed a second large canvas, the projected *Rialto*, in time for the exhibition in April 1820.

Rome, from the Vatican is a masterpiece of manipulated perspective management which is so controlled that the viewer has the distinct impression of actually walking down that corridor towards the blanked off doorway with the empty plinth at the end. In Turner's day, as now, there is Alessandro d'Este's bust of Raphael on the plinth, but this is absent from the painting because Raphael himself is there on the balcony, with his model, fully clothed, beside him. The model, 'La Fornarina' (the baker's daughter) was Margherita Luti, Raphael's mistress. The whole intricate, stage-managed spectacle of the painting is underscored by the title Turner gave it. Sometimes his titles concealed rather more than they revealed, but in this case what could be clearer than *Rome, from the Vatican. Raffaelle, Accompanied by La Fornarina, Preparing his Pictures for the Decoration of the Loggia*. Like any thoughtful artist,

left: detail of [70]

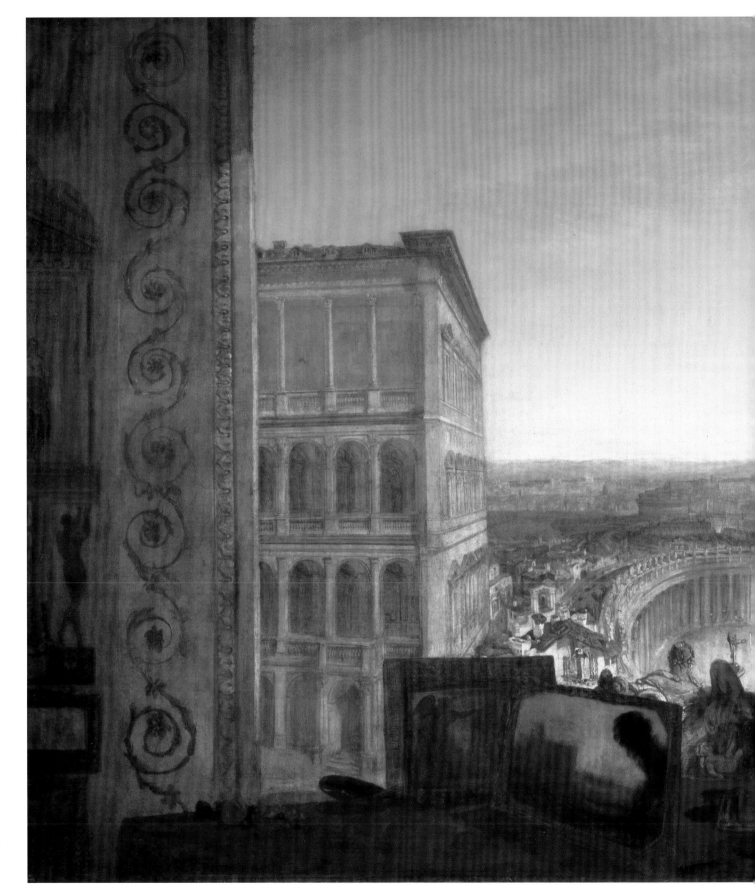

[59] *Rome,
from the Vatican.
Raffaelle,
Accompanied by
La Fornarina,
Preparing his
Pictures for the
Decoration of the
Loggia*, 1820
Tate, London

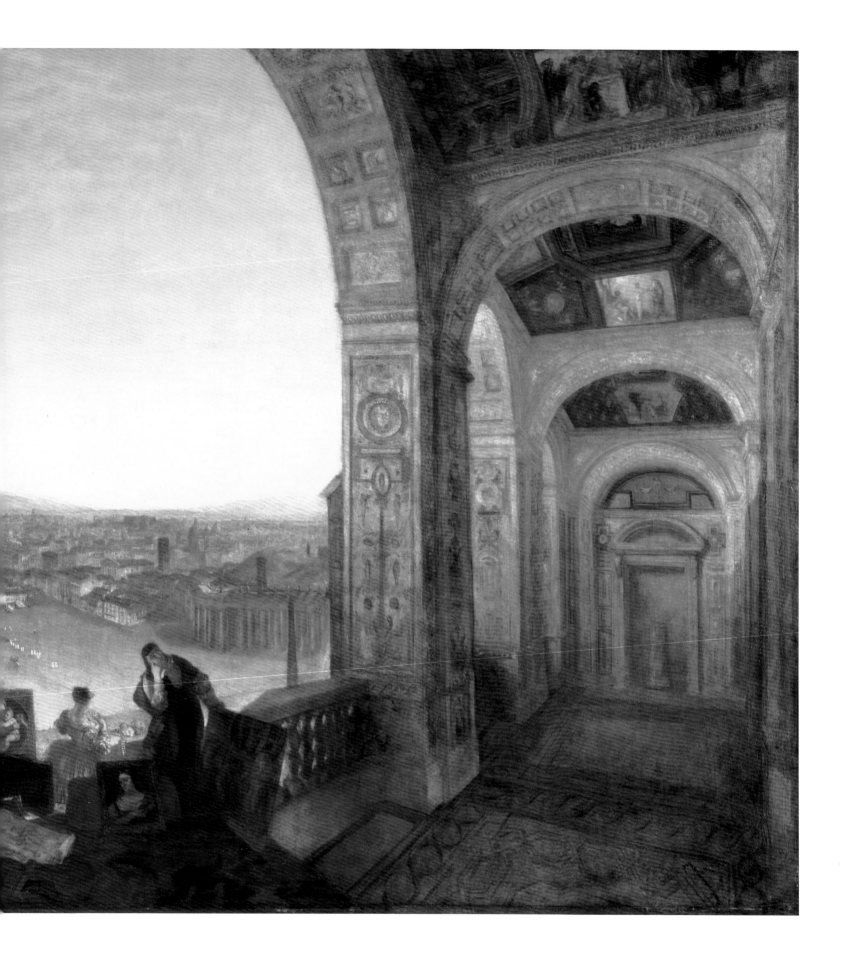

Raphael is here presented in the act of creation, making choices, taking decisions.[5] Around him are some of the paintings he has to choose from. In the centre is the *Madonna della Sedia*, painted in Rome in 1516 when Raphael was working on the frescoes for Pope Leo X in the adjacent Stanze. Although this work is now in the Pitti Palace in Florence, it is of Roman origin, and so it is perfectly reasonable that it should be seen here propped up against the balcony, beside the model for the Madonna, 'La Fornarina' herself. There are other paintings including Raphael's own images from the Loggia which, in this conceit, the artist is admiring. Partly obscured on the left is the expulsion of Adam and Eve from the Garden of Eden, and on the right is Noah and his sons building the ark. Here these are depicted as easel paintings; in reality they are frescoes. At Raphael's feet is the portrait of 'La Fornarina', thought in Turner's day to have been by Raphael.[6] In the foreground, curiously, is what seems to be Claude's *Enchanted Castle*, or perhaps Turner's own *Dido Building Carthage* of 1815. Beyond is a reclining figure of Father Tiber in the manner of Bernini, looking out onto Rome.[7] On the carpet are scattered some drawings of Bernini's colonnade, seen in the

middle-distance of Turner's view of the Piazza.[8] This is a charming anachronism of course, because Raphael was dead seventy-eight years before Bernini was born.

Rome, from the Vatican is a rich and complex work, painted and displayed in the year of the three hundredth anniversary of Raphael's death. It has many meanings: it expresses the temporal power of the Vatican in its highly decorated modern buildings; the triumph of Christianity over antique paganism in the Vatican's appropriation of Roman architectural and decorative forms; the presence of a deep and cultured history in the figure of Raphael with his works around him; the active presence of the Roman church as represented by the religious procession entering St Peter's Square; and the vastness of the distant city of Rome surrounded by its enclosing hills. The centrality of artistic culture and the power of creativity in human life are expressed by Turner through the figure of Raphael, his model and his works at a dominant point in the painting. The standard leitmotif, the dome and bulk of St Peter's Basilica, is out of sight, but on the distant horizon are the twin towers of the church of Santissima Trinità del Monte, which were close to the house where Turner's friends Thomas

[60] Detail from *Rome, from the Vatican*
Tate, London

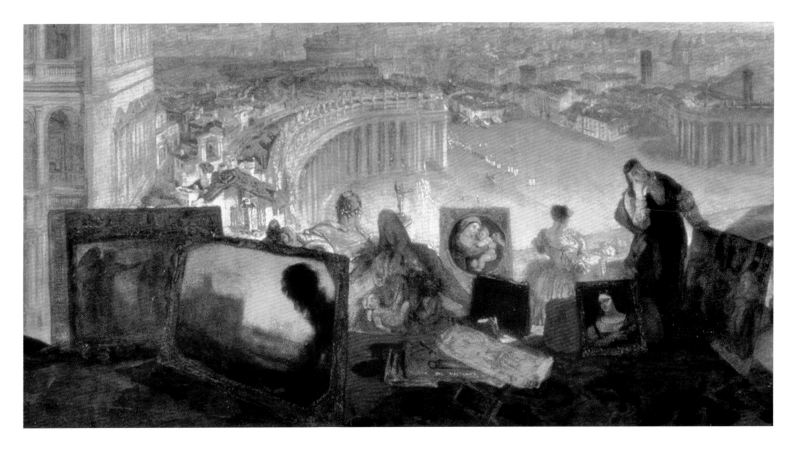

[61] *Interior of St Peter's, Rome*, 1821

The Pierpont Morgan Library, New York, The Thaw Collection

patron, and of Turner's extraordinary generosity and loyalty to the man who had given him encouragement and money when he was starting out on his career.

The Italian watercolours are expansive and detailed works, full of atmosphere and incident, and based in each case on studies that Turner had so assiduously made in Rome, and elsewhere. For details in the *Interior of St Peter's, Rome* [61] he turned to his 'Tivoli and Rome' and 'St Peter's' sketchbooks;[11] for *The Rialto, Venice* to the 'Milan to Venice' sketchbook;[12] and for others to 'St Peter's' and 'Rome: Colour Studies' sketchbooks.[13] Unlike the watercolours Turner had painted for James Hakewill before he had set foot south of the Alps, those acquired by Fawkes are on a grand scale. They are comparable in content, spirit and unifying intent to those English subjects Turner had already made for engraving, such as the Southern Coast series. However, their scale dwarfs the Southern Coast works and the watercolours produced for Hakewill which suggests that Turner had a wider ambition for them.

When considered alongside the thirty or more watercolour and gouache drawings made in Rome, which may have their roots in a putative royal commission, these larger works were painted at a time when Turner and the printmaker George Cooke were drawing up a new contract that would bind them together. Together with Turner and the artists Augustus Wall Callcott, Frederick Nash, William Westall and others, Cooke agreed in July 1820 to engrave fifteen plates of London subjects, about one a year for fourteen years – such was the slow pace of the fine art engraving trade.[14] This contract effectively fell apart after a few years, and Turner did not embark on his London watercolours until 1824.[15] It is known that by the end of the decade Turner had made a new arrangement with the engraver Charles Heath to produce watercolours for a projected series of picturesque views of Italy, but this also evaporated, despite the fact that three Italian subjects were advertised in the summer of 1829 to 'appear in the course of next Spring' [62].[16]

The existence of the seven detailed and ambitious Italian subjects from 1820 suggests that Turner had business in mind, and not just a kindness for Fawkes, now sick and on the verge of bankruptcy. Although no documentary evidence has yet been found to support this, Turner's characteristic bullishness in his dealings with engravers points to the conclusion that these were watercolours that were begun as an engraving contract that failed. If this was indeed the raw material for a

and Maria Graham lived, and the part of Rome in which Turner himself stayed. But more than that, they also marked the point where Turner believed that Claude had lived in Rome. So while Raphael dominates the figures and the conception of the work, Turner's hero Claude is there too, both in the foreground framed painting and in the distant vista.

Walter Fawkes had sent Turner on his way to Italy with the help of a private exhibition of watercolours at Grosvenor Place, and welcomed him back to London with the plan of a second, probably smaller, show. But Fawkes fell ill soon after preparing the exhibition, and rather than the popular event of the previous year it became a friends and family affair only.[9] Included in the exhibition, for which no catalogue has survived, may have been some of the seven new large watercolours of Rome, Naples and Venice. These were acquired by Fawkes, although there is no evidence to suggest that this series was painted for him: a very unlikely prospect given the fact that he was in no position to pay for them. Fawkes had been, since around 1818, in debt to Turner to the tune of £3,000,[10] and it is unlikely that he ever paid for the fifty-one Rhine subjects that he had acquired in 1817 and 1818, or for the large painting *Dort, or Dordrecht* (Yale Center for British Art, New Haven) which was delivered to his Yorkshire home Farnley Hall in 1818. Thus, his 'ownership' of the Italian views will have been a result of a mutual affection between the artist and his

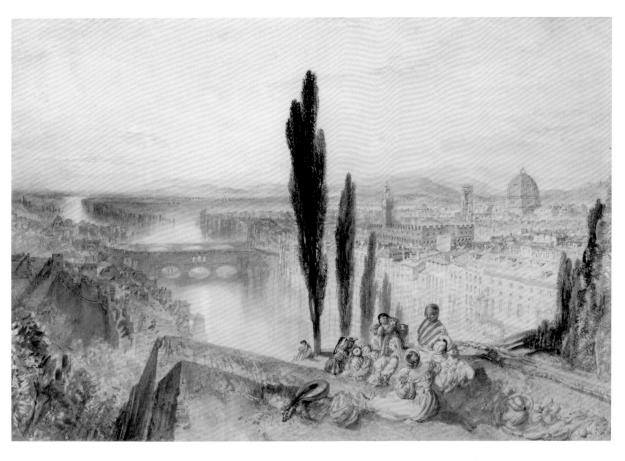

[62] *Florence from San Miniato, c.*1827
The Herbert Art Gallery
and Museum, Coventry

series of engravings, Turner's putative 'picturesque views in Italy' would have been a reasonably viable business proposition to follow the Hakewill project, with a wider appeal than that of the *History of Richmondshire*, a publication of recent Turner watercolours embarked upon at great financial risk by Longman's from 1819 to 1823.

Although it is likely that Turner was in anticipation of a royal patron while he was in Rome, it is also possible that his energies were driven in part by the commercial imperative of a large and important contract which remained secure until 1820 or 1821. The royal commission and the engraving contract are not mutually exclusive. But by the early 1820s large images were, as engravings, risky propositions. They simply took far too long to produce, as John Murray found, to his fury, when Hakewill increased the number of plates in the *Views in Italy* publication without his permission, which incurred further heavy costs.[17] While Turner's English subjects remained an attractive business prospect as large-scale engravings, from the mid-1820s his European subjects, of France, Germany and Italy all appeared as small vignettes or full-page book illustrations. The market for European

travel and literary subjects had changed from images to frame and hang on a wall to ones to enjoy in a book, with text: a switch from the domestic, to the personal [63–7].

Nevertheless, Turner and his engravers did still engage with the possibility of publishing large-scale Italian subjects, specifically *Snow Storm: Hannibal and his Army Crossing the Alps* of 1812 and *Dido and Aeneas* of 1814. These Turner discussed as potential subjects with the publisher and print-dealer J.O. Robinson, with whom he also considered the possibility of painting grander Italian subjects, 'one year for painting each picture, and two to engrave it'.[18] As oil paintings, however, these were a different artistic and commercial prospect: they could be exhibited with more éclat, and sold for higher prices. Neither of these subjects was in the event taken up by Robinson,[19] and while he might have offered to engrave paintings of the calibre of *Rome, from the Vatican, The Bay of Baiae* or *Forum Romanum*, nothing came of it. Turner's ambition for such engravings was that they should match in substance what he believed to be among the greatest prints, those made in the late

right, clockwise:

[63] Samuel Rogers,
Italy, A Poem, published 1830
Private Collection

[64] *The Temples of Paestum,*
*c.*1826–7, for Samuel Rogers's
Italy, A Poem
Tate, London

[65] *A Villa (Villa Madama
– Moonlight), c.*1826–7, for
Samuel Rogers's *Italy, A Poem*
Tate, London

[66] *Galileo's Villa, c.*1826–7,
for Samuel Rogers's *Italy,
A Poem*
Tate, London

[67] *Genoa, c.*1832, for
The Works of Lord Byron, 1833
Sterling and Francine Clark
Art Institute, Williamstown,
Massachusetts, gift of the Manton
Art Foundation in memory of Sir
Edwin and Lady Manton

A burden or a curse when misemployed,
But to the wise how precious—every day
A little life, a blank to be inscribed
With gentle deeds, such as in after-time
Console, rejoice, whene'er we turn the leaf
To read them? All, wherever in the scale,
Have, be they high or low, or rich or poor,
Inherit they a sheep-hook or a sceptre,
Much to be grateful for; but most has he,
Born in that middle sphere, that temperate zone,
Where Knowledge lights his lamp, there most secure,
And Wisdom comes, if ever, she who dwells
Above the clouds, above the firmament,
That Seraph sitting in the heaven of heavens.
 What men most covet, wealth, distinction, power,
Are baubles nothing worth, that only serve
To rouse us up, as children in the schools
Are roused up to exertion. The reward
Is in the race we run, not in the prize;
And they, the few, that have it ere they earn it,
Having, by favour or inheritance,
These dangerous gifts placed in their idle hands,
And all that should await on worth well-tried,
All in the glorious days of old reserved
For manhood most mature or reverend age,
Know not, nor ever can, the generous pride
That glows in him who on himself relies,
Entering the lists of life.

PÆSTUM.

THEY stand between the mountains and the sea;
Awful memorials, but of whom we know not!
The seaman, passing, gazes from the deck.
The buffalo-driver, in his shaggy cloak,
Points to the work of magic and moves on.
Time was they stood along the crowded street,

[68] *Lancaster from the Aqueduct Bridge, c.*1825
Lady Lever Art Gallery, National Museums Liverpool

[69] *Richmond Hill, c.*1820–5
Lady Lever Art Gallery, National Museums Liverpool

right:

[70] *Minehead, Somersetshire, c.*1820
Lady Lever Art Gallery, National Museums Liverpool

[71] *Hythe, Kent,* 1824
Guildhall Art Gallery, City of London

[72] *Edinburgh from Calton Hill,* 1818–20
National Gallery of Scotland, Edinburgh

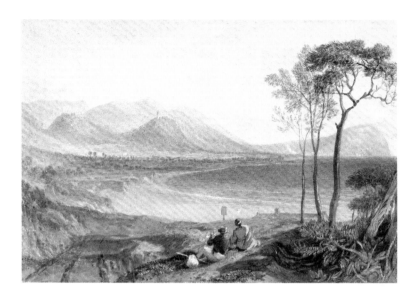

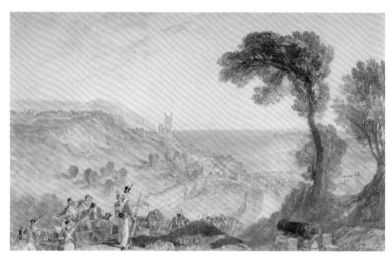

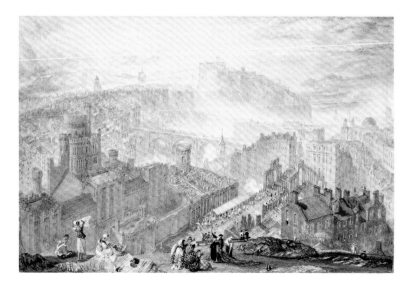

eighteenth century by William Woollett after classical masterpieces by Richard Wilson. Turner told Robinson: *Whether we can in the present day contend with such powerful antagonists as Wilson and Woollett would be at least tried by size, security against risk, and some remuneration for the time of painting ... To succeed would perhaps form another epoch in the English school; and, if we fall, we fall by contending with giant strength.*[20]

This expressed Turner's ambition, not only for his art, but also for what his art represented as a standard-bearer for British painting, exploring subject matter that was the common-ground of European artists.

Expenditure of time and effort on the large, Italian watercolours came to nothing in commercial terms, and Turner probably gave the seven unengravable paintings to Walter Fawkes. Then he began again with watercolours that would have a market both as engravings and as paintings. These, in the 1820s, were British subjects, published as engravings in the series *Rivers of England*, *Ports of England*, *Picturesque Views in England and Wales* and *Provincial Antiquities of Scotland*. Experience of Italy, however, had altered Turner's perception of Britain for ever. Gone were the damp, atmospheric landscapes of the southern coast and of Yorkshire. In their place came Lancaster shining under a Mediterranean sun [68], the sun setting over the Roman campagna that was in fact Richmond and Twickenham [69], Minehead, the very image of the Bay of Naples [70], Hythe in Kent in a Claudian setting [71], and Edinburgh from Calton Hill, set out like an intact Roman Forum from the Palatine [72]. Even a place as English as Virginia Water is given the look, and the light, of a melancholy Venetian moment [73]. While he spent much of the 1820s attending to commissions which incurred journeys to Scotland and northern Europe, in his mind's eye Turner returned to Italy again and again. Writing to an old friend in Derbyshire, the watercolour painter James Holworthy, he reflects on Rome almost exactly six years after he left it:

Phillips ... started for the immortal[21] *city, as Eustace calls it, Rome, and I expect he will come home as plump as your Turkey with stuffing!! Hilton, Wilkie, and Dawson Turner formed the quartetto amico;*[22] *they were when I last heard of them feeding away upon M. Angelo, Rafilo, Domenicino, Gurcenio, Corregio, not Stuffarcio, Pranzatutto, Gurgeco, Phillippo mezzo, Guini, Notto Tomaso; and if they have not ere this time passed the Alps, we shall not have any fruits of their gathering in the Exhibition this year I fear,*

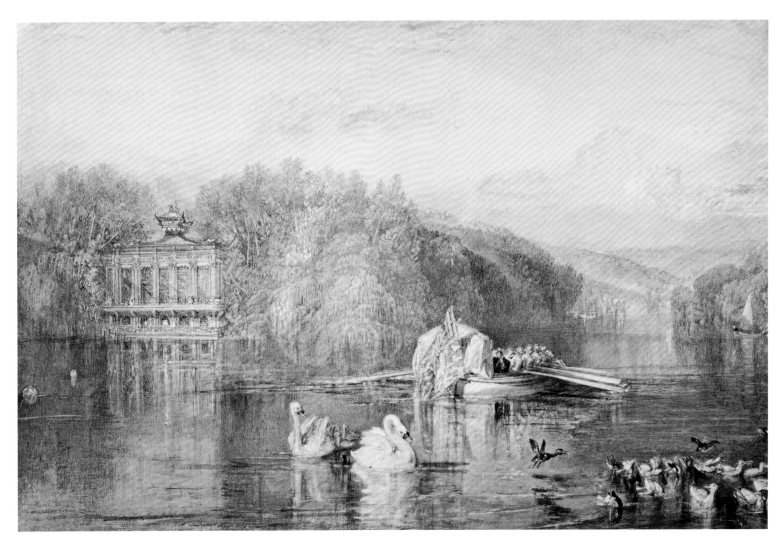

[73] *Virginia Water, c.*1829
Private Collection on loan
to the National Gallery of
Scotland, Edinburgh

for Mont Cenis has been closed up some time, tho the papers say some hot-headed Englishman did venture to cross a pied a month ago, and what they considered there next to madness to attempt, which honor was conferred once on me and my companion de voiture.[23]

This was at least the second time he had returned, so to speak, to the scene at the top of the Alpine pass, the first being a watercolour of the coach crash that he made for Fawkes. Clearly the excitement remained with him. But just as significant as his memory of the coach crash is Turner's enjoyment by proxy of his friends' partying and gallery-going. He too had 'fed upon' Michelangelo, Raphael, Domenichino, Guercino, Correggio and others when he had been in Rome, and had no doubt indulged in enough 'Stuffarcio, Pranzatutto and Gurgeco' (i.e. over-eating) to last him a long time. He brings his ribald humour to bear when he adds 'Phillippo mezzo, Guini,

Notto Tomaso', which may mean 'pint-sized Phillips, not Thomas, the unpleasant Italian'. 'Guini' was an insulting nineteenth-century term for an Italian. When the party got home in late April, Phillips had clearly caught the sun, having 'returned quite a carnation to what he went', although the stress of being responsible for hanging the 1826 Academy exhibition soon, as Turner noted, brought Phillips back to his original colour.[24]

Over the nine years between Turner's first and second visit to Rome he exhibited, in addition to *Rome, from the Vatican*, only three more large Italian subjects. His companion picture to *Rome, from the Vatican*, now titled *The Rialto, Venice*, never appeared, and languished in the stacks in his studio gradually disintegrating, a state from which it has proved impossible to mount a rescue.[25] Turner also failed to send anything to the 1821 Academy exhibition, and showed only one small work in 1822. His

new gallery in Queen Anne's Street was still a building site at the end of 1820, 'it rains and the roof is not finished,' he wrote to William Wells.[26] Further, he was embroiled in a court case with a tenant, his uncle died and left him some property, and he was heavily involved in Royal Academy administration and finance.[27] All this was time-consuming and debilitating, and will certainly have contributed to his inability to produce oil paintings efficiently. In addition, he had embarked on the largest painting he had ever produced, and on which so much of his desire for royal recognition hung, *The Battle of Trafalgar* for the king.

In 1823 he exhibited *The Bay of Baiae, with Apollo and the Sibyl* [74] a chromatic feast of blues, yellows and oranges which drew on his recollections and water-colours of Naples. 'Waft me to sunny Baiae's shore', he wrote in the exhibition catalogue by way of introduction to the painting, an exhortation and a wish perhaps directed as much to himself as to his audience. Here Turner weaves ancient, ruined Italy into Ovid's story of the Cumaean Sybil, who asked for as many years of life as there were grains of sand in her palm. Apollo granted her wish, but not the eternal youth that her request implied. So she aged and crumbled and faded away until all that was left was her voice. With the inscription 'LIQUIDAE PLACUERE BAIAE'[28] on the entablature to the left, and the busy shipping in the distance, Turner returned in triumph to Italy. Time is stretched in this painting and the Italy of ancient myth rubs shoulders with the activity of the Italy of Turner's day. Literary allusions pepper the canvas: the white rabbit, symbol of Venus; the snake,

symbol of ever-present evil; and the dead and broken lower branches of the tree on the right, suggestive of the coming fate of the Sibyl.

'Gorgeous', 'seductive' said the press of *The Bay of Baiae*, while a fellow academician, John Northcote, blustered, 'Turner has an outrageous Landscape with all the colours of the Rainbow in it.'[29] George Jones RA teased his friend by writing on the frame 'SPLENDIDE MENDAX' ['magnificent fakery'], a joke which Turner enjoyed hugely, leaving the inscription in place. The high tone of the painting led Turner across the following two years to paint the more prosaic subjects of Dieppe and Cologne with a similarly gorgeous palette of yellow, orange and blue, drawn directly from his reflections on his Italian experience.[30] Here he attempted to melt together the calm of Dutch painting with the hot, all-revealing light of Italy. Much the same can be said of two other exhibition oils of 1826 and 1827, which were views of Mortlake Terrace. The moods of these paintings wrestle and flux between a workaday English riverside atmosphere with a gardener honing his scythe, and a dreamy Italian manner of languid golden boats on a still and shining water, Venice-on-Thames.[31]

With *Forum Romanum* of 1826 [75] Turner is back again, unequivocally, in familiar territory. There is the bold arch, embracing everything – classical paganism, Christian piety, and ancient and modern Rome – an identical device to that in the abandoned *Rialto, Venice*. In reality in the Forum there is no arch to make such a splendid statement in front of the Arch of Titus, and nor is the upper plaque on the Arch of Titus set quite so high. This too is 'splendide mendax', the tumble of fallen capitals and masonry being laid out at the artist's pleasure, and not as they appeared in the ruined Forum at the time, as Turner well knew. But Turner does, nonetheless, give an idea of the state of the Arch which, in his day, was falling to bits and encased in brickwork. It was taken down and rebuilt in 1822. While the relationship between the Arch of Titus and the Basilica of Maxentius on the right, and with the distant Capitol and associated buildings is more or less correct, this is artifice laid on artifice to create a magnificent panorama of ruin, religion and reconstruction.

By the time *Forum Romanum* had reached the Royal Academy for exhibition, it had acquired an extension to its title: *for Mr. Soane's Museum*. This was probably Turner's way of saying that the work was already sold, a rare practice for him as his paintings were usually only

[74] *The Bay of Baiae, with Apollo and the Sibyl,* 1823
Tate, London

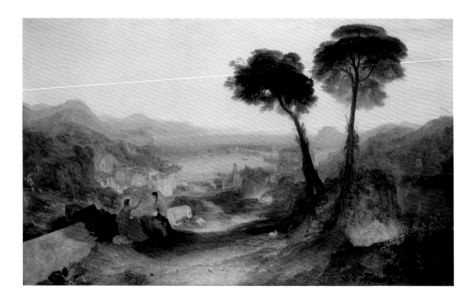

available for purchase when they went on exhibition. Soane was evidently fussed that Turner should get the archaeological details right, as he had himself spent months in the Forum drawing and recording the remains. 'I have altered the inscription upon the Arch of Titus and it is said to be now quite right,' Turner told Soane.[32] It was not exactly right, in fact, as the vertical and horizontal spacing between the lines and letters is far too generous. Whether this was one of the reasons for Soane's ultimate rejection of the painting is not clear, but refuse it he did, saying that 'the picture did not suit the place or the place the picture'.[33] What Soane had in mind was that *Forum Romanum* should hang in the picture gallery in his house in Lincoln's Inn Fields, among the elaborately engineered series of flaps and doors on which Soane had hung his collection of paintings. In the event the painting would have been too large even to get into the ground floor of the house, as was demonstrated in 2007 when it came briefly to what is now the Sir John Soane's Museum to be displayed in a temporary exhibition in a specially adapted room in the basement.[34] Turner took Soane's rejection philosophically, not to say with some disinterest. 'I like candour,' he responded, 'and my having said that if you did not like it when done I would put it down in my book of Time!!'[35]

Press criticism of *Forum Romanum* was unexpectedly cutting, though this would certainly not have been a factor in Soane's decision to reject the work. It was seen to be too yellow. 'Mr Turner ... seems to have sworn fidelity to the *Yellow Dwarf*, if he has not identified himself with that important necromancer. *He* must be the author of gamboge light,' reported the *Literary Gazette*.[36] Discussing Turner's *Cologne*, his *Mortlake, Early (Summer's) Morning* and *Forum Romanum* a critic wrote:

In all, we find the same intolerable yellow hue pervading every thing; whether boats or buildings, water or water-men, houses or horses, all is yellow, yellow, nothing but yellow, violently contrasted with blue ... Mr Turner has degenerated into such a detestable manner, that we cannot view his works without pain.[37]

Yellow was a delicate subject for Turner at this time. He was using it with determination, confiding to Holworthy that he was the subject of criticism on this account, 'but I must not say yellow, for I have taken it *all* to my keeping this year, so they say, *and so I meant it should be*'.[38] This habit built up to such an extent, as Turner reported in 1830 to George Jones, then in Rome, that their mutual friend Francis Chantrey advised him to put the yellow away, 'I wish I had you by the button-hole,

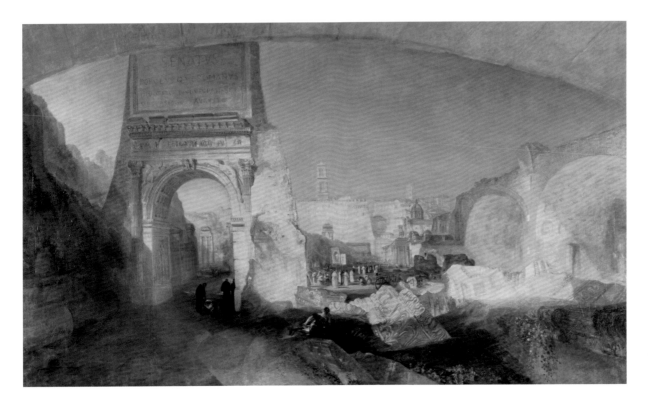

[75] *Forum Romanum, for Mr Soane's Museum,* 1826
Tate, London

notwithstanding all your grumblings about Italy and yellow ... [Chantrey] requests, for my benefit, that you bottle up all the yellows which may be found straying out of the right way.'[39] Turner's obsession with yellow evolved out of the fact that a good reliable pigment was by the mid-1820s beginning to be commercially available. Earlier yellows, such as King's Yellow and Indian Yellow were vegetable-based and fugitive, which meant that they were light sensitive and unlikely to last. However, the colour chemist George Field, a long-time acquaintance of Turner, was developing a yellow with a more stable, alkaline base, which, through companies such as Winsor and Newton, and Roberson, was more readily available to artists.[40]

Within the sketchbooks there is ample evidence of Turner's close and knowledgeable interest in the manufacture of colour. In the early years of his career, artists made their own colours, or they were supplied by colour-grinders who mixed them unreliably and inconsistently, and delivered them as powder, cakes or in animal bladders.[41] Later, the manufacture of pigments had become scientific and empirical, following the chemical researches of Humphry Davy, Michael Faraday, George Field and others. Turner's endlessly enquiring nature drew him to listen carefully to colourmen and to watch and note their methods. Thus, in the 'Chemistry and "Apuleia"' sketchbook[42] from 1813, Turner writes thirteen pages of detailed analysis of colour composition, most of which appears to concern yellows.[43] Even before he left for Italy his knowledge of paint was, therefore, drawing him inexorably towards yellow, the colour that he would most need to convey Italian light. His understanding developed further in the 1820s or 1830s when he came to know Michael Faraday, and discussed the nature of pigments with him. It appears from Faraday's first biographer Henry Bence Jones that the questioning always seemed to come from Turner:

[Faraday] made Turner's acquaintance at Hullmandel's,[44] and afterwards often had applications from him for chemical information about pigments. Faraday always impressed upon Turner and other artists the great necessity there was to experiment for themselves, putting washes and tints of all their pigments in the bright sunlight, covering up one half, and noticing the effect of light and gases on the other.[45]

Insight such as this on Turner's enquiring mind is invaluable, illuminating as it does a level of persistence which might have been exasperating to people who were less generous with their knowledge and advice than Faraday. It also indicates that the discourse between the two men – one might even suggest friendship – lasted over many years.[46]

In 1819, in the weeks before he travelled to Italy, Turner left behind in the public's eye the supreme statement of England and Englishness, *England, Richmond Hill*. In just the same way in April and May 1828, while in preparation for Rome once more, he left behind another new painting for his public to remember him by: *Dido Directing the Equipment of the Fleet, or The Morning of the Carthaginian Empire*. This is now a wreck, and in no condition to display, but a photograph taken in 1917 reveals its former grandeur, and indicates that it was once worthy to hang beside *Dido Building Carthage* and *The Decline of Carthage*. So satisfied with it was Turner that he engaged John Pye to engrave it.[47] Some of the press comment was glowing: 'extremely beautiful and powerful', commented *The Times*; 'extremely brilliant, hardy, and powerful' remarked the *Athenaeum*. The *Literary Gazette*, however, was more analytical:

It is really too much for an artist to exercise so despotic a sway over the sun, as to make that glorious, and ... independent luminary, act precisely in conformity to his caprice; pouring its rays on objects upon which they could not possibly fall, and hiding them from others in the direct line of their influence.[48]

The tragic ruin of this painting was caused by early blistering, the result no doubt of the artist using an untried and experimental medium or varnish, and part of the price now being paid for Turner's endless experiments with process.[49]

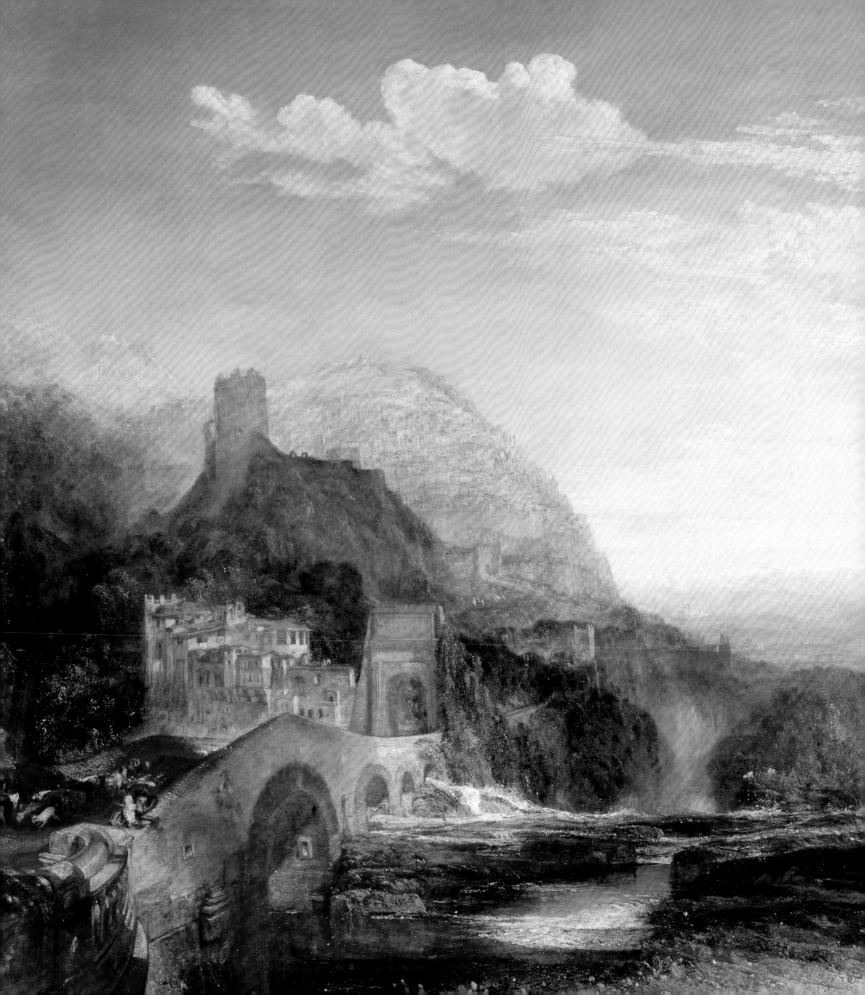

A Roman Triumph

Turner left his own account of travelling to Rome in 1828. 'Two months nearly getting to this Terra Pictura, *and at work*,' he told George Jones on 13 October.[1] He had left London in August, date unknown, and travelled first to Paris where he wrote ahead to Charles Eastlake to ask his friend to order for him two large canvases, more than eight feet long, and five feet wide. He proposed to start work straight away, and to begin a monumental painting for Lord Egremont which would be painted 'con amore'. This would be Turner's 'first brush in Rome ... a companion picture for his beautiful *Claude*'.[2]

It was a gruelling journey, and by the time he reached Italy he was way behind his schedule. Turner had gone via Lyon, reaching the Mediterranean at Marseille and had made a detour from Avignon to Nîmes. 'I must see the South of France,' he told Jones 'which almost knocked me up, the heat was so intense ... and until I got a plunge in the sea at Marseille, I felt so weak that nothing but the change of scene kept me onwards to my distant point.'[3] He travelled along the coast to Genoa, then by boat to La Spezia where he turned inland to Massa and the Carrara marble quarries. By boat again to Livorno (Leghorn), then he travelled via Florence, Siena, Orvieto, Viterbo and Ronciglione to Rome. Remembering Carrara, he continued in his letter to Jones:

Tell that fat fellow Chantrey that I did think of him, then ... of the thousands he had made out of those marble craigs which only afforded me a sour bottle of wine and a sketch; but he deserves everything that is good, though he did give me a fit of the spleen at Carrara.

He had arranged to stay at 12 Piazza Mignanelli, with Charles Eastlake, in the rooms which were still rented by Maria Graham, now Mrs Callcott. Turner also took a painting studio off the Corso, the road leading from the Piazza del Popolo to the Forum, in the heart of the area still populated by artists. Number 12 is a tall

left: detail of [77]

house with a high basement tucked beneath the balustraded 'Rampa'. It reaches from Piazza Mignanelli to the Piazza di Santissima Trinità del Monte where there is now an entrance door in the corner. The area below the Rampa was a sculptor's studio with well-appointed space to work inside and out, and good access onto the Piazza for delivery of raw marble and the consignment of completed sculpture. The landlord, Giuseppe Ugo, evidently shared the studio, or let it, as Keller's 1824 directory lists the Edinburgh-born sculptor Thomas Campbell at number 12. In the 1830 edition it is re-occupied by Ugo,[4] but in the 1828 census return 'Studio di Scoltura' is crossed out, and 'Porta' inserted.[5] Number 12 Piazza Mignanelli is an address with a rich history of use by English and Scottish artists and writers. Not only did the Callcotts, Charles Eastlake and Turner stay there, but it was also the studio of Thomas Banks in the 1770s and of the Scottish sculptor James Durno, who worked in Piazza Mignanelli with Banks.

Turner's 'first brush in Rome', the work painted for Lord Egremont, was titled, when it was exhibited in London in 1830, *Palestrina – Composition* [77]. It is curious that such a major canvas, eight feet long by nearly six feet high, should be painted of a place for which no sketches by Turner seem to exist, neither from the 1819 nor the 1828 sketchbooks. However, he might have had an intention to visit Palestrina as he wrote the name of the town twice in his 1819 'Route to Rome' sketchbook.[6] The word 'Composition' that Turner seems to have added to the title suggests artifice, but one which might just have a particular intention. In Rome in 1828 a two-volume book by Giuseppe Baini was published with the title *Memorie Storica-Critiche della Vita e delle Opere di Giovanni Pierluigi da Palestrina*. This established the composer Palestrina's posthumous reputation as the foundation stone of sixteenth-century polyphony and church music. That Turner was greatly moved by

music is well established – he played the flute, and sang in informal groups as a young man, amassed sheet music in his house, and had musician friends. He was not, however, comfortable with foreign languages, so when Turner wrote in his letter to Eastlake that he would paint a picture for Egremont 'con amore', he was giving that phrase a particular meaning. While he was very fond of Egremont, it would not have been appropriate for him, a London artist, to propose to paint a picture for a peer of the realm 'with love', so another meaning must be considered. The term 'con amore' is also a musical one describing performing 'with enthusiasm', and given Turner's habit of weaving intricate humorous meaning into his correspondence, it is possible that he was hinting here that the painting would have some kind of pre-meditated musical connection, and that the Palestrina allusion was pre-planned.

In 1828 Turner was fifty-three years old, well enough in health despite his turn at Marseille, and a sobering influence on the group of exuberant and successful English and Scottish artists, particularly sculptors, then resident in Rome. There were some signs of discontent with his learned, literary manner. The English painter Thomas Uwins asserted in a letter from Naples that 'Turner depends too much on his gods and goddesses and his classical story.'[7] Nevertheless, his fame drew the attention of Roman artists and the general public, few of whose remarks were flattering. Turner experienced a good deal of chatter when he let people see his work, something which he found sufficiently frustrating to oblige him to temporarily stop painting *Palestrina* for Lord Egremont, and his *Vision of Medea* [78], and begin 'a small three by four to stop their gabbling', as he wrote to Chantrey.[8] This was *View of Orvieto* [79] a typical composition which, although Italian, has less about it of Italy and rather more of a view from *Picturesque Views in England and Wales*. Even the title tallies, and it is clear from correspondence that *Picturesque Views* was on his mind as he was expecting to receive proof engravings of the series from the publisher Charles Heath.[9] Turner reworked *View of Orvieto* when he got it home, so it is not known what the Roman audience actually saw, but it is clearly based on drawings in the 'Florence to Orvieto' sketchbook.[10] A fourth painting that he completed, or brought near to completion, in Rome was *Regulus* [76], a smaller sized work on the Carthaginian theme that had so preoccupied him in the months before he left London.

Convincing suggestions have been proposed as to why Turner should have chosen to paint *Vision of Medea* in Rome, when the main source appears to be a production of *Medea in Corinto* by J.S. Mayr performed in London in 1826–8.[11] A specifically Roman connection has been put forward, namely that Julius Caesar presented a painting of Medea by Timomachus to the temple of Venus Genetrix in the Forum.[12] This is a reasonable and useful proposition, to which can be added the fact that Turner's old acquaintance Humphry Davy was also in Rome in December 1828.[13] Davy had written a long account of a vision he had had when sitting alone in the Coliseum in the moonlight in 1819, which Turner may have known. In his vision, a voice speaks to Davy:

The brilliant coloured fluids are the result of such operations as on the earth would be performed in your laboratories, or more properly in your refined culinary apparatus, for they are connected with their system of nourishment ... In a limited sphere of vision, in a kind of red hazy light similar to that which first broke in upon me in the Colosseum, I saw moving round me globes which appeared composed of different kinds of flame and of different colours. In some of these globes I recognised figures which put me in mind of the human countenance, but the resemblance was so awful and unnatural that I endeavoured to withdraw my view from them.[14]

Davy's vision is similar in certain respects to the one

[76] *Regulus*, 1828–37
Tate, London

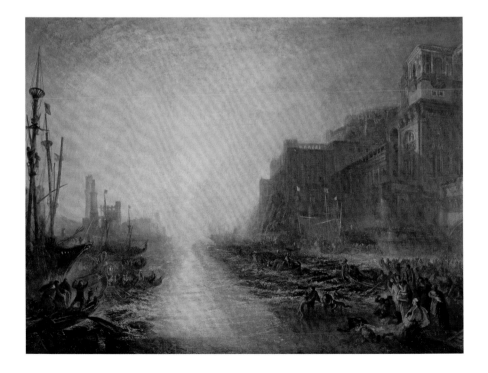

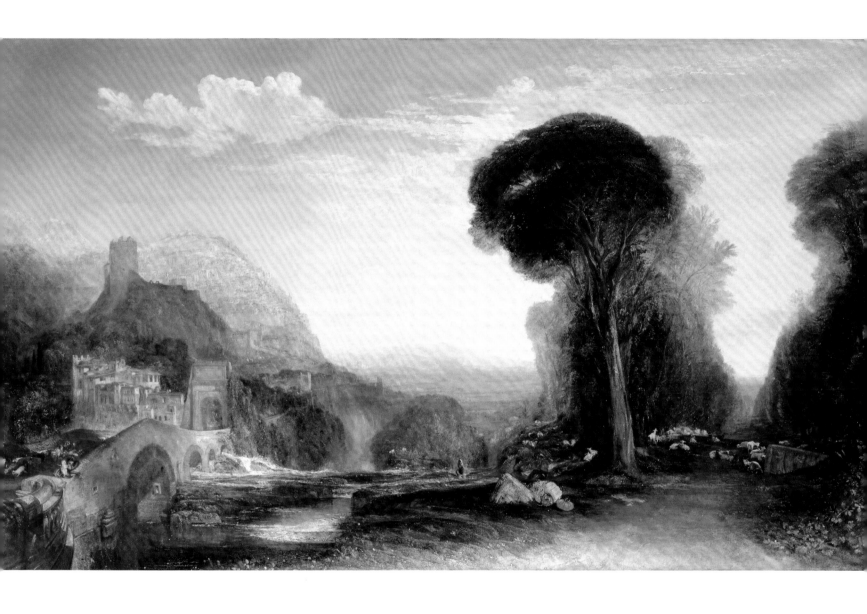

[77] *Palestrina – Composition*, 1828
Tate, London

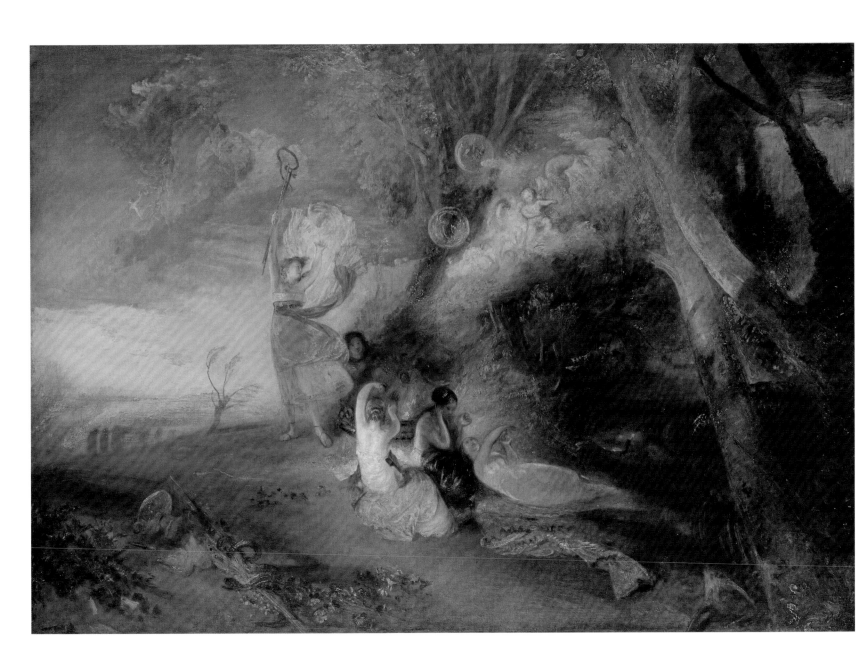

[78] *Vision of Medea*, 1828
Tate, London

in Turner's painting. Medea was a witch, a poisoner, an alchemist who brewed deadly potions. She was the wife of Jason the leader of the Argonauts and had two children by him, but when Jason abandoned her for another woman she killed them. Turner depicts her in a pose derived from Joshua Reynolds's *Macbeth and the Witches* (National Trust, Petworth), another group of sinister woman alchemists, and places beside her the tools of her poisoning practice. Above her, Turner floats bubbles, the lower one containing a distinctly human form, a male figure brandishing a club. This looks suspiciously like Hercules, one of Jason's fellow Argonauts, who had also murdered his children (and his wife). As so often with Turner, the references come thick and fast, and are intricately interwoven. Turner may also have been remembering the bubbles in Raphael's *Dream of Pharoah* in the Vatican loggia that he had studied so carefully in 1819. The similarity in composition between *Vision of Medea* and Turner's *Venus and Adonis* [12] of 1803, and their joint source in Titian is also worth noting. But, the

hot Titianesque colours, 'the red hazy light' in *Vision of Medea*, and Turner's use of inhabited bubbles parallel more closely Humphry Davy's highly-coloured verbal expression.

This time Turner's business in Rome was entirely different to the tasks he had set himself nine years earlier. Then, he moved about energetically to sketch in all parts of the city. But having done that in 1819 he had the information in his sketchbooks and did not need to do it all again. As his letter to Eastlake from Paris indicates, he now had painting to do, and he set to it with a will. By the end of the first week in November he had *Palestrina*, *Vision of Medea* and *View of Orvieto* on the go, and he had also done the rounds of the studios. Those that interested him, on the evidence of his letter to Chantrey, were the English, Scottish and Danish sculptors, of whom he singles out William Ewing, John Gibson, Joseph Gott, George Rennie, the nephew of the engineer John Rennie, Bertel Thorvaldsen and Richard Wyatt, a distant cousin of Turner's old friend and tutor the

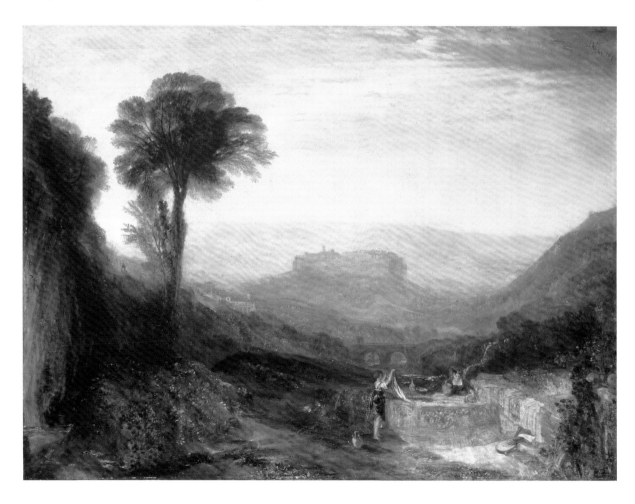

[79] *View of Orvieto*, 1828
Tate, London

architect James Wyatt. News of sculptors was evidently what Chantrey wanted to hear, and he gets it in a letter from Turner:

Sculpture, of course, first, for it carries away all the patronage, so it is said, in Rome; but all seem to share in the goodwill of the patrons of the day. Gott's studio is full. Wyatt and Rennie, Ewing, Buxton, all employed. Gibson has two groups in hand, "Venus and Cupid", and "The Rape of Hylas", three figures, very forward, though I doubt much of it will be in time (taking the long voyage into the scale) for the Exhibition, though it is for England ... Thorwaldson is closely engaged on the late Pope's (Pius VII) monument.[15]

It is curious that Turner does not mention Thomas

neighbourhood: Penry Williams in the Via Babuino, Jean-Baptist Joseph Wicar in the Via Vantaggio, and Joseph Severn in the Via Maroniti. Turner will certainly have known Wicar's work as his thirty-feet-long canvas *The Son of the Widow of Nain* had been a spectacular exhibit at the Egyptian Hall in Piccadilly in 1817.[17] Canova's studio, which he passed on to Adamo Tadolini, remained in use by the Tadolini family of sculptors until the 1960s. It is now a museum, heavily disguised as a café and restaurant, and is crammed with sculpture in halted progress, and with all the dusty plastered paraphernalia of the sculptor's art.

Turner also found time to become involved in another activity, namely acquiring a piece of antique

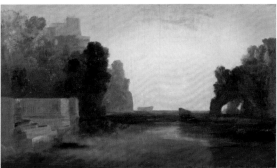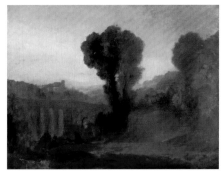

Campbell, chipping away at his marble in the Piazza Mignanelli basement. The reason for this high level of sculptural activity was the recent presence in Rome of the most celebrated neoclassical sculptor Antonio Canova, and latterly of the Danish master Bertel Thorvaldsen. Both sculptors were generous in their teaching, and employed small armies of assistants to make sculpture of all sizes – from greyhounds and poodles, cats and monkeys, to the monuments demanded and paid for by clients as varied, rich and powerful as the pope in Rome and the aristocracy in Britain. Turner witnessed it all at what was perhaps the apogee of activity for sculptors in Rome.[16]

Centring around one of Canova's former studios in the Via Babuino, the British sculptors who lived in the area were Joseph Gott and Richard Wyatt in the Via Babuino, Lawrence MacDonald in the Via Margutta, John Gibson in the Via Fontanella, William Ewing and (until recently) Richard Westmacott at the Via Gregoriana and George Rennie at number 504 the Corso. All saw Canova and Thorvaldsen as their sculptural mentors. Painters also lived in and around the

sculpture for his patron Lord Egremont to install in new sculpture galleries at Petworth House in Sussex. Whether this errand was given to Turner before he left London is not clear, but a letter from Egremont survives which indicates that Turner had found something for him: Egremont wrote, 'I shall be glad to have the Torso.'[18] This was later heavily restored and built up with added arms, head and legs into a standing figure of Dionysus.[19]

The 'gabbling' that Turner experienced from the locals early in his months in Rome came to a head when he put on a small display of new paintings at the Palazzo Trulli, on the Quirinal Hill. Far from stopping the 'gabbling', the show, despite its modest size and brevity, attracted a thousand visitors and caused a sensation, and not only because Turner framed his works in rope painted with yellow ochre.[20] 'The Romans have not yet done talking about the Paesista Inglese,' Eastlake told Maria Callcott months later; and 'the people here cannot understand his style at all,' wrote the antiquary David Laing.[21] 'Is he trifling with his great powers?' asked the sceptical Thomas Uwins.[22] The main thrust of criticism was later

expressed by the Austrian artist Josef Anton Koch, then resident in Via della Quattro Fontane:

Notwithstanding the large and vulgar crowd which had collected to see the exhibition of the world-famous painter Turner, the works were so beneath all criticism and the mediocrity which is admired by the modern world, that it would have been better for poor Turner if he had himself got lost in this "excellence" ... This show was much visited, ridiculed and hooted ... The old Caccatum non est pictum [crapped is not painted] was still a refrain to make you laugh, for you know how little it takes to keep people happy. The pictures were surrounded by ship's cable instead of gilt frames ... Suffice it to say that whether you turned the picture on its side or upside down, you could still recognize

who had a studio in the Palazzo Corea, now demolished, but formerly to the west of the Corso, and referred to him affectionately in letters written after his return to London.[26] It is likely that this was the building in which Turner rented his studio, alongside the history painters Luigi Cochetti and Tommaso Minardi.[27]

While he brought four paintings towards completion, Turner began a number of others which he sent home incomplete. Seven of them, all landscapes, were originally painted on one long canvas, and not separated until 1913–14 [80–6, 87]. Others included a *Reclining Venus* and some tentative and incomplete figure studies, indicating that while in Rome Turner was indeed much more studio-based than he had been in 1819, and drew from

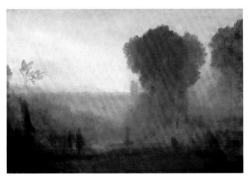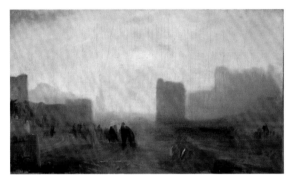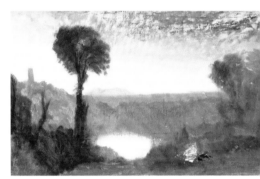

left to right:

[80] *Sketch for 'Ulysses Deriding Polyphemus'*, 1828
Tate, London

[81] *Italian Bay*, 1828
Tate, London

[82] *Ariccia (?): Sunset*, 1828
Tate, London

[83] *Overlooking the Coast, with Classical Building*, 1828
Tate, London

[84] *Italian Landscape with Tower, Trees and Figures*, 1828
Tate, London

[85] *Classical Harbour Scene*, 1828
Tate, London

[86] *Lake Nemi*, 1828
Tate, London

as much in it. In sum, it is in the English Mylord-taste of Anglican fantasy, roughly what the French call tableau foueté [flogged painting].[23]

Circulated at about the same time as the exhibition was a scatological drawing of a nude woman leaning on the dome of St Paul's and breaking wind into a trumpet pointing in the direction of St Peter's. The words 'Turner! Turner! Turner!' emerge from the trumpet, and below is written 'Oh charlatan, crapped is not painted'. Below, a dog is defecating and barking '*Anch'io son pittore*' ('I too am a painter'), the words Correggio is reputed to have uttered when he saw Michelangelo's ceiling in the Sistine Chapel.[24] Today, this would be what is called a bad press; in Rome, then, it was a prime example of the clash of taste between the painterly English artists and the sharper, more brightly coloured German or Austrian manner of artists such as Josef Koch admired by Eastlake and Callcott. Turner himself had already noted Koch's name down in one of his 1819 sketchbooks and almost certainly met him and knew his work.[25] He also struck up a friendship with another Austrian painter, Wenzel Peter, a Professor at the Accademia di San Luca

the life model.[28] They also suggest that he might have seen too much sculpture. Finally, there were three large unfinished landscapes. Letters home while he was in Rome, and further letters written back to Rome in 1829 and 1830 reflect on Turner's activities, and suggest that he made no significant journeys out of the city during this visit. He reported back to Sir Thomas Lawrence, whose concern in 1819 for the Raphael frescoes in the Vatican had been palpable, that Michelangelo's *Last Judgement* in the Sistine Chapel had:

suffer'd much by scraping and cleaning particularly the sky on the lowermost part of the subject so that the whole of the front figures are in consequence one shadde [sic]. And it will distress you to hear that a Canopy (for the Host, the Chapel being now fitted up for divine service) is fixed by 4 hoops in the Picture, and altho' nothing of the picture is obliterated by the points falling in the sky part, yet the keynote of the whole – sentiment – is lost, for Charon is behind said canopy, and the rising of the dead and the Inferno are no longer divided by his iron mace driving out the trembling crew from his fragile bark.[29]

This would not in fact have been news to Lawrence, as

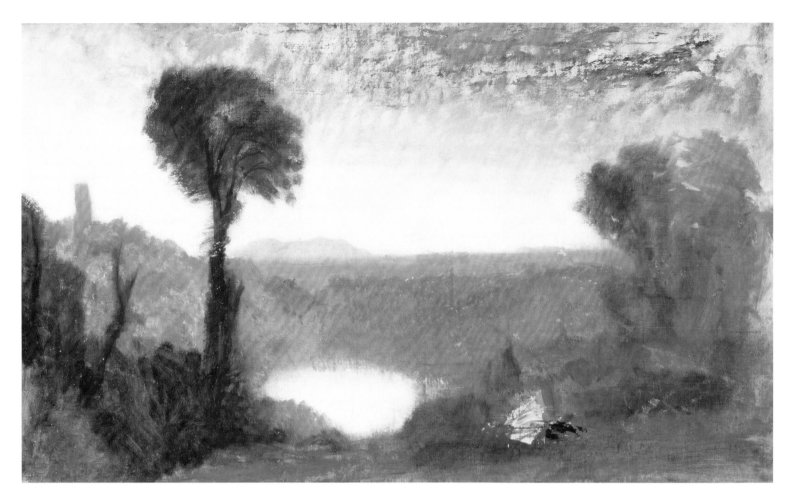

[87] *Lake Nemi*, 1828
Tate, London

the canopy and therefore the damage done by its hooks, was already present in 1819.[30]

Turner left Rome on or around 1 January 1829.[31] 'My last two or three days in Rome were all in a whirl,' he told Eastlake later, 'with parties and visits and last minute arrangements'.[32] He found the time and emotion to write a poem on the subject in a blunt, faint pencil. It is practically illegible, but wisps of sense do float from it, 'Farewell a second time the Land of all Bliss / that cradled liberty could wish and hope / … Why go then. No gentle traveller / Cross thy path … / The yellow brimm'd Tiber / … lost … of Imperial Rome …' and so on.[33] It is quite clear that despite, or even because of, the controversy which surrounded his exhibition, Turner was extremely happy in Rome, and would gladly return. While Venice became for him a source of poetic inspiration in the 1840s, Rome had a different effect. For Turner Rome was living history, the ancient and the modern rolled together, the latter emerging from the former in a continuous and interdependent creative tension.

Turner spent his last few hours in Rome with Eastlake, who helped him get his pictures rolled for the long sea journey, and safely delivered to the quayside at Ostia. Turner himself would travel overland, without his larger canvases. The antique torso for Egremont was also packed up and sent to the quayside. Turner seemed to make a habit of attempting to cross the Alps at the worst time of year: so it had been in January 1820, and so it was nine years later. On his return and from the comfort of his own fireside he described to Eastlake how appalling the journey had been. It looks as if Turner and his fellow travellers had tried to make a dash for it over the Apennines before the January snows set in, but they did not get far. It began to snow when they reached Foligno, only ninety-five miles north of Rome, and it got worse and worse until they made Bologna. Turner recounted to Eastlake:

though more of ice than of snow, that the coach from its weight slide about in all directions, that walking was much more preferable, but my innumerable tails would not do

that service so I soon got wet through and through, till at Sarre-valli [Serravalle di Chienti; between Foligno and Tolentino] *the diligence zizd into a ditch and required 6 oxen, sent three miles back for, to drag it out; this cost 4 Hours that we were 10 Hours beyond our time at Macerata, consequently half starved and frozen we at last got to Bologna.*[34]

This was the same route Turner had taken on the way to Rome the first time. It was a sensible decision in theory as it allowed him to get over the mountains to the Adriatic coast, and then to follow the long, straight and more-or-less flat road as far as Milan. The drawings he made on the way have a feeling of the rough road and the heavy snow falls.[35] Some reflect the difficulty of drawing in a bumping coach, the uncontrollable pencil line, skittering meaninglessly over the page. This put Turner into an uncharacteristic bad temper. 'Damn the fellow!' he exclaimed when the coach driver whipped the horses into movement as the sun rose at Macerata, 'he has no feeling!' This remark comes from a lucky account left by one of Turner's fellow travellers to Bologna, who described the artist on this journey 'continually popping his head out of the window to sketch whatever strikes his fancy'.[36]

In his letter to Eastlake Turner continues his tale: *But there* [Bologna] *our troubles began instead of diminishing – the Milan diligence was unable to pass Placentia* [now Piacenza]. *We therefore hired a voitura, the horses were knocked up the first post, sigr turned us over to another lighter carriage which put my coat in full requisition night and day, for we never could keep warm or make our day's distance good, the places we put up at proved all bad till Firenzola* [Fiorenzuola, between Parma and Piacenza] *being even the worst for the down diligence people had devoured everything eatable (Beds none).*

There are some lines missing at this point in this much-quoted letter, which is untraced since it was published and sold in 1914. Turner clearly enjoyed all this, however miserable and cold he might have felt at the time, and dwelt dramatically on the coach crash that seems to have been inevitable whenever Turner took to the mountains. He continues, '[we] crossed Mont Cenis on a sledge – bivouaced in the snow with fires lighted for 3 Hours on Mont Tarate while the diligence was righted and dug out, for a Bank of Snow saved it from upsetting'. The coach crash on the mountain happened on 22 January, if the inscription on the watercolour Turner painted of the scene is correct. He painted a glowing

image of passengers warming themselves by a huge fire as the stricken coach is righted. Turner, observant as ever, with his top hat firmly on his head, and presumably sitting on his tails, is silhouetted against the flames. As Eastlake had said to Maria Callcott, 'He is used to rough it.'[37]

As late as May 1829 Turner was still hoping to return to Rome that same summer, but doubted if he ever would, 'June will be too early for my return; August [or Sept deleted] will overtake me I fear and I rather tremble at the heat of July in Rome.'[38] By 11 August, when he wrote again to Eastlake, he had taken the decision not to return, 'lamenting as I do I cannot see you all next year in Rome'. He added with regret words that suggest he is hoping that Wenzel Peter will be able to let his rooms – presumably his painting room; but that was not possible as Peter died in 1829.[39] That Turner had intended to come back is shown by the fact that he left £10 on account at Torlonia's bank in Rome, and a further £10 at the Rome agency of Hammersley's bank. He had also retained an option on his painting room, now reluctantly given up, and admitted guilt at becoming a burden, through his indecision, on Giuseppe Ugo. He signs off by saying, 'Remember me to all friends not forgetting the ladies.'[40]

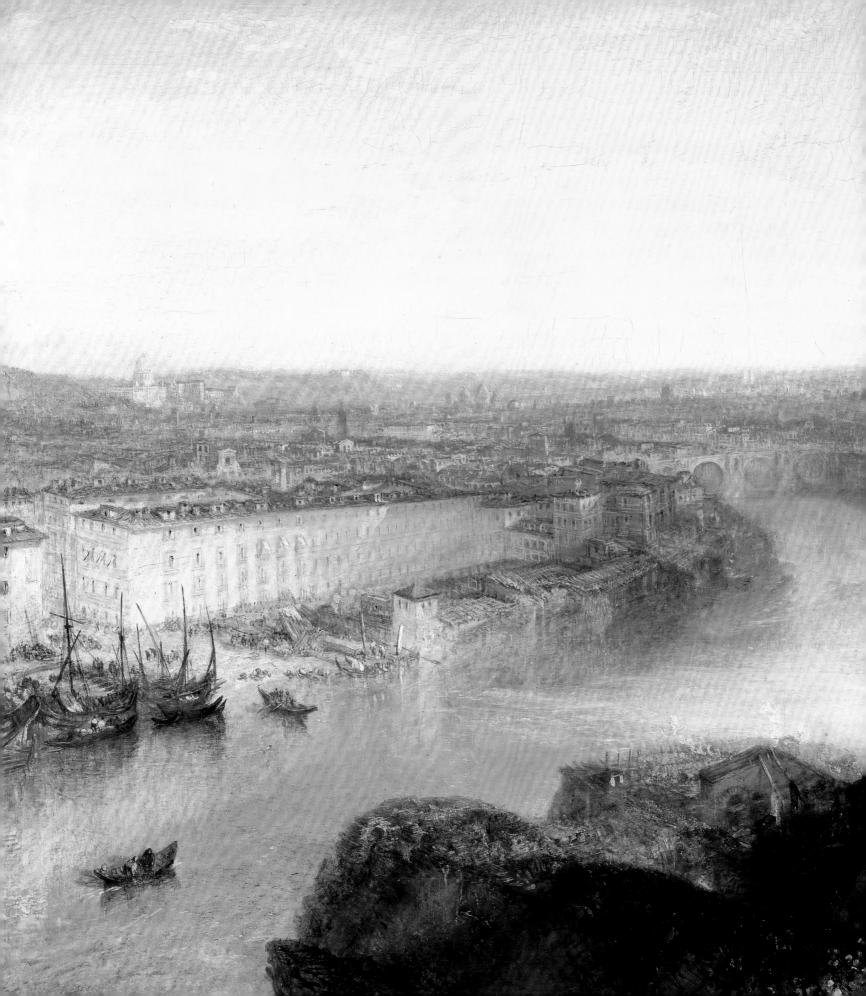

Italy Ancient and Modern

Just as in January 1820 when he rushed home over the Alps, so in January 1829 Turner had a picture in his mind, and an ever-diminishing amount of time in which to paint it. One of the smaller paintings he had made in Rome was an oil study of a giant on a mountainside, holding his left hand to his head and waving his right arm, with a crowded boat in the sea beneath [80]. A volcano smokes gently in the distance. There is quite enough in this fluent and rapidly painted work to indicate that this is, specifically, the beginnings of an idea for a painting of the moment, taken from Homer's *Odyssey,* when Ulysses and his crew make their escape from the one-eyed Polyphemus, after blinding him with a burning stake. But, interestingly, this study was not painted in the normal way with the canvas on a stretcher, set up on an easel. It was painted, as one of the seven landscape studies, on the long roll of canvas [80–6], perhaps some of the material that Turner had asked Eastlake to supply while he was already en route to Rome.[1] It can be deduced that the seven works were painted horizontally, as a kind of frieze, from the fact that they are all very nearly the same height.[2] Thus it may be that in Turner's painting room in the Corso he had around the walls a long banner of canvas with the beginnings of landscape studies painted on it. This not only gives something of an idea of what the studio might have looked like when Turner occupied it, but it also makes clear that these views, and by extension others, were painted away from the subjects, and some may be fanciful.

When travelling home, Turner fondly imagined that his canvases were already on board ship en route to the Port of London, and that he would get them back in his studio in a week or two. He was mistaken. When he wrote to Eastlake on 16 February he said:
!!! Hope that my Pictures are half way home and insured for 500 and you have the invoice; pray tell me how they are directed, who consigned to in London, they and the Torso, for I begin to be figgetty about them.[3]

Four of them at least were finished near enough for exhibition at the Royal Academy in late April, and, discounting the roll of seven, among the others in the consignment were an eight feet long *Reclining Venus,* and the three large and magnificent landscape studies, also eight feet long, in their incomplete state. These were very significant works by any standards and waiting to be completed in time for the Academy. But they did not come and, at some point in February or March, Turner must have given up hope of their arriving in time and so made emergency arrangements. He was up against it, as he told his old friend Clara Wells, Mrs Wheeler, in March, 'I must not allow myself the pleasure of being with you on Saturday to dinner. Time Time Time. So more haste the worse speed.'[4]

He signs this note not with his name, but with an artist's palette as a coughing mouth with varnish spilling out of a jar onto the floor. It was unusual that Turner should miss out on a party, so he must have felt under huge pressure. In the end, the works that he submitted to the Academy were *The Banks of the Loire* (now lost), which may have been painted before he went to Italy, *The Loretto Necklace,* a painting which combines views of Loreto and the aqueduct at Recanati, both of which Turner passed through in 1819 and on his recent return from Rome, and what Ruskin was to call 'the *central picture* in Turner's career', *Ulysses Deriding Polyphemus – Homer's Odyssey* [88].[5]

Unless he brought the roll of seven studies back with him on the coach, Turner will have painted this masterpiece without having the initial oil sketch beside him. This hardly mattered, as *Ulysses Deriding Polyphemus* was a subject he had had in his mind's eye and in his sketchbooks from as early as 1805 [89]. The composition of a flotilla of boats and the giant high up on a

left: detail of [93]

massing rock in the background had not changed: the essential amendments since 1805 are the repositioning of Ulysses' ship by moving it to the centre, and consequently lessening the importance of the other ships; a slight rise in the point of view; and the addition of the arched rocks and the sunset. This return to a twenty-five year-old compositional idea demonstrates how integrated were Turner's thought processes. There is also little here to indicate that Turner's inspiration was dependent on his recent Roman sojourn. The ingredients are more Greek than Italian; the Greek flag on Ulysses' ship sailing to freedom away from Italy demonstrates Turner's sympathy for the Greeks in their long struggle for freedom from Turkish domination. This had very recently come to a head when the British and Greek navies annihilated the Turks and Egyptians at the Battle of Navarino in October 1827. The horses of Apollo which ride across the sun derive from the Elgin Marbles and the arched rocks have as their source rock formations in the Bay of Naples. As Turner says in the painting's full title, the subject comes from Homer's *Odyssey*, specifically Alexander Pope's translation from the Greek which Turner seems to have had on his shelves for more than twenty years, though he follows Pope in giving the Greek hero his Latin name, Ulysses. Only the multitudinous figures climbing the masts of Ulysses' ship indicate that Turner might have consulted the 'Vatican Fragments' sketchbook of 1819. It has been suggested that the bright colours derive from Turner's study of the frescoes in the Campo Santo, Pisa, when he travelled south in 1828 and this is of course possible.[6] The evidence of the paintings of the 1820s, however, suggests that the sumptuous colour in *Ulysses Deriding Polyphemus* had been long

awaiting its expression, and refers more to the painting of Turner's modern German and Austrian friends in Rome than to medieval Italians.

After successfully managing the pressure of 'Time Time Time' Turner delivered *Ulysses Deriding Polyphemus* safely to the Royal Academy. The *Morning Herald* observed that Turner's colouring had 'for some time been getting worse and worse', which at least suggests the recognition of continuity.[7] It went on, 'in fact it may be taken as a specimen of *colouring run mad* – positive vermillion – positive indigo and all the most glaring tints of green, yellow, and purple contend for mastery of the canvas, with all the vehement contrasts of a kaleidoscope or Persian carpet; … truth, nature and feeling are sacrificed for melodramatic effect.'

By the beginning of May, when this review was published, Turner seems to have given up hope of receiving his canvases from Rome. 'No tidings of my pictures up to the present time', he wrote to Eastlake a week or so after the Academy exhibition had opened.[8] They eventually turned up at the dockside on 20 July, 'too late for anything and disturbed all my plans', Turner grumbled.[9] Nevertheless, they came in handy for two subsequent Academy exhibitions: in 1830 he showed *View of Orvieto* and *Palestrina – Composition*, and in 1831 *Vision of Medea. Regulus* was not exhibited until 1837 when Turner reworked it in front of his peers on Varnishing Day, and showed it at the British Institution.

Having already completed *Vision of Medea*, Turner was able to submit a further seven paintings to the 1831 Royal Academy exhibition, including *Caligula's Palace and Bridge* [90]. These range in subject matter from seascapes on the Suffolk and Dutch coastlines to British

[88] *Ulysses Deriding Polyphemus – Homer's Odyssey*, 1829
The National Gallery, London

[89] Composition study, which later informed *Ulysses Deriding Polyphemus – Homer's Odyssey* from the 'Wey, Guildford' sketchbook [Finberg XCVIII], 1805
Tate, London

seventeenth-century history, as well as classical Roman history and literature. They serve as a reminder that Italian subjects certainly did not monopolise Turner's output even at a time when his recent Italian experience was uppermost in his thoughts. *Caligula's Palace and Bridge*, perhaps Turner's ultimate Claudean extravaganza, dwells on the folly of empire and the hubris of power. In dappled evening light, it shows the emperor's crumbling palace and parts of the four kilometre bridge that spanned the bay from Baiae to Pozzuoli. Caligula allegedly had the bridge built to confound a prophecy that there was as much chance of his becoming emperor as there was of Caligula riding his horse across the Bay of Baiae. In his version of the story, Turner has upgraded the bridge from one of boats, to one built in stone, but the moral is clear: when empires fall their ruins become a playground for idling peasantry and courting couples.

[90] *Caligula's Palace and Bridge*, 1831
Tate, London

In 1833 or soon after, Turner read, and wrote marginal comments in, *Vestiges of Ancient Manners and Customs, Discoverable in Modern Italy and Sicily*.[10] Written by the Revd John James Blunt, a young clergyman who had travelled in Italy, a copy had been sent to Turner by its publisher John Murray who thought it might be of interest. Blunt's account of Italian customs evidently intrigued Turner sufficiently to draw out of him energetic marginalia which depended entirely on the artist's personal experiences of Italy. Against Blunt's remark about the oaths sworn by Italians, 'their first exclamation of wonder or of grief is, Santa Maria!', Turner has pencilled the objection 'Not always!!! the common exclamation is very far from being of a *celestial* character. Sometimes however the mother shares it with her Son as in *Gesu – Maria*.' Turner adds dismissively, 'Santa Maria is only common in the Mysteries of Udolpho.'[11]

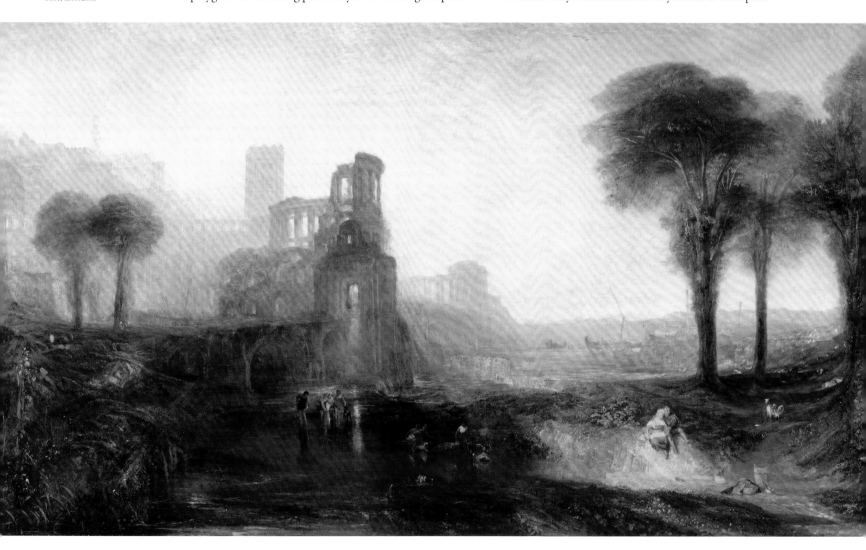

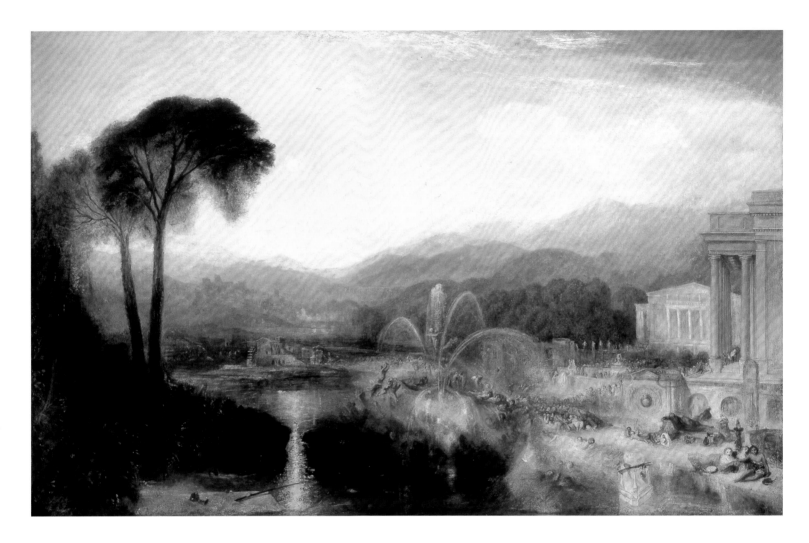

Turner comes across as a thorough but pedantic reader, with a pawky sense of humour, a direct point of view, and all too willing to engage in conversation. When Blunt talks in fanciful language about how anyone might willingly accept inferior wine for the pleasure of 'seeing the fantastic branches of the vine twisting themselves about the arms of the trees', Turner splutters, 'Not I for one – and I suspect the author is of my opinion notwithstanding this mawkish discharge of picturesque sentimentality.'[12]

Turner also gives his opinion on the Italian style of begging, on the pagan roots of the carnivals at Rome and Verona, and on why religious ceremonies use ox drawn carts, 'I *answer* – because it is a mode of conveyance peculiar to the country, wagons with oxen are common all over Italy – no obligation however to Juno or Cybele or Ceres, who probably could find no other description of coach.'[13] One marginal comment shows that the date

of Turner's reading must be fairly soon after 1833, the year he first visited Vienna. Commenting on Blunt's discussion of the drink 'vermut', (vermouth), he writes:

Has this <u>Vermut grape</u> been introduced by the Austrians? Where does it grow? I have certainly drunk a <u>mixture</u> at Vienna called Vermut – it is served in coffee or other cups & is wine with an infusion of worm wood – I suspect strongly that the <u>Italian</u> Vermut has been brewed to fit Columella & shew reading.[14]

This particular, and clearly recalled, memory of vermut is very interesting, coming as it does at or around the time Turner was painting *The Fountain of Indolence* [91]. This painting, which, given Turner's predilection for James Thomson's poetry, may have taken as its source Thomson's *Castle of Indolence*, shows hundreds of happy naked people drinking, dancing and floating about in a generally dazed fashion beneath a crystal fountain, recalling Thomson's words:

[91] *The Fountain of Indolence*, 1834
The Beaverbrook Art Gallery / The Beaverbrook Foundation, New Brunswick

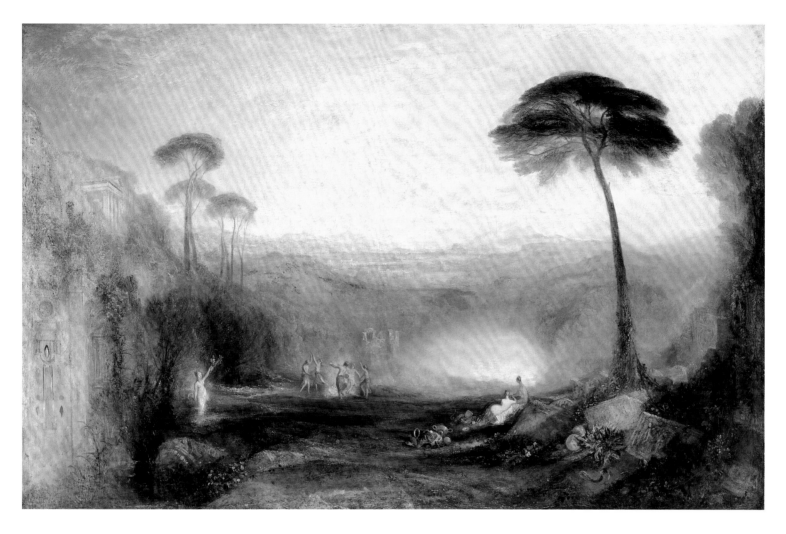

[92] *The Golden Bough*, 1834
Tate, London

There each deep draughts, as deep he thirsted drew;
It was a fountain of nepenthe rare;
Whence, as Dan Homer sings, huge pleasaunce grew,
And sweet oblivion of vile earthly care;
Fair gladsome waking thoughts, and joyous dreams
 more fair.[15]

'Huge pleasaunce' is certainly what Turner supplies, as well as a palatial and long-established Roman settlement, with an enclosed bosky courtyard lined with statues, a lake, a mill and a mill stream. Further back there is an aqueduct and a majestic range of mountains leading away far into the distance. In the centre, high spouting, is a magnificent crystal fountain. 'Dan' Homer, as Thomson describes his and Turner's hero,[16] also wrote about nepenthe, an opiate that chased away sorrow. But there may be more to this than Homer and James Thomson. Four years before Turner painted *The Fountain of Indolence* John Murray published,

posthumously, Humphry Davy's *Consolations in Travel, or the Last Days of a Philosopher*. Here is yet more of the long and occasionally visionary account of the rise and fall of civilisations which Davy wrote in Rome, around the time when he and Turner were together there in 1819 and which they probably had discussed.[17] While *The Fountain of Indolence* is by no means an interpretation of Davy's text, in which the author sees 'the whole face ... of the ancient world adorned with miniature images of this splendid metropolis', painting and text share common themes: the classical buildings have all the appearance of a library or venerable seat of learning; crowds mass in the courtyard; the range of figure sculptures on the parapet indicate continuity; and the enigmatic globe on the wall surrounded by swirling figures carved in stone suggests that advanced study of geography and astronomy may be carried on here. In the distance is a mill, busily at work, and an aqueduct bringing water from the Apennines.

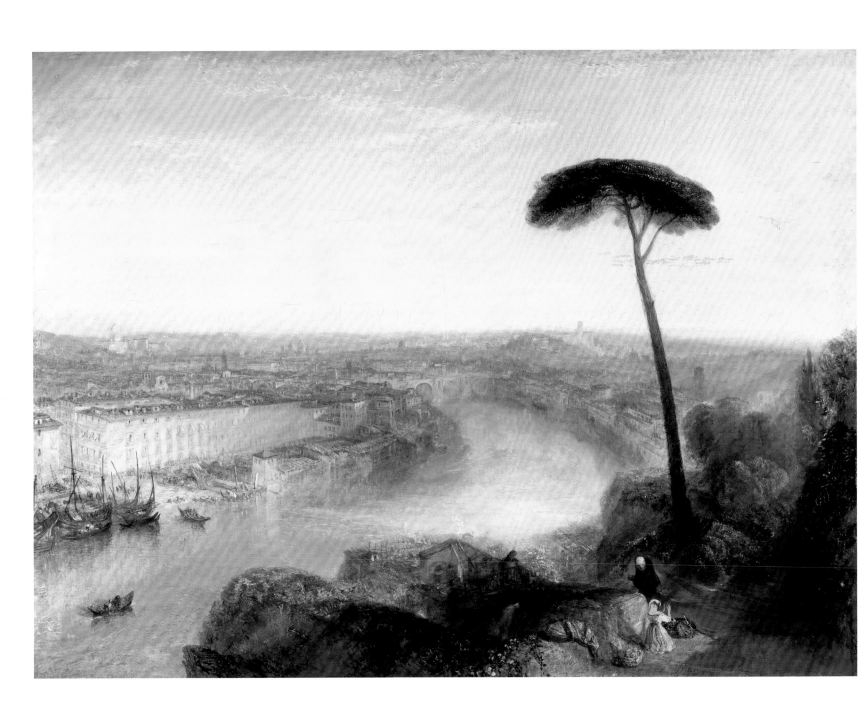

[93] *Rome, from Mount Aventine*, 1836
The Earl of Rosebery, on loan to the National Gallery of
Scotland, Edinburgh

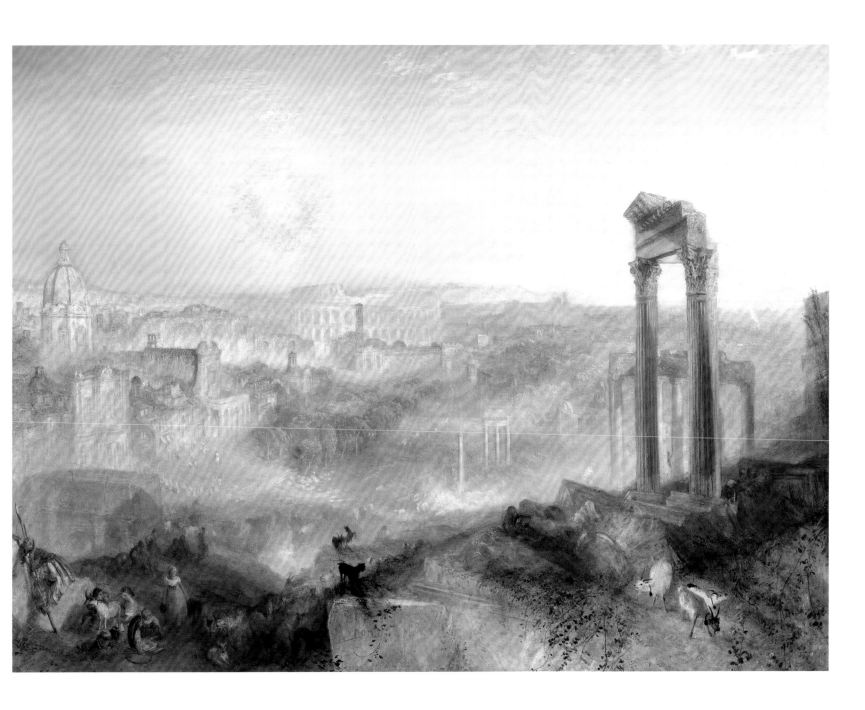

[94] *Modern Rome – Campo Vaccino*, 1839
The Earl of Rosebery, on loan to the National Gallery of
Scotland, Edinburgh

As Turner depicts it, this landscape, cultivated in agri-cultural as well as learned terms, represents the apogee of civilisation, now being taken over and endangered by, in Davy's words, 'an idle and luxurious population'.

With the fountain Turner may be giving a nod to the painting *The Garden of Earthly Delights* by Hieronymous Bosch, which was known through engravings, but there is also a source much closer to home which chimes with Turner more elegantly than the caustic inhumanities of Bosch. There are many fountains in Turner's works, and spheres and bubbles had been appearing in his rich and complex oeuvre since at least the 1810s when he was preparing his lectures on perspective. These forms are an extension of the vortices that had been a characteristic of Turner since before 1812 when they reached a climax in *Snow Storm: Hannibal and his Army Crossing the Alps*. One very significant contemporary and friend of Turner, the visionary artist John Martin, also used spheres and bubbles in his art.

There is nothing quite like this extraordinary paint-ing in Turner's oeuvre, a piece of fantasy that makes even *Vision of Medea* seem stagey. He exhibited it first at the Royal Academy in 1834, and then five years later under the amended title *The Fountain of Fallacy* at the British Institution.[18] It is impossible to say whether he changed anything other than the painting's title before its 1839 showing, but he did add a verse of his own by way of attempted explanation. The attempt failed; the verse is more opaque even than the painting:

Its Rainbow-dew diffused fell on each anxious lip,
Working wild fantasy; imagining;
First, Science in the immeasurable Abyss of thought,
Measured her orbit slumbering.

Turner's reference to science and the 'immeasurable abyss of thought' suggests an engagement with the kind of intellectual depths that Davy plumbed; the rest may convey the truism that natural scientific processes go on despite human inattention.

Whatever it is that Turner 'means' by this painting, it is clear that the history, myth and the romance of ancient Italy, by now instilled in him by both experience and learn-ing, stirred him to his roots. The 1830s saw a re-emergence of specifically Roman (and some Greek) subjects among Turner's exhibited works, now exceeding in number his paintings in all other subject categories, except seascapes. The themes of Roman history and myth interweave within the group, for example, *Caligula's Palace and Bridge* [90], *The Golden Bough* [92], *Mercury and Argus, Cicero at his*

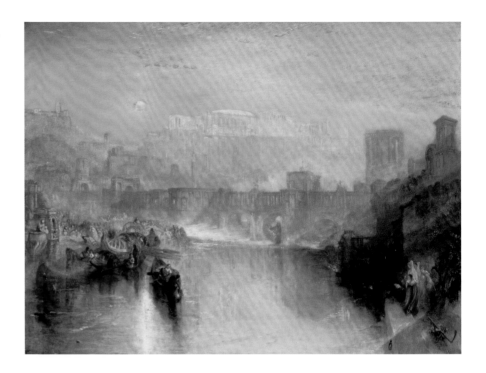

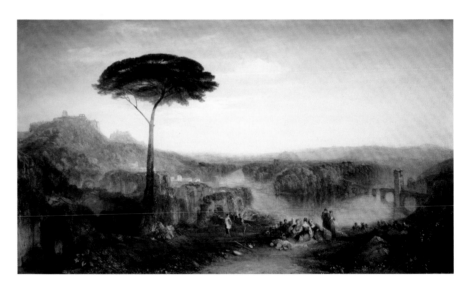

[95] *Ancient Rome: Agrippina Landing with the Ashes of Germanicus*, 1839
Tate, London

[96] *Childe Harold's Pilgrimage – Italy*, 1832
Tate, London

Villa [138], *Rome, from Mount Aventine* [93], *Modern Italy – the Pifferari* [98], *Ancient Italy: Ovid Banished from Rome*, *Ancient Rome: Agrippina Landing with the Ashes of Germanicus* [95], *Modern Rome – Campo Vaccino* [94], and a work that draws together travel, modern literature and biography, *Childe Harold's Pilgrimage – Italy* [96]. Other themes of composition and content include the unfinished *The Arch of Constantine, Rome* [97] with its embryonic narrative in the shadowy figures, and paintings which demonstrate Turner's characteristic practice of massing buildings in piles which climb to dizzying heights and melt into the distance. With the gilded skies and sunsets, these are now so much part of Turner's expression that their original sources in Claude and Poussin have been transcended.

Hanging with *The Fountain of Indolence* when it was first shown was *The Golden Bough*, a wide expansive landscape comparable to *Childe Harold's Pilgrimage* of two years earlier. The Cumaean Sibyl, Deiphobe, stands in front of the mouth of Hades, here dressed up in the cheery style of Raphael's decorations in the Vatican. She waves triumphantly about her head a bough from the tree which, as described in Virgil's *Aeneid*, has to be carried as an offering to Proserpine by anyone who wishes to enter the underworld. High on the left is an adaptation of Turner's 1819 sketch of the Temple of Clitumnus. The mood of the painting is joyous – dancing figures in the middle distance, a reclining nude, a deep mysterious mist rising from Lake Avernus. This volcanic crater, marking the entrance to Hades, gave off poisonous fumes that were said to kill birds as they flew over it. If expressing the dangers of the lake was not among Turner's intentions, he has added a snake and a fox on the right to suggest the possibility of discord. Elements in this work had appeared in Turner's *Lake Avernus: Aeneas and the Cumaean Sibyl* [27] of twenty years earlier. This is another instance of Turner returning to familiar subject matter and reworking it.

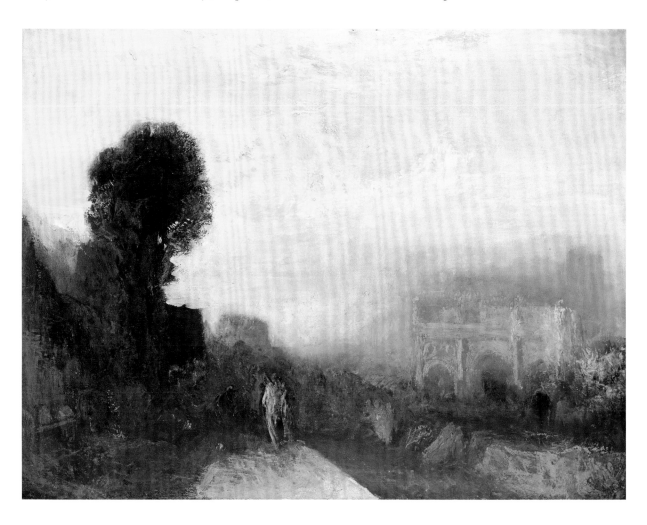

[97] *The Arch of Constantine, Rome*, c.1835
Tate, London

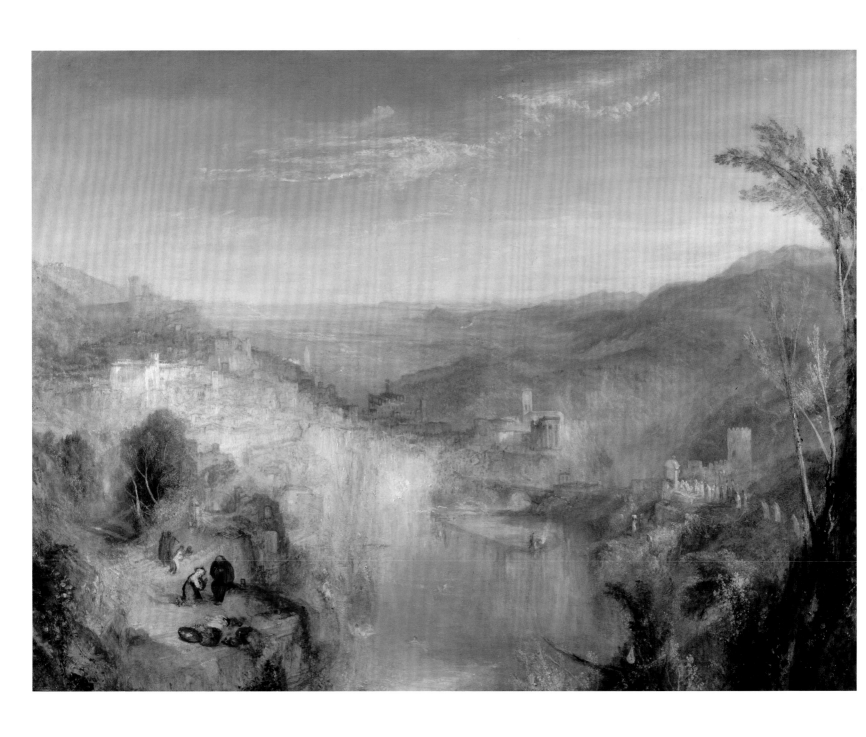

[98] *Modern Italy – the Pifferari*, 1838
Kelvingrove Art Gallery and Museum, Glasgow

The Golden Bough shares, with *England: Richmond Hill*, *Childe Harold's Pilgrimage* and *Rome from Mount Aventine* along with many other major works, the feature of the high-rising umbrella pine. A classic element of the Roman landscape, umbrella pines rise in their hundreds above the Borghese Gardens, on the Pincian and the Aventine Hills, and are a staple of Turner's observations of the city. By breaking the skyline in his paintings they give added height to the subject and allow the viewer's eye to rise with the aerial perspective. In *Rome from Mount Aventine* it is not the foreground figures nor even the horizon, which are at eye level but the small, broken branch two-thirds of the way up the tree trunk. This is a very subtle piece of art-direction, a sleight of hand that is practically unnoticeable until the viewer sees that he has given the stubby branch an extra amount of golden glow behind it. For all its artifice, this painting was, according to Walter Thornbury, Turner's first biographer, a faithful 'copy' of the modern Roman landscape, to the extent that Turner depicts contemporary building work, and uses the long line of late eighteenth-century architecture, the hospice of S. Michele, to thrust its way into the composition and create a firm foil for the soft curve of the Tiber.[19] Painted for one of his patrons, Munro of Novar, this work was derived from studies made by Turner in 1828. Another painting of modern Rome first owned by Munro is *Modern Rome – Campo Vaccino* a sunset moment in which modern, that is sixteenth- and seventeenth-century Rome, rises up from the ruins of the Roman Forum, with the Coliseum in the background and the Arch of Septimus Severus and the Temple of Saturn flanking the foreground. There is activity throughout the painting: goats are herded by the hardworking family on the left, and people spill out of the churches beyond. In bands of modulated light and shade continuing into the far distance, Rome is recreating itself through the labour of its people into a new and thriving civilisation. A foreground stone is inscribed 'PONT MAX', the familiar abbreviation, seen all over Rome, of the words 'Pontifex Maximus', the title given to emperors and popes, meaning 'greatest bridge-builder'. Even an archaeologist is contributing to the reconstruction – he is there standing on a ladder between the columns of the Temple of Saturn on the right.

The year 1839 represents a watershed in Turner's exhibiting career, and it is possible to detect a theme and a sense of purpose in his exhibited paintings which is clearer than any since 1803. In 1839 he exhibited the work which has carried his fame bravely across a century and a half, *The Fighting Temeraire*. But what accompanied it on the walls of the Royal Academy is equally significant. Alongside this grand statement which evokes national pride, liberty and change were four works of classical content that continue the theme of liberty sparked off by *The Fighting Temeraire*. The pendant pair *Ancient Rome: Agrippina Landing with the Ashes of Germanicus. The Triumphal Bridge and Palace of the Caesars Restored* and *Modern Rome – Campo Vaccino* jointly reflect the impact on Turner of Thomson's poem *Liberty*, which tells the story of the triumph and decline of liberty in ancient Rome.[20] The little-known *Pluto Carrying off Proserpine*, currently not in exhibitable condition, narrates the Roman myth of loss of liberty, the abduction by the god of the underworld of the beautiful daughter of Ceres.[21] The fourth painting, *Cicero at his Villa* shows the great Roman champion of liberty and justice walking in his garden above his magnificent villa, the fruit of hard work rather than inheritance. Two lines of figure sculptures flanking a terrace evoke continuity and a developed culture, and carry a similar burden of meaning to the parapet sculptures in *The Fountain of Indolence*.

Why these five paintings exploring liberty and human endurance and failure, and a sixth, the reworked *Fountain of Indolence* at the British Institution, should come together on the walls of London's two main exhibiting salons in the same year is unclear. But it may be significant that 1838 and 1839 were the years of the birth and first expression through petition, argument and riot of the demands for liberty by the Chartist movement in Britain.

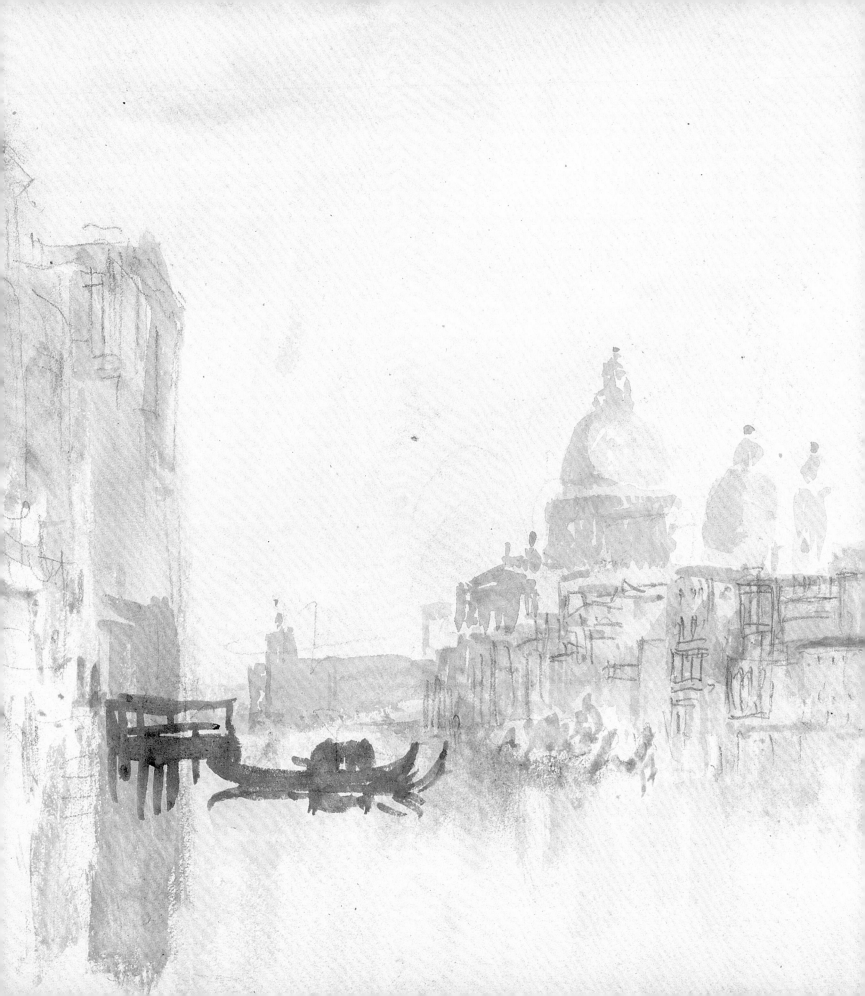

The Light of Venice

Turner and Venice are inseparable, though in being so they distort our understanding of the nature and strength of the bond that grew between Turner and Italy as a whole. While he was in Venice for no more than four weeks across his whole life – in 1819, 1833 and 1840 – Turner's engagement with the city as a subject for his painting came to be an idiosyncrasy of old age.

Turner did not 'invent' Venice before he had seen it, in the same way that he 'invented' Carthage (and by extension Rome) in 1815 and 1817, nor did he exhibit oil paintings with Venetian subjects until 1833, by which time he was in his late fifties. Even then, one of his works, *Bridge of Sighs ... Canaletti Painting* [100] may have been an afterthought and painted rapidly, in jest, while another, *Ducal Palace, Venice*, now known only through an engraving, appears surprisingly pedestrian.[1] It was not until 1834, with the whole panoply of his Roman work to date behind him, that Turner embarked on his first great Venetian subject. This was baldly and simply titled *Venice* [99].[2] It was painted when Venice was fresh in his mind, in the few months after he returned from his tour in 1833 to Berlin, Prague and Venice, but even so it was not painted entirely instinctively, or as far as is known through Turner's own initiative, but was commissioned by the Manchester cotton-king Henry McConnel.[3] *Venice* was, however, the start of a late series of great Venetian oils that continued in 1835 with *Venice, from the Porch of Madonna della Salute*, and carried on until 1846. The titles of the works tended to become longer and more obtuse, and the series that began as *Venice* ended with *Going to the Ball (San Martino)* and *Returning from the Ball (St Martha)*. So assertive was Turner's interest in Venice in his later years that art historians have tended to become overwhelmed by it, to the extent that a pair of paintings depicting the arrival in Portsmouth of King Louis-Philippe of France was considered to be part of the Venetian oeuvre until as late as 2003.[4] One reason

for the determined colonisation of Turner's late canvases into a new painterly Venetian empire is the late nineteenth-century obsession with Venice as expressed by artists and writers such as John Ruskin, Thomas Mann, Walter Pater and John Singer Sargent.

With the exception of the few watercolours painted in Venice, and three made around 1820–1 with the ulterior motive of engraving them, Venice did not appear in Turner's oeuvre between 1819 and 1833, in which time he exhibited forty-two oil paintings of other subjects.[5] Instead, he took his audience to Rome in these years, to Naples, Orvieto, Palestrina, Dieppe, Cologne, Rotterdam, Cowes, the Isle of Wight, Helvoetsluys, Staffa, and the West Indies. His leaving incomplete in 1820 the enormous canvas *The Rialto, Venice* seems to be, in light of this, a deliberate and purposeful act. So what put him off Venice in the 1820s? In 1819, while he spent longer in Venice and Naples, than in any other Italian city apart from Rome, it remains the case that Rome was his goal. Single-minded as he was, his work shows that he found enough to say about the decaying classical grandeur of Rome without being distracted by Venice. Venice, to Turner, was not yet a subject.

The decay of Rome as expressed by Turner concerns, generally speaking, its buildings and its landscapes. Roman decay, in Turner, is about place, and to express it he weaves together the city's past and present, sometimes in pendant canvases such as *Ancient Rome* and *Modern Rome* and *Ancient Italy* and *Modern Italy*. Grand, melancholy past is offset in these works by determined vigorous survival, in which Baroque churches and towers push their way up through the ruins like fungi on a fallen trunk. The priesthood is omnipresent in the 'modern' subjects, either in procession or prayer, and local people do the best they can in the circumstances, while archaeologists and artists scratch away at the ruins. Despite the ruin, there is always new life in Rome. Turner's approach

to Venice, however, is quite different. He does not show a ruined city – why should he? – the fabric of Venice may have been eroded, but ruined it certainly was not. The first two Venetian subjects, exhibited before Turner left for the city in 1833, were painted from studies he had made fourteen years earlier. Their relative artificiality and the subsequent change of tone are thus only to be expected. Both show a bustling, workaday Venice: in *Bridge of Sighs ... Canaletti Painting* Turner gives us a busy artist at his easel, with a gondola uncharacteristically whizzing in from the right. In *Venice* on the other hand, there are dozens of figures, but certainly no bustle. This is a rich and distinguished Venice at the beginning of a decline which, over the years, Turner was to express more and more plainly. From the evidence of the drawings of 1819, Turner considered Venice to be both active and buoyant; his later experience of the city, however, clearly altered his view to the extent that with one of the works, *The Sun of Venice Going to Sea* [101], he quoted some more of his excruciating poetry, foreshadowing civic decline:

> *Fair Shines the morn, and soft the zephyrs blow,*
> *Venezia's fisher spreads his painted sail so gay,*
> *Nor heeds the demon that in grim repose*
> *Expects his evening prey.*[6]

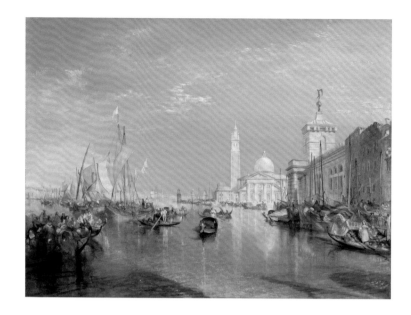

The decay of Venice seen through Turner's eyes during the 1830s and 1840s is not expressed through its fabric, but through its people. His Venice, by comparison with his views of a Rome in revival, is a place of poignancy and decline, peopled by men and women whose sole activity appears to be indolence and display.

It is interesting that the year he exhibited, for the first time, *The Fountain of Indolence* with its melancholy view of fragile human nature, was the same year in which the beginnings of Turner's personal reflections on Venice seem to have come to the fore. Indeed, although there is no way of knowing, it is possible that *The Fountain of Indolence* set a train of thought going in Turner's mind that found a developed expression through the vehicle of Venice. What Turner found when he went to Venice the second time in 1833 filled two sketchbooks and further sheets of paper.[7] He used pencil in these quick studies, some of which suggest he had stormy weather this time, and he made few, if any, watercolours[8]. This was a brief trip, lasting less than a week from 9 September, but one in which he moved energetically around the city from the Hotel Europa, a former palace at the southern end of the Grand Canal looking across to the Salute.[9] The busy

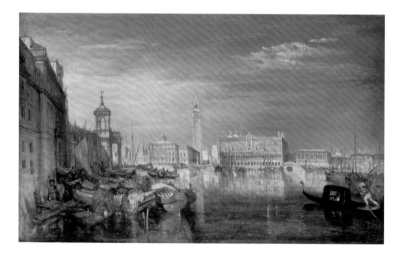

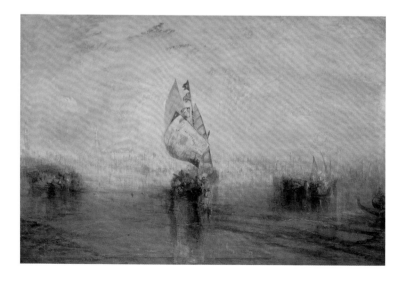

left:

[99] *Venice*, 1834
National Gallery of Art, Washington
DC, Widener Collection

[100] *Bridge of Sighs, Ducal
Palace and Custom-House, Venice:
Canaletti Painting*, 1833
Tate, London

[101] *The Sun of Venice
Going to Sea*, 1843
Tate, London

[102] *The Doge's Palace,
from the Bacino*, from the
'Storm' sketchbook, 1840
Walker Art Gallery, National
Museums Liverpool

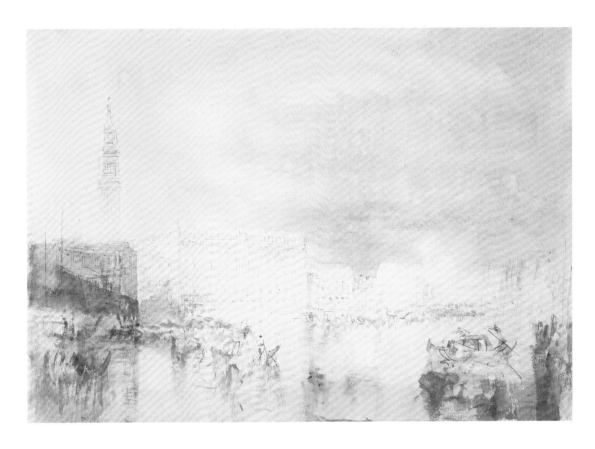

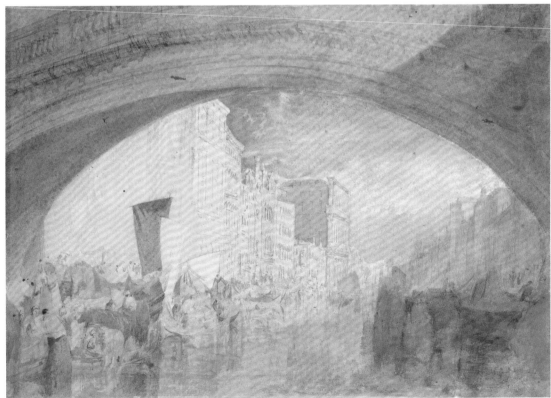

[103] *The Grand Canal, with the
Palazzo Grimani, from below the
Rialto Bridge, Venice*, c.1820
National Gallery of Ireland, Dublin

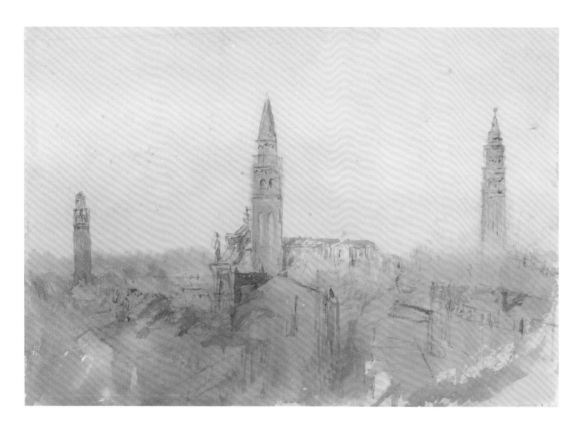

[104] *Venice: Looking North from the Hotel Europa, with the Campaniles of San Marco, San Moise and Santo Stefano,* 1840
Tate, London

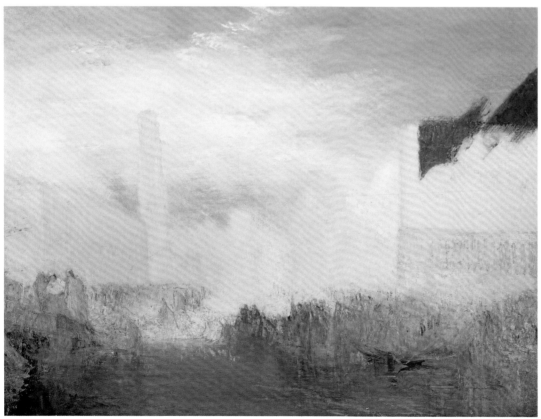

[105] *Venice, the Piazzetta with the Ceremony of the Doge Marrying the Sea,* c.1835
Tate, London

nature of the sketchbooks suggests that he is in Venice again to collect information, not atmosphere. He spent some time in St Mark's Basilica, and on the northern edge of the city along the Fondamente Nuovo, amassing nearly two hundred pages of material which he would use in the long series of paintings beginning with *Venice* in 1834 and *Venice, from the Porch of Madonna della Salute* of the following year [106]. Both of these have viewpoints close to the Hotel Europa, and depict activity which he witnessed daily.

He will have heard about, but not have seen because it had been abandoned since 1797, the ceremony in which the Doge renews the eternal bond of Venice and the sea

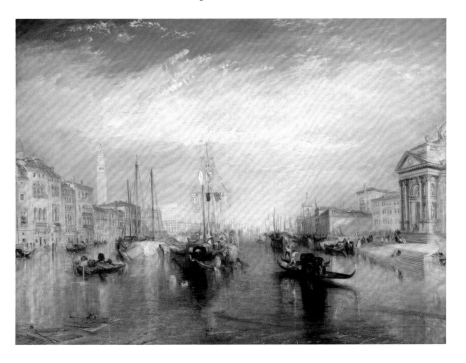

[106] *Venice, from the Porch of Madonna della Salute*, 1835
The Metropolitan Museum of Art, bequest of Cornelius Vanderbilt, 1899 (99.31)

by symbolically 'marrying' them with a ring thrown into the water beyond the Doge's Palace. This is the subject of an unfinished canvas, *Venice, the Piazzetta with the Ceremony of the Doge Marrying the Sea* [105] which has a similar composition to *Venice, from the Porch of Madonna della Salute*. They share the distant Campanile of St Mark on the left, the firm structure of a building on the right, and action on the water in the middle. The canvases are of identical size, and the latter is clearly on track for completion, despite the errors Turner has made in the roofline of the Doge's Palace – there is no upper sloping roof as suggested here. The viewpoint of the unfinished canvas is clearly visible in the centre of the horizon of the exhibited work. Given the similarity in

the way the paint is handled, particularly in the sky, it is possible that this was intended for exhibition in 1835 but in the event abandoned for reasons unknown.

For his third Venetian subject, *Juliet and her Nurse*, Turner takes a vantage point from the roof of what is now the Correr Museum looking down onto St Mark's Square. There are no surviving studies by Turner of the square from this viewpoint. The fireworks that flare up in the distance on the right reflect Turner's enjoyment of firework displays while he was in Venice. In 1837 he reverted to another tried and tested viewpoint for his next Venetian subject, and developed studies he had made on the pavement and jetties outside the Hotel Leone Bianco where he had stayed in 1819. In all these paintings it is languor among diminishing riches that Turner has chosen to associate with Venice, in contrast to the stout-hearted industry under adverse conditions that he ascribes to the modern Romans.

It is clear from the two Venice subjects exhibited at the Royal Academy in 1840 that Turner needed to refresh his vision. Both replay the themes of his visit in 1833, and, in particular *Venice, the Bridge of Sighs* (Tate), has a crusty familiarity which forbids Turner from taking the imaginative and dangerous leaps that make his art so exhilarating to follow. He had to go back to Venice, and did so that same summer. He was in the city for two weeks this time, from 20 August to 3 September,[10] and stayed again at the Hotel Europa. Venice was becoming as popular a subject for art connoisseurs in the 1830s and 1840s as it was as a destination for tourists. Responding as Turner did to the art market, Venice came more prominently into his repertoire because these were subjects which he knew would fetch buoyant prices. It has to be stressed that Turner was not always led by purely aesthetic considerations, and would chose extraordinary subjects – such as the South Atlantic whaling fleet – because he expected they would sell.

When he went to Venice in 1840 it was at more or less the same time of year as his 1819 and 1833 visits – early September – so it is worth noting that the only Venice he ever saw was late summer Venice with its long days, its storms, mists, and its particular light. Snowbound or flooded winter Venice, or sparkling, light blue, spring Venice, were outside his experience. Turner's Venetian oeuvre, therefore, lacks the variety and seasonable changeability of, for example, Walter Sickert's or John Singer Sargent's Venice.

It was on the 1840 visit that Turner painted the

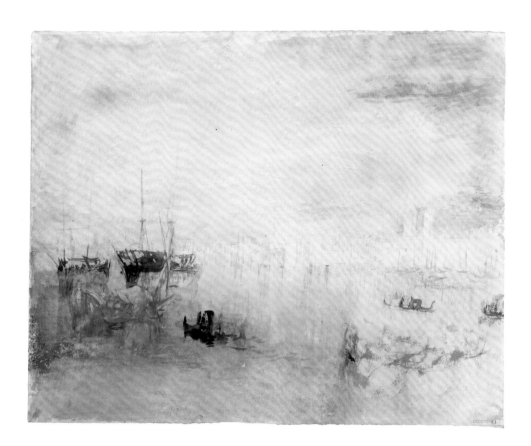

[107] *Venice: Shipping Moored off the Riva degli Schiavoni*, 1840
Tate, London

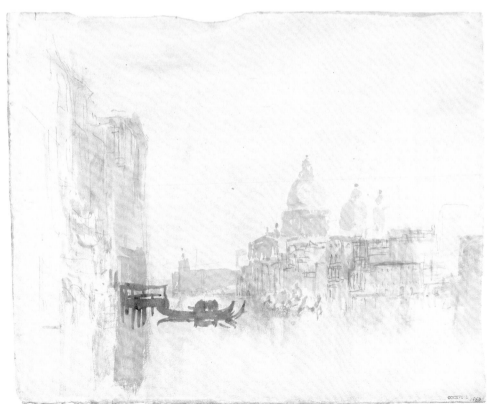

[108] *Venice: Santa Maria della Salute with the Traghetto San Maurizio*, 1840
Tate, London

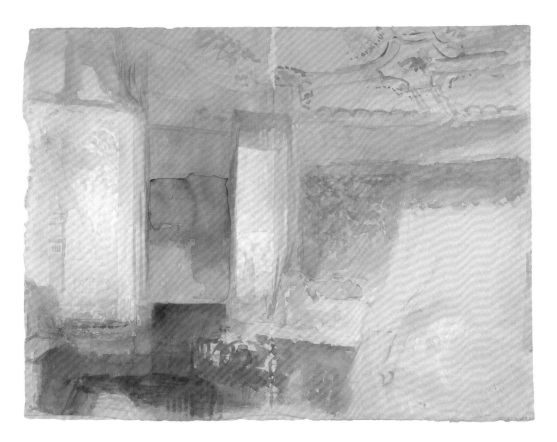

[109] *Turner's Bedroom in the Palazzo Giustiniani (the Hotel Europa), Venice,* 1840
Tate, London

[110] *Among the Chimney-pots above Venice; the Roof of the Hotel Europa, with the Campanile of San Marco,* 1840
Tate, London

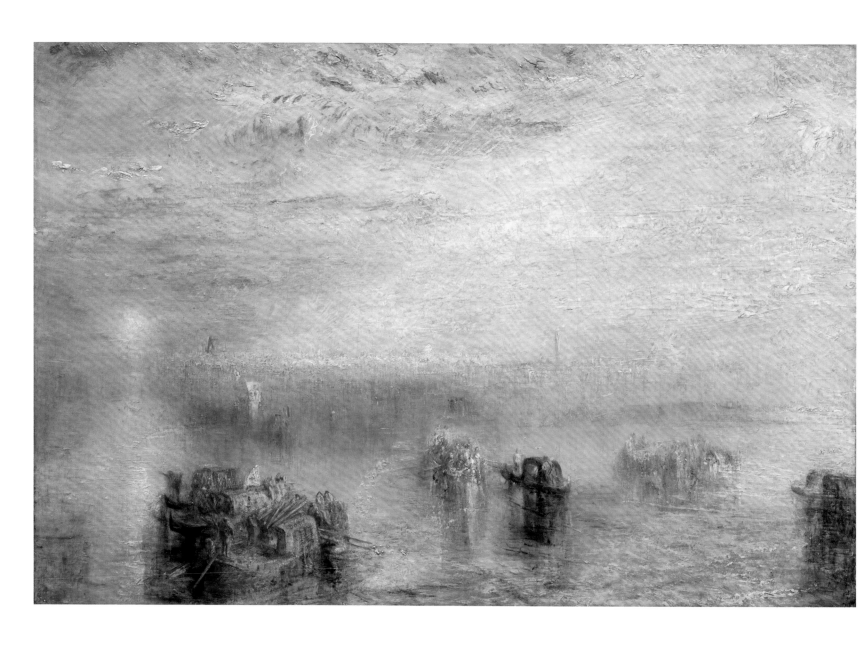

[111] *Approach to Venice*, 1844
National Gallery of Art, Washington DC,
Andrew W. Mellon Collection

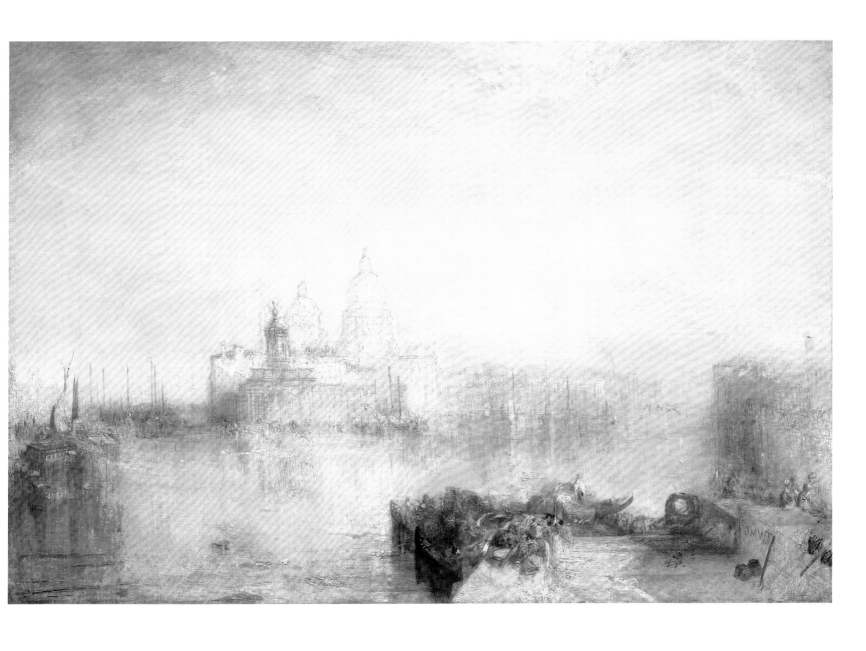

[112] *Dogana, and Madonna della Salute, Venice*, 1843
National Gallery of Art, Washington D C, given in memory of
Governor Alvan T. Fuller by The Fuller Foundation, Inc.

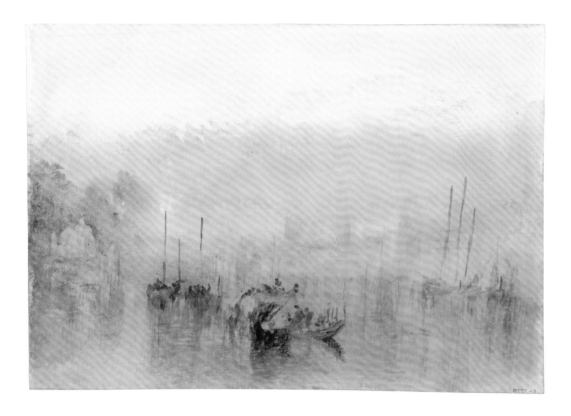

[113] *Venice: Shipping in the Bacino,*
with the Entrance to the Grand Canal
from the 'Roll Sketchbook of Venice'
[Finberg CCCXV], 1840
Tate, London

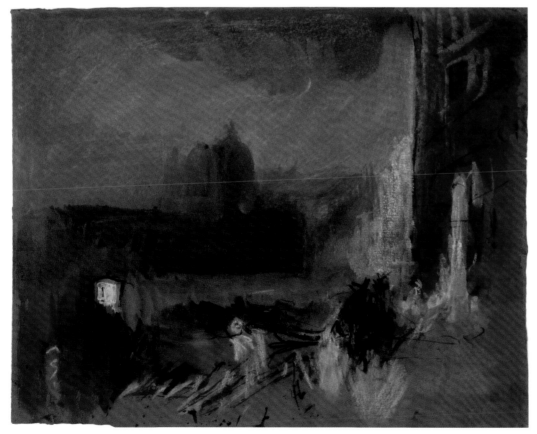

[114] *Venice: The Salute from*
the Traghetto del Ridotto, *c.*1840
Tate, London

shimmering watercolours which associate him forever with Venice, and in which his genius is distilled [102, 107, 108, 113]. While he came to paint and exhibit more oils of Venetian subjects – they sold very well – the watercolours made of the city in 1840 show him to have reached the pinnacle of his achievement after more than fifty years of working in the medium. He has travelled a very great distance in his art since he painted his four watercolours in Venice in 1819. On his 1840 visit Turner seems to have become a nocturnal animal. There are watercolours of St Mark's Square and its surroundings at night [114], there are fireworks, lightning storms, theatrical performances, prostitutes greeting clients, firelight and long dark journeys up side canals. The morning after also becomes a potent subject – the roof tops and towers seen from his hotel bedroom [104, 110], crumpled sheets on his bed, and ample evidence, if any were needed, that a woman helped him keep his bed warm [109]. The watercolours from this time, of which there are well over one hundred loose sheets, are celebrations of a vivacious, energetic and joyful old age. Turner was sixty-five by now, and still going strong. This late-flowering experience recharged his creativity and led to the burst of activity that produced as many as seventeen exhibited oils of Venice subjects over the following seven years, including one of the finest, *Approach to Venice* [111], a painting that John Ruskin described as 'the most perfectly *beautiful* piece of colour of all I have seen produced by human hands, by any means, or at any period.' The boats appear to be arriving in Venice from the north, across the lagoon, in a flotilla that echoes the one in the watercolour of around 1829, *Virginia Water* [73], itself a transcription into an English context of a Venetian scene. When *Approach to Venice* was first exhibited in 1844 Turner quoted in the catalogue a couplet from Byron's *Childe Harold's Pilgrimage*, 'The moon is up, and yet it is not night, The sun as yet disputes the day with her.'

Turner's composition, and the balance of light and shade within it, evokes Byron's sentiments to perfection. At least five other Venice oils, including *Venice, with the Salute*, may not be wholly finished, but as these are all at more or less the same stage of development, it is possible that Turner considered them finished. While Turner's Rome retains a high level of physicality to the last, Turner's Venice becomes mistier and mistier, less and less *there*.

Venice gave Turner a renewed courage in his expression of light and water which led in turn to such masterpieces as *Rain, Steam, and Speed* of 1844, *The Arrival and Disembarkation of Louis-Philippe at Portsmouth* of late 1844 or 1845, the *Whalers* of 1845 and 1846, and the four paintings exhibited in 1850 at the Royal Academy in which he returned for the last time to the story of Dido and Aeneas. He produced Venetian subjects until the end of his life. One evening in late August or early September 1840 the much younger artist William Callow had spotted him and said, 'Whilst I was enjoying a cigar in a gondola I saw Turner in another one sketching San Giorgio, brilliantly let up by the setting sun. I felt quite ashamed of myself idling away my time whilst he was hard at work so late.'[11]

Radical Old Man

On 7 October 1840 Turner settled down to write a business letter. 'I should have answered your letter sooner,' he wrote to his long-suffering solicitor George Cobb, 'but have only arrived from Venice a few hours.'[1] Such was the flinty energy of the man that he was able so rapidly to get back onto the treadmill of his everyday life, here dealing with a difficult tenant of one of his properties. Travel, to Turner, was part of normal life, and he added to George Cobb the hope that 'we may meet again ere long – by rail-road, either at Brighton or London'. So well-woven, indeed, was travel, history and narrative into Turner's life that in the 1840s he used the head of Ulysses on his wax letter seal.[2] Almost exactly a year later, having 'only return'd from Switzerland last night',[3] he sent the engraver William Miller detailed criticism of Miller's engraving of *Modern Italy – The Pifferari* [98]:

The foreground will be required to be more spirited and bold; open work, dashing Wollett like touches and bright lights; so do all you can in the middle and lower [?] part of the Town and leave it all for the present in front … Now for the good parts – the greatest part of the sky, all the left side, the upper castle and Palace and partly round to the Sybil Temple – Town *and procession on right side, and the water in the middle particularly good and I hope to keep it untouched if possible.*

Engraving was still the most effective medium available for getting images distributed, and in his mid- to late-sixties Turner was as determined as ever to widen the audience for his work. This creates a dilemma for his present audience, because for every effort he made in clarifying the engravings he seems to have made a counter effort of mystifying his paintings. The final decade of his life – he had eleven years to live when he left Venice for the last time – is marked by returns and reassessments of the interests of his youth and maturity. In terms of place, he returned to Aosta and the Alps in 1836 and again in 1844, and he revisited subjects which he had first recorded as engravings in his 'Liber Studiorum' nearly forty years earlier.[4] In *Landscape: Woman with a Tambourine* he gives us a recollection of the broken Bridge of Augustus at Narni[5] and in *Europa and the Bull* [115], a suggestion of the Bay of Naples. Myth, invention and reality are so wrapped together in Turner's late work that it is difficult to know where one begins and another ends. The canvas with the dull, cautious title *Landscape with a River and a Bay in the Distance* [116] may also be based on a 'Liber Studiorum' engraving, *The Junction of the Severn and the Wye*, but in doing so Turner transforms even his own sources. *Landscape with a River and a Bay in the Distance* is as much a memory of the Roman campagna, the Saône at Macon, and the Thames at Richmond, as it is of the Severn and the Wye. Its bleak, reticent surface and

left: detail of [121]

[115] *Europa and the Bull,* c.1840–50

Taft Museum of Art, Cincinnati, Ohio, bequest of Charles Phelps and Anna Sinton Taft

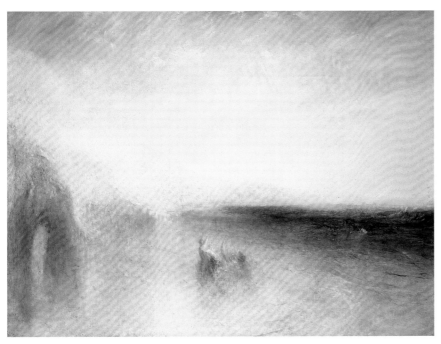

determined formal arrangement suggests that it is also a fading memory of Turner's hero Claude.

In the weeks before he returned to Venice in 1840, Turner exhibited seven paintings at the Royal Academy, among them *Neapolitan Fisher-girls Surprised Bathing by Moonlight* [117]. Not only by moonlight, for Vesuvius appears to be conveniently erupting on the left, and a lighthouse casts a yellow beam across the water. Indeed, it is not entirely clear if the painting shows night time or moonlight at all. Like another of Turner's paintings in the 1840 exhibition, *Rockets and Blue Lights* (Clark Art Institute, Williamstown, Mass), *Neapolitan Fisher-girls* has multiple sources of light within near-darkness, and four centres of activity ranged in a line across the canvas. This lateral narrative effect is a characteristic of Turner, and one which has been evident in other works, notably in *Rome, from the Vatican*. It underlines Turner's sense of purpose as a story-teller, and encourages the viewer to 'read' his paintings from side to side. *Neapolitan*

Fisher-girls provides a strong plot, with groups of figures moving in and out of the shadows, shifting light sources, and a dramatic backdrop. Turner's title for the painting appears, however, to conceal some submerged operatic elements which seem to refer to action in Daniel Auber's opera *Masaniello*, first performed in Paris in 1828 and in English at a Drury Lane theatre in 1829.[6] In the opera, Masaniello (Tommaso Aniello), a fisherman of Naples, leads a revolt against Spanish rule in 1647, driven in part by his anger at one of the Spanish oppressors having seduced and then abandoned his sister, Fenella. Misunderstanding and divided loyalty inevitably follow with the result that attack is threatened. Masaniello is poisoned, Fenella kills herself, and Vesuvius erupts. We might reasonably read the fitfully-lit group on the extreme right as either Masaniello or Fenella on the point of death, and the huddled fisher-girls, left and centre, as being terrified, surely not just 'surprised', by advancing Spanish authorities. Why Turner gave the

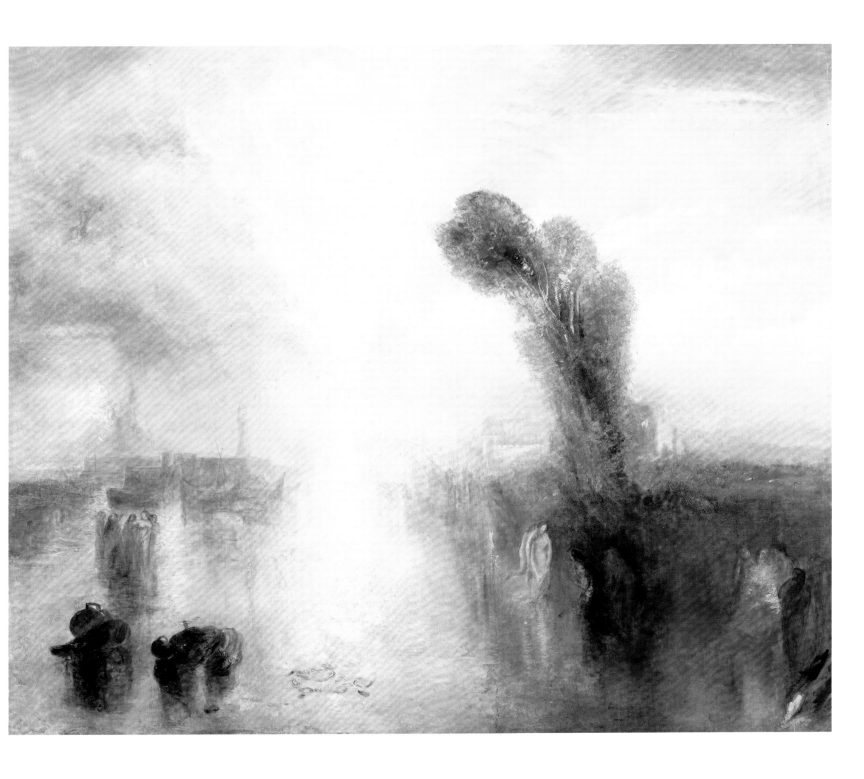

[117] *Neapolitan Fisher-girls Surprised Bathing by Moonlight*, 1840 (?)
The Huntington Library, Art Collections, and Botanical Gardens, San Marino, California

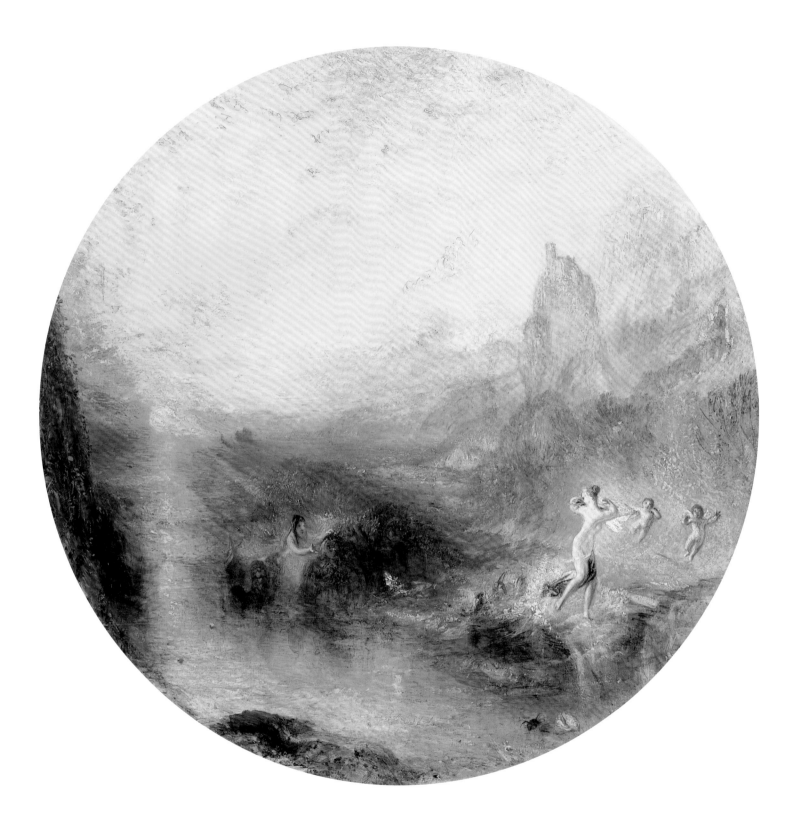

[118] *Glaucus and Scylla*, 1841
Kimbell Art Museum, Fort Worth, Texas

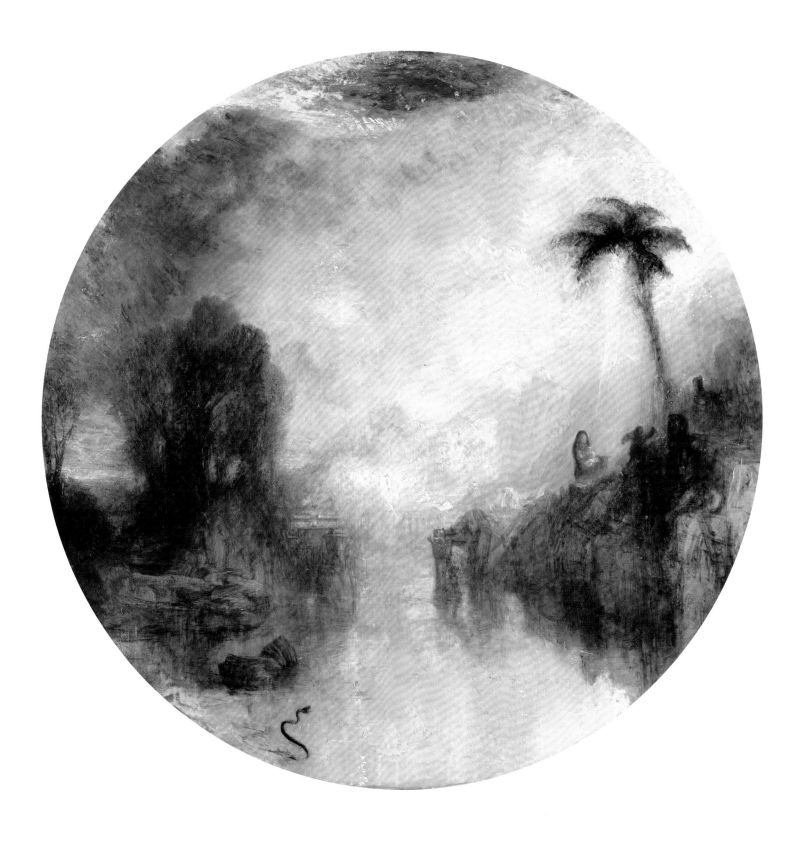

[119] *Dawn of Christianity (Flight into Egypt)*, 1841
Ulster Museum, Belfast

painting such a limp and mystifying title has not been explained, but this new interpretation is strengthened by the fact that six years later the artist exhibited another work on the theme of Masaniello. This was *Undine Giving the Ring to Massaniello, Fisherman of Naples*,[7] which shows the fisherman surrounded by fisher-girls now transformed into water-sprites, all inspired by an amalgam of Auber's opera and Jules Perrot's ballet *Ondine*, first performed in London in 1843.[8] It should be added that in these pictures Turner is not just giving us historical fairy tales, but is reminding us of the unstable political situation in Europe. Auber's *Masaniello* rapidly became popular, its music and arias being performed widely. A duet in the opera, 'Amour sacré de la patrie', became a clarion call for revolution, and indeed a performance of the opera in Brussels in 1830 sparked a riot which signalled revolution. In the 1840s Europe's revolutions threatened to spread to Britain in the wake of Chartism, so it was no idle choice that led Turner to take *Masaniello* as his subject matter. In his response to politics, as much as in his painting, Turner was a radical old man.

Further instability, of a meteorological rather than political kind, appears in Turner's later work. His *Snowstorm, Avalanche and Inundation – A Scene in the Upper Part of the Val d'Aosta, Piedmont* [120] expresses on one canvas practically every natural disaster known to man. There is even a very un-Alpine suggestion of an erupting volcano in the splash of fiery orange on the mountainside near the centre. Exhibited in 1837, the year after Turner revisited Aosta with Munro of Novar, *Snowstorm, Avalanche and Inundation* is a premonition of Turner's later manner, and may be a conscious, if good-natured, attempt to upstage the work of his friend John Martin, who was temporarily distracted from painting his great works of urban and geological cataclysm by dogged pursuit of plans to supply fresh water to London.[9] Be that as it may, the work also harks back to Turner's own cataclysmic subjects, such as *Snow Storm – Hannibal and his Army Crossing the Alps* and *Loch Coruisk, Skye* (National Gallery of Scotland), and suggests that Turner is here publicly reclaiming his own ground, and reflecting on just how terrifying real weather can be. In his later years Turner continued his life-long practice of painting and exhibiting pictures in pairs. Thus, *Glaucus and Scylla* [118] and *Dawn of Christianity (Flight into Egypt)* [119] hang together even though they depict ideas that appear to differ

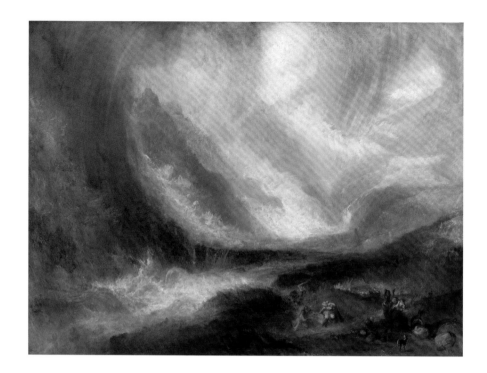

[120] *Snowstorm, Avalanche and Inundation – A Scene in the Upper Part of the Val d'Aosta, Piedmont*, 1837
The Art Institute of Chicago, Frederick T. Haskell Collection, 1947.513

[121] *The Val d'Aosta*, c.1840–50
National Gallery of Victoria, Melbourne, Australia, purchased with the assistance of a special grant from the Government of Victoria and donations

widely, Christianity and classical myth. The former, a Titianesque composition in which Turner may be reflecting on his visits to Venice, is predominantly blue, and picks up traces of the red and orange of the latter, while *Glaucus and Scylla* itself has touches of the blue of its companion painting. In this way, Turner ties the two works together visually, and subtly emphasises their pairing. But more, they are both concerned with stories of flight, the holy family escaping from Palestine into Egypt, and Scylla fleeing from the sea god Glaucus. In the background of *Glaucus and Scylla* is the Sicilian hill town of Taormina.

Turner made his final visit to the Alps in 1844, aged sixty-nine, most probably with a travelling companion the painter, inventor and obsessive Hannibal-chaser William Brockedon. An inscription Turner made in his 'Grindelwald' sketchbook suggests that they had Hannibal in mind, and explored one or more of his supposed Alpine crossing points; Turner writes in a very uncertain hand 'No matter what bef[ell] Hannibal – WB and JMWT passed the Alps from (?near) Fombey (?) Sep 3 1844.'[10] It is possibly out of this or an amalgam of late journeys in the Alps that Turner painted his last evocation of Aosta, *The Val d'Aosta* [121]. The mountains, it appears, have melted into the sea. In returning to the area above Aosta in these late works, Turner is completing the circle of his life that began with his early drawings and watercolours of Aosta and the mountains.

There is a profound physicality about Turner's late oil paintings, one which belies his age and diminishing health. He paints with fingers and thumbs, rags and brushes. Although it is not known how quickly he worked – he must surely have slowed down from the passionate energy of his youth – it is clear from the one hundred or more canvases that are known from the last decade of his life that his drive never slackened. In the quantity of work produced, there are as many canvases from his last decade as there are from the 1820s, his most productive period. Painting was Turner's job, and he was a very diligent and determined worker.

A final re-engagement in Turner's life was with the myth of Dido and Aeneas that had so exercised him in earlier decades. The characteristic ingredients are all present in the four paintings in this final exhibited cycle of works: the golden light and red and orange chromatics, the towering cities layer upon layer, the teeming figures, and the passion for narrative.[11] They are also, incredibly, in the three feet by four feet format that he used for exhibition paintings in his prime. With these four paintings, exhibited at the Royal Academy in 1850, Turner distils his impressions of the Italy of myth that he had so profitably discovered as a young man. Aeneas, in founding Rome, had provided Turner with one of his richest sources of inspiration. In *The Visit to the Tomb* [123] he returns to the subject of Dido visiting the tomb of her murdered husband Sychaeus, as first alluded to in *Dido Building Carthage* [30]. In this and *The Departure of the Fleet* [122], carrying Aeneas away from Carthage to travel to Italy, we may sense Turner is saying farewell. Where Turner ends, Rome begins.

[122] *The Departure of the Fleet*, 1850
Tate, London

[123] *The Visit to the Tomb*, 1850
Tate, London

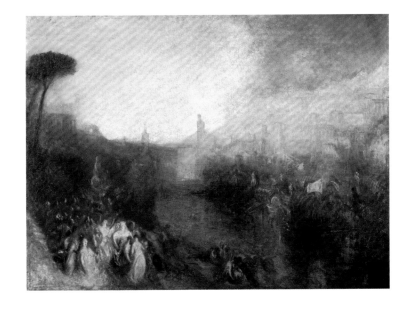

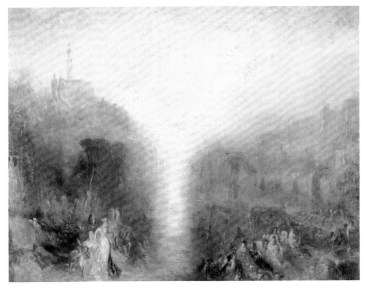

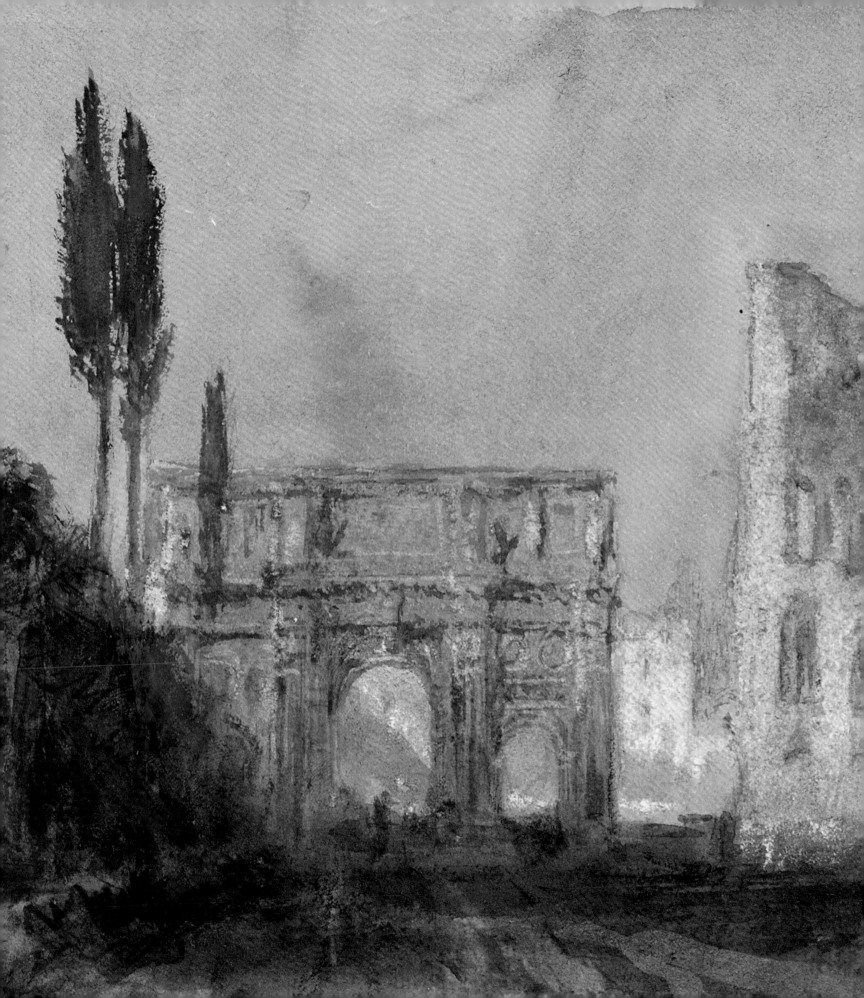

An Italian Treasury: Turner's Sketchbooks

NICOLA MOORBY

Twice on the road home from Italy, heavy snow in the Alps upset Turner's carriage forcing the unlucky artist to abandon his vehicle and flounder on foot in the hostile conditions. Despite the bravado of his pictorial renditions of these dramatic accidents,[1] the experience of being overturned in the mountains would have been both alarming and inconvenient and, amidst the chaos of the ordeal, Turner's thoughts must have anxiously turned to the safety of his luggage, particularly the bags containing his most precious and irreplaceable belongings, his sketchbooks.

Aside from fulfilling a long cherished personal dream, the primary purpose of Turner's Italian tours was to assemble a body of visual material which could inform and inspire his artistic practice back home in London. It was his sketchbooks, ready to hand at every stage of the journey, which embodied the repository of his experiences. His use of them extended before, during and after his travels, and they became an invaluable tool not only in preparing for and recording his Italian experiences, but also for digesting and interpreting them. As physical objects, they grant the most immediate and uninhibited link to the artist, offering, in a way which a painting cannot, a glimpse over his shoulder as he worked in the field. Collectively, they contain hundreds of drawings, mostly in pencil, the most expedient and portable medium for on-the-spot sketching, representing the instinctive dialogue between the artist's hand and eye and the subject directly before him. Twenty-three books define the twenty-six weeks of the 1819–20 expedition to Italy,[2] whilst a further ten relate to the tour of 1828–9.[3] The dimensions of these objects vary from small notebooks for brief memoranda, to larger albums suitable for more elaborate compositions, but the majority are of a size convenient enough to fit in a pocket but with pages large enough to hold an identifiable landscape scene.[4]

Turner made notes prior to departing from England in 1819 from a popular travel guide, *A Classical Tour through Italy* by Revd John Chetwode Eustace.[5] Whilst he ultimately rejected the author's suggested itinerary, other aspects of the text may have struck a chord during his mental preparation for the forthcoming tour. In the 'Preliminary Discourse' of the book Eustace discusses the essential 'Objects of Attention' which should occupy the intellectual traveller of 'unprejudiced mind' during a tour of the country. Most pertinently for Turner, he championed the scenery of the landscape, since, as Eustace explains, 'the face of nature in Italy … seldom or never disappoints the traveller, or falls short of his expectations, however high they may have been previously raised'.[6] In addition, he advocates focusing attention on the ruins of classical antiquity, examples of modern architecture such as churches, palaces and museums, and most importantly of all, observation of everyday life, those 'manners, customs and opinions, together with the different lights which religion, government, and climate throw upon the characters of nations and individuals'.[7] Together with occasional commentary on artistic treasures, these four categories of study encompass the breadth of Turner's interests as evidenced by the Italian sketchbooks, jostling for his attention and alternating with recurring frequency between the pages.

Despite having a horror of being what the eighteenth-century Welsh landscape artist, Richard Wilson, described as too 'mappy' in his paintings, many of Turner's sketchbook drawings are exactly that, accurate 'mappy' outlines which fix spatial relationships and the essential contours of place but which lack descriptive depth[8] [124]. Atmospheric and incidental detail is either absent, or is suggested through the use of economic devices such as cross-hatching for areas of deep shadow or looping lines to indicate trees and foliage. A simple circle above the horizon is the shorthand for the setting sun or for particularly bright daylight. Where recurring

architectural details such as columns, arches or windows appear within a building Turner records one example only and indicates the number of times the individual element is repeated. Occasionally, topographical sketches are endorsed with written place names. Turner's idiosyncratic, phonetic spelling of unfamiliar Italian words such as 'Pissegnio' (Pissignano) and 'S Jacomo' (San Giacomo) suggests that smaller towns and villages were probably pointed out to him by native guides and locals.[9] Other annotations summarise atmospheric effects or attribute layers of meaning to sparingly drawn lines using a limited selection of terms such as 'water', 'vapour', 'sea', 'sky', 'olives', 'road', 'ruins' and 'snow'. Descriptive colour notes hint at his innate sensitivity to chromatic and tonal balance. One sketch in the Santa Lucia district of Naples depicts a funeral procession [126] and with a dispassionate artist's eye Turner notes the vibrant colours of Italian 'morte', the ornate red and gold of the pall, the long, blue cloaks of the mourners and the white figures bearing tapers, so unlike the sombre black of English mourning. Within landscape sketches meanwhile, the hue he indicates most often is red, usually present in small details such as the skirt or scarf of a peasant's costume. Amidst the overwhelming expanses of blue sky, sea and lakes and the verdant greenery of hills and plains, such tiny bright splashes would have stood out in pleasing complementary contrast. When revisiting the sketches in the future, the single written word 'red' would have been sufficient to trigger the memory of the entire scene, causing all of the colours to sing out and flood the penciled outlines in his mind.

Along with itinerary notes, financial calculations and other biographical interjections, Turner's written inscriptions and his locational mapping of the landscape have proved to be the best source of documentary information about his movements in Italy.[10] Although he labelled and imposed a numbering system on his sketchbooks after his return, he was by no means regimented in his use of the books during his tour, and to the modern eye the content of the pages can sometimes seem confusing and undisciplined. Drawings of a certain location might appear consecutively, or might be scattered throughout a sketchbook, squeezed into a corner of another page or inserted upside down on the back of a convenient blank. Some of the sketches, particularly those identifiable as executed from a moving carriage, or those from the 1828 sketchbooks, where Turner was less thorough in his approach, are so rough

and schematic as to resist interpretation at all. In order to make sense of these jottings the artist himself relied on two vital components: his memory and his imagination. Unlabelled drawings required his personal recall to make sense of which sketch relates to which place, especially when multiple details appear on the same page, or where they are arranged in a confusing order across more than one sheet. It is also easy to fall into the trap of thinking that if no pictorial evidence is apparent, it therefore did not happen. Turner used the books purely for his own purposes and if it was of no use to him to make sketches, he wasted no time in doing so. It must be assumed therefore that there were some experiences and sights that contributed to his understanding of Italy that are not represented within the sketchbooks. In 1828, for example, Turner reported to his friend Sir Thomas Lawrence that the ceiling of the Sistine Chapel was 'as grand magnificent and overwhelming to contemplating [sic] as ever', indicating that he must have visited it on his previous trip in 1819.[11] Yet there are no drawings evident within the sketchbooks to corroborate this.[12] He did, however, take the opportunity to record the less well-known exterior façade of the Sistine Chapel, an unusual

[124] *Five Sketches of Lake Albano, including the Monastery and Tomb at Palazzola* from the 'Albano, Nemi, Rome' sketchbook [Finberg CLXXXII], 1819 Tate, London

[125] *The Exterior Façade of the Sistine Chapel, Rome* from the 'Albano, Nemi, Rome' sketchbook [Finberg CLXXXII], 1819
Tate, London

[126] *A Funeral Procession and a View of the Quay at Santa Lucia, Naples* from the 'Gandolfo to Naples' sketchbook [Finberg CLXXXIV], 1819
Tate, London

view from the north-west corner of the Vatican, which he would have been unlikely to have seen depicted before [125].

Another way in which Turner relied on memory during his travels was in his adoption of viewpoints and themes made famous by other artists. Turner brought certain aesthetic expectations to his first experience of Italy and many of the sketches he made there resonate with his memories of other people's works. The eighteenth-century English man of letters Joseph Addison wrote that 'a Man who is in Rome can scarce see an object that does not call to Mind a Piece of a Latin Poet or Historian.'[13] A similar associative sense pervades Turner's sketchbooks, although the cultural names peppering his Italian landscapes are not those of

classical authors, but painters whose work had forged his preconceived notions prior to him ever setting foot in the country. He looked for the spirit of this imagined Italy at every mile of his journey and a page in the 'Ancona to Rome' sketchbook reveals his relief and jubilation at finally finding 'the first bit of Claude' near Osimo in the Marche.[14] He continued to see traces of Claude in Umbria, the Alban Hills and the Roman Campagna, where he was also reminded of Richard Wilson.[15] Uppermost in his mind at Tivoli was the work of Gaspard Dughet, also known as Gaspard Poussin due to the similarity of his style with his brother-in-law Nicolas.[16] [127].

When deciding where to pull out his sketchbook and start drawing, Turner also relied on his knowledge of

[127] *View of Tivoli from the North-East, with the Temple of Vesta at Sunset* from the 'Tivoli and Rome' sketchbook [Finberg CLXXIX], 1819
Tate, London

earlier artists, who had already honed the selection of the most picturesque spots and subjects. The definition of a successful view was one which contained maximum visual interest for the viewer whilst displaying a location to good advantage; the best prospects represented a valuable currency for the landscape artist. Although Turner was perfectly capable of seeking out vistas for himself, he was also keen to tick off the great and celebrated sights of Italy, and in this he was following in the footsteps of a long artistic tradition. Familiarity with the work of Piranesi, John 'Warwick' Smith and John Robert Cozens proved advantageous when locating the key pictorial highlights of the Italian experience such as the view of the Bay of Baiae from Posillipo, or Florence as seen from Fiesole. Similarly, a significantly large number of sketches repeat vantage points that Turner would have known from the work of James Hakewill, the artist whose drawings formed the basis of the watercolour illustrations Turner prepared for *A Picturesque Tour of Italy* (published 1820). Comparison of a number of Turner's 1819 sketches with those by Hakewill show that on arrival at many locations Turner frequently adopted the same viewpoint as that chosen by his colleague; and, more strikingly, this is also the case for the views he had not illustrated for the *Picturesque Tour of Italy*. When visiting the tomb of Cecilia Metella, on the Via Appia Antica near Rome, for example, Turner had already painted it in a watercolour based on a drawing by Hakewill,[17] and he continued to choose viewpoints and framing devices identical to those in other sketches by him [128, 129].[18]

Turner later recycled this same view of the dramatically receding road and the buildings flanking the approach to the mausoleum in another watercolour, *Tomb of Cecilia Metella, Rome*, 1830, an illustration for Canto IV of Byron's *Childe Harold's Pilgrimage*.[19]

It may also have been Hakewill's drawings of the vale of Domodossola and the Simplon Pass which persuaded Turner to take his unusual route from Turin. Instead of heading directly for Venice via Milan, the 'Turin, Como, Lugarno, Maggiore' and the 'Passage of the Simplon' his sketchbooks show that he took an extended detour around the lakes and back into the Alps via Vogogna, Domodossola and Gondo, before backtracking south again to Milan.[20] This unorthodox circuit is hard to explain unless Turner had a personal incentive for wishing to see the Simplon Pass and it may have been Hakewill's depictions of the mountains recently opened up by Napoleon's tunnels which fired him to include it on his itinerary.[21] In the 'Route to Rome' sketchbook, Hakewill had advised Turner to 'Go leisurely over the Mountains. The descent on the Italian Side the finest. Good Inn at Domodossola.'[22] Material from this part of the journey later informed a vignette illustration for *Scott's Prose Works*, published in 1836.[23]

The more interesting or challenging Turner found an individual location, the more sketches he devoted to exploring and recording it. Conversely, places where the visual dividends were few, such as the unrelenting stretch of road between Nepi and Rome, merited little or no attention.[24] Particularly stimulating locales, meanwhile,

[128] *The Via Appia Antica: the Circus of Maxentius: and Two Views Approaching the Tomb of Cecilia Metella* from the 'Albano, Nemi, Rome' sketchbook [Finberg CLXXXII], 1819 Tate, London

[129] James Hakewill, *Tomb of Cecilia Metella from the Church of St Sebastian*, 1817 The British School at Rome Library

[130] *Rome, Looking North from the Janiculum, with St Peter's and the Castel Sant'Angelo* from the 'Albano, Nemi, Rome' sketchbook [Finberg CLXXXII], 1819
Tate, London

inspired him to supplement the swift practicality of pencil with more detailed studies employing tonal and colour effects. A general survey of the sketchbooks therefore provides an indication of the hierarchy of places which Turner found most aesthetically rewarding. This list broadly corresponds with the inherited structure of the traditional Grand Tour, a sightseeing framework which prioritised Rome above all places, followed by the other principal Italian cities, Venice, Florence and Naples, and encompassed additional highlights such as Tivoli, Pompeii and the Falls of Terni.[25]

Most of the sketches from the 1819–20 tour are devoted to views of Rome, its monuments and streets, its hills and river, and panoramas of the city from elevated

[131] *Rome, Looking North from the Janiculum, with the Castel Sant'Angelo and the Church of San Giovanni dei Fiorentini* detail from the 'Rome: Colour Studies' sketchbook [Finberg CLXXXIX], 1819
Tate, London

and distant perspectives. Turner used a range of sketchbooks here, dictated by the desire to experiment with various types of drawing. On the long journey to the Eternal City he had used similar sized books sequentially, filling up one before reaching for another. When ranging across the capital, however, he seems to have employed several books simultaneously, interchanging different formats and types of papers so that his interpretation of place exists within a matrix. Whilst sketching the view from the Janiculum hill looking north towards the castle of St Angelo and the church of San Giovanni dei Fiorentini, for example, Turner first outlined the basic topography in pencil across a double page spread in the 'Albano, Nemi, Rome' sketchbook [130]. He then switched to the larger 'Rome: Colour Studies' sketchbook to create a more elaborate, detailed and tonal composition employing white highlights on the grey washed ground [131]. Views incorporating that most quintessential of Roman sites, the Colosseum, appear throughout five different sketchbooks in both watercolour and pencil. Cross-referencing of these drawings reveals that Turner covers the famous amphitheatre from a multitude of angles both close up and from a distance, including from the north,[26] the south-east,[27] the south,[28] the south-west,[29] the west,[30] and the north-west.[31] He also depicted the interior,[32] and the view from within looking out,[33] and was absorbed by the way that the arches were transformed by daylight and moonlight [132]. In fact, his visual exploration in 1819 was so thorough that further study was rendered unnecessary and consequently the Colosseum barely features in the 1828 sketchbooks.

To a lesser extent, Turner also varied his sketchbook

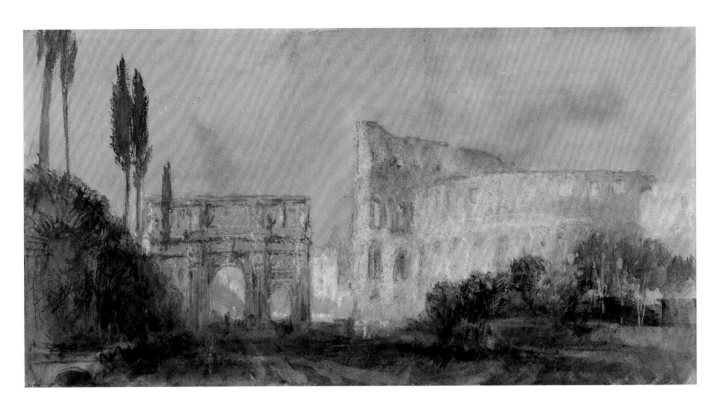

left:

[132] *The Colosseum and the Arch of Constantine* from the 'Small Roman Colour Studies' sketchbook [Finberg cxc], 1819
Tate, London

[133] *Tivoli* from the 'Naples: Rome. Colour Studies' sketchbook [Finberg clxxxvii], 1819
Tate, London

approach in Venice and Naples, deploying colour as well as pencil work in response to the unique combination of architecture, water and sky offered by each place. Florence, however, yielded far fewer sketches, all of which were of a purely topographical nature and were executed in pencil.[34] In 1819 these were contained within a single book, the 'Rome and Florence' sketchbook,[35] whilst in 1828 they were spread sparingly across two, the 'Genoa and Florence' sketchbook and the 'Florence to Orvieto' sketchbook.[36] Mostly, Turner seems to have preferred to depict the city from a distance. Within Florence he restricted himself largely to the Piazza Signoria, the river Arno from the Lugarno and the Boboli Gardens, ignoring the exterior of the famous churches such as the Duomo and Santa Croce.

The only other location where use of sketchbooks and media was varied to any great extent was at Tivoli, a town twenty miles east of Rome whose natural and man-made wonders were well worth the four hour drive for an artist such as Turner.[37] Combining all four of Eustace's 'Objects of Attention', Tivoli represented an alluring combination of breathtaking scenery, Renaissance architecture and classical remains. 'It seemed almost as though Nature had herself turned painter, when she viewed this beautiful and perfect composition,' wrote Charlotte Eaton in her account published in 1820.[38] Turner sketched the decaying glories of Hadrian's Villa and the Villa d'Este but the tamed and structured gardens did not engage him as much as the classical ruins of the Temples of Vesta and the Sibyl, and the so-called Temple of Maecenas (now known as the Sanctuary of Hercules the Victor), perched above the precipitous gorge with the waters of the Aniene river plunging in dramatic cascades over the side. As in Rome, he worked up a number of studies on washed grey paper using soft dark pencil work and lifted white highlights to depict Tivoli's streaming cascatelli, shadowy groves and grottoes, and ghostly antique ruins. He also turned to watercolour, adapting his technique to suit the nature of the subject [133]. Unlike his smoother, more tonal studies of Rome, at Tivoli he exploited the textural qualities of the paint, using a mixture of wet washes and tacky paint applied with a drier brush, or even at times his fingers, to render the verdant slopes and lush waterfalls. Interestingly, no immediate finished compositions in oil or watercolour resulted from this large body of material and it was not until the late 1820s that Turner began to reference Tivoli within his paintings.

Access to Turner's sketchbook material today is a privilege not afforded to people during his own lifetime. Although it was customary for artists, both professional and amateur, to make portable visual records of their travels at the time, the pictorial archive formed by the sketchbooks was not intended for general consumption, or to be circulated amongst friends like postcards or holiday snapshots. In fact, Turner discouraged viewers because he found no-one was able to appreciate his 'rough draughts [drafts]' but himself.[39] Many early commentators also found the cursory, inexpressive contents of the Italian sketchbooks disappointingly at odds with Turner's glorious, emotive interpretations in oil and watercolour.[40] 'Valueless', 'inferior' and 'careless' is how John Ruskin described some of them on the wrappers in which they were stored during the late nineteenth century.[41] The intrinsic value of the Italian sketches, however, lies not with how they are seen by other people, but how the artist himself employed and interpreted them. Turner's first biographer, Walter Thornbury, used an unusual analogy to describe the sketchbooks, calling them Turner's 'cheque-books'.[42] Whilst on its own a cheque is a symbolic representation for a stated sum of money, it is ultimately worthless unless the riches it denotes are actually present in the bank. Turner's sketchbooks embody a similar principle. The private tools of a professional at work, they constitute hundreds of dashed-off visual 'cheques', the beginnings of ideas which Turner could later choose to cash. They function in an emblematic way, designed to trigger a private treasury of information stored within the artist's imagination and memory. It was the act and the habit of sketching as much as the end result which defined and assimilated Turner's Italian experiences, and the sketchbooks are a visual hoard of facts and processes without which he would have been lost. Vacillating between received knowledge and new discovery, the trajectories traceable within them are as much artistic as geographical.

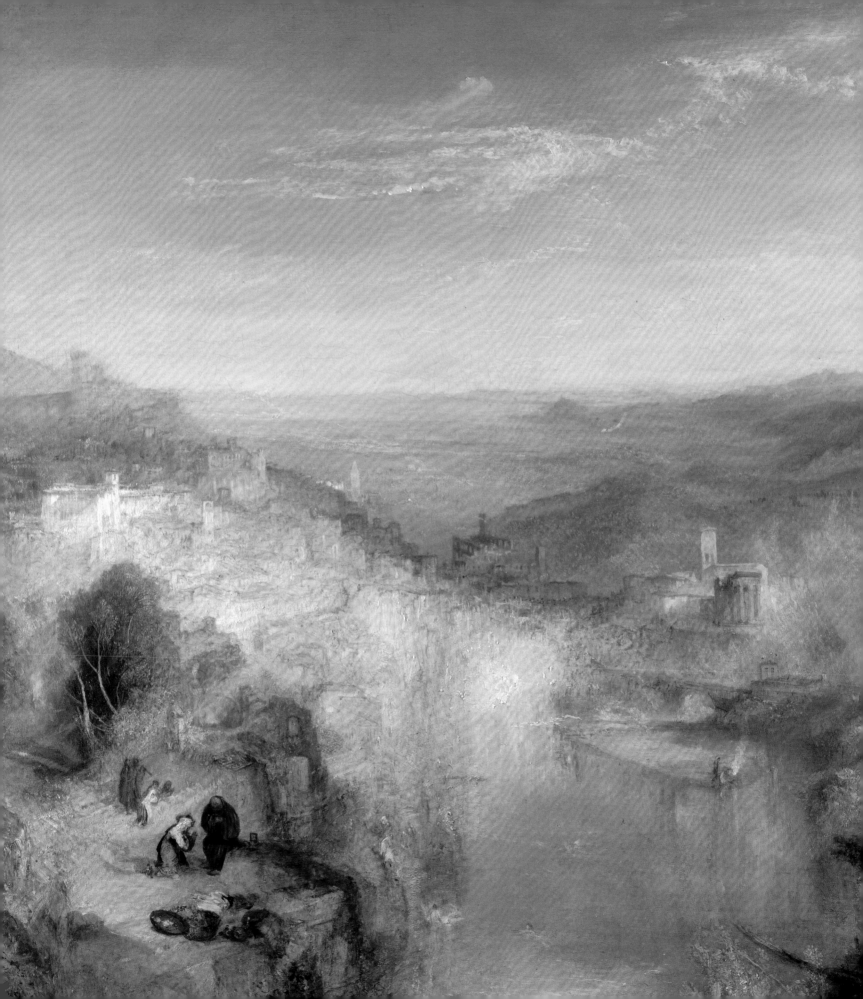

Turner and Munro of Novar: Friendship, Collecting and Italy

CHRISTOPHER BAKER

A critic writing in the *Morning Post* newspaper on 3 May 1836, described Turner's *Rome from Mount Aventine* [94] as 'one of those amazing pictures by which Mr. Turner dazzles the imagination and confounds all criticism ...'[1] Such a judgement would certainly have pleased the man who was to buy the painting from the Royal Academy's exhibition that year – the Scottish landowner and collector Hugh Andrew Johnstone Munro of Novar (1797–1864) [134].[2] Novar had, however, long been convinced of the merits of Turner's work. In 1833 he had financed Turner's trip to Venice, and he has the unique status of being the only one of Turner's patrons to travel with him to Italy; in the summer of 1836 they journeyed together to Turin.

Novar's association with the artist had first developed in the mid-1820s, and Turner visited Novar's home in the Highlands of Scotland in 1831. Over the following decades Novar was to build one of the greatest collections of Turner's oil paintings and watercolours ever assembled, many of which were works exploring Italian themes. However, the warm friendship they enjoyed went far beyond the business of selling and buying pictures, and was sustained until the end of Turner's life. So who was this man who had an important role in furthering Turner's career, shared his enthusiasm for Italy and its art, and offered him congenial company, but has been described as an insubstantial, 'shadowy' and 'elusive' figure?[3]

Novar was one of the most energetic, although perhaps least fully appreciated, collectors of the nineteenth century. He enjoyed considerable wealth and used it to fill his townhouses in London and his home in Scotland with an extraordinary collection of old master and contemporary British paintings.[4] Gustav Waagen, the renowned German scholar who surveyed British collections in the mid-nineteenth century, considered that he was not motivated by vanity or ostentation, but that for him 'the love of art alone [was] the inducement'.[5] By 1853 Novar was sufficiently respected as a collector and man of taste to be called as a witness by the Parliamentary Select Committee held in that year to consider the future of London's National Gallery.[6]

Novar's family has a distinguished history; the Clan Novar can trace its origins back to the eleventh century, although the lands of the Novar estate were not acquired until the late sixteenth century. Novar House at Evanton, north of Inverness, overlooking the Cromarty Firth [135] was chiefly the creation of General Sir Hector Munro of Novar (1726–1805), who had made his fortune as an officer in the British army in India. The circumstances which led to Novar inheriting it could have featured in the pages of the most melodramatic of Victorian novels: Sir Hector's two sons were killed, one by a tiger and the other by a shark, and so the estate transferred to his brother, Sir Alexander Munro of Novar (died 1809), a diplomat and Commissioner of Excise, who was Novar's father.

Born in London in 1797, Novar at first set out on a conventional academic and legal career, but this does not appear to have suited his temperament. From 1814 to 1817 he was a gentleman commoner (or undergraduate) at Christ Church, Oxford, but left without taking his degree. He was then admitted to Lincoln's Inn, although he was never called to the Bar. His enthusiasm for art is reputed to have been inspired by a curious inheritance from his father – a painting by Murillo, *Spanish Girl and Duenna Looking out of a Window*, which had been presented to Sir Alexander when he was Consul General in Spain 'by a noble Spanish family, to whom he had rendered services, as a mark of their gratitude'.[7] It was a version of a composition, chiefly known through the artist's *Two Women at a Window* (National Gallery of Art in Washington).[8] This work apparently prompted the collecting which became the chief pre-occupation of his life.

Novar primarily bought paintings through London auctions,[9] although he probably made some acquisitions during his European tours. He also appears to have acquired works directly from artists. The connection with Turner was undoubtedly his most important contact of this kind, but by no means the only one, as there is evidence to suggest he knew the English painters John Constable and Sir Edwin Landseer, as well as the Scottish artists, David Roberts, Sir Francis Grant and William Simpson.[10] Novar also had international connections; in Paris in 1837 he met the Hungarian artist Károly Brocky and, in the following year, invited him to visit London; he subsequently bought a large number of his works.[11] He knew the French painter Théodore Gudin, who is chiefly renowned for depicting naval battles; Gudin was in turn a friend of Sir David Wilkie, and spent the latter part of his life in Scotland.[12] This all suggests that Novar was a very sociable man, however, Turner implies that when he first met him, he was painfully shy. In a letter of 1826 to the watercolour painter and collector James Holworthy, who was a mutual friend, Turner describes Novar as a man who 'has lost a great deal of that hesitation in manner and speech, and has I think been spoken to not to blush as heretofore; so

French manners does some good with good subjects ...'[13] Later anecdotes confirm Turner's impression that Novar overcame his reticence: he was variously described as someone who 'lived a sensuous life' and became 'a vulgar good natured man'.[14]

In 1831, after staying with Sir Walter Scott at Abbotsford in the Scottish Borders, Turner undertook the long journey to the Novar estate in the Highlands, which was the most northerly point of all his tours. Novar later suggested that the artist used his studies of the Cromarty Firth for the background of the painting *Mercury and Argus* (National Gallery of Canada).[15] This was a fanciful notion perhaps, but, nonetheless, a pleasing attempt on the collector's part to link Turner's Scottish experiences with his Italianate paintings. From Turner's perspective, although he may not have been consciously aware of it, Novar conformed to a distinctive pattern of patronage Turner developed. Beyond London, his most loyal supporters were wealthy landowners who had travelled to Europe, developed a knowledge of old master paintings and become champions of British art, such as Lord Egremont, Walter Fawkes and Sir John Leicester. With Egremont, Fawkes, Leicester and Novar being based in Sussex, Yorkshire, Cheshire and Scotland

[134] John Raphael Smith, *Hugh Andrew Johnstone Munro of Novar* [detail], 1820s
Private Collection

[135] Novar House, Evanton

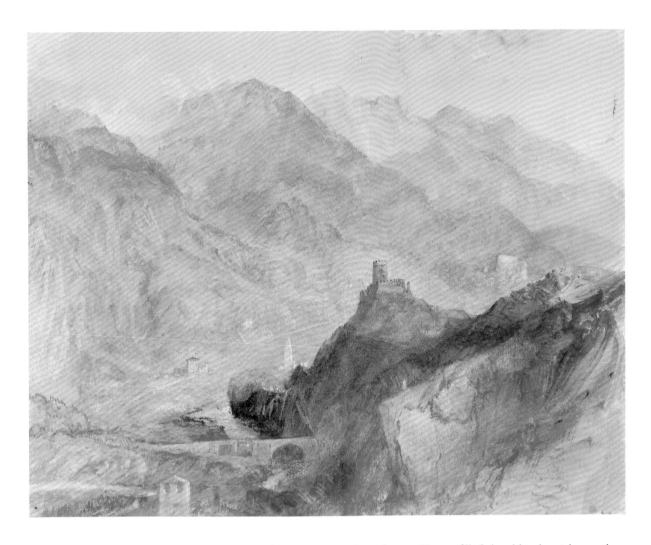

[136] *Chatel Argent, in the Val d'Aosta, near Villeneuve*, 1836
National Gallery of Scotland, Edinburgh

respectively, Turner astutely nurtured a series of patrons evenly spread across Britain in key areas of his activity as an artist.

TRAVELLING TO ITALY

By 1836 Turner and Novar were firm friends, in spite of the age difference between them: Turner was sixty-one and Novar was thirty-nine. They were unconventional (for example, both had fathered illegitimate children),[16] and they shared a passion for painting and travel. It was Turner who suggested to Novar that he might accompany him on a sketching tour in order to help Novar alleviate a bout of depression, apparently prompted by the prospect of pursuing a political career. During the late summer of 1836, they journeyed together through France and Italy to Turin. En route they stopped in Arras, Rheims, Chaumont, Dijon, Geneva, Bonneville and Chamonix, before travelling through the Val d'Aosta.[17]

Along the way Turner filled sketchbooks with pencil drawings and produced some exquisite watercolour studies [136].

Turner is said to have persuaded his travelling companion to devote himself to painting[18] and during their journey Novar adopted the role of a willing and informal apprentice, with Turner assisting him when he got into difficulties.[19] This episode is of great interest, because it reveals not only aspects of the friendship between the two men, but also provides an intimate insight into Turner's working methods. The fullest account of it is provided by Turner's first biographer, Walter Thornbury, who wrote:

Turner enjoyed himself in his way – which was a sort of honest Diogenese way – but he disliked teasing questions as to how he got this or that colour. On one occasion, in the Aosta Valley, he was dissatisfied with a sketch, which he altered and sponged till the drawing got a sort of white

greenness about it which was not pleasant. He became quite fretful thereat, and his abuse of colour-sketching wound up with the remark, 'I could have done twice as much with the pencil.' His first inquiry in the morning when they started to sketch was always, 'Have you got the sponge?' It was with a sponge that Turner obtained many of his misty and aerial effects.

Turner never rhapsodised about scenery, but at some distance from his companion – generally much higher – applied himself to work in a silent, concentrated frame of mind. The superior elevation he required for the purpose of obtaining greater distance and more of a bird's-eye view. The sketches were rapid, and with the aid of his tremendous memory were completed subsequently, at leisure, at the inn ... his touch was so sure and decisive, and his materials were of the rudest – brushes worn away to single hairs, and now thrice as valuable as they were when new.

If you bore with his way, Mr Munro said, it was easy to get on very pleasantly with him.[20]

The artist and critic John Ruskin further enriched the anecdotes:

[Novar] got into great difficulty over a coloured sketch. Turner looked over him a little while, then said, in a grumbling way – 'I haven't got any paper I like; let me try yours.' Receiving a block book, he disappeared for an hour and a half. Returning he threw the book down, with a growl saying – 'I can't make anything of your paper.' There were three sketches on it, in three distinct states of progress, showing the process of colouring from beginning to end, and clearing up every difficulty which his friend had got into. This was a cited as an instance of Turner's curious dislike 'to appear kind'.[21]

At the end of their trip Novar offered to buy the sketches Turner had made along the way – no doubt assuming that they would form a remarkable souvenir of his trip and complement the artist's oil paintings which he already owned. However, Turner refused, unwilling to give up a stock of images that might be used as the basis for later paintings. But, Novar 'found' in his luggage a sketchbook Turner had used in Britain, which the artist allowed him to keep: this was presumably another instance of him being generous by stealth. Novar could not have been too disappointed that this was his only memento, as he was soon to have the opportunity to make further major acquisitions of his friend's work.

NOVAR'S TURNERS

Novar eventually acquired a very important group

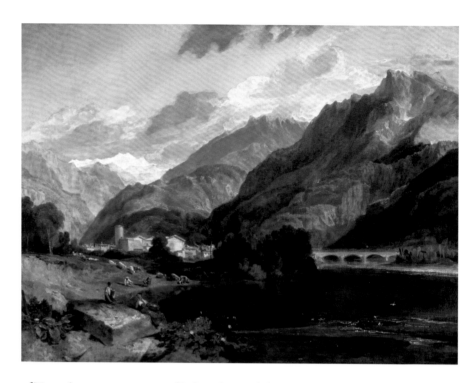

of Turner's mature paintings of Italian themes. They formed the centrepiece of his Turner collection, which consisted of eighteen outstanding oils and nearly 130 watercolours.[22] The oil paintings ranged in date from about 1800 to the mid-1840s and so conveyed a powerful sense of Turner's development as an artist. Eleven of them explored Italian or Italianate subjects, and most of these dated from the mid – to late 1830s, the period when there was the most sustained contact between the patron and artist in connection with their Italian trip.

The earliest works from this Italianate group, *Bonneville, Savoy with Mont Blanc* [137] and *Venus and Adonis* [12], date from around 1803 to 1805, and were bought by Novar in 1830, when he was starting to build his collection in earnest, and his friendship with Turner was developing. Bonneville was one of the sites they were to visit together six years later, and *Venus and Adonis*, which is one of Turner's clearest homages to the old master tradition, being dependent on the work of Titian and Veronese, would have appealed to a man like Novar who was also collecting work by these artists. He was clearly very keen to acquire these two rather different pictures, being willing to pay as much as £200 for each of them, although in the event he secured them for 83 guineas each.[23]

The second group of Italian oils to enter Novar's collection date from the period 1835 to 1836 and are

[137] *Bonneville, Savoy with Mont Blanc*, 1803 Dallas Museum of Art, Foundation for the Arts Collection, gift of Nancy Hamon in memory of Jake L. Hamon with additional donations from Mrs Eugene D. McDermott, Mrs James H. Clark, Mrs Edward Marcus and the Leland Fikes Foundation, Inc.

connected with Turner's journey to Venice in 1833, which Novar had paid for. The earlier of the two, *Venice from the Porch of the Madonna della Salute*, represents a curious hiccup in the otherwise good relationship between the two men. It appears that Novar had commissioned a watercolour, but was presented instead with this oil, which according to Thornbury he 'never much took to'. Turner was said to be 'mortified at seeing his patron's disappointment [and] at first declined to sell him the picture; but finally consented'.[24] By contrast *Juliet and her Nurse*, a spectacular nocturnal Venetian scene bought by Novar from Turner in the following year is not known to have prompted any negative judgement on his part. It was though famously, and viciously, criticised in the press, so prompting John Ruskin's life-long defence of Turner's achievements.

The third group of Turner's Italian paintings Novar acquired are major pictures from the mid- to late-1830s: *Rome from Mount Aventine* [93], *Modern Italy – The Pifferari* [98], *Ancient Italy – Ovid Banished from Rome* and *Modern Rome – Campo Vaccino* [94]. These were all bought either directly from the artist in the year of their creation or from the Royal Academy when first exhibited. They were supplemented later by two other purchases of works from the 1830s, which Novar had to wait a decade to acquire, *Snowstorm, Avalanche and Inundation – a Scene in the Upper Part of the Val d'Aosta, Piedmont* and *Cicero at his Villa . Snowstorm, Avalanche*

[138] *Cicero at his Villa*, 1839
Private Collection

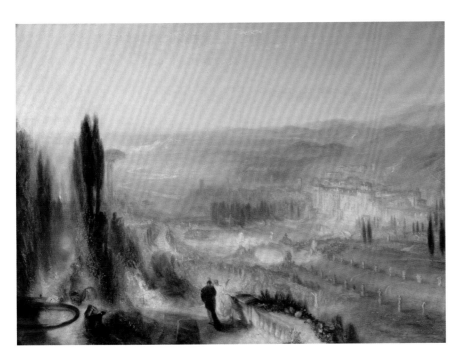

and Inundation ... was a natural addition to his collection as it was directly connected with his trip to Italy with Turner, while *Cicero at his Villa* [138], in terms of classical theme and palette, complemented very effectively the other works from the 1830s in his collection. Of Turner's late Italian paintings, Novar bought only one; in 1860, he acquired the dream-like *Neapolitan Fisher-girls Surprised Bathing by Moonlight* [117], and lived with it for the last five years of his life.

The watercolours by Turner in Novar's collection covered a broad range of subjects, and perhaps predictably included works related to Novar's own enthusiasms and experience. They featured, for example, an important group of illustrations made for Sir Walter Scott, a splendid depiction of Christ Church,[25] where Novar had been a student, and dramatic Alpine studies, which must have acted as a reminder of his own sketching trip with the artist. The Italian watercolours included Venetian scenes, and an especially charming view of Florence from San Miniato [62]. Novar kept them all 'in portfolios under the ottomans in the drawing room'[26] of his London house, and integrated Turner's oil paintings with his vast collection of old master and British painting.

NOVAR'S OLD MASTER AND BRITISH COLLECTION

Novar's collection was one of the most distinguished built up by any Victorian connoisseur. It encompassed an extraordinary variety of acquisitions, and was described as being housed in 'apartments literally crammed with choice treasures of ancient Art, and a goodly gathering of the gems of the British school'.[27] An overview is provided in accounts which were published in 1847 and 1857 of visits to Novar's London homes, and by a catalogue of the collection compiled just after his death in 1865 by the painters William Frost and Henry Reeve.[28] A review of the catalogue reveals impressive statistics. The collection boasted 178 Italian and Spanish paintings; the Italian works included canvases said to be by Albano, Giovanni Bellini, Canaletto, Annibale Carracci, Correggio, Domenichino, Guardi, Reni, Raphael, Rosa, Tiepolo, Titian and Veronese. The fate of two of the 'Raphaels' illustrate the unreliability of some of these attributions; the *Madonna dei Candelabri*, now in the Walters Art Gallery, Baltimore, which in Novar's day was considered to be the most prized work in his collection, is no longer thought to be by Raphael, but *The Holy Family with the Infant St John the Baptist 'The Novar Madonna'* in Edinburgh [141], is appreciated as an important

work by Giulio Romano.[29] The attributions of some of his outstanding Venetian paintings have proved more durable; Novar purchased Titian's *Rest on the Flight into Egypt* (Marquess of Bath), Veronese's *The Vision of St Helena* (National Gallery, London)[30] and Tiepolo's *The Martyrdom of St Agatha* (Gemäldegalerie, Berlin).

He also owned 219 Dutch and Flemish pictures, such as Rembrandt's *Lucretia*, (National Gallery of Art, Washington), Jan Steen's *The Effects of Intemperance* (National Gallery, London) and Sir Peter Paul Rubens's *The Reconciliation of Jacob and Esau* [139]. The 129 German and French paintings in the collection included Poussin's *Virgin and Child* (Museum and Art Gallery, Brighton) and *Venus and Adonis* (Kimbell Art Museum, Fort Worth), and Claude's *Landscape with St Philip Baptising the Eunuch* (National Museum of Wales, Cardiff). They also featured twelve pictures attributed to Watteau.[31] The 349 British paintings Novar acquired included works by Bonington [140], Constable, Etty, Gainsborough, Landseer, Lawrence, Reynolds, Stothard, Ward, Wilkie and Wilson. There were also a substantial number of watercolours, drawings and engravings, bronzes and antique marbles among his possessions.

The interest of this formidable collection, which in its entirety contained about 2,500 objects, lies not only in its role as a reflection of Novar's taste, but also in the fact that Turner must have known, and very probably studied and discussed much of it. From his youth, Turner had learnt a great deal from old master and British paintings which he had seen in the houses of his patrons. By the time he became friends with Novar he had the additional satisfaction of knowing his own landscapes were closely integrated with the work of artists such as Titian and Poussin, and the paintings of his particular heroes, Claude and Wilson.

TURNER AND NOVAR IN LONDON

The journey that Turner and Novar undertook to Turin in 1836 appears to have prompted the plotting of more exotic travels: the two men had apparently 'a sort of half-resolution ... that they should visit the East in company'.[32] Sadly, this adventure was never realised. Turner was only ever to make such a journey in his imagination, by creating watercolours of scenes in the Holy Land and India that were based on the work of other artists. They did, however, continue to meet intermittently in London. On these occasions it was Turner's habit to ask his friend each time he travelled down from Scotland

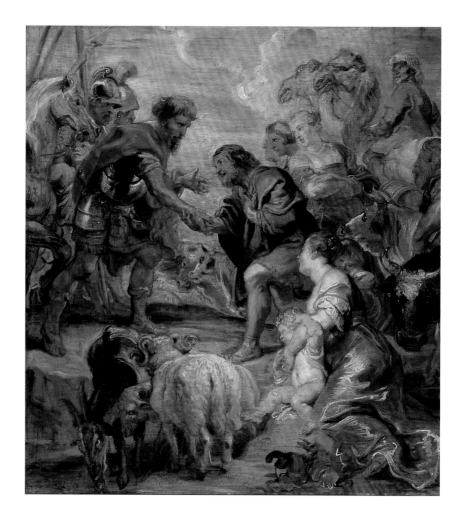

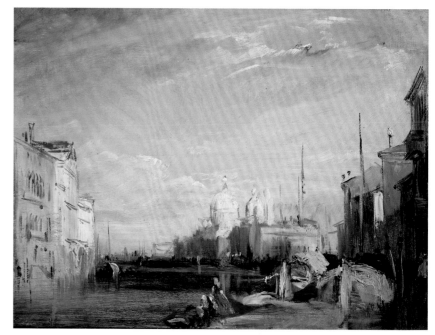

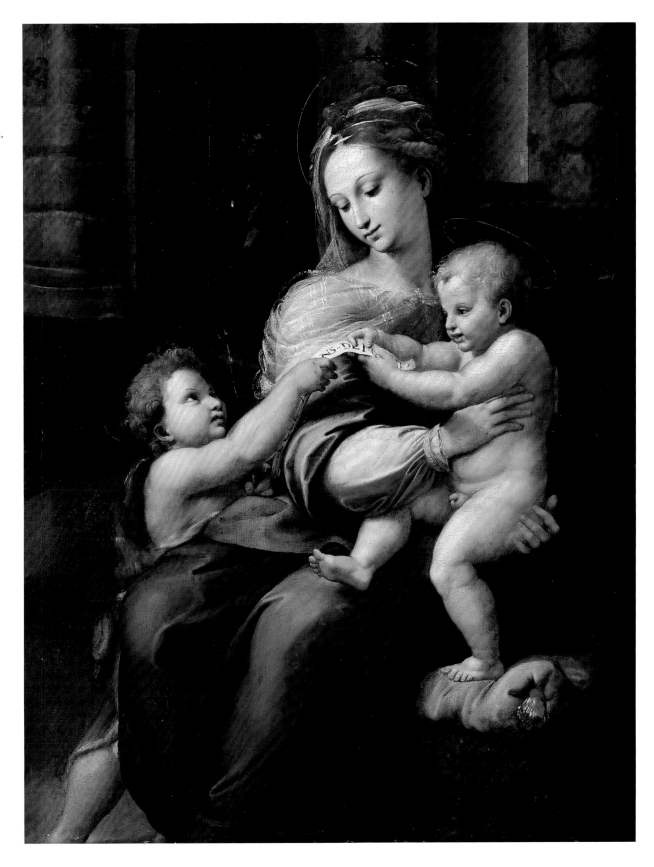

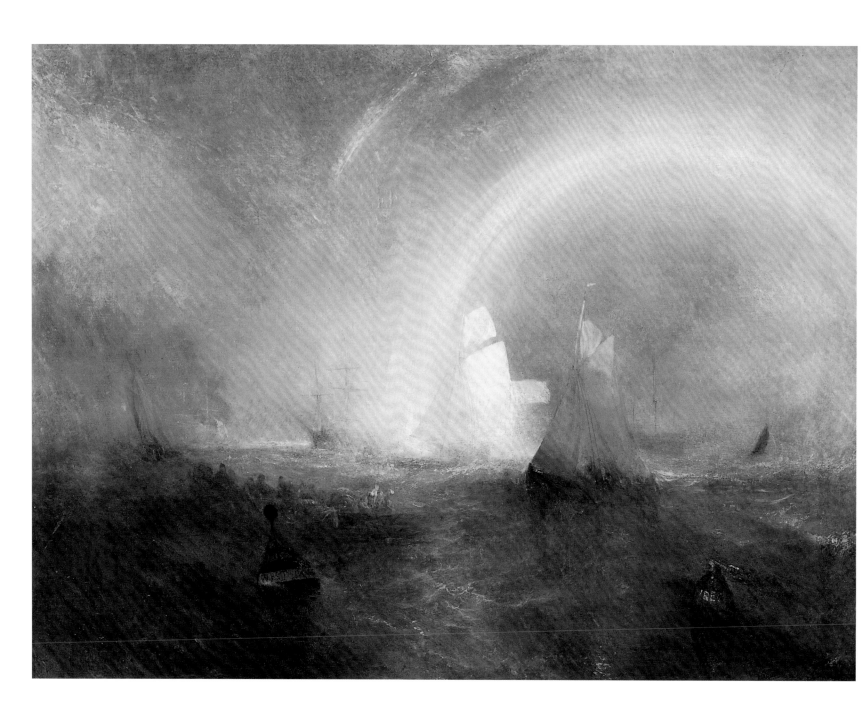

[142] *The Wreck Buoy, c.*1807, reworked 1849
Sudley House, National Museums Liverpool

'how they got on at 'Modern Aythens [sic]' and whether 'Thomson and that set had discovered Titian's secret yet.'[33] This mischievous question, which refers to the painter the Revd John Thomson (1778–1840), presumably highlighted what Turner perceived as the limited skills of contemporary Scottish artists.

Most of the surviving anecdotes which record the relationship between Turner and Novar in London involve eating and looking at pictures. The painter David Roberts recalled enjoying the company of both men over dinner at Novar's house.[34] Turner also provided hospitality, and one evening invited Novar to dine with him at Greenwich; after supper they went to look at the artist's monumental painting of *The Battle of Trafalgar* (National Maritime Museum, Greenwich). While viewing it they were approached by a man who clearly having: no idea who Turner was, dismissed the picture as being 'like a carpet', and urged them to study its companion instead, a canvas by De Loutherbourg.[35] Much later in Turner's career, Novar was given a rather different insight into the sort of problems with which his friend had to cope. On 20 May 1846 he visited Turner's studio to admire the painting *The Opening of the Wallhalla* (Tate Britain). The writer Elizabeth Rigby (who was later to become Lady Eastlake) was also present. The picture had been lent to an exhibition in Munich and returned to Turner disfigured with 'sundry spots on it'. Novar suggested that they could be rubbed out and Miss Rigby offered her handkerchief, but 'the old man edged us away and stood before his picture like a hen in a fury'.[36]

The final recorded encounter between the two men provides a perfect coda to their relationship. Three years after the problem of the 'sundry spots', Novar agreed to send *The Wreck Buoy*, an early painting by Turner, which he owned, from Scotland to London for an exhibition. Turner, seeing it for the first time in many years was deeply dissatisfied, and embarked on a campaign of radical re-painting. Novar sat by his side, watching with horror as the artist spent 'six laborious days transforming it'. His fear was misplaced, however, as the picture 'came out gloriously' [142].[37]

It was a measure of Turner's esteem for Novar that in 1844 he was made one of the four trustees of Turner's charity for the 'relief of decayed and indigent artists'. He was also appointed one of the executors of his estate. On 30 December 1851, Novar attended the artist's house in Queen Anne Street in London to hear the reading of Turner's will. It had been a long and emotional day;

Turner's funeral in St Paul's Cathedral had been preceded by a procession consisting of nineteen carriages which had taken three hours to weave its way through London. The will stated that the artist's wish was that the contents of his studio be kept together and presented to the nation, which ultimately it was. Novar's own collection, by contrast, did not remain intact; it was consigned to auction by his nephew H. Munro Butler Johnson, and sales were held at Christie's between 1867 and 1880.[38] They created a sensation because of the high quality of the works on offer, and there was fierce competition between dealers and collectors.[39] The auction of 'modern' paintings on 6 April 1878 was, according to *The Times*, viewed by as many as 15,000 visitors.[40] While *The Observer* reported that the sale of old masters on 1 June attracted:

Cabinet Ministers with aesthetic tastes ... Ex-Cabinet Ministers ... large contingents of clubmen ... the lady critics ... [as well as] country cousins and loungers ... On entering the apartment they were confronted by a fierce blast of hot air, a buzzing of tongues, then a solemn moment of silence, then the final thump of the fateful hammer.[41]

The old master and British paintings were very widely dispersed, and this has made it difficult to establish a sense of Novar's considerable achievement as a collector. It does, however, seem entirely appropriate that three of the greatest pictures he owned of Italian subjects by his friend Turner (*Modern Italy – The Pifferari, Modern Rome – Campo Vaccino* and *Rome, from Mount Aventine*) have returned to Scottish collections.

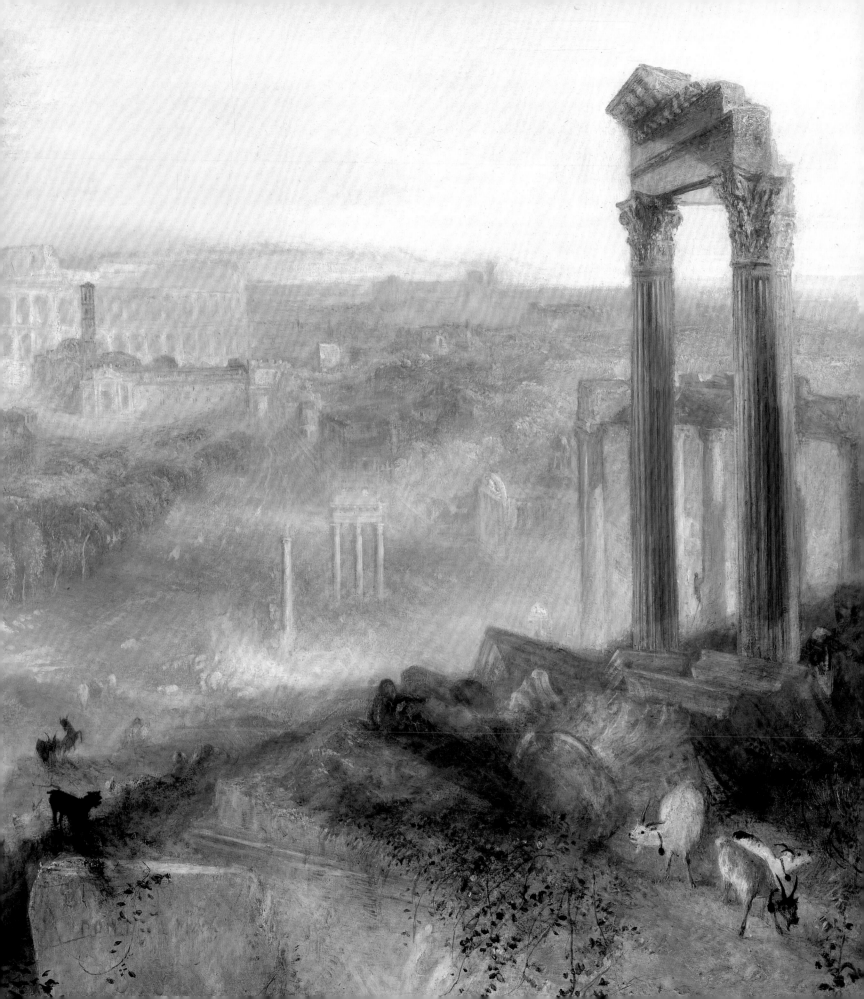

The Rosebery Turners

JACQUELINE RIDGE

The extraordinary skill and mastery of Turner is often diminished by the condition of his paintings, whose surfaces become altered through his choice of painting materials and their particular sensitivity to conservation treatments. In the past, cleaning and/or lining[1] of a painting on canvas might have occurred every fifty years or so, and it is unusual to find nineteenth-century works that have not been subjected to either treatment. Turner's neglect of the paintings that languished unsold in his studio, together with a flood in 1928 of the stores, which housed a proportion of the Turner Bequest to the nation, has had the effect of accelerating the restoration cycle yet further. It is a rare joy therefore to find works over 180 years old by this artist, which remain in an 'authentic' state, with their paint surfaces almost as they were at the time of their exhibition at the Royal Academy in London, relatively untouched by the ravages of time and completely unrestored.[2]

The two works by Turner, *Rome from Mount Aventine* [93] and *Modern Rome: Campo Vaccino* [94] from the Rosebery Collection, which are on loan to the National Galleries of Scotland, fall into this category.[3] Never varnished[4] and somewhat through chance left unlined, they provide an opportunity to luxuriate in the illusionistic effects created by Turner through his subtle nuances of colour and array of paint textures. Of the two works, the more frequently illustrated is *Modern Rome: Campo Vaccino*[5]. This painting was shown at the Royal Academy in 1839, and purchased by Munro of Novar directly from the exhibition.[6] At the Royal Academy, it was displayed alongside its pendant, *Ancient Rome: Agrippina Landing with the Ashes of Germanicus: the Triumphal Bridge and Palace of the Caesars Restored*[7] which was formally transferred to the Tate Gallery as part of the Turner Bequest in 1939. The other Rosebery work, which was possibly commissioned by Novar between 1828 and 1829, is *Rome from Mount Aventine*.[8] This was exhibited at the Royal

Academy in 1836 along with two other paintings, *Juliet and her Nurse*[9] which is considered in some respects to be a complementary work to *Rome from Mount Aventine*, and *Mercury and Argus*,[10] now in the National Gallery of Canada. *Modern Rome: Campo Vaccino* and *Rome from Mount Aventine* entered the collection of the Earl of Rosebery in 1878[11] and, aside from their occasional inclusion in exhibitions, they have remained with his descendants. The fact that they have only passed through two collections has been a significant factor in ensuring their 'authentic' condition.

MATERIALS AND METHOD

Turner's stretchers and canvases of this period were sometimes not of the best quality, with stretchers being cobbled together from salvaged timber.[12] Such a support was used for *Rome from Mount Aventine*. The work comprises a single canvas[13] that has been stretched and attached with sprigs (small metal pins) to a crude, knotted and dark, twisted-grain wood stretcher [143].[14] The source may be Italy as poorer quality wood, including lengths still retaining their bark,[15] was used for the stretcher of a work Turner is known to have painted and exhibited in Rome. The use of sprigs has also been identified as something that is specific to Turner's Roman works[16] and to canvases purchased by Turner in Italy,[17] although his Italian canvas is generally of a heavier weight and coarser weave than the type used in this painting. If *Rome from Mount Aventine* is on a canvas and stretcher purchased in Rome it is possible that the painting process was started during Turner's tour to Italy of 1828–9. Although not painted literally *en plein air*, a statement made in the 1865 catalogue of Novar's collection that this work was 'painted for Mr Munro on the spot' would indicate that its conception and part of its execution took place in Italy. A similar canvas and a stretcher of the same size have also been used for *Juliet and her Nurse*.[18]

In contrast, *Modern Rome* has been painted on a stretched canvas of much better quality, with a primed canvas attached by iron tacks, over an underlying plain, unprimed canvas – 'a loose lining', again attached with tacks to a stretcher. This stretcher is robust and made with good, straight-grained timber. Although there is neither a visible label nor a mark confirming who supplied it, it is typical of a quality product bought from a reputable artist's supplier or colourman. The pendant work *Ancient Rome*, which is exactly the same size, has a stretcher and canvas from the colourman Thomas Brown; this is indicated by an ink stamp visible on the reverse of the primed canvas.[19] Choosing two layers of canvas for *Modern Rome* would not only have given Turner a surface with far less spring against the brush, thereby allowing for more vigorous paint application but, in the longer term, it may also have slowed the development of brittle cracking in the paint. This type of cracking – often seen as a network of cracks over the entire surface of a painting – develops through a combination of movement in the canvas and an increasing brittleness in the paint layer as it ages. It draws the eye to an artificial surface or plane that is in direct conflict with the illusion proposed by the artist. In this work there is little evidence of such disfigurement, allowing the viewer to engage unimpeded with the artist's intention. In *Rome from Mount Aventine* some areas of cracks have developed in the sky, the pattern of which reflects the tension and stress generated during the drying of the heavy yellow glaze Turner would have applied towards the completion of the work. However, there is no continuous crack network.

Both paintings, which are typical of Turner's work of all but his earliest period, have a white priming or preparation layer applied to the canvas.[20] If the canvas used for *Rome from Mount Aventine* was indeed one originating from his English studio rather than Italy, this layer may have been applied prior to the canvas being stretched, perhaps as part of a bulk preparation of canvases. The priming layer is relatively thin and a slight sense of canvas weave still remains. In contrast, the canvas used for *Modern Rome* has a thicker priming layer which completely coats and conceals the weave providing a very smooth surface on which to apply paint. Although applied by an artist's colourman, the particular characteristics of this preparatory layer, such as its degree of absorbency and its colour and smoothness, may well have been specified by Turner. The priming, even when

[143] *Rome from Mount Aventine*: The sprigs (small metal pins) used to hold the stretched canvas to the edge of the stretcher. Old brush hairs are trapped behind the pin, and drips of liquid paint have run down the edge of the canvas.

not visible to the naked eye, plays a critical role in the final appearance of a painting, and the artist uses its particular optical and physical properties as the basis for his choice of paint colour. It is widely acknowledged that alterations in the balance of paint colours can occur when excess adhesive migrates into a painting during the lining process. As both these works remain unlined it is evident that there has been no change in the preparatory layer. Both works have pin holes at one or more corners which may be the result of spacer pins pressed into the canvas to allow pictures to be stacked against one another while the paint was still wet. Alternatively, these holes could be linked to a system that Turner used to plot linear perspective.

Turner's choice of painting materials was always complex and would include an array of binding media such as oil, resin, wax and allegedly watercolour, which he combined with both traditional tried and tested colours as well as the latest new pigments that were increasingly available in the first half of the nineteenth century. His use of wax and resins have made some of his works especially vulnerable to heat and cleaning solvents. Additionally, the practice of lining, which, in the past, has sometimes employed extreme levels of heat, moisture and pressure, can cause the subtle touches and fleeting paint applications to fuse together irreversibly. The effect of heat can also cause a darkening of resinous paint, thus fundamentally changing the tonal balance of a composition. Injudicious lining can result in even more significant 'topographical' changes such as the flattening of the paint texture or impasto, and the enhancement of the appearance of the canvas weave.[21]

With these two paintings, however, it is possible to see a full range of remarkably well-preserved painting techniques: stiff paint allows sharp spiky impasto

above, clockwise:

Four details from *Rome from Mount Aventine* [93]

[144] Stiff paint allows sharp spiky impasto to be used to describe fleeting clouds, lit up by the sunlight.

[145] The repetitive nature of the modern building construction is rapidly executed by Turner with a fine brush and white paint.

[146] Tiny brushstrokes define buildings, boats and groups of people busy at work. Here boats are being made ready to sail.

[147] The liquid, brown paint applied with a fine brush to finalise details throughout the painting is seen used here for the figures and the structure of the boat.

left:

[148] *Rome from Mount Aventine*: the overlays show the areas discussed. See also the large reproduction on page 84.

left, clockwise:

Five details from
Modern Rome [94]

[149] Limp impasto gives
form to soft, distant clouds.
The hard edge of a brush has
been dragged through the still
wet paint.

[150] Cloth or possibly sails
laid out on the river bank are
rapidly executed with a fine
brush and white paint.

[151] The rambling briars in
the foreground are painted
with a very liquid paint; finger
prints and brush handle work
demonstrate the immediacy
of these final applications.

[152] A tiny figure is perched
perilously on a ladder leaning
against a column.

[153] Wet paint is moved and
pushed with the end of the
brush creating incised lines
and calligraphic marks to
render architectural details.

right:

[154] *Modern Rome*: the overlays show the areas
discussed. See also the large reproduction on page 85.

to delineate fleeting cloud structures, lit up by evening and morning light [144]; limp impasto, as if laid onto the canvas with a soft brush, gives form to soft distant clouds [149]; tiny brushstrokes define buildings, boats and groups of people busy at work; and wet paint is moved and pushed with the handle end of the paint brush to create incised lines and indented calligraphic marks [153]. In *Rome from Mount Aventine* the umbrella pine appears almost sculpted onto the picture plane with tiny, final brushstrokes applied to give a sense of leaf and branch. The immediacy of Turner's technique is demonstrated by the paint he applied with his finger tips [151], whilst his vigorous execution is signified in places by hairs from his brush caught up in the paint. Towards the end of his career, Turner increasingly used white paint and this is visible in both works where translucent, almost wash-like applications of white oil colours are used to create atmospheric lighting effects, and opaque white touches are applied to define buildings and architectural elements.

Turner adjusted the quality of his paint with diluents, such as turpentine, resulting in dribbles and drips which

[155] Detail from *Modern Rome:* An excess of dryers added to the paint to speed up drying causes the paint film to crack and to tear apart. At the bottom left-hand corner Turner hides such a disfigurement by painting a figure and a staff with a bundle of belongings attached. Here the tip of the staff is seen together with a rivulet of liquid paint running down the paint surface.

run onto the folded-over canvas edges. The direction of these drips confirms that the painting was worked on in an upright position despite the liquidity of the paint. The addition of gelling materials such as megilp,[22] allowed thick layers of translucent glaze colour to be applied, and where needed further transparent wetting layers were also added to ensure that the full saturation of colour was achieved.

A sense of time passing as work on the paintings progressed is also recorded. In *Rome from Mount Aventine*, as a result of carrying the canvas when the paint was still wet, fingerprints are registered in the paint along the top. Less obvious drying cracks, apparent only in the lower layers of paint, can be seen when the surface is closely scrutinised suggesting that the work was painted over a number of years. In *Modern Rome* where an excess of dryers[23] were probably added to the paint causing colours to tear themselves apart, Turner's opportunistic approach to compositional elements is revealed by a carefully placed figure and a staff which have been added to cover up the disfigurement [155].

With these two works the painting methodology is broadly the same: they are built up from areas of single colour that define individual elements, over which translucent glazes and semi-opaque scumbles are repeatedly applied. However, some aspects of the creative process differ, which reflects their differing function. *Rome from Mount Aventine* records a specific location, and preparatory drawings from his trip to Rimini and Rome between 1828 and 1829 have been linked with it.[24] Unusually for this late date, the drawings are an accurate topographic record of the view and are therefore unlike the idiosyncratic records of architectural details and figure groups amongst other subjects, which fill the rest of the related sketchbook. This reflects the purpose of the work as a commissioned record of a particular location and aside from some adjustment to the composition (horizontally it is compressed and vertically it is stretched) the painting follows the drawing closely.[25] Examination of the painting using infrared reflectography[26] reveals a few drawing lines, including what appear to be ruled lines to position the architecture and perspective of the building on the left river bank.[27] Such tight control has been followed by systematic painting [145] in certain areas, and Turner's approach to the repetitive features of this modern, municipal building is to draw in the sketchbook only the first two runs of windows as an aide-mémoire.

In *Modern Rome,* where Turner has created a sense of Rome as a modern city constructed from a series of known elements, no such complete drawing exists. Rather, the artist has relied on his collection of drawn elements and memories to piece together a fantastic city. Subsequently, and more typically, no drawing was detected on the canvas and the paint application was much looser. Where a straight, crisp line was required, Turner seems to have painted up to a straight edge or ruler [153]. A tiny figure perilously perched on a ladder leaning against a column perhaps recalls Turner's experiences from his first trip to Rome in the summer of 1819, when the interest in plotting and recording the ancient monuments in Rome was at its peak [152].[28]

Part of the ritual of exhibiting at the Royal Academy was that the four or five days prior to the public viewing were reserved as varnishing days, when artists were allowed to add finishing touches and to apply their final varnishes. Turner's use of these days is infamous: on occasion, what arrived as a simple oil sketch was transformed into a highly finished work of art in the space of a few hours of intense activity. Brinkmanship also featured, with major adjustments to colour and brightness being made to counteract and reduce the impact of works by other artists which were hung nearby.

Being untouched subsequent to their exhibition at the Royal Academy, the impact of varnishing day on these two works is interesting to consider. No written record of extensive repainting exists for either of the paintings, but examination of the surfaces with ultraviolet light can help to identify where the last touches of paint were applied. Such an examination for *Rome from Mount Aventine* shows that with a liquid brown paint applied with a fine, pointed brush, architectural details and figure groups were enhanced throughout at a late stage [146–7]. Further touches of white paint may also have been applied. In *Modern Rome*, there are passages of what now appear as pale yellow glazing, for example, in the centre, that may have been the result of additional wetting out. Further colouring to conceal cracking in the figure group was also applied, along with all the rambling briars and goats in the foreground. Once these subtle refinements were complete, visitors to the Royal Academy exhibition would have been captivated as we still are today by Turner's remarkable virtuosity.

Chronology

1775

· Joseph Mallord William Turner born at 21 Maiden Lane, Covent Garden, London. Son of William, a barber and wig-maker and his wife Mary Turner (née Marshall).

· Births of the novelist Jane Austen and the artist Thomas Girtin.

· James Watt builds his steam engine.

· Start of the American War of Independence.

1778

· Birth of Mary Ann, Turner's sister.

· Birth of the essayist William Hazlitt.

1783

· Death of Turner's sister.

· William Pitt the Younger becomes Prime Minister.

· Treaty of Paris ends the American War of Independence.

1787

· Paints his earliest surviving signed and dated watercolours. His work is displayed in his father's shop window for sale.

· Mozart's *Don Giovanni* first performed in Prague.

1789

· Stays with an uncle at Sunningwell, near Oxford, which he visits. Employed in the offices of London architects including Thomas Hardwick to make and colour drawings of buildings. Taught to paint in watercolour by Thomas Malton, Jr. On 11 December admitted to the Royal Academy Schools as a student.

· Storming of the Bastille in July.

· Mutiny aboard HMS *Bounty* in the South Pacific.

· George Washington elected first President of the United States of America.

1790

· Hears Sir Joshua Reynolds give his final Discourse, on the importance of the Italian old masters to students of the Royal Academy. His first work is exhibited at the Royal Academy.

1792

· Enters the life class at the Royal Academy. Meets John Soane, by now a successful architect.

· Death of Sir Joshua Reynolds.

1793

· Awarded prize by the Royal Society of Arts for landscape drawing.

· Louis XVI executed on 21 January.

· Outbreak of war between France and Britain on 1 February.

· Louvre established as the national art gallery of France.

1794

· Begins making watercolour copies of Italian and other subjects in Dr Thomas Monro's house.

· Glorious First of June, British victorious in naval battle with the French.

1795

- Exhibits eight watercolours at the Royal Academy. Receives commissions for engravings. Visits Isle of Wight.
- Birth of John Keats.
- Seditious Meetings Act passed.

1796

- Exhibits his first oil painting, *Fishermen at Sea*, at the Royal Academy.
- Edward Jenner introduces smallpox vaccine.
- Napoleon invades Italy.
- Spain declares war on Great Britain.

1797

- Exhibits two oil paintings and four watercolours at the Royal Academy. Tours the Scottish Borders and the Lake District.
- Venice falls to Napoleon.

1798

- Tours Wales and visits Richard Wilson's birthplace in Montgomeryshire.
- French defeated at the Battle of the Nile.

1799

- Elected an Associate of the Royal Academy. Moves to rooms in Harley Street.
- First watercolours of Oxford commissioned for engraving. Sees the 'Altieri' Claudes at William Beckford's London home.
- Income Tax introduced.
- Foundation of the Royal Institution.
- Napoleon appointed First Consul of France.

1800

- His mother admitted to Bethlem Hospital for the insane where Dr Monro is the physician. Turner's earliest known poetry, with his painting *Dolbadern Castle*, published in Royal Academy catalogue.
- Napoleon defeats the Austrians at the Battle of Marengo.
- Thomas Jefferson elected President of the United States of America.

1801 (or late 1800)

- Turner's companion Sarah Danby gives birth to their daughter, Evelina.

- Nelson defeats Danes at Battle of Copenhagen.

1802

- Becomes a full member of the Royal Academy, at aged twenty-seven the youngest ever elected. From July to October: travels to France, through Calais and Paris, and to Switzerland and Aosta, Italy. Spends three weeks in Paris studying old master paintings in the Louvre, making notes in his 'Studies in the Louvre' sketchbook.
- In March, Treaty of Amiens signed, temporarily ending the war between France and England.

1803

- *Festival upon the Opening of the Vintage at Macon*, *Holy Family* and other paintings made in the light of his 1802 journey exhibited at the Royal Academy.
- Becomes a member of the Royal Academy Council.
- Britain and France at war.
- Napoleon's troops at Boulogne in preparation for an invasion of Britain.

1804

- Paints *Venus and Adonis*. Death of his mother at Bethlem Hospital. Opens his own picture gallery at his house at 64 Harley Street. *Festival upon the Opening of the Vintage at Macon* sold to Lord Yarborough. Starts painting out of doors on the Thames.
- Napoleon declares himself Emperor of France.
- Spain declares war on Britain.
- Society of Painters in Watercolour founded.

1805

- Rents Sion Ferry House, Isleworth. No works exhibited at the Royal Academy.
- In October Nelson's fleet defeats those of Spain and France at the Battle of Trafalgar.
- In December Napoleon defeats the Austrians at the Battle of Austerlitz.

1806

- Rents a house on the river Thames at West End, Hammersmith. Exhibits *Narcissus and Echo* (1804) and *The Goddess of Discord* at the British Institution.
- Elgin Marbles put on show in the garden of Lord Elgin's house in London.
- A state funeral for Lord Nelson held at St Paul's Cathedral.

1807

- Elected Professor of Perspective at the Royal Academy. Buys a plot of land at Twickenham. First part of *Liber Studiorum* published.
- Signing of the Abolition Act prohibits the slave trade in Britain.
- Gas street lighting introduced in London.

1808

- Paints views of Tabley Hall for Sir John Leicester. Makes his first visit to Farnley Hall, near Leeds, home of Walter Fawkes, and begins his long series of watercolours of Wharfedale views.
- Sir Walter Scott's long poem *Marmion* published.

1809

- Exhibits *Thomson's Aeolian Harp* at the Royal Academy. Visits Petworth House, the Sussex home of Lord Egremont, for the first time.
- Birth of Charles Darwin.

1810

- Travels to Farnley Hall, where he becomes a regular visitor until Fawkes's death in 1825. Moves to 44 Queen Anne Street.
- Nazarene Brotherhood founded.

1811

- Exhibits *Mercury and Herse* at the Royal Academy. Gives the first series of lectures as Professor of Perspective at the Royal Academy. Writes a long poem about the history and destiny of Britain. Travels extensively in the south-west of England.
- Prince of Wales becomes Prince Regent.
- Luddite riots in Nottingham.

1812

- Begins construction of Sandycombe Lodge, Twickenham, to his own design (completed 1813). *Snow Storm: Hannibal and his Army Crossing the Alps* exhibited at the Royal Academy.

- First two Cantos of Byron's *Childe Harold's Pilgrimage* published.
- Birth of Charles Dickens.
- In June Napoleon invades Russia but in October is forced to retreat.

1813

- Makes second Devonshire tour. In May attends Royal Academy dinner and sits next to John Constable.

- *Pride and Prejudice* by Jane Austen published.
- Napoleon defeated at the Battle of Leipzig.

1814

- First instalment of engravings from *Picturesque Views of the Southern Coast of England* published. Exhibits *Apullia in Search of Appullus* at the British Institution and *Dido and Aeneas* at the Royal Academy.

- Allied armies enter Paris. Napoleon banished to Elba; war with France ends with a grand celebration in London.
- *The Times* printed by steam press.
- The first steam locomotive, George Stephenson's *Blucher*, is constructed and tested at Cillingwood Railway, Northumberland.
- Dulwich Picture Gallery designed by John Soane opens.

1815

- Exhibits *Dido Building Carthage* at the Royal Academy. The sculptor Antonio Canova visits London, and calls on Turner at his gallery.

- In March Napoleon escapes from Elba and regains power in France; Napoleon finally defeated at the Battle of Waterloo in June.
- Congress of Vienna establishes European national borders.

1816

- Elected chairman of directors, and treasurer of the Artists' General Benevolent Fund.
- Tours Yorkshire and north of England.

- Byron leaves England, never to return. Third Canto of *Childe Harold's Pilgrimage* published.
- British Museum buys the Elgin Marbles.
- David Brewster invents the kaleidoscope.

1817

- *Decline of the Carthaginian Empire* exhibited at the Royal Academy. Travels on the Continent for the first time since 1802: visits Belgium, Holland and the Rhineland.

- Death of Jane Austen.
- Waterloo Bridge in London opens.
- Potato famine in Ireland.

1818

- Makes watercolours for Hakewill's *Picturesque Tour of Italy*. Commissioned by Sir Walter Scott to contribute illustrations to *The Provincial Antiquities and Picturesque Scenery of Scotland*. Visits Edinburgh and the Lowlands of Scotland.

- *Frankenstein* by Mary Shelley, and Fourth Canto of Byron's *Childe Harold's Pilgrimage* published.

1819

- Final part of the *Liber Studiorum* published. Shows sixty watercolours in an exhibition at Walter Fawkes's London house in Grosvenor Place. *England: Richmond Hill* exhibited at the Royal Academy. Begins a six month visit to Italy: stays in Turin, Milan, Verona, Padua, Venice, Bologna, Faenza, Cesena, Rimini, Ancona, Loreto, Spoleto, Foligno, and elsewhere on the way to Rome. Travels subsequently, with Thomas Donaldson, to Naples, Sorrento, Amalfi and Paestum. Meets many English friends in Rome, including Francis Chantrey, Maria Graham, Humphry Davy and Thomas Moore. Elected member of the Accademia di San Luca through Canova's sponsorship. Travels home via Florence and Mont Cenis. Enlarges his Queen Anne Street house to include a new picture gallery.

- Peterloo Massacre in Manchester.
- Cardinal Consalvi publishes edict outlawing bandits in Italy.

1820

- In February returns home from Italy. *Rome, from the Vatican* exhibited at the Royal Academy. Paints series of large watercolours of Italian subjects, probably for an engraving contract that was cancelled. Inherits cottages in Wapping. Alterations at 44 Queen Anne Street underway.

- Death of George III and accession of his son George IV, formerly the Prince Regent.
- Death of Benjamin West, President of the Royal Academy.

1821

- Travels to Paris and Northern France to make studies for a series of engravings of Seine views.

- Michael Faraday discovers electro-magnetic rotations.
- Death of Joseph Farington.
- Death of Napoleon on St Helena.

1822

- Travels to Edinburgh by sea to paint George IV's state visit. Opens his refurbished and extended gallery in Queen Anne Street.

- Turkish invasion of Greece.
- Death of Antonio Canova.

1823

- *Bay of Baiae* exhibited at the Royal Academy. Works on the royal commission for *The Battle of Trafalgar*.

- Construction of Smirke's extension to the British Museum starts.
- Electric Telegraph invented by Francis Ronalds.

1824

- Watercolours for *Views in London and its Environs* commissioned. Travels in East Anglia. Visits Belgium, Luxembourg, Germany and Northern France. Pays last visit to Farnley Hall, home of Walter Fawkes.

- Lord Byron dies in Greece.

· The National Gallery in London founded (located in Pall Mall until 1837).

1825

· *Picturesque Views in England and Wales* series commissioned by Charles Heath. Tours the Low Countries. Death of Walter Fawkes.

· Death of Henry Fuseli, Professor of Painting at the Royal Academy.
· Stockton to Darlington Railway opens.

1826

· *Forum Romanum* exhibited at the Royal Academy. It is intended for John Soane, who refuses it. Samuel Rogers commissions Turner to illustrate his collection of poems, *Italy*. Visits northern France.

· Royal Scottish Academy in Edinburgh founded.

1827

· Stays with John Nash at East Cowes Castle, Isle of Wight, and at Petworth with Lord Egremont. First three parts of *Picturesque Views in England and Wales* published.

· Death of William Blake.
· Turkish fleet annihilated by Greek and British navies at the Battle of Navarino.

1828

· Exhibits *Dido Directing the Equipment of the Fleet* at the Royal Academy. Gives his final series of perspective lectures at the Royal Academy. Lord Egremont commissions series of paintings for the Carved Room at Petworth.

· Third visit to Italy, travelling via Marseille and Nice, staying at 12 Piazza Mignanelli, Rome. Exhibits paintings made in Rome at the Palazzo Trulli, Via dei Quirinali, to much local criticism. Meets English and Scottish friends in Rome, many of them sculptors; probably also meets Humphry Davy in Rome.

· The Duke of Wellington becomes prime minister.
· Death of Goya in Bordeaux.
· Death of Richard Parkes Bonnington.

1829

· Returns to London in February. Exhibits *Ulysses Deriding Polyphemus* at the Royal Academy. *England and Wales* subjects exhibited at the Egyptian Hall, Piccadilly, London. Visits Paris, Normandy and Brittany. His father dies, and Turner makes his first will.

· Death of Sir Humphry Davy.
· The Metropolitan Police Act sets up an organised police force for London.
· Greece recognised as a nation state.

1830

· Exhibits *Palestrina – Composition* at the Royal Academy. Samuel Rogers's *Italy* published.

· Death of Sir Thomas Lawrence.
· Death of George IV and accession of his brother William IV.
· In July, revolution in Paris leads to the abdication of Charles X and puts Louis-Philippe on the throne of France.

1831

· Exhibits *Caligula's Palace and Bridge* at the Royal Academy. In summer, travels to Scotland to stay with Sir Walter Scott at Abbotsford, and to gather material for Scott's *Poems*.

· Faraday discovers electromagnetic induction.
· HMS *Beagle* sails to the Southern Oceans with Charles Darwin on board.

1832

· *Childe Harold's Pilgrimage* exhibited at the Royal Academy. Becomes a regular visitor to Margate. In autumn, travels to the Channel Islands, and to Paris. At Christmas, visits at Petworth and at East Cowes Castle.

· Reform Bill passed.
· Cholera epidemic in Britain.

1833

· Exhibits two oils of Venice at the Royal Academy. Travels down the Rhine and Danube to Munich and Vienna, and on through Switzerland to Venice, where he spends five or six days. Publication of first volume of *Turner's Annual Tour: Wanderings by the Seine*; second and third volumes in 1834 and 1835 respectively.

· Slavery in British Empire abolished.
· First crossing of Atlantic by a steamship.

1834

· *The Golden Bough* and *The Fountain of Indolence* exhibited at the Royal Academy. Travels to Scotland. Houses of Parliament burn down; Turner among the onlookers.

· Uprising in Piedmont, Garibaldi sentenced to death but escapes and travels to America.
· Tolpuddle Martyrs transported to Australia.

1835

· Exhibits two paintings of the *Burning of the Houses of Lords and Commons*. Visits Copenhagen, Berlin, Dresden, Prague, Nuremburg, the Rhine and Rotterdam.

· William Henry Fox Talbot takes the first negative photograph.

1836

· *Juliet and her Nurse* and *Venice* exhibited at the Royal Academy, the former prompting a bitter attack on Turner in *Blackwood's Magazine*. Tours France, Switzerland and the Val d'Aosta with Munro of Novar.

· Royal Academy's last annual exhibition at Somerset House.

1837

· First Royal Academy exhibition in rooms adjacent to the new National Gallery, Trafalgar Square; Turner exhibits *Snowstorm, Avalanche and Inundation*. Travels to Paris. Death of Lord Egremont on 11 November. Resigns as Professor of Perspective.

· Opening of the National Gallery in Trafalgar Square, London.
· Death of William IV, accession of his niece, afterwards Queen Victoria.
· Death of John Constable.
· Death of Sir John Soane.

1838

- *Modern Italy* and *Ancient Italy* exhibited at the Royal Academy. Last set of engravings for *England and Wales* published.
- Coronation of Queen Victoria.
- Beginnings of the Chartist rebellions in England.

1839

- Exhibits *The Fighting Temeraire* at the Royal Academy, also *Cicero at his Villa*, *Ancient Rome* and *Modern Rome*, and *Pluto Carrying off Proserpine*.
- *The Fountain of Indolence* exhibited at the British Institution under the title *The Fountain of Fallacy*. Travels to Belgium, Luxembourg and Germany.

1840

- Exhibits *Slavers Throwing Overboard the Dead and Dying, Rockets and Blue Lights*, *New Moon* and *Neapolitan Fisher-girls* at the Royal Academy. Meets John Ruskin for the first time. Travels to Venice, through Rotterdam and down the Rhine, returning through Munich and Coburg.
- Marriage of Queen Victoria to Albert of Saxe-Coburg-Gotha.
- Penny Post established by Rowland Hill.

1841

- From July to October travels in Switzerland. Exhibits six oils at the Royal Academy.
- Death of Sir David Wilkie.
- Death of Sir Francis Chantrey.
- Robert Peel becomes Prime Minister.

1842

- From August to October travels in Switzerland via Belgium. Exhibits five oils at the Royal Academy.
- *Illustrated London News* first published.
- Death of John Sell Cotman.

1843

- From August to November visits the Tyrol and north Italy for the last time.

- Exhibits *The Sun of Venice going to Sea* at the Royal Academy. First volume of John Ruskin's *Modern Painters* published.
- Brunel's ss Great Britain launched in Bristol.
- First tunnel under the Thames opens.
- William Wordsworth becomes Poet Laureate.

1844

- Exhibits *Rain, Steam, and Speed – The Great Western Railway* at the Royal Academy.
- Final visit to Switzerland, travels in the Alps with William Brockedon. In October, travels to Portsmouth to witness the arrival of King Louis-Philippe of France, on a state visit.
- Death of Sir Augustus Wall Callcott.
- First wireless message transmitted by electromagnetic telegraph, invented by Samuel Morse.

1845

- Appointed Acting President of the Royal Academy during illness of Sir Martin Archer Shee, and later in the year Deputy President. Makes two trips to France: in May, to Boulogne and environs; and in the autumn, his last foreign trip, to Dieppe and Picardy.
- While at Dieppe, dines with the French monarch Louis-Philippe at his château at Eu.

1846

- *Undine* exhibited at the Royal Academy. Moves to 6 Davis Place, Chelsea, with Mrs Booth.
- Repeal of the Corn Laws.

1847

- *The Golden Bough* and *Dogano ... from the Steps of the Europa* bequeathed to the nation by Robert Vernon, becoming the first works by Turner to hang in the National Gallery.
- Charlotte Bronte's *Jane Eyre* and Emily Bronte's *Wuthering Heights* published.
- Introduction of the Factory Act which restricted working hours of women and children.

1848

- For the first time since 1824 Turner does not exhibit at the Royal Academy, probably through ill health.
- Pre-Raphaelite Brotherhood founded.
- Revolutions across Europe.
- Garibaldi returns to Italy.

1849

- Exhibits an earlier work, *Venus and Adonis*, at the Royal Academy. Suffers from ill health during much of this year.
- Rome declared a republic.
- Venice comes under Austrian rule.
- John Ruskin's *Seven Lamps of Architecture* published.
- Charles Dickens's *David Copperfield* starts appearing in serial form.

1850

- Exhibits for the last time at the Royal Academy, four sequential paintings on the theme of Dido and Aeneas.
- Death of William Wordsworth.

1851

- Visits the Crystal Palace under construction in Hyde Park, London. Attends Varnishing Days at the Royal Academy, and the private view and banquet. Confined through illness to his bed in his house in Chelsea. Turner, aged seventy-six, dies at his home on 19 December and is buried with great ceremony in the crypt of St Paul's Cathedral on 30 December.
- From May to October the Great Exhibition is held in the Crystal Palace in Hyde Park.

Exhibition Checklist

This list features the works that are included in the Edinburgh version of the exhibition; please consult the Ferrara and Budapest catalogues for the loans to those venues. It is arranged in four sections with works by Turner appearing first in chronological order followed by works by other artists. D and NG numbers refer to National Gallery of Scotland accession numbers. The standard catalogues of Turner's works are referred to with the following abbreviations:

FOR OIL PAINTINGS: B&J 1984
Martin Butlin and Evelyn Joll,
The Paintings of J.M.W. Turner, 2 vols, New Haven and London, 1977, revised edition 1984

FOR WATERCOLOURS: WILTON
Andrew Wilton, *J.M.W. Turner,
His Art and Life*, New York, 1979

FOR DRAWINGS: FINBERG
A.J. Finberg, *A Complete Inventory of
the Drawings of the Turner Bequest, with which are
Included Twenty-three Drawings bequeathed by
Mr Henry Vaughan*, 2 vols, London, 1909

FOR PRINTS: RAWLINSON
W.G. Rawlinson, *The Engraved Work
of J.M.W. Turner R.A.*, 2 vols, London, 1908–13

Paintings

JOSEPH MALLORD WILLIAM TURNER
1775–1851

Dolbadern Castle, North Wales, 1800
Oil on canvas, 119.4 × 90.2cm
Royal Academy of Arts, London
B&J 1984, 12 · plate 8

Holy Family, 1803
Oil on canvas, 102 × 141.5cm
Tate, London
B&J 1984, 49 · plate 18

*Châteaux de St Michael, Bonneville,
Savoy,* 1803
Oil on canvas, 91.5 × 122cm
Yale Center for British Art, New Haven,
Paul Mellon Collection
B&J 1984, 50 · plate 19

*The Pass of St Gothard, c.*1803–4
Oil on canvas, 80.6 × 64.2cm
Birmingham Museums and Art Gallery
B&J 1984, 146 · plate 15

Thomson's Æolian Harp, 1809
Oil on canvas 166.7 × 306cm
Manchester Art Gallery
B&J 1984, 86 · plate 26

*A View of the Castle of St Michael,
near Bonneville, Savoy,* 1812
Oil on canvas, 92 × 123.2cm
Philadelphia Museum of Art, John G. Johnson
Collection, 1917
B&J 1984, 124 · plate 20

Lake Avernus: Æneas and the Cumaean Sibyl,
1814–15
Oil on canvas, 72 × 97cm
Yale Center for British Art, New Haven, Paul
Mellon Collection
B&J 1984, 226 · plate 27

*Rome, from the Vatican. Raffaelle,
Accompanied by La Fornarina, Preparing his
Pictures for the Decoration of the Loggia,* 1820
Oil on canvas, 117 × 335.5cm
Tate, London
B&J 1984, 228 · plate 59

Lake Nemi, 1828
Oil on canvas, 60.5 × 99.5cm
Tate, London
B&J 1984, 304 · plate 87

Palestrina – Composition, 1828
Oil on canvas, 140.5 × 249cm
Tate, London
B&J 1984, 295 · plate 77

View of Orvieto
Painted in Rome, 1828; reworked 1830
Oil on canvas, 91.5 × 123cm
Tate, London
B&J 1984, 292 · plate 79

Vision of Medea, 1828
Oil on canvas, 173.5 × 241cm
Tate, London
B&J 1984, 293 · plate 78

Caligula's Palace and Bridge, 1831
Oil on canvas, 137 × 246.5cm
Tate, London
B&J 1984, 337 · plate 90

*Christ Driving the Traders from the Temple,
c.*1832
Oil on mahogany, 92 × 70.5cm
Tate, London
B&J 1984, 436 · plate 58

The Fountain of Indolence, 1834
Oil on canvas, 106.5 × 166.4cm
The Beaverbrook Art Gallery / The Beaverbrook
Foundation, New Brunswick
B&J 1984, 354 · plate 91

The Golden Bough, 1834
Oil on canvas, 104 × 163.5cm
Tate, London
B&J 1984, 355 · plate 92

The Arch of Constantine, Rome, c.1835
Oil on canvas, 91 × 122cm
Tate, London
B&J 1984, 438 · plate 97

Venice, the Piazzetta with the Ceremony of the Doge Marrying the Sea, c.1835
Oil on canvas, 91.5 × 122
Tate, London
B&J 1984, 501 · plate 105

Rome, from Mount Aventine, 1836
Oil on canvas, 91.6 × 124.6cm
The Rosebery Collection, on loan to the National Gallery of Scotland, Edinburgh
B&J 1984, 366 · plate 93

Modern Italy – the Pifferari, 1838
Oil on canvas, 92.5 × 123cm
Kelvingrove Art Gallery and Museum, Glasgow
B&J 1984, 374 · plate 98

Modern Rome – Campo Vaccino, 1839
Oil on canvas, 90.2 × 122cm
The Rosebery Collection, on loan to the National Gallery of Scotland, Edinburgh
B&J 1984, 379 · plate 94

Neapolitan Fisher-girls Surprised Bathing by Moonlight, 1840 (?)
Oil on canvas, 65.1 × 80.3cm
The Huntington Library, Art Collections, and Botanical Gardens, San Marino, California
B&J 1984, 388 · plate 117

Venice with the Salute, c.1840–5 (?)
Oil on canvas, 62 × 92.5cm
Tate, London
B&J 1984, 502

Landscape with a River and a Bay in the Distance, c.1840–50
Oil on canvas, 94 × 123cm
Musée du Louvre, Paris
B&J 1984, 509 · plate 116

Landscape with River and Distant Mountains, c.1840–50
Oil on canvas, 92 × 122.5cm
Walker Art Gallery, National Museums Liverpool
B&J 1984, 517

Dawn of Christianity (Flight into Egypt), 1841
Oil on canvas, circular, diameter 78.5cm
Ulster Museum, Belfast
B&J 1984, 394 · plate 119

Glaucus and Scylla, 1841
Oil on panel, 79 × 77.5cm
Kimbell Art Museum, Fort Worth, Texas
B&J 1984, 395 · plate 118

Dogana, and Madonna della Salute,Venice, 1843
Oil on canvas, 63 × 93cm
National Gallery of Art, Washington DC, given in memory of Governor Alvan T. Fuller by The Fuller Foundation, Inc., 1961
B&J 1984, 403 · plate 112

Approach to Venice, 1844
Oil on canvas, 62 × 94cm
National Gallery of Art, Washington DC, Andrew W. Mellon Collection, 1937
B&J 1984, 412 · plate 111

The Val d'Aosta, c.1840–50
Oil on canvas, 91.4 × 121.9cm
National Gallery of Victoria, Melbourne, purchased with the assistance of a special grant from the Government of Victoria and donations from Associated Securities Limited, the Commonwealth Government (through the Australia Council), the National Gallery Society of Victoria, the National Art Collections Fund (Great Britain), The Potter Foundation and other organisations, the Myer family and the people of Victoria, 1973
B&J 1984, 520 · plate 121

CLAUDE LORRAIN (CLAUDE GELLÉE)
c.1604–1682
Landscape with Apollo and the Muses, 1652
Oil on canvas, 186 × 290cm
National Gallery of Scotland, Edinburgh
NG 2240 · plate 5

RICHARD WILSON 1713/14–1782
Rome from the Ponte Molle, 1754
Oil on canvas, 100.5 × 137cm
National Museum of Wales, Cardiff · plate 9

Watercolours, Drawings and Sketchbooks

JOSEPH MALLORD WILLIAM TURNER
1775–1851

Rome: The Tiber with the Aventine on the Left, 1794–7
Blue, brown and grey wash over black chalk on paper, 27.5 × 48.5cm
National Gallery of Scotland, Edinburgh
D 5023.55 · plate 7

Vesuvius and the Convent of San Salvatore, 1794–7
Watercolour and black chalk on paper, 32.2 × 49cm
National Gallery of Scotland, Edinburgh
D 5023.42 · plate 6

Hafod, c.1798
Watercolour on paper, 61 × 91.5cm
Lady Lever Art Gallery, Port Sunlight, National Museums Liverpool
Wilton 331

Mount Snowdon, Afterglow, 1798–9
Watercolour with some scraping-out on paper, 52.7 × 75.5cm
National Gallery of Scotland, Edinburgh
D 5284

Aosta: The Arch of Augustus, Looking South to Mt Emilius, 1802
From the 'Grenoble' sketchbook
Chalk, pencil and watercolour on paper, 21.2 × 28.3cm
Tate, London
Finberg LXXIV 10 · plate 3

Chamonix: Glacier des Bossons, 1802
Watercolour and gouache on prepared paper, 32.6 × 47.8cm
Private Collection
Wilton 356 · plate 13

Lake of Thun, from Unterseen, 1802
Watercolour and pencil with scraping-out on prepared paper, 31.5 × 47cm
The Whitworth Art Gallery, The University of Manchester
Wilton 359

The Passage of Mount St Gothard, Taken from the Centre of the Teufels Broch (Devil's Bridge), Switzerland, 1804
Watercolour with scraping-out on paper, 98.5 × 68.5cm
Abbot Hall Art Gallery, Kendal
Wilton 366 · plate 16

Montanvert, Valley of Chamouni, 1806 (?)
Watercolour and scraping-out over pencil on paper, 27.8 × 39.5cm
Amgueddfa Genedlaethol Cymru, National Museum of Wales, Cardiff
Wilton 376 · plate 14

Roman Forum, from the Capitol, c.1816
Watercolour on paper, 14 × 21.6cm
The Whitworth Art Gallery, The University of Manchester
Wilton 704 · plate 33

Bay of Naples (Vesuvius Angry), c.1817
Watercolour on paper, 17.6 × 28.4cm
Williamson Art Gallery, Birkenhead
Wilton 698 · plate 35

Cascade of Terni, c.1817
Watercolour on paper, 22.2 × 13.3cm
Blackburn Museum and Art Gallery
Wilton 701 · plate 38

Gibside, Co. Durham, from the South West, c.1817
Watercolour on paper, 26.2 × 43.1cm
The Bowes Museum, Barnard Castle, County Durham
Wilton 557 · plate 32

Florence, from the Ponte alla Carraia, c.1816–17
Watercolour on paper, 14 × 21cm
The Whitworth Art Gallery, The University of Manchester
Wilton 713 · plate 36

Forum Romanum, 1818
Watercolour on paper, 14 × 21.6cm
National Gallery of Canada, Ottawa, gift of F.J. Nettlefold, Nutley, Sussex, 1948
Wilton 705 · plate 34

Narni with the Bridge of Augustus, 1819
From the 'Ancona to Rome' sketchbook (open at pages 61a–62)
Pencil on paper, 11.1 × 18.5cm
Tate, London
Finberg CLXXVII

Parts of the Ash Urn of T. Flavius Eucharistus; and Parts of the Base of the Statue of Attius Insteius Tertullus; A Torso; Grave Altar of Q. Gaius Musicus and Volumnia Ianuaria, 1819
From the 'Vatican Fragments' sketchbook (open at pages 19a–20)
Pencil on paper, 16.2 × 10.2cm
Tate, London
Finberg CLXXX · plates 49, 50

The Colosseum and Basilica of Constantine, 1819
From the 'Rome: Colour Studies' sketchbook (open at page 20)
Pencil and watercolour on paper, 22.8 × 36.8cm
Tate, London
Finberg CLXXXIX · plate 56

The Arch of Constantine and the Colosseum, 1819
From the 'Rome: Colour Studies' sketchbook (open at page 29)
Pencil and watercolour on paper, 23.3 × 37cm
Tate, London
Finberg CLXXXIX · plate 52

Ruins in Rome: View from the Palatine, 1819
From the 'Rome: Colour Studies' sketchbook (open at page 30)
Pencil and watercolour on paper, 23.2 × 36.9cm
Tate, London
Finberg CLXXXIX · plate 54

The Claudian Aqueduct, 1819
From the 'Rome: Colour Studies' sketchbook (open at page 36)
Gouache and watercolour on paper, 22.9 × 36.9cm
Tate, London
Finberg CLXXXIX · plate 55

Piazza del Popolo, with the Churches of Santa Maria in Monte Santo and Santa Maria de' Miracoli, 1819
From the 'Rome: Colour Studies' sketchbook (open at page 52)
Pencil and watercolour on paper, 23.4 × 36.5cm
Tate, London
Finberg CLXXXIX · plate 46

View over the Roman Campagna, 1819
From the 'Rome: Colour Studies' sketchbook (open at page 34)
Watercolour on paper, 25.4 × 40.1cm
Tate, London
Finberg CLXXXVII · plate 57

Naples: Vesuvius, 1819
From the 'Rome: Colour Studies' sketchbook (open at page 18)
Pencil and watercolour on paper, 25.3 × 40.3cm
Tate, London
Finberg CLXXXVII

The Castel dell'Ovo, Naples, with Capri and Sorrento in the Distance: Early Morning, 1819
From the 'Rome: Colour Studies' sketchbook (open at page 2)
Watercolour on paper, 25.7 × 40.4cm
Tate, London
Finberg CLXXXVII · plate 51

Twelve Sketches Inspired by Select Views in Italy by John Warwick Smith, c.1819
From the 'Italian Guide Book' sketchbook (open at page 18)
Ink on paper, 15.5 × 9.9cm
Tate, London
Finberg CLXXII

Edinburgh from Calton Hill, 1818–20
Watercolour over pencil with gouache and scraping out on paper, 16.7 × 24.9cm
National Gallery of Scotland, Edinburgh
D 5446 · plate 72

The Grand Canal, with the Palazzo Grimani, from below the Rialto Bridge, c.1820
Watercolour on paper, 28.3 × 40.7cm
National Gallery of Ireland, Dublin
Wilton 725 · plate 103

Minehead, Somersetshire, c.1820
Watercolour and pencil on paper, 15.2 × 22.2cm
Lady Lever Art Gallery, Port Sunlight, National Museums Liverpool
Wilton 469 · plate 70

Hythe, Kent, 1824
Watercolour on paper, 14 × 22.9cm
Guildhall Art Gallery, London
Wilton 475 · plate 71

Tomb of Cecilia Metella, Rome, c.1832
Watercolour and scraping-out on paper, 11.1 × 21.6cm
Manchester Art Gallery
Wilton 1214

Lancaster from the Aqueduct Bridge, c.1825
Watercolour with gouache on paper, 28 × 39.4cm
Lady Lever Art Gallery, Port Sunlight, National Museums Liverpool
Wilton 786 · plate 68

Galileo's Villa, c.1826–7
For Samuel Rogers's *Italy, A Poem*
Watercolour on paper, 24.1 × 30.7cm
Tate, London
Finberg CCLXXX 163 · plate 66

The Temples of Paestum, c.1826–7
For Samuel Rogers's *Italy, A Poem*
Watercolour, gouache and scraping-out on paper,
24.1 × 29.7cm
Tate, London
Finberg CCLXXX 148 · plate 64

Florence, from San Miniato, c.1827
Watercolour on paper, 29 × 42.5cm
The Herbert Art Gallery and Museum, Coventry
Wilton 727 · plate 62

A Villa (Villa Madama – Moonlight) c.1826–7
For Samuel Rogers's *Italy, A Poem*
Watercolour on paper, 29.7 × 24.1cm
Tate, London
Finberg CCLXXX 159 · plate 65

Virginia Water, c.1829
Watercolour on paper, 29 × 44.3cm
Private Collection on loan to the National Gallery
of Scotland, Edinburgh
Wilton 519 · plate 73

Genoa, c.1832
Watercolour and pencil on paper, 17 × 25.6cm
Sterling and Francine Clark Art Institute,
Williamstown, Massachusetts, gift of the Manton
Art Foundation in memory of Sir Edwin and Lady
Manton
Wilton 1231 · plate 67

The Doge's Palace from the Bacino, 1840
Pencil and watercolour, with scratching-out and
details added using a pen dipped in watercolour
Walker Art Gallery, National Museums Liverpool
Wilton 1373 · plate 102

*Among the Chimney-pots above Venice;
the Roof of the Hotel Europa, with the
Campanile of San Marco, 1840*
Gouache, pencil and watercolour on paper,
24.5 × 30.6cm
Tate, London
Finberg CCCXVI a 36 · plate 110

*Turner's Bedroom in the Palazzo Giustiniani
(the Hotel Europa), Venice, 1840*
Watercolour and gouache on pale buff paper,
23 × 30.2cm
Tate, London
Finberg CCCXVII b 34 · plate 109

*Venice: Looking North from the Hotel Europa,
with the Campaniles of San Marco, San Moise
and Santo Stefano, 1840*
Watercolour and gouache on paper, 19.8 × 28.2cm
Tate, London
Finberg CCCXVI a 3 · plate 104

*Venice: The Salute from the Traghetto
del Ridotto, c.1840*
Watercolour and gouache on red-brown paper,
25 × 30.7cm
Tate, London
Finberg CCCXVIII c 11 · plate 114

*Venice: Santa Maria della Salute with the
Traghetto San Maurizio, 1840*
Pencil and watercolour on paper, 24.5 × 30.4cm
Tate, London
Finberg CCCXVI a 1 · plate 108

*Venice: Shipping in the Bacino, with the
Entrance to the Grand Canal, 1840*
From the 'Roll Sketchbook of Venice'
Watercolour on paper, 22.1 × 32.1cm
Tate, London
Finberg CCCXV 4 · plate 113

*Venice: Shipping Moored off the Riva degli
Schiavoni, 1840*
Gouache and watercolour on paper, 24.6 × 30.5cm
Tate, London
Finberg CCCXVI a 31 · plate 107

SIR WILLIAM ALLAN 1782–1850
Joseph Mallord William Turner
Ink on paper
Scottish National Portrait Gallery, Edinburgh
PG 1786

JOHN ROBERT COZENS 1752–1797
Temple of Maecenas at Tivoli, 1779–82
Blue and brown watercolour washes over pencil on
paper, 24.5 × 20.9cm.
National Gallery of Scotland, Edinburgh
D 5023.52

The Colosseum from the North, 1780
Washes of blue-grey watercolour over pencil on
paper, 36.1 × 52.8cm
National Gallery of Scotland, Edinburgh
D 5023.13 · plate 4

GEORGE DANCE 1741–1825
Joseph Mallord William Turner, 1800
Black chalk on paper, 25.5 × 19.5cm
Royal Academy of Arts, London · plate 1

RICHARD WILSON 1713/14–1782
Temple of the Sibyl, Tivoli, c.1752
Black and white chalk on paper prepared with a
brown wash, 24.8 × 41cm
National Gallery of Scotland, Edinburgh
D 4667

Prints

JOSEPH MALLORD WILLIAM TURNER
& FREDERICK CHRISTIAN LEWIS 1779–1856
Bridge and Goats, c.1806–7
Mezzotint on paper, 23 × 31.5cm
From the *Liber Studiorum*
Royal Academy of Arts, London
Rawlinson 43

JOSEPH MALLORD WILLIAM TURNER
& CHARLES TURNER 1773–1857
Woman and Tambourine, 1807 (?)
Mezzotint on paper, 20.6 × 28.7cm
From the *Liber Studiorum*
Royal Academy of Arts, London
Rawlinson 3

JOSEPH MALLORD WILLIAM TURNER
& CHARLES TURNER 1773–1857
Mount St Gothard, 1808
Mezzotint on paper, 20.6 × 28.6cm
From the *Liber Studiorum*
Royal Academy of Arts, London
Rawlinson 9

JOSEPH MALLORD WILLIAM TURNER
& ROBERT DUNKARTON 1744–1811?
Temple of Minerva Medica, 1811
Mezzotint on paper, 20.7 × 28.9cm
From the *Liber Studiorum*
Royal Academy of Arts, London
Rawlinson 23

JOSEPH MALLORD WILLIAM TURNER
& WILLIAM SAY 1768–1834
Apullia in Search of Appulus, 1811–19 (?)
Mezzotint on paper, 20.9 × 29.2cm
From the *Liber Studiorum*
Royal Academy of Arts, London
Rawlinson 72

JOSEPH MALLORD WILLIAM TURNER
& WILLIAM SAY 1768–1834
Glaucus and Scylla, 1811–19 (?)
Mezzotint on paper, 20.9 × 28.8cm
From the *Liber Studiorum*
Royal Academy of Arts, London
Rawlinson 73

JOSEPH MALLORD WILLIAM TURNER
& WILLIAM SAY 1768–1834
Scene in the Campagna, 1812
Mezzotint on paper, 20.7 × 28.7cm
From the *Liber Studiorum*
Royal Academy of Arts, London
Rawlinson 38

JOSEPH MALLORD WILLIAM TURNER
& HENRY DAWE 1790–1848
Isleworth, 1819
Mezzotint on paper, 20.9 × 29.2cm
From the *Liber Studiorum*
Royal Academy of Arts, London
Rawlinson 63

COUNT ALFRED GUILLAUME GABRIEL
D'ORSAY 1801–1852
Joseph Mallord William Turner
Lithograph on paper, 28.5 × 7.7cm
National Gallery of Scotland, Edinburgh

WILLIAM MILLER 1796–1882
AFTER JOSEPH MALLORD WILLIAM TURNER
Ducal Palace, Venice
Engraving on paper, 42.3 × 34.5cm
National Gallery of Scotland, Edinburgh

GIOVANNI BATTISTA PIRANESI 1720–1778
Veduta del Tempio della Sibilla in Tivoli
Etching on paper, 38 × 61cm
National Gallery of Scotland, Edinburgh

GIOVANNI BATTISTA PIRANESI 1720–1778
Veduta dell Piazza di Monte Cavallo
Etching on paper, 38 × 61cm
National Gallery of Scotland, Edinburgh

GIOVANNI BATTISTA PIRANESI 1720–1778
Veduta del Campidoglio
Etching on paper, 38 × 61cm
National Gallery of Scotland, Edinburgh

GIOVANNI BATTISTA PIRANESI 1720–1778
Veduta del Tempio di Giovane Tonante
Etching on paper, 38 × 61cm
National Gallery of Scotland, Edinburgh

GIOVANNI BATTISTA PIRANESI 1720–1778
Veduta di Campo Caccino
Etching on paper, 38 × 61cm
National Gallery of Scotland, Edinburgh

GIOVANNI BATTISTA PIRANESI 1720–1778
Veduta della Piazza del Popolo
Etching on paper, 38 × 61cm
National Gallery of Scotland, Edinburgh · plate 47

GIOVANNI BATTISTA PIRANESI 1720–1778
Veduta dell'Anfiteatro Flavio ditto il Colosseo
Etching on paper, 38 × 61cm
National Gallery of Scotland, Edinburgh

GIOVANNI BATTISTA PIRANESI 1720–1778
Veduta del Porto di Ripa Grande
Etching on paper, 38 × 61cm
National Gallery of Scotland, Edinburgh

GIOVANNI BATTISTA PIRANESI 1720–1778
Veduta del Tempio di Bacco
Etching on paper, 38 × 61cm
National Gallery of Scotland, Edinburgh

GIOVANNI BATTISTA PIRANESI 1720–1778
*Veduta del Mausoleo d'Elio Adriano (Castello
S. Angelo)*
Etching on paper, 38 × 61cm
National Gallery of Scotland, Edinburgh

CHARLES TURNER 1773–1857
Joseph Mallord William Turner, 1856
Mezzotint on paper, 37 × 29.2cm
Scottish National Portrait Gallery, Edinburgh

Books and Miscellaneous

LUDOVICO ARIOSTO 1474–1573
Orlando Furioso, published Venice, 1565
Private Collection

REVD JOHN JAMES BLUNT 1794–1855
*Vestiges of Ancient Manners and Customs,
Discoverable in Modern Italy and Sicily,*
published London, 1823
Private Collection

WALTER FAWKES 1769–1825
*The Chronology of the History of Modern
Europe,* published York, 1810
Private Collection

OLIVER GOLDSMITH 1730–1774
*The Roman History, from the foundation of the
City of Rome, to the Destruction of the Western
Empire,* published London, 1786
Private Collection

JAMES HAKEWILL 1778–1843
*A Picturesque Tour of Italy from Drawings made
in 1816–1817,* published London, 1820
Private Collection

CHAMBERS HALL 1786–1855
*The Picture: A Nosegay for Amateurs,
Painters, Picture-Dealers, Picture-Cleaners,
Liners, Repairers, and all the Craft; being the
Autobiography of A Holy Family, by Raphael
Faithfully Written from Actual Dictation of the
Picture Herself,* published London, 1837
Private Collection

JOHN HENLEY (EDITOR)
*The Antiquities of Italy. Being the Travels of
the Learned and the Reverend Bernard de*

*Montfaucon from Paris through Italy in the
Years 1698 and 1699,* published London, 1725
Private Collection

SIR RICHARD COLT HOARE 1758–1838
Hints to Travellers in Italy, published London,
1815
Private Collection

THOMAS HOPE 1770–1831
Costume of the Ancients, published London,
1809
Private Collection

REVD THOMAS SMART HUGHES 1786–1847
Travels in Sicily, Greece and Albania, 2 volumes,
published London, 1820
Private Collection

FRANCISCUS JUNIUS 1545–1602
The Painting of the Ancients in Three Bookes …,
published London, 1638
Private Collection

THOMAS MOORE 1478–1535
*Byron's Life and Works, with his Letters and
Journals, 3 of 17 volumes,* published London,
1832–3
Private Collection

ALEXANDER POPE 1688–1744
The Odyssey of Homer, published London, 1725
Private Collection

ALEXANDER POPE 1688–1744
The Iliad of Homer, published London, 1773
Private Collection

SAMUEL ROGERS 1763–1855
Italy, A Poem, published London, 1824
Private Collection

JOHN RUSKIN 1819–1900
The Stones of Venice, vol.1, published London,
1851
Private Collection

Venice. Venezia. Venedig.
Plan of Venice with small inset vignette of St Mark's
Square and inset scroll map of the environs, as well
as a range of principal buildings along lower border.
Engraving on two sheets of joined paper, 38 × 58 cm
National Gallery of Scotland, Edinburgh

Turner's Handmade Watercolour Box
Royal Academy of Arts, London

Turner's Watercolour Palette
Royal Academy of Arts, London

Bibliography

ANONYMOUS 1847
Anonymous, 'Visits to Private Galleries. The Collection of H.A.J. Munro, Esq., of Novar', *The Art-Union, Monthly Journal of the Fine Arts, and the Arts, Decorative, Ornamental*, vol.9, 1847, pp.253–5

ANONYMOUS 1857
Anonymous, 'Visits to Private Galleries of the British School, The Collection of Hugh Munro, Esq., Hamilton Place, Piccadilly', *The Art-Journal*, vol.III, May 1857, pp.133–5

ARMSTRONG 1902
Sir Walter Armstrong, *Turner*, London, 1902

ASHBY 1925
Thomas Ashby, *Turner's Visions of Rome*, London and New York, 1925

BAILEY 1997
Anthony Bailey, *Standing in the Sun – A Life of J.M.W. Turner*, London, 1997

BAKER 2006
Christopher Baker, *J.M.W. Turner. The Vaughan Bequest*, National Galleries of Scotland, Edinburgh, 2006

BLACK 1985
Jeremy Black, *The British and the Grand Tour*, London, 1985

BOWER 1990
Peter Bower, *Turner's Papers: A Study of the Manufacture, Selection and Use of his Drawing Papers 1787–1820*, exhibition catalogue, Tate Britain, London, 1990

BRIGSTOCKE 1978
Hugh Brigstocke, 'The Rediscovery of a Lost Masterpiece by Giulio Romano', *The Burlington Magazine*, vol.CXX, no.907, October 1978, pp.665–6

BROWN 1992
David Blaney Brown, *Turner and Byron*, exhibition catalogue, Tate Britain, London, 1992

BROWN AND MANN 1990
Jonathan Brown and Richard G. Mann, *Spanish Paintings of the Fifteenth through Nineteenth Centuries*, National Gallery of Art, Washington, DC, 1990

B&J 1984
Martin Butlin and Evelyn Joll, *The Paintings of J.M.W. Turner*, 2 vols, New Haven and London, 1977, revised edition 1984

COMPANION 2001
Evelyn Joll, Martin Butlin and Luke Herrmann (eds), *The Oxford Companion to J.M.W. Turner*, Oxford, 2001

COOK AND WEDDERBURN 1903–12
Edward T. Cook and Alexander Wedderburn (eds), *The Works of Ruskin*, 39 vols, London, 1903–12

CROAL AND NUGENT 1996
Melva Croal and Charles Nugent, *Turner Watercolours from Manchester*, exhibition catalogue, USA tour and Whitworth Art Gallery, Manchester, 1996

CUBBERLEY AND HERRMANN 1992
Tony Cubberley and Luke Herrmann, *Twilight of the Grand Tour: A Catalogue of the Drawings by James Hakewill in the British School at Rome Library*, Rome, 1992

EATON 1820
Charlotte Eaton, *Rome in the Nineteenth Century*, Edinburgh, 1820

EUSTACE 1813, 1815
Revd John Chetwode Eustace, *A Classical Tour through Italy*, 2 vols, London, 1813, revised edition, 4 vols, 1815

FARINGTON, *DIARY*
Kenneth Garlick, Angus Macintyre and Kathryn Cave (eds), *The Diary of Joseph Farington R.A. 1793–1821*, 16 vols, New Haven and London, 1978–84

FINBERG 1909
A.J. Finberg, *A Complete Inventory of the Drawings of the Turner Bequest*, vol.I, London, 1909

FINBERG 1930
A.J. Finberg, *In Venice with Turner*, London, 1930

FINBERG 1961
A.J. Finberg, *The Life of J.M.W. Turner, R.A.*, Oxford, 1939, revised edition 1961

FROST AND REEVE 1865
William E. Frost and Henry Reeve, *A Complete Catalogue of the Paintings, Watercolour Drawings and Prints in the Collection of the late Hugh Andrew Johnstone Munro, Esq., of Novar, at the time of his death deposited in his house, No 6 Hamilton Place, London, with some additional paintings at Novar*, privately published, London, 1865

GAGE 1969
John Gage, *Colour in Turner: Poetry and Truth*, London, 1969

GAGE 1980
John Gage, *The Collected Correspondence of J.M.W. Turner, with an early diary and a memoir by George Jones*, Oxford, 1980

GAGE 1987
John Gage, *J.M.W. Turner 'A Wonderful Range of Mind'*, New Haven and London, 1987

GARLICK 2004
Kenneth Garlick, 'Munro, Hugh Andrew Johnstone, of Novar (1797–1864)', *Oxford Dictionary of National Biography*, Oxford, 2004–8: online at http://www.oxforddnb.com

GPV
Gazzetta Privilegiata di Venezia

GELLER 1996
K. Gellér, 'Károly Brocky', in J. Turner (ed.), *The Dictionary of Art*, London, 1996

HAMILTON 1997
James Hamilton, *Turner – A Life*, London, 1997

HAMILTON 2003 A
James Hamilton, *Turner, The Late Seascapes*, New Haven and London, 2003

HAMILTON 2003B
James Hamilton, *Turner's Britain*, London, 2003

HAMILTON 2007
James Hamilton, *London Lights – The Minds that Moved the City that Shook the World*, London, 2007

HARRISON 2000
Colin Harrison, *Turner's Oxford*, exhibition catalogue, Ashmolean Museum, Oxford, 2000

HERMANN 1968
Luke Hermann, *Ruskin and Turner: A Study of Ruskin as a Collector of Turner ... incorporating a Catalogue Raisonné of the Turner Drawings in the Ashmolean Museum*, Oxford, 1968

HERMANN 1999
Frank Hermann, *The English as Collectors, A Documentary Sourcebook*, London, 1972, revised edition 1999

HILL 2000
David Hill, *Le Mont-Blanc et la Vallée d'Aoste*, exhibition catalogue, Musée Archéologique Régional, Aoste, 2000

HOLLOWAY 1991
James Holloway, 'H.A.J. Munro of Novar', *Review of Scottish Culture*, vol.VII, 1991, pp.9–13

HUMFREY 2004
Peter Humfrey, Timothy Clifford, Aidan Weston-Lewis and Michael Bury, *The Age of Titian, Venetian Renaissance Art from Scottish Collections*, exhibition catalogue, National Gallery of Scotland, Edinburgh, 2004

INIGUEZ 1981
D. Angulo Iniguez, *Murillo, Catalogo Critico*, Madrid, 1981

IRWIN 1982
Francina Irwin et al., *Turner in Scotland*, exhibition catalogue, Aberdeen Art Gallery and Museum, 1982

LLOYD WILLIAMS 1992
Julia Lloyd Williams, *Dutch Art and Scotland, A Reflection of Taste*, exhibition catalogue, National Gallery of Scotland, Edinburgh, 1992

LYLES 1992
Anne Lyles, *Turner: The Fifth Decade*, exhibition catalogue, Tate Britain, London, 1992

MILLER 2007
James Miller, 'The Ullens Collection: the Open Market', *Important Turner Watercolours from the Guy and Myriam Ullens Collection*, Sotheby's, 4 July 2007, pp.24–7

POWELL 1987
Cecilia Powell, *Turner in the South: Rome, Naples, Florence*, New Haven and London, 1987

POWELL 1998
Cecilia Powell, *Italy in the Age of Turner: 'The Garden of the World'*, exhibition catalogue, Dulwich Picture Gallery, London, 1998

RAIMBACH 1843
M.T.S. Raimbach (ed.), *Memoirs and Recollections of the late Abraham Raimbach*, London, 1843

RAWLINSON 1908–13
W.G. Rawlinson, *The Engraved Work of J.M.W. Turner R.A.,* 2 vols, London, 1908–13

REDFORD 1888
George Redford, *Art Sales*, London, 1888, vol.I, pp.270–80

ROBERTSON 1978
David Robertson, *Sir Charles Eastlake and the Victorian Art World*, Princeton, 1978

SEBAG-MONTEFIORE 2001
Charles Sebag-Montefiore, 'Munro of Novar, Hugh Andrew Johnstone (1797–1864)', in Evelyn Joll, Martin Butlin and Luke Hermann (eds), *The Oxford Companion to J.M.W. Turner*, Oxford, 2001, pp.194–5

SHANES 1990
Eric Shanes, *Turner's England 1810–38*, London, 1990

STAINTON 1985
Lindsay Stainton, *Turner's Venice*, London, 1985

STARKE 1828
Mariana Starke, *Information and Directions for Travellers on the Continent*, sixth edition, London, 1828

TB
Turner Bequest, the artist's bequest of his work to the nation, held at Tate Britain, London

TMJ
Wilfred S. Dowden (ed.), *The Journal of Thomas Moore*, 6 vols, Newark and London, 1983–91

THORNBURY 1862, 1877, 1897, 1970
Walter Thornbury, *The Life and Correspondence of J.M.W. Turner R.A.*, London, 1862, revised editions 1877, 1897, and 1970

TSN
Turner Society News

WAAGEN 1838
G.F. Waagen, *Works of Art and Artists in England*, London, 1838

WAAGEN 1854
G.F. Waagen, *Treasures of Art in Great Britain*, vol. II, London, 1854

WARRELL 2002
Ian Warrell, *Turner et le Lorrain*, exhibition catalogue, Musée des Beaux-Arts de Nancy, 2002

WARRELL 2003
Ian Warrell, with Jan Morris, Cecilia Powell and David Laven, *Turner and Venice*, exhibition catalogue, Tate Britain, 2003–4; Kimbell Art Museum, Fort Worth, 2004; Museo Correr, Venice, 2004–5; CaixaForum, Barcelona, 2005; London, 2003

WARRELL 2008
Ian Warrell, *J.M.W. Turner*, exhibition catalogue, National Gallery of Art, Washington, DC; Dallas Museum of Art; Metropolitan Museum of Art, New York; London, 2008

WHITTINGHAM 1987
Selby Whittingham, 'Watteaus and "Watteaus" in Britain c.1780–1851' in F. Moreau and M. Morgan Grasselli, *Antoine Watteau (1684–1721) le peintre, son temps et sa légende*, Paris and Geneva, 1987, pp.269–77

WHITTINGHAM 1996
Selby Whittingham, 'Munro of Novar, H.A.J.', J. Turner (ed.), *The Dictionary of Art*, London, 1996, vol.22, pp.314–5

WILTON 1979
Andrew Wilton, *J.M.W. Turner, His Art and Life*, New York, 1979

WILTON 1980
Andrew Wilton, *Turner and the Sublime*, exhibition catalogue, Art Gallery of Ontario, Toronto; Yale Center for British Art, New Haven; The British Museum, London; London, 1980

WILTON 1982
Andrew Wilton, *Turner Abroad: France, Italy, Germany, Switzerland*, London 1982

WILTON 1987
Andrew Wilton, *Turner in his Time*, London, 1987

WILTON 1990
Andrew Wilton, *Painting and Poetry, Turner's 'Verse Book' and his Work of 1804–1812*, Tate, 1990

WILTON 2007
Andrew Wilton, *Turner in his Time*, London, 1987, revised edition 2007

Notes and References

INTRODUCTION
PAGES 9–11

1. Following his 1802 journey to Aosta, Turner travelled to Italy on six occasions, in 1819, 1828–9, 1833, 1836, 1840 and 1843.

2. Kenneth Clark, *Landscape into Art*, London, second edition, 1956, p.111.

3. Important contributions to the study of Turner's engagement with Italy include Brown 1992, Hill 2000, Powell 1987, Powell 1998, Warrell 2002, Warrell 2003, Wilton 1980 and Wilton 1982.

4. See chapter 6, note 33, of James Hamilton's essay.

5. B&J, 388.

DREAMS OF ITALY · PAGES 13–17

1. Harrison 2000, p.38.

2. I-A, – B, – F; 'Oxford' sketchbook, II; III, sheets A-E.

3. Joshua Reynolds, Discourse XV, *Discourses*.

4. Useful accounts of Turner's early life and influences are to be found in Bailey 1997, Finberg 1909, Gage 1987, Hamilton 1997, Wilton 1987 and others.

5. 'Wilson' sketchbook, XXXVII, pp.78–9 and 86–7.

FROM THE MOUNTAIN TOP
PAGES 19–25

1. Farington's journal of his Paris visit is included in Farington, *Diary*, 27 August 1802, vol.V, p.1809.

2. Raimbach 1843, p.37.

3. Raimbach 1843, p.5 on.

4. 'Studies in the Louvre' sketchbook, LXXII, pp.24–5, inscribed by Turner 'Titian and his Mistress'.

5. 'Small Calais Pier' sketchbook, LXXI, pp.62a and 63a.

6. 'Studies in the Louvre' sketchbook, LXXII, pp.24–23a.

left: detail of [35]

7. He has written the word 'back' on page one, an instruction to the binder, which the binder appears to have disregarded as he has made this page the front.

8. 'Studies in the Louvre' sketchbook, LXXII, p.28a.

9. See Hamilton 1997, p.81, for a consideration of why Turner might have painted the figures in this way.

10. Cecilia Powell, 'Turner's Travelling Companion of 1802: A Mystery Resolved?', TSN, no.54, February 1991, p.12–15.

11. Ibid.

12. Gage 1987, p.42.

13. *Art Treasures Exhibition*, Manchester, 1857, provisional catalogue, p.111, quoted Gage 1980, p.302.

14. Hill 2000.

15. 'I went to the Picture gallery and saw Turner who returned from Switzerland two or three days ago. He found that country in a very troubled state, but the people well inclined to the English. Grenoble is about a day's journey beyond Lyons … It took him four days to go from Paris to Lyons.', Farington, *Diary*, 30 September 1802, vol.V, p.1890.

16. Raimbach names Sir Benjamin West, Turner, Thomas Phillips, John Opie, Thomas Daniell, Martin Archer Shee and John Flaxman as having made the effort to get to Paris, Raimbach 1843, p.50–1; Farington adds Henry Fuseli and Jean-Jacques Masquerier to the list, Farington, *Diary*, 5 October 1802, vol.V, p.1901–2.

17. Farington, *Diary*, 1 October 1802, vol.V, p.1890.

18. Quoted B&J 1984, 48.

19. The later version of this subject [20] was exhibited in 1812.

20. 'Finance and Property' entry in *Companion*.

21. Farington, *Diary*, 22 May 1804, vol.VI, p.2328.

22. John Burnet and John Cunningham, *Turner and his Works*, London, 1852, p.78–9, quoted in B&J 1984, 47.

23. B&J 1984, 50.

24. T.F. Dibdin, *Reminiscences of a Literary Life*, London, 1836, vol.II, pp.686–9.

25. Hamilton 1997, p.224–5; David Hill, *Turner's Birds: Bird Studies from Farnley Hall*, London, 1988; and Anne Lyles, *Turner and Natural History – The Farnley Project*, exhibition catalogue, Tate Britain, London, 1988.

26. *Tabley, the Seat of Sir J.F. Leicester, Bart: Windy Day*, B&J 1984, 98, and *Tabley, Cheshire, the Seat of Sir J.F. Leicester, Bart: Calm Morning*, B&J 1984, 99.

27. Helen Dorey, *John Soane and J.M.W. Turner – Illuminating a Friendship*, exhibition catalogue, Sir John Soane's Museum, London, 2007.

28. Quoted in Howard Colvin, *A Biographical Dictionary of British Architects 1600–1840*, London and New Haven, 1995, p.1107.

'TURNER SHOULD COME TO ROME'
PAGES 27–37

1. Farington, *Diary*, 11 May 1804, vol.VI, p.2319–20.

2. *True Briton*, 9 May 1803.

3. Thornbury 1897, p.121–2. This suggests that Trimmer's father's insurers forbade him from taking part in 'dangerous sports' like sailing.

4. Hamilton 1997, p.16–18.

5. 'Studies for Pictures: Isleworth' sketchbook, XC, pp.1, 49a, 52a, 59 and passim.

6. Oliver Goldsmith, *The Roman History from the Foundation of the City of Rome to the Destruction of the Western Empire*, new edition, London, 1786, vol.2, inside front cover. This is now in a private collection.

7. Ibid., pp.3 and 8.

8. 'Wey, Guildford' sketchbook, XCVIII, p.5.

9. Studies for *Garden of the Hesperides* are in 'Hesperides I' sketchbook, XCIII, pp.1, 3, 3v and 8–10.

10. John Ruskin, *Modern Painters*, London, 1860, vol.5, part IX, chapter X, paragraph 24. What Ruskin goes on to explain is that in his view the dragon

represents the resurrected dragon, after St George's slaying of it: 'The fairy English Queen once thought to command the waves, but it is the sea-dragon now who commands her valleys.'

11. Turner's copy of Livy *The Roman History* (1686) is missing. The library was looked after and catalogued by Turner's uncle's descendant C.W.M. Turner, and remains in a private collection. Its contents are listed in Wilton 1987, pp.246–7.

12. One, *Windsor Castle from the Thames*, c.1805 (B&J 1984, 149), he does not seem to have exhibited, but sold directly to Lord Egremont. This canvas he signed 'I. M. W. Turner RA ISLEWORTH'.

13. B&J 1984, 72; Eric Shanes, *Turner's Human Landscape*, London, 1990, pp.24–8; Wilton 1990, p.50–3; and Hamilton 2003 B, p.81–4.

14. In the 1862 exhibition it was cat.no.330, B&J 1984, 86.

15. James Thomson, *The Seasons*, 'Summer', ll 1425–7 and 1435–7, first published in 1727.

16. Wilton 1990, p.30–45 and passim.

17. He included lines of Milton, Thomson, Pope, Spenser and others as epigraphs for some of his exhibited pictures.

18. J.M.W. Turner, 'Lines to a Gentleman at Putney, requesting him to place one [an Aeolian Harp] in his grounds', quoted in B&J 1984, 86. See also Wilton 1990, no.44.

19. Maurice Davies, *Turner as Professor*, exhibition catalogue, Tate Britain, London, 1992, p.18–21; and Hamilton 2007, p.55–6.

20. 'Devonshire Coast no. 1' sketchbook, CXXIII, p.30v. Transcription by Rosalind Turner, in Wilton 1990, p.170.

21. B&J 1984, 114.

22. B&J 1984, 34.

23. Thornbury 1862, p.123.

24. Illustration 183 from Cesare Ripa, *Iconologia*, London, 1709. See William Chubb, 'Minerva Medica and the Tall Tree', *Turner Studies*, 1981, vol.1, no.2, p.31.

25. Quoted Hamilton 2007, p.205.

26. John Murray to Lord Byron, 9 April 1814, in Andrew Nicholson (ed.), *The Letters of John Murray to Lord Byron*, Liverpool, 2007, no.38.

27. David Brown, *Turner and Byron*, exhibition catalogue, Tate Britain, London, 1992, gives a full account of the mutual artistic debt between painter and poet.

28. Virgil, *The Aeneid*, Book 1, ll 605–6, translated by John Dryden, first published in 1697.

29. He also knew Henry Coxe's book, *A Picture of Italy: being a guide to the antiquities and curiosities of that classical and Interesting country*, London, 1815, second edition 1818, and referred to it in his 'Artists' Benevolent Fund' sketchbook, CLXIII, p.1.

30. Preface in Richard Colt Hoare, *Hints to Travellers in Italy*, London, 1815.

31. Henry Sass, *A Journey to Rome and Naples, performed in 1817; giving an account of the present state of society in Italy, and containing observations on the fine arts*, London,1818, p.5–6..

32. 'Route to Rome' sketchbook, CLXXI, pp.38a, 37a, 36a and 35a-35. The instructions are written from the back of the book.

33. Ibid., p.20.

34. All are superbly reproduced in Cubberley and Herrmann 1992.

35. 'Route to Rome' sketchbook, CLXXI, pp.9 and 13.

36. Eustace 1815, vol.1, pp.2 and 5.

37. 'Italian Guide Book' sketchbook, CLXXII, p.15.

38. Royal Academy Archive, LAW/3/52.

39. *Literary Gazette*, 22 May 1819.

40. William Carey, *Some Memoirs of the Patronage and Progress of the Fine Arts in England and Ireland*, London, 1826, p.147.

TURNER'S ROUTE TO ROME
PAGES 39–53

1. National Galleries of Scotland, D5181b, W502; letter dated Monday 26 July 1819; Gage 1980, 85.

2. Gage 1980, 84.

3. Hamilton 1997, p.333–4.

4. 'Paris, France, Savoy' sketchbook, CLXXIII, p.1a.

5. 'Calais Pier' sketchbook, LXXXI, pp.58–9.

6. 'Turin, Como, Lugano, Maggiore' sketchbook, CLXXIV, p.80, and 'Passage of the Simplon' sketchbook, CXCIV, which Federico Crimi has shown follows directly from CLXXIV, F. Crimi, 'Turner e il Verbano. Sulle verdute del Porto di Arona e dell'Isola Bella', *Verbanus*, no.27, 2006, pp.177–202.

7. GPV, 5 June 1819.

8. GPV, 20 July 1819.

9. GPV, 6 September 1819. Confusingly, there are two entries for that day that might be him: one is 'Turner, G[entiluomo] I[nglese]' recorded as having arrived from Milan, and the other, also from Milan, is 'Curner, William, G. I.' To complicate matters further, on 8 and 9 September another William Turner, also 'G. I.' is listed as arriving from Milan

[GPV 17 September 1819]. So, now there are three possible Turners in Venice. On the day that our third candidate arrives, Mr 'Curner', now listed as 'Curner, VVilliam, Gentiluomo' departs for Ferrara, while one of the two 'Turners' remains until 12 or 13 September, and appears to go back to Milan. He is described on departure as a 'possidente', that is, a property owner. It has generally been accepted [Warrell, 2003, p.16] that J.M.W. Turner's departure date was 12 or 13 September, and that this record [GPV, 20 September 1819] refers to him. But J.M.W. Turner did not go back to Milan, but to Bologna via Ferrara. It seems likely, on balance, that J.M.W. Turner is the visitor to Venice erroneously listed as William Curner, and that he was in the city for eight or nine days from 1 to 8 or 9 September.

10. 'Milan to Venice' sketchbook, CLXXV, p.49.

11. 'Milan to Venice' sketchbook, CLXXV; 'Venice to Ancona' sketchbook, CLXXVI; and 'Como and Venice' sketchbook, CLXXXI.

12. 'Como and Venice' sketchbook, CLXXXI, p.3. This has recently been identified as looking from the Hotel Tre Re towards the now demolished tower of S. Giovanni in Conca, with Sant'Alessandro in Zebedia beyond. I am grateful to Federico Crimi and Ian Warrell for this information.

13. 'Milan to Venice' sketchbook, CLXXV, p.79.

14. 'Milan to Venice' sketchbook, CLXXV, p.40a. This is a very odd and meagre detail, which is on the same sheet as a study of Venice. The unanswerable question remains, why did he only take such a tiny detail here? The painting was destroyed by fire in the 1860s.

15. 'Venice to Ancona' sketchbook, CLXXVI, p.10a.

16. Ibid., p.1a.

17. Ibid., p.20a.

18. GPV, 21 and 22 September 1819.

19. 'Route to Rome' sketchbook, CLXXI and passim.

20. 'Lines Written Among the Euganean Hills', line 52, by Percy Bysshe Shelley, written in 1818, published 1819.

21. 'Venice to Ancona' sketchbook, CLXXVI, p.22a.

22. Ibid., pp.26–34.

23. Ibid., p.25, 26a and 26b.

24. Ibid., p.32a

25. Ibid., p.86.

26. Ibid., p.43.

27. Ibid., p.47. This is no longer a hotel, but houses offices including a dentist, a lawyer and a solicitor.

28. Ibid., pp.53a, 55a and 56.

29. Ibid., p.58a-60; 'Ancona to Rome' sketchbook,

CLXXVII, pp.34, 38a-43 and 48–79.

30. Thomas Lawrence to Joseph Farington, 6 October 1819, Royal Academy Archive, LAW/3/73.

31. 'Italian Guide Book' sketchbook, CLXXII, p.11.

32. Mary Somerville to her mother, 8 January 1818, Somerville Papers, Bodleian Library, Oxford, MS FP-4.

33. Census, 'Stati d'Animi', Archivio Storico di Vicariato di Roma, 1819, Parish of Sant'Andrea delle Frate. Ugo is given as aged thirty-four. His eldest child, Scipione, became a sculptor. Scipione's bust of L.A. Moratori (1850) is in the Borghese Gardens. Alfonzo Panzetti, *Dizionario degli Scultore Italiani*, 2003, vol.2, p.944.

34. 'Vatican Fragments' sketchbook, CLXXX, inside back cover.

35. Gage 1980, 86.

36. Donaldson's passport, 8 May 1818, RIBA/V&A Archive, DoT/1/2/1.

37. Maria Graham, *Memoirs of the Life of Nicholas Poussin*, London and Edinburgh, 1820. See also Nancy Scott, '"Dear Home", a sculptor's view of Rome 1867–71: the unpublished letters of Anne Whitney', *Sculpture Journal*, 2008, vol.17, no.1, pp.19–35.

38. Maria Graham, *Three Months Passed in the Mountains East of Rome During the Year 1819*, London, 1820, p.188ff.

39. Ibid., appendix, Edict of Cardinal Consalvi, 18 July 1819, pp.231–7.

40. Samuel Rogers mentioned the umbrella to Ruskin. Ruskin Library, University of Lancaster, MS 54/C, quoted in Gage 1980, p.280.

41. Humphry Davy's notebook 14g, p.45, Royal Institution Archive.

42. Ibid.

43. Letter dated 25 May 1818 in John Davy, *Fragmentary Remains*, London, 1858, pp.220f. Quoted in David Knight, *Humphry Davy – Science and Power*, Cambridge, 1992, p.118.

44. Humphry Davy to Michael Faraday, 16 November 1819, Royal Institution Archive, MS F8,368. Frank A.J.L. James (ed.), *The Correspondence of Michael Faraday*, vol.1, 1811–31, London, 1991, no.107.

45. TMJ, p.254.

46. TMJ, p.261.

47. TMJ, p.251.

48. Mariana Starke, *Letters from Italy; containing a View of the Revolutions in that Country, from the Capture of Nice, by the French Republic, to the Expulsion of Pius VI from the Ecclesiastical State: Likewise Pointing out the matchless Works of Art which still Embellish Pisa, Florence, Siena, Rome, Naples, Bologna, Venice &c., also specifying the expense incurred by residing in various parts of Italy, France &c., so that persons who visit the Continent from economical motives may select the most eligible Places for permanent Residence, With instructions for Invalids, relative to the Island of Madeira; and for the use of Invalids and families who may wish to avoid the Expense attendant upon travelling with a Courier*, second edition, revised, corrected and considerably enlarged, by an itinerary of Chamouni, and all the most frequented Passes of the Alps, Germany, Portugal, Spain, France, Holland, Denmark, Norway, Sweden, Russia and Poland, two vols, London, 1815, p.274ff.

49. 'Vatican Fragments' sketchbook, CLXXX.

50. Drawings of Capitoline Museum sculpture are in 'Vatican Fragments' sketchbook, CLXXX, p.52a–8.

51. Ibid., p.9.

52. 'D . M . / T . FLAVIO . EVCH / ARISTO . FECIT / FLAVIA . SABINA . FILIA . PIENTISSI / MA . PATRI . DVL / CISSIMO. This is now in Bay XLII of the Lapidary Gallery of the Vatican Museum. Listed *Corpus Insc. Latinam*, 1886, vol.VI, pt.3.

53. 'Vatican Fragments' sketchbook, CLXXX, p.11.

54. Ibid., p.19.

55. RIBA/V&A archive, DOT/3/1.

56. 'Gandolfo to Naples' sketchbook, CLXXXIV; 'Pompeii, Amalfi, Sorrento and Herculaneum' sketchbook, CLXXXV; and 'Naples, Paestum and Rome' sketchbook, CLXXXVI.

57. John Soane the younger to his father, 15 November 1819, Sir John Soane's Museum.

58. *Eruption of the Souffrier Mountains, in the Island of St Vincent, at Midnight, on the 30th April, 1812 from a Sketch Taken at the Time by Hugh P.Keane, Esq*, exhibited 1815, University of Liverpool.

59. Humphry Davy to Michael Faraday, 10 December 1819, Royal Institution Archive MS F8, 368; Frank A.J.L. James (ed.), *The Correspondence of Michael Faraday*, vol.1, 1811–31, London, 1991, no.108.

60. 'Albano, Nemi, Rome' sketchbook, CLXXXII, p.26. The 'certificato per passaporto' recording Turner's departure from Naples is in the Archivio de Stato di Napoli, Ministero degli Affari Esteri, 6291.

61. 'Pompeii, Amalfi, Sorrento and Herculaneum' sketchbook, CLXXXV, p.68.

62. 'Tivoli and Rome' sketchbook, CLXXIX and 'Tivoli' sketchbook, CLXXIII.

63. The titles that Turner and Finberg gave the sketchbooks do not always accurately reflect the contents, and nor do the sequences of the drawings on the pages always reflect a reasonable or even a likely route. The first clues to the order in which they might have been used is Turner's own partial, and sometimes lost, numbering system, which he seems to have devised soon after his return to London in early February 1820. Even this does not give a realistic order, and the circumstances under which Turner numbered the books is unknown. See Hamilton 1997, p.204.

64. 'Rimini to Rome' sketchbook, CLXXVIII; 'Vatican Fragments' sketchbook, CLXXX; 'Albano, Nemi, Rome' sketchbook, CLXXXII; 'St Peter's' sketchbook, CLXXXVIII; 'Rome Colour Studies' sketchbook, CLXXXIX; 'Small Roman Colour Studies' sketchbook, CXC; 'Rome and Florence' sketchbook, CXCI; an eighth 'Tivoli and Rome' sketchbook, CLXXIX, has a detailed section of studies in the Vatican.

65. They are of different sizes, so Finberg named the smaller one 'Small Roman Colour Studies'. Turner inscribed the larger one 'Rome: Colour Studies' and the smaller 'Roma: Colour Studies'.

66. 'Vatican Fragments' sketchbook, CLXXX, p.1 and 3; 'Rome: Colour Studies' sketchbook, CLXXXIX, p.45; and 'Rome and Florence' sketchbook, CXCI, p.6a-7.

67. So called in Turner's day because the Apollo Belvedere was sited there.

68. Thomas Moore indicated that in 1819 the loggia was at least partially glazed, because the frescoes were 'much injured by the air, except on the ceilings – Murat [one of Napoleon's marshals] had windows put here to preserve them', TMJ, 30 October 1819, p.244.

69. 'Tivoli to Rome' sketchbook, CLXXIX, p.21.

70. Ibid., p.24.

71. Katharine Eustace (ed.), '"Questa Scabrosa Missione" Canova in Paris and London in 1815', *Canova: Ideal Heads*, exhibition catalogue, Ashmolean Museum, Oxford, 1997, pp 9–38.

72. TMJ, 13 November 1819, p.254.

73. It is catalogued by the National Portrait Gallery, London (no.954) as being of Maria Callcott, the sitter's name from her second marriage.

74. Thomas Lawrence to Joseph Farington, 14 May 1819 ['1818' is written], Royal Academy Archive, LAW/3/39.

75. Henry Sass, *A Journey to Rome and Naples*, London, 1818, p.119.

76. Transcription taken from the body of the text of the letter referred to below. The date of this

intervention by the Prince Regent is not known.

77. Alexander Day lived at 11 Piazza Trinità del Monte, above and behind 12 Piazza Mignanelli. Stati d'Animi.

78. I am most grateful to Professor Michael Caesar of the University of Birmingham for translating this long letter to Sig Cav Gaspare Landi, President of the Academy of St Luke (vol.68 / no.66, Archive, Accademia di San Luca, Rome). It has not been possible to transcribe it in full here, but an extract reads: 'The Prefect of the Holy Apostolic Palaces and Maggiordomo to His Holiness is not of the opinion that tracing should be allowed because of the danger, perhaps indeed the certainty, that its effect would only be to make them deteriorate more than they have already.'

79. Cecilia Powell, 'Topography, imagination and travel: Turner's relationship with James Hakewill', *Art History*, vol.5, no.4, December 1982, pp.408–25.

80. 'Letter from Rome', *Literary Gazette*, no.148, 20 November 1819, p.747.

ASSIMILATING THE ITALIAN SUN
PAGES 55–67

1. Farington, *Diary*, 2 February 1820.

2. The canvas is in store at Tate, N05543, B&J 1984, 245.

3. Finberg 1961, p.268.

4. Turner to William Wells, 13 November 1820, Gage 1980, 89.

5. Cecilia Powell has pointed out that in the background, just beside Raphael's head, is the Piazza Rusticucci, where Raphael died on 6 April 1520, see Powell 1987, p.116.

6. It is now attributed to Sebastiano del Piombo.

7. Cecilia Powell interprets the babies falling off Father Tiber's lap as Romulus and Remus, see Powell 1987 p.59.

8. In 1820, Raphael was thought to have also been a sculptor and an architect.

9. A letter from Turner to his friend Clara Wheeler, 4 May 1820, explains this, see Gage 1980, 87.

10. Hamilton 1997, p.185–6.

11. 'Tivoli and Rome' sketchbook, CLXXIX and 'St Peter's' sketchbook, CLXXXVIII.

12. 'Milan to Venice' sketchbook, CLXXV.

13. 'St Peter's' sketchbook, CLXXXVIII and ''Tivoli and Rome' sketchbook, CLXXIX.

14. Document in J.F. Lewis Collection, Free Library of Philadelphia, quoted in Shanes 1990, pp.11 and 280, n.38.

15. Ibid., pp.128–9, 271 and 272, see also Eric Shanes, 'Turner's "Unknown" London Series', *Turner Studies*, 1981, vol.1, no. 2, pp.36–42.

16. W726–31, see also Gage 1980, appendix 11.

17. John Murray to James Hakewill, 21 July 1818, John Murray Letter Book, John Murray Archive, National Library of Scotland, MS 41908, 41909. Letter quoted in part in Cecilia Powell, 'Topography, imagination and travel: Turner's relationship with James Hakewill', *Art History*, vol.5, no.4, December 1982.

18. Turner to J.O. Robinson, 28 June 1822, see Gage 1980, 97.

19. *Snow Storm: Hannibal and his Army Crossing the Alps* was never engraved, and *Dido and Aeneas* not until 1824 by W.R. Smith.

20. Gage 1980, 97.

21. He has crossed out 'Eternal' here.

22. Thomas Phillips RA, portrait painter; William Hilton and Sir David Wilkie, painters; and Dawson Turner, banker and amateur naturalist.

23. Turner to James Holworthy, endorsed 7 January 1826, Gage 1980, 112.

24. Turner to James Holworthy, postmarked 5 May 1826, Gage 1980, 116.

25. Had it been exhibited, it is likely to have been named by Turner with a title such as 'Rialto, Venice, from the Grand Canal...' with a literary extension to the title which might perhaps have invoked Shylock, the Doge, or the decline of empire.

26. Turner to William Wells, 13 November 1820, Gage 1980, 89.

27. Hamilton 1997, pp 207–13.

28. Horace, *Odes*, 3.4, 20:

As yours, yes, yours, O Muses, do I climb to my lofty Sabine hills, or go to cool Praeneste [Palestrina], or sloping Tibur, or to cloudless Baiae, has it but caught my fancy.

29. Quoted B&J 1984, 230.

30. These are *Harbour of Dieppe (Changement de Domicile)*,1825 (B&J 1984, 231), and *Cologne, the Arrival of a Packet Boat, Evening*,1826 (B&J 1984, 232). Both works are in the Frick Collection, New York.

31. These are *The Seat of William Moffatt, Esq., at Mortlake. Early (Summer's) Morning*,1826 (B&J 1984, 235), in the Frick Collection, New York and *Mortlake Terrace, the Seat of William Moffatt, Esq. Summer's Evening*, 1827 (B&J 1984, 239), in the National Gallery of Art, Washington DC.

32. Turner to John Soane, 1 May 1826, Gage 1980, 114.

33. Soane's note is attached to the letter from Turner accepting Soane's decision to refuse the work, 8 July 1826, see Gage 1980, 117. See also Helen Dorey, *John Soane and J.M.W. Turner – Illuminating a Friendship*, exhibition catalogue, Sir John Soane's Museum, London, 2007, p.14, and James Hamilton, review of the above, TSN, no.106, August 2007, pp.12–13, with a note by 'C. F. P.' [Cecilia Powell].

34. Helen Dorey, *John Soane and J.M.W. Turner – Illuminating a Friendship*, exhibition catalogue, Sir John Soane's Museum, London, 2007.

35. Turner to Soane, 8 July 1826, Gage 1980, 117.

36. *Literary Gazette*, 13 May 1826.

37. Press cutting from *British Press*, 30 April 1826, possibly written by Robert Balmanno, Gage 1980, 115.

38. Turner to James Holworthy, 5 May 1826, Gage 1980, 116, author's italics.

39. Turner to George Jones, 22 February 1830, Gage 1980, 161.

40. John Gage, *George Field and his Circle*, exhibition catalogue, Fitzwilliam Museum, Cambridge, 1989.

41. Turner himself took the processes as his subject in his painting *An Artists' Colourman's Workshop*, Tate, B&J 1984, 207.

42. 'Chemistry and "Apuleia"' sketchbook, CXXXV.

43. Joyce Townsend, 'Turner's Writings on Chemistry and Artists' Materials', TSN, no.62, December 1992, pp.6–10 and Joyce Townsend, *Turner's Painting Techniques*, London, 1993.

44. Charles Hullmandel, lithographer. See James Hamilton, *Faraday – The Life*, London, 2002, pp.212–14 and passim, and Hamilton 2007, pp.192–7 and passim.

45. Henry Bence Jones, *Life and Letters of Faraday*, vol.1, London, 1870, pp.377–8. This account comes from George Barnard, Faraday's brother-in-law.

46. James Hamilton, *Faraday – The Life*, London, 2002, pp.241–2 and 360–1.

47. Gage 1980, 138 and 139. The engraving was never made. The 1917 photograph of the painting is illustrated in Hamilton 1997.

48. *The Times*, 6 May 1828; *Athenaeum*, 7 May 1828; and *Literary Gazette*, 3 May 1828; quoted B&J 1984, 241.

49. While the relining and transfer to plywood of this work in 1871 and 1917 may have been ill-conceived, they were laudable attempts to conserve this great, late work. It would be unfair to analyse the painting too closely from an old photograph, but what it appears to be is a monumental evocation of the Thames, perhaps of the Pool of London, dressed up in Carthaginian glory.

1. Turner to George Jones, 13 October 1828, Gage 1980, 141.

2. Turner to Charles Eastlake, postmarked 23 August 1828, Gage 1980, 140. The 'Claude' was *Landscape with Jacob and Laban* owned by Lord Egremont (Petworth House, Sussex).

3. Gage 1980, 141.

4. Enrico de Keller, *Elenco di Tutti gli Pittori Scultori Architetti Miniatori Incisori in Gemme e in Rame Scultore in Metallo e Mosaicisti aggiunti gli Scalpellini Pietrari, Perlari ed Altri Artefici … Essitenti in Roma l'Anno 1824*, Rome, 1824. Another edition was published in 1830.

5. Archivo Storico di Vacariato di Roma, census returns, 'Stati d'Animi' Parish of S Lorenzo in Lucina, 1828, Piazza Mignanelli. It is possible that no. 12 was given its upper floor in the 1870s.

6. 'Route to Rome' sketchbook, CLXXI, pp.5a and 28.

7. Thomas Uwins to Joseph Severn, 26 August 1828, see Sarah Uwins, *A Memoir of Thomas Uwins* RA, London, 1858, vol.2, p.237.

8. Turner to Francis Chantrey, 6 November 1828, Gage 1980, 142.

9. Gage 1980, 141.

10. 'Florence to Orvieto' sketchbook, CCXXXIV, p.32a, ff.

11. Cecilia Powell, '"Infuriate in the wreck of hope", Turner's *Vision of Medea*, *Turner Studies*, vol.2, 1982, no.1, pp.12–18.

12. Jerrold Ziff, 'But Why *Medea* in Rome?', ibid., p.19.

13. Lady Davy to John Murray, 18 December 1828, John Murray Archive, National Library of Scotland, Acc.12604/1320. The preface to Humphry Davy, *Consolations in Travel, or the Last Days of a Philosopher*, London, 1830 is dated 'Rome, 21 Feb 1829'.

14. Humphry Davy, *Consolations in Travel, or the Last Days of a Philosopher*, London, 1830, p.52.

15. Gage 1980, 142.

16. John Gibson wrote to Thomas Donaldson on 5 April 1829: 'I feel very happy here surrounded by all that I can desire as to the advantages of my art. Since your departure I have increased my establishment and have four good studios in the via Fontanella Babuino and a flower garden in the mids[t] of them and a fountain perpetually playing the music of which I hear whilst I am forming my nymphs & loves in marble and when tired I lay down my chisel and walk among my roses & orange trees – it is here I conceive all my classical subjects. Fortune smiles on this spot for everything which I have done in clay for this last ten years has given satisfaction and have been ordered in marble by some of our principal nobility.' RIBA/V&A Archive, DoT/1/3/1.

17. Hamilton 2007, p.172.

18. Lord Egremont to Turner, 2 December 1828, Gage 1980, 146.

19. Margaret Wyndham, *Catalogue of the Collection of Greek and Roman Antiquities in the Possession of Lord Leconfield*, Petworth, 1925, no.14.

20. An advertisement placed presumably by Turner in the *Diario di Roma* dated 17 December 1828 indicates that he intended to show only two landscapes ('paesaggi') for one week from 18 December, *Diario di Roma*. In the event, there may have been more. Gage 1969, p.247, n.143, suggests that these were *View of Orvieto* and *Regulus*.

21. R.B. Gotch, *Maria, Lady Callcott*, London, 1937, p.280; also David Laing, *Etchings by Sir David Wilkie and Andrew Geddes*, Edinburgh, 1875, pp.21–2.

22. Thomas Uwins to Joseph Severn, 3 February 1829, see Sarah Uwins, *A Memoir of Thomas Uwins* RA, London, 1858, vol.2, p.239.

23. Joseph Anton Koch, *Moderne Kunstchronik*, Velten, 1834 (ed. Jaffé, 1905), pp.109–10. The English translation quoted here is by John Gage, in Gage 1969, pp.104–5 and p.247, n.147.

24. Gage 1987, p.8.

25. '"Remarks" Italy' sketchbook, CXCIII, p.99.

26. Gage 1980, 147, 149 and 154.

27. Gage 1980, 154. Cochetti and Minardi are listed in Enrico de Keller, *Elenco di Tutti gli Pittori Scultori Architetti Miniatori Incisori in Gemme e in Rame Scultore in Metallo e Mosaicisti aggiunti gli Scalpellini Pietrari, Perlari ed Altri Artefici … Essitenti in Roma l'Anno 1824*, Rome, 1824.

28. B&J 1984, 296–8, and landscapes, 299–317.

29. Turner to Sir Thomas Lawrence, postmarked in England 15 December 1828, Gage 1980, 144.

30. Henry Sass, *A Journey to Rome and Naples*, London, 1818, p.120.

31. Turner to Charles Heath, 28 November 1828, Gage 1980, 145.

32. Turner to Charles Eastlake, 16 February 1829, Gage 1980, 147.

33. 'Roman and French Note Book' sketchbook, CCXXXVII, p.8a-9.

34. Turner to Charles Eastlake, 16 February 1829, Gage 1980, 147

35. 'Rimini to Rome' sketchbook, CLXXVIII. This was given by Finberg to the 1819/20 tour of Italy, but it has now been correctly assigned to January 1829. Strictly speaking it should be retitled 'Rome to Rimini', as the order of the drawings reflects this.

36. Sarah Uwins, *A Memoir of Thomas Uwins* RA, London, 1858, vol.2, p.240.

37. Charles Eastlake to Maria Callcott, 5 November 1828, V&A, National Art Library, 86.PP.14.

38. Turner to Charles Eastlake, 2 May 1829, Gage 1980, 149.

39. Turner to Charles Eastlake, 11 August 1829, Gage 1980, 154.

40. Ibid. He refers to Ugo as 'Chevalier Ugo'. The friends he names are the artists Penry Williams, Andrew Geddes, Andrew Wilson, William Theed, and Mr and Mrs Joseph Severn.

1. B&J 1984, 302–8.

2. There is only a 5mm variation vertically between them, while their horizontal dimension has a 225 mm variation between the longest and the shortest.

3. Turner to Charles Eastlake, 16 February 1829, Gage 1980, 147.

4. Turner to Clara Wheeler, 19 March 1829, Gage 1980, 148.

5. John Ruskin, *Notes on the Turner Collection of Oil-Pictures*, London, 1856, 13.136.

6. Gage 1969, pp.95–6.

7. *Morning Herald*, 5 May 1829.

8. Turner to Charles Eastlake, postmarked 2 May 1829, Gage 1980, 149.

9. Turner to Charles Eastlake, 11 August 1829, Gage 1980, 154.

10. The copy is inscribed 'From the publisher'.

11. J. J. Blunt, *Vestiges of Ancient Manners and Customs, Discoverable in Modern Italy and Sicily*, London, 1823. Copy formerly owned by Turner, p.40.

12. Ibid., p.211.

13. Ibid., p.83.

14. Ibid., p.261. 'Columella' is the Roman writer on viticulture, Lucius Lunius Moderatus Columella, alluded to in Blunt's text.

15. James Thomson, Castle of Indolence, Verse 27.

16. 'Dan' here is an archaic term of honour, meaning 'Master'. It is still used in Spanish, as 'Don'.

17. Humphry Davy, *Consolations in Travel, or the Last Days of a Philosopher*, London, 1830, p. 24–7.

18. Conflicting evidence has suggested that these are two distinct paintings, but it is now generally accepted that they are one and the same. For a full analysis see B&J 1984, nos. 354 and 376, and Gage 1987, pp.224–7. See also James Hamilton, *Turner and the Scientists*, exhibition catalogue, Tate, 1998, pp.71–2.

19. Thornbury 1897, p.105,

20. B&J 1984, 378 and 379.

21. National Gallery of Art, Washington DC, B&J 1984, 380.

THE LIGHT OF VENICE
PAGES 91–101

1. See B&J 1984, 349 and 352.

2. See B&J 1984, 356.

3. Julian Treuherz, 'The Turner Collector: Henry McConnel, Cotton Spinner', *Turner Studies*, vol.6, 1986, no.2, pp.37–42.

4. Warrell 2003, pp.255–7.

5. One vignette, *Venice*, was painted for engraving by Edward Goodall for Rogers's extended poem *Italy*, 1830.

6. Lines by Turner from his unfinished poem 'Fallacies of Hope', appended to his painting *The Sun of Venice Going to Sea*, B&J 1984, 402.

7. 'Venice up to Trento' sketchbook, CCCXII, and 'Venice' sketchbook, CCCXIV, see Warrell 2003, p.258.

8. The dating of the six watercolours which may have been made in 1833 is uncertain, see Warrell 2003, pp.19 and 258.

9. This building now houses the administrative offices of the Venice Biennale.

10. GPV, 21 August, and 4 September 1840.

11. H.M. Cundall (ed.), *William Callow: An Autobiography*, London, 1908, p.66–7.

RADICAL OLD MAN · PAGES 103–109

1. Turner to George Cobb, 7 October 1840, Gage 1980, 238.

2. Used as the seal on the envelope containing his letter to Clara Wheeler, 12 December 1840, British Library Add. MS 50119, fo.45, Gage 1980, 239 [erroneously dated in Gage 21 Dec 1840]. Illustrated in Hamilton 2003 A, fig.90.

3. Turner to William Miller, 22 October 1841, Gage 1980, 246.

4. Gillian Forrester, *Turner's 'Drawing Book', The Liber Studiorum*, Tate, 1996.

5. B&J 1984, 513.

6. In French this is *La Muette de Portici (The Dumb Girl of Portici)*. Sheila M. Smith, 'Contemporary Politics and "The Eternal World" in Turner's *Undine* and *The Angel Standing in the Sun*', *Turner Studies*, vol.6, 1986, no.1, pp.40–50.

7. The spelling of Masaniello in the title is Turner's own.

8. Hamilton 2003 A, p.55–6.

9. Hamilton 2007, chapter 14.

10. This reading has been disputed. I have followed Finberg's transcription, while Gage prefers 'No matter what bit Hannibal Elia [?] preferred the Alps September 3 1844 WB and JMWT.' 'Grindelwald' sketchbook, CCCXLVIII, p.17. Frankly, Finberg's reading makes more sense. Gage 1987, p.246, n.30 ('Grindelwald' sketchbook reference given erroneously here as CCXLVIII) suggests that 'Fombey' could be a mis-hearing of Pommat or Formazza.

11. *Mercury Sent to Admonish Aeneas*, B&J 1984, 429; *Aeneas Relating his Story to Dido* (destroyed), B&J 1984, 430; *The Visit to the Tomb*, B&J 1984, 431; and *The Departure of the Fleet*, B&J 1984, 432.

AN ITALIAN TREASURY
PAGES 111–117

1. *Snow Storm, Mont Cenis*, 1820 (Birmingham Museum and Art Gallery) and *Messieurs les voyageurs on their Return from Italy (par la diligence) in a Snow Drift upon Mount Tarrar – 22nd of January, 1829* (The British Museum, London).

2. The sketchbooks from 1819 are: 'Route to Rome' sketchbook, CLXXI; 'Italian Guide Book' sketchbook, CLXXII; 'Paris, France, Savoy' sketchbook, CLXXIII; 'Turin, Como, Lugarno, Maggiore' sketchbook, CLXXIV; 'Milan to Venice' sketchbook, CLXXV; 'Venice to Ancona' sketchbook, CLXXVI; 'Ancona to Rome' sketchbook, CLXXVII; 'Tivoli and Rome' sketchbook, CLXXIX; 'Vatican Fragments' sketchbook, CLXXX; 'Como and Venice' sketchbook, CLXXXI; 'Albano, Nemi, Rome' sketchbook, CLXXXII; 'Tivoli' sketchbook, CLXXXIII; 'Gandolfo to Naples' sketchbook, CLXXXIV; 'Pompeii, Amalfi, Sorrento and Herculaneum' sketchbook, CLXXXV; 'Naples, Paestum and Rome' sketchbook, CLXXXVI; 'Naples: Rome Colour Studies' sketchbook, CLXXXVII; 'St Peter's' sketchbook, CLXXXVIII; 'Rome: Colour Studies' sketchbook, CLXXXIX; 'Small Roman C.Studies' sketchbook, CXC; 'Rome and Florence' sketchbook, CXCI; 'Return from Italy' sketchbook, CXCII; 'Remarks (Italy)' sketchbook, CXCIII; 'Passage of the Simplon' sketchbook, CXCIV.

3. The sketchbooks from 1828 are: 'Orleans to Marseille' sketchbook, CCXXIX; 'Lyon to Marseille' sketchbook, CCXXX; 'Marseille to Genoa' sketchbook, CCXXXI; 'Coast of Genoa' sketchbook, CCXXXII; 'Genoa and Florence' sketchbook, CCXXXIII; 'Florence to Orvieto' sketchbook, CCXXXIV; 'Rimini to Rome' sketchbook, CLXXVIII; 'Rome, Turin and Milan' sketchbook, CCXXXV; 'Viterbo and Ronciglione' sketchbook, CCXXXVI; 'Roman and French Notebook' sketchbook, CCXXXVII.

4. For example, eleven of the 1819 sketchbooks are approximately 111 x 186mm, a size described by Peter Bower as 'Post Octavo', see Bower 1990, pp.115–6. The smallest book is the 1828 'Roman and French' sketchbook (71 x 88mm) and the largest is the 1819 'Naples: Rome Colour Studies' sketchbook (406 x 225mm).

5. 'Italian Guide Book' sketchbook, CLXXII; Powell 1987, p.14.

6. Eustace 1813, p.liv.

7. Eustace 1813, p.xlviii.

8. H.A.J. Munro, quoted in Hill 2000, p.263.

9. For example in the 'Ancona to Rome' sketchbook, CLXXVII, folio 11 is inscribed 'Calterola' for Caldarola, folio 19 is inscribed 'Reginia' and 'Potensia' for Helvia Recina and the river Potenza, folio 36 is inscribed 'Pissegnio' meaning Pissignano, folio 37 'S Jacomo' refers to San Giacomo and folio 47a 'Pio di Lugo' for Piedilcuo.

10. As reflected by previous scholars studying Turner in Italy, for example Finberg 1909 and 1930, Ashby 1925, Wilton 1982, Powell 1987, Hamilton 1997, and Warrell 2003.

11. Turner to Sir Thomas Lawrence, postmarked 15 December 1828, reproduced in Gage 1980, no.144, p.122.

12. As Cecilia Powell has argued, this is probably because such an exercise would have constituted a waste of his time. Reproductive images of Michelangelo's mighty frescoes were so readily available that it would not have represented good use of his energies to sketch images accessible through other sources, see Powell 1987, pp.66–7.

13. Joseph Addison, *Remarks on Several Parts of Italy & Co. In the Years 1701, 1702, 1703*, third edition, London, 1726 p.176, quoted in Cubberley and Herrmann 1992 p.39.

14. 'Ancona to Rome' sketchbook, CLXXVII 6, see Powell 1987, p.29, reproduced with photograph of modern-day Osimo.

15. For example, 'Albano, Nemi, Rome' sketchbook,

CLXXXII 15 a, 26a, and 28a.

16. For example, 'Tivoli to Rome' sketchbook, CLXXIX 41, and 49a.

17. *Rome, Tomb of Cecilia Metella*, 1818 (Private Collection), W709, based upon Hakewill's drawing, reproduced in Cubberley and Herrmann 1992, no.3.27, p.208. Engraved for Hakewill's *Picturesque Views in Italy*, R153.

18. British School at Rome, Library, reproduced in Cubberley and Herrmann 1992, nos.3.36, 3.37, 3.38 and pp.217–9.

19. Manchester City Galleries, W1214, engraved by Edward Finden for *Landscape Illustrations ... of Lord Byron*, 1833–4, R410.

20. 'Turin, Como, Lugarno, Maggiore' sketchbook, CLXXIV and 'Passage of the Simplon' sketchbook, CXCIV. I am grateful to Federico Crimi and James Hamilton for confirming this route.

21. Cubberley and Hermann 1992, nos.1.35–1.37 and pp.109–111.

22. 'Route to Rome' sketchbook, CLXXI 3.

23. Sketches from 'Turin, Como, Lugarno, Maggiore' sketchbook, CLXXIV 88a-91, relate to *The Simplon* (whereabouts unknown), W1112, engraved by W. Miller, R535.

24. In the 'Ancona to Rome' sketchbook, CLXXVII there are no identifiable sketches after Nepi until a sketch labelled 'Primero V. of Roma', CLXXVII 85a-86, and a view of the medieval Torre del Cornacchie (Tower of Crows) on the Via Cassia, CLXXVII 86a.

25. Jeremy Black, *The British and the Grand Tour*, Dover, 1985, p.5.

26. 'Albano, Nemi, Rome' sketchbook, CLXXXII 53; 'St Peter's' sketchbook, CLXXXVIII 22; and 'Small Roman Colour Studies' sketchbook, CXC 8.

27. 'Vatican Fragments' sketchbook, CLXXX 6.

28. 'Rome: Colour Studies' sketchbook, CLXXXIX 9, 19; 'Small Roman Colour Studies' sketchbook, CXC 4.

29. 'Rome: Colour Studies' sketchbook, CLXXXIX 20, 23, 29, 43a.

30. 'St Peter's' sketchbook, CLXXXVIII 73a-74; 'Rome: Colour Studies' sketchbook, CLXXXIX 37, 50.

31. 'Rome: Colour Studies' sketchbook, CLXXXIX 28, 44.

32. 'Small Roman Colour Studies' sketchbook, 14a, 18, and 38; 'Rome: Colour Studies' sketchbook, CLXXXIX 13, and 51.

33. 'Rome: Colour Studies' sketchbook, CLXXXIX 58.

34. Cecilia Powell has argued that the paucity of sketches in Florence and Turner's unwillingness to use colour may have been due to the fact he first visited in December when temperatures discouraged working out-of-doors, see Powell 1987, p.93.

35. 'Rome and Florence' sketchbook, CXCI.

36. 'Genoa and Florence' sketchbook, CCXXXIII and 'Florence to Orvieto' sketchbook, CCXXXIV.

37. Starke 1828, p.255.

38. Eaton 1820, vol.3, p.339.

39. In a letter to his father dated 15 November 1819, Sir John Soane's son wrote, 'Turner was in the neighbourhood of Naples, making rough pencil sketches to the astonishment of the fashionables who wonder of what use these rough draughts can be – simple souls!' The *London Magazine* of 1820 remarked on Turner's reluctance to permit access to his sketchbooks, see Powell 1987, p.50 and pp.202–3, note 34. Turner's friend Henry Scott Trimmer described the 'outline' drawings in sketchbooks 'which he [Turner] used to say no one could make out but himself', quoted in Thornbury 1970, p.364.

40. See Ashby 1925, p.2.

41. See Finberg 1909, vol.I, pp.516, 520, 524, 526, 542, 546, and 550.

42. Thornbury 1970, p.484.

TURNER AND MUNRO OF NOVAR
PAGES 119–127

1. B&J 1984, 366.

2. For Novar see Anonymous 1847; Anonymous 1857; Armstrong 1902; B&J 1984; Finberg 1961; Frost and Reeve 1865; Gage 1980; Gage 1987; Garlick 2004; Hamilton 1997; Hill 2000; Holloway 1991; Irwin 1982; Lyles 1992; Miller 2007; Redford 1888; Sebag-Montefiore 2001; Thornbury 1877; Waagen 1838; Waagen 1854; Warrell 2003; Whittingham 1987; Whittingham 1996; Wilton 1979; and Wilton 1987. To these sources can be added the obituary that appeared in the *Inverness Courier* on 1 December 1864. It should be noted that Lloyd Williams 1992 and Humfrey 2004 mistakenly confuse him with his son (1819–1895), who shared his name, and who became a distinguished classical scholar in Cambridge.

3. Irwin 1982, p.62; Whittingham 1987, p.275; and Holloway 1991, p.13.

4. Novar's first London home was in Park Street, near Grosvenor Square. By 1857 he had moved to Hamilton Place, Piccadilly; it can be inferred from the description given in Anonymous 1857, p.133 that this house included a studio in which he did his own painting.

5. Quoted in Holloway 1991, p.12.

6. Robertson 1978, p.291.

7. Frost and Reeve 1865, p.9. It appears this work was withdrawn from the 1878 sale of Novar's collection because it was recognised as a copy; see Redford 1888, p.275.

8. Iniguez 1981, p.308, and Brown and Mann 1990, pp.105–9.

9. Sebag-Montefiore 2001, p.195 notes that Novar bought works at the auctions of the collections of Lord Northwick (1838), the Duke of Lucca (1840), Stowe (1848) and Samuel Rogers (1856).

10. Frost and Reeve 1865, pp.61–130, and Holloway 1991, p.10.

11. Frost and Reeve 1865, pp.101–3, and Gellér 1996. Turner shared Novar's high opinion of Brocky; see Delia Millar, *The Victorian Watercolours and Drawings in the Collection of Her Majesty The Queen*, London, 1995, vol.I, p.134.

12. Gage 1987, pp.3 and 244.

13. Gage 1980, p.103 and pp.272–3.

14. Holloway 1991, p.13; Whittingham 1987, p.275.

15. B&J 1984, 367. This suggestion was made to Ruskin in a letter from Munro of Novar (Ruskin Library, University of Lancaster, MSS 54C). A second letter from the collector to Ruskin survives in the same collection (MSS 54E); both are transcribed in full in Hill 2000, pp.262–3.

16. Novar had a number of children: the most prominent was his son who shared his name and became a classical scholar; see note 2. Turner had two illegitimate daughters, Evelina and Georgiana.

17. For the fullest account of this journey see Hill 2000, pp261–30.

18. Finberg 1961, p.360

19. Novar's own drawings appear to have disappeared, although some works have been claimed as examples of his draughtsmanship.

20. Thornbury 1877, pp.103–4.

21. John Ruskin, *Modern Painters*, final volume, cited in Finberg 1961, p.361.

22. The oil paintings were: B&J 1984, 12, 38, 46, 150, 348, 362, 365, 366, 371, 374, 375, 379, 385, 388, 407, 415, 428 and 550. For the watercolors see Frost and Reeve 1865.

23. B&J 1984, 46 and 150.

24. Thornbury 1877, p.105, and B&J 1984, 362.

25. Recently acquired by the Ashmolean Museum, Oxford.

26. Anonymous 1847, p.255.

27. Anonymous 1847, p.253.

28. Anonymous 1847; Anonymous 1857; Frost and Reeve 1865.

29. Brigstocke 1978.

30. Nicholas Penny, *National Gallery Catalogues, The Sixteenth Century Italian Paintings, vol. II, Venice 1540–1600*, National Gallery, London, 2008, p.393.

31. Whittingham 1987, pp.275–6.

32. Thornbury 1877, p.104.

33. Thornbury 1877, p.140.

34. Thornbury 1877, p.228.

35. B&J 1984, 252.

36. B&J 1984, 401.

37. B&J 1984, 428, and Thornbury 1877, pp.105, 581 and 597.

38. Sebag-Montefiore 2001, p.195 notes that the sales were held at Christie's in May 1867, June 1877, April 1878, June 1878, and March 1880. Some sales from the collection were also made in 1860, during Novar's lifetime; see Redford 1888, p.270

39. Miller 2007 pp.25–6.

40. Redford 1888, p.270.

41. Redford 1888, p.278.

THE ROSEBERY TURNERS
PAGES 129–134

1. Lining is a process by which a further canvas is glued to the back of the painting canvas to give extra support. The process in the past has generally involved heat, moisture and pressure, while the painting was placed face down on a table.

2. See also Martin Wyld and Ashok Roy, 'The Making of *The Fighting Temeraire*' in Judy Egerton, *Turner The Fighting Temeraire*, London, 1995, pp.121–3, for the only other published description of the technical examination of a pristine Turner oil painting.

3. In *Rome from Mount Aventine* there is a minor restoration from the 1970s confined precisely to distinct small areas of paint loss at the right-hand side and at the lower left-hand corner.

4. Examination has shown that Turner selectively applied very thin layers of varnish to passages of paint during execution to ensure the colours were wetted out fully before continuing the painting process. This is a common practice at this date for most artists. The finished paintings have never had a complete layer of varnish applied either by Turner himself or by a later hand.

5. B&J 1984, 379.

6. Munro of Novar was a friend of Turner and the only collector to accompany Turner to Italy.

7. B&J 1984, 378.

8. B&J 1984, 366.

9. B&J 1984, 365.

10. B&J 1984, 367.

11. After Munro's death in 1864, his collection was sold at a series of sales in London between 1867 and 1880.

12. Joyce H. Townsend, *The Materials of J.M.W. Turner: priming and supports*, Studies in Conservation No 39, 1994, pp.145–53.

13. The top of the canvas is a selvedge: the edge of a fabric is woven so that it will not fray or ravel.

14. A stretcher is a wood framework that allows tensioning of the canvas, in contrast to a strainer that has fixed corners and does not. This is consistent with all works on canvas by Turner.

15. Personal communication with Stephen Hackney at Tate, London.

16. B&J 1984, pp.170–4.

17. Joyce Townsend in her PhD thesis notes that the two canvases of notable dimensions are recorded as being stretched and attached by sprigs. These two works can be related by their specific sizes to a letter from Turner to Charles Eastlake asking for canvases to be ordered and ready for him when he arrived in Rome. A further work, *Judith and the Head of Holofernes* is of the same size as *Rome from Mount Aventine* and is also detailed as having holes in the canvas edges that appear to be left from an earlier attachment with sprigs. This painting is thought to be a work painted in Rome from 1829.

18. Personal communication with Michael Pierce at the National Gallery of Art, Washington DC.

19. A Tate conservation record from 1962, recording information during lining of this work, notes a canvas stamp, Brown/163. High Holborn/London., on the reverse of the painting canvas. This address and the stamp's format were used for materials produced from 1838 confirming that this painting was produced in England. The stamp would only have been revealed during the lining process as this necessitates the removal of the loose lining from its stretcher and would show the hidden reverse of the painting canvas.

20. Personal communication with Joyce Townsend. Of the 210 works on canvas listed in Townsend's PhD thesis, it is clear that after the early 1820s works by Turner generally have discoloured but originally had white primings.

21. Personal communication with Joyce Townsend, regarding information in her PhD thesis. Of the 210 works on canvas spanning Turner's complete oeuvre that are listed in Townsend's thesis, only eleven remain unlined in 1991.

22. Megilp is jelly-like material comprised of linseed oil prepared with a lead containing drier, and mastic varnish. It is added to paint by artists to give it more body and to enable it to produce thick glaze colours as well as thin washes when it is brushed out.

23. Dryers or siccatives are materials that will speed up the drying of oil paint. At this date, driers mostly contained lead compounds.

24. 'Rimini and Rome' sketchbook, CLXXVIII, 4a–7.

25. Powell 1987, p.106.

26. Infrared reflectography allows layers below the paint to be seen. This technique can reveal drawing and under layers that are not seen in visible light.

27. Powell 1987, p.160. Powell records that the building is the hospice of S. Michel which was completed around 1800.

28. Frank Salmon, 'Storming of Campo Vaccino': British Architects and the Antique Buildings of Rome after Waterloo, *Architectural History*, vol.38, 1995, pp.146–75.

Acknowledgements

Planning this exhibition has been a joy from day one. There are countless people to thank, in Scotland, England and Italy: at the National Galleries of Scotland, principally Janis Adams, Christopher Baker, Anne Buddle, Michael Clarke, John Leighton, Elinor McMonagle, Helen Monaghan, Jacqueline Ridge, Charlotte Robertson, Olivia Sheppard and Helen Smailes; and at Ferrara, Andrea Buzzoni, Maria Luisa Pacelli. Alessandra Cavallaroni, Tiziana Giuberti, Barbara Guidi, Ilaria Mosca, Federica Sani, Chiara Vorrasi and all the staff of the Galleries of Modern and Contemporary Art and Ferrara Arte. I spent two happy weeks at the British School at Rome, where Maria Pia Malvezzi, Susan Russell, Valerie Scott, Andrew Wallace-Hadrill and Geraldine Wellington were always helpful and welcoming, as was Angela Cipriani at the Accademia di San Luca, Edith Cicerchia, Maria Serlupi Crescenzi and all the staff at the Vatican Museums. Federico Crimi generously shared his research on Turner's 1819 route around the Italian lakes. At Tate Britain I met support and encouragement at every turn, from Julia Beaumont-Jones, David Brown, Stephen Deuchar, Matthew Imms, Nicola Moorby (for particular help in transcribing Turner's tortuous handwriting) Ian Warrell and Andrew Wilton. Friends and colleagues at the University of Birmingham include Clelia Boscolo, Anna Maria Bucci, Professor Michael Caesar, Paolo De Ventura, Clare Mullett, Jonathan Nicholls and Gerry Slowey.

My warm thanks for support, advice and hospitality go also to Sir Nicholas and Lady Bacon, Julian and Isabel Bannerman, Chloe Blackburn, Louise Brodie, Philip and Carol Brodie, Iain G. Brown, Lord Egremont, Christopher Hamilton, Colin Harrison, David Hill, Giacomo, Marina and Valentina Ivancich Biaggini, Ian Ker, Alison and Andrew Kinghorn, Alison McCann, David McClay, Marco and Angelica Manfredi, Anna Manieri, James and Mary Miller, Andrew Moore, Felicity Owen, Catherine Payling, Mark Pomeroy, Donald and Shirley-Anne Sammut, Nancy Scott, Sarah Taft, Rosalind Turner and Andrew Wyld.

My love and thanks as always to Kate and Marie Hamilton and Tahima Rahman, fellow travellers on our reconstruction in 2007 of Turner's 1819 route to Rome. My chapters are dedicated to the memory of Patrick Hamilton, painter and teacher, 1923–2008.

JAMES HAMILTON

Index of Names

ANGERSTEIN, John Julius (1735–1823), banker and collector 14

AUBER, Daniel (1782–1871), opera composer 104, 108

BANKS, Thomas RA (1735–1805), sculptor 69

BECKFORD, Sir William (1760–1844), collector and landowner 14

BERNINI, Gianlorenzo (1598–1680), artist 58

BLUNT, Revd John James (1794–1855), parson and writer 81, 82

BONINGTON, Richard Parkes (1801/2–1828), artist 124

BONOMI, Joseph (1739–1808), architect 14

BOURGEOIS, Sir Francis, RA (1756–1811), artist 27

BROCKENDON, William (1787–1854), artist, inventor and traveller 109

BYRON, Lord (1788–1824), poet 9, 33, 40, 42, 101

CALLCOTT, Alexander Wall (1779–1844), artist 43, 69

CALLCOTT, Maria see Graham, Maria

CAMPBELL, Thomas (1791–1858), sculptor 69, 74

CANOVA, Antonio (1757–1822), sculptor 10, 40, 52, 74

CAREY, William (1759–1839), writer 37

CHANTREY, Sir Francis, RA (1781–1841), sculptor 24, 41–2, 45, 52, 67, 70, 73

CLAUDE Lorrain (1600–1682), artist 10, 14, 32, 59, 113

CONSALVI, Cardinal (1757–1824), papal secretary of state 52

COOKE, George (1781–1834), engraver 31, 53, 59

COZENS, John Robert (1752–1797), artist 14, 17

DANBY, Sarah (1760?–1861), mother of Turner's daughters 23

DARLINGTON, Earl of (1766–1842), collector and landowner 20

DAVY, Sir Humphry (1778–1829), scientist and teacher 45–6, 48–9, 52, 67, 70, 83, 86

DAY, Alexander (1745–1841), artist and dealer 52

DOBREE, Samuel (1759–1827), banker and collector 24

DOMENICHINO (1581–1641), artist 19, 20

DONALDSON, Thomas (1795–1885), architect 44–5, 48

DURNO, James (1745–1795), sculptor 69

EASTLAKE, Sir Charles (1793–1865), artist 45, 69, 73, 76

EGREMONT, Lord (1751–1837), collector and landowner 69, 70, 74, 120–1

EUSTACE, Revd John Chetwode (c1762–1815), priest and writer 34, 36, 111

EWING, William (active 1820s), sculptor 73, 74

FARADAY, Michael (1791–1867), scientist and teacher 48–9, 67

FARINGTON, Joseph (1747–1821), artist and diarist 19, 22, 24, 52, 55

FAWKES, Walter (1769–1825), landowner, collector and politician 20, 24–5, 37, 53, 59, 63, 64, 120–1

FIELD, George (1777–1854), scientist and colourman 67

FLAXMAN, John, RA (1755–1826), sculptor 45

GIBSON, John, RA (1790–1866), sculptor 73, 74

GIULIO Romano (1492 or 1499–1546), artist 125

GOTT, Joseph, RA (1785–1860), sculptor 73, 74

GRAHAM, Captain Thomas 44, 59

GRAHAM, Maria (later Mrs Callcott) (1785–1842), traveller and writer 44, 45, 52, 59, 69

HAKEWILL, James (1778–1843), archtect and artist 34, 36, 36, 37, 47, 59, 60, 114, 114

HARDWICK, Thomas the Younger (1752–1829), architect 14

HEATH, Charles (1785–1848), engraver 59, 70

HILTON, William (1786–1839), painter 63

HOARE, Sir Richard Colt (1758–1838), collector and landowner 14, 32, 34

HOLWORTHY, James (1780–1841), artist 63, 66

HULLMANDEL, Charles (1789–1850), lithographer and printer 67

JACKSON, John RA (1778–1831), artist 41–2

JONES, George, RA (1786–1869), artist 65, 67, 69

KOCH, Josef Anton (1768–1839), artist 74–5

LAWRENCE, Sir Thomas, PRA (1769–1830), artist 36, 42, 52, 75, 112

LEICESTER, Sir John (1762–1827), collector and landowner 24, 25, 120I

LOWSON, Newbey (c1773–1853), collector and amateur artist 20, 22

MACDONALD, Lawrence (1799–1878), sculptor 74

MARTIN, John (1789–1854), artist 86, 108

MILLER, William (1796–1882), engraver 103

MONRO, Dr Thomas (1759–1833), physician and collector 14

MOORE, Thomas (1779–1852), poet and diarist 46–7

MUNRO of Novar (1797–1864), collector and landowner 89, 108, 119–27, 120, 129

MURRAY, John (1778–1843), publisher 33, 34, 45, 53, 60, 81, 83

NORTHCOTE, James, RA (1746–1831), artist 65

OPIE, John (1761–1807), artist 19

PETER, Wenzel (1745–1829), artist 75, 77

PHILLIPS, Tomas, RA (1791–1845), artist 63, 64

PIRANESI, Giovanni Battista (1720–1728), architect 14, 43

POPE, Alexander (1688–1744), poet 80

PRINCE REGENT (later George IV) (1762–1830) 52–3

PYE, John (1782–1874), engraver 67

RAIMBACH, Abraham (1776–1843), engraver 19

RAPHAEL (1483–1520), artist 52–3, 55, 58

RENNIE, George (1802–1860), sculptor 73, 74

REYNOLDS, Sir Joshua, PRA (1723–1792), artist 14

ROBINSON, J.O. (fl.1818–25), engraver 60, 63

ROGERS, Samuel (1763–1855), banker and poet 60

ROSEBERY, earls of 129

RUBENS, Peter Paul (1577–1640), artist 124

RUSKIN, John (1819–1900), writer and critic 11, 29, 101, 117, 122, 123

SASS, Henry (1787–1844), collector, writer and teacher 34, 52

SCOTT, Sir Walter (1771–1832), novelist and poet 120, 123

SEVERN, Joseph (1793–1879), artist 74

SHEE, Martin Archer, PRA (1769–1850), artist 19

SMITH, John Raphael (1752–1812), artist 120

SOANE, John, RA (1753–1837), architect 14, 24, 25, 53, 66

SOMERVILLE, Mary (1780–1872), scientist and writer 44

SPENCER, George, 2nd earl (1758–1834), statesman and president of Royal Institution 46

TADOLINI, Adamo (1788–1868), sculptor 74

THOMSON, James (1700–1748), poet 30–1, 82–3, 89

THOMSON, Revd John (1778–1840), painter 127

THORNBURY, Walter (1828–1876), Turner's first biographer 27, 89, 117, 121

THORVALDSEN, Bertel (1770–1844), sculptor 73, 74

TITIAN (1487/90–1576), artist 19–20, 20, 23

TRIMMER, Revd Henry Scott (c1780–1859), parson and friend of Turner 27

TURNER, Dawson (1775–1858), banker, collector and naturalist 63

UGO, Giuseppe (b.1785), sculptor 44, 69, 77

UGO, Scipione (1808–1855), sculptor 151

UNWINS, Thomas (1782–1857), artist 70

WELLS, Clarissa (Mrs Wheeler) (c.1790–c.1871), amateur artist and friend of Turner 79

WELLS, William (1764–1836), father of artist Clarissa Wells 65

WEST, Sir Benjamin, PRA (1738–1820), artist 19

WESTMACOTT, Richard, RA (1775–1856), sculptor 74

WICAR, John-Baptist Joseph (1762–1834), artist 74

WILKIE, Sir David, RA (1785–1841), artist 24, 63

WILLIAMS, Penry (1802–1885), artist 74

WILSON, Richard (1712/13–1782), artist 17, 17, 42, 45, 63, 111, 112

WOOLLETT, William (1735–1785), engraver 63

WYATT, James (1746–1813), architect 14, 25

WYATT, Richard (1795–1850), sculptor 73, 74

YARBOROUGH, Lord (1749–1823), collector and landowner 20, 24, 25

Index of Places

In the indexes numbers in italics refer to images.

Albano 49
Lake Albano *112*
Alps 20–2, *21–2*, 32, *32*, 76, 77, 103, 108, 109, 111, 114
Ancona 48, 49
Aosta 13, *14*, 22, 29, 103, 108, 109
Aosta Valley 25, 32, *102*, 108, *108*, 121, *121*
Apulia 32
Ariccia (?) *74*
Arras 121
Assisi *37*
Aventine Hills 89
Bay of Baiae 65, *65*, 81, 114
Bay of Naples *36*, 80, 103
Bologna 42, 76–7
Bonneville *24*, 121, 122, *122*
Carrara 42, 45, 69
Carthage 32, *33*
Cesena *41*, 42
Chalons-sur-Saône 39
Chamonix *21*, 121
Chaumont 121
Civita Castellana 42
Cologne 65
Convent of San Salvatore *15*, 17
Cornwall 31
Cromarty Firth 120
Devon 31
Dieppe 65
Dijon 121
Dolbadern Castle *16*, 17
Domodossola 114
Edinburgh 63, *63*
Faenza *40–1*, 42

Fano 42
Ferrara 42
Fiorenzuola 77
Florence *36*, *60*, 114, 117
Foligno 42
Forlî 42
Forlimpopoli 42
Geneva 121
Genoa *61*
Gibside 34, *34*
Gondo 114
Holland 80
Hythe 63, *63*
Imola 42
Isleworth 27
Lake Albano *112*
Lake Avernus (Lago d'Averno) *30*, 31, 32, 87
Lake Como 39, 40
Lake Maggiore 39
Lake Nemi *75*, 76
Lancaster *62*, 63
London 59
Loreto 79
Louvre 19–20, 23
Macerata 77
Macon *23*
Marseille 69, 70
Mergellina 49
Milan 39, 40, *41*, 114
Minehead *54*, 63, *63*
Mont Blanc *122*
Mont Cenis 77
Mont Tarate 77
Naples *47*, 48, 59, 104, 112, *113*, 117
Narni 42, 103
Orvieto 70
Oxford 13, *13*
Padua 42

Palestrina *68*, 69, *71*
Paris 19, 22–3, 39
Passy 39
Perugia *37*
Pesaro 42
Petit St Bernard Pass 29
Pisa 80
Pissignano *112*
Recanati 79
Rheims 121
Richmond 30, *62*, 63, 67
Rimini 42
Rome *12*, *15*, 17, *17*, *38*, 42–8, *43*, *44*, *46*, *47*, 48, 49, *50–1*, 52–3, 55, *56–8*, 59, 69–77, *78*, *84–7*, *86–7*, 89, 91–2, *110*, 114, *114*, 115, *115*, *128*, 129, *131–3*, 133–4
 Colosseum *14*, 47, *51*, 115, *116*
 Forum *26*, *35*, 65–6, *66*
 12 Piazza Mignanelli 69
 St Peter's 59, *59*
 Sistine Chapel 112–13, *113*
Rovigo 42
St Gothard Pass *18*, 22
San Giacomo *112*
Simplon Pass 114
Skye 108
Spoleto *37*, 42
Suffolk 80
Sunningwell 13
Taormina 109
Terni *37*, 42
Thames, River 27, *27*, 30–1, 67
Tivoli 45, 46, 49, *113*, *113*, *116*, 117
Tournus 39
Turin 39, 119

Twickenham 30, 63
Vatican 49, 52, 53, 55, 58
Venice 39–41, *41*, 59, 90, 91–101, *92–5*, *96–100*, 117, 123
 Rialto *8*, *40–1*, 55, 59, 64
Verona 39
Vesuvius *15*, 17, 48, 104
Vienna 82
Virginia Water 63, *64*
Vogogna 114
Wales 17